AN ANTHOLOGY OF
GRAPHIC FICTION,
CARTOONS, & TRUE STORIES

Edited by IVAN BRUNETTI

Yale University Press, New Haven & London

EDITOR: Ivan Brunetti
ASSISTANT EDITORS: Chris Ware and Laura Mizicko
KIBITZER: Daniel Raeburn
PRODUCTION ASSISTANTS: Jeremy Smith and John Kuramoto
ADDITIONAL PRODUCTION AND RESEARCH ASSISTANCE: Sarah Gleich, Chris Ware, Laura Mizicko, Tom Devlin, David Bernstein, Rebecca Rosen, Kim Thompson, Gary Groth, Eric Reynolds, Adam Grano, Greg Sadowski, Paul Baresh, Glenn Bray, M. Todd Hignite, and Daniel Boron-Brenner.

THANKS also to Tim Samuelson, Adele Kurtzman, King Features Syndicate, United Feature Syndicate, The Ohio State University Cartoon Research Library, Janey Fire and The American Folk Art Museum, Monte Frank, Jeannie Schulz, Geoffrey Hayes, The A+D Gallery of Columbia College Chicago (for hosting *The Cartoonist's Eye* exhibit, a preview of this book), Debra Riley Parr, Elizabeth Burke-Dain, Matt McClintock, John Upchurch, Chip Kidd, Bob Keck, Rob Stolzer, Alvin Buenaventura, David Mandel, Albert Moy, Denis Kitchen, Scott Eder, James Mortensen, Andrei Molotiu and the University of Louisville, The Pratt Manhattan Gallery, The Saul Steinberg Foundation, Janet Hicks, Karen Nangle, Kristine Anstine, Marc Crisafulli, Jonathan Bieniek, Chris Coffin, Phillip King, Lindsay Toland, The Center for Cartoon Studies, Chicago Comics, Quimby's, every single artist in this book, all the friends and family who offered emotional support (too numerous to list here, unfortunately), and John Kulka for suggesting this project in the first place and helping it come to fruition.

Many of these comics first appeared in books and magazines published by Fantagraphics Books, Drawn and Quarterly, Raw Books and Graphics, Pantheon Books, Highwater Books, Gingko Press, Doubleday Books, Henry Holt and Company, Last Gasp, Kitchen Sink Press, Top Shelf, and Alternative Comics, and this anthology is greatly indebted to all of them, as well as to these inspiring volumes: *The Smithsonian Book of Newspaper Comics*, *The Smithsonian Book of Comic-Book Comics*, and *McSweeney's No. 13*.

SPECIAL THANKS to Peter Birkemoe for allowing us to use an adapted version of The Beguiling's *15th Anniversary Print* as part of the dustjacket design. The Beguiling bookstore is located in Toronto, Canada.

DEDICATED TO: G. and R. B. Kruse
DUSTJACKET DESIGN AND ILLUSTRATIONS: Seth
CASE COVER: Karl Wirsum, *Odd Nancy Out* and *This Is Only a Slugged Question*
ENDPAPERS: Chris Ware, from *The Acme Novelty Library* (Pantheon Books, 2005)
FOLLOWING THREE PAGES: Marc Bell, *Supernatural Hot Rug and Not Used*
TABLE OF CONTENTS ILLUSTRATIONS: Onsmith

Set in Scala Sans by BW&A Books, Inc.
Printed in China through World Print.

LIBRARY OF CONGRESS CATALOGING-IN-PUBLICATION DATA
An anthology of graphic fiction, cartoons, and true stories / edited by Ivan Brunetti.
 p. cm.
ISBN-13: 978-0-300-11170-5 (cloth : alk. paper)
ISBN-10: 0-300-11170-3 (cloth : alk. paper)
1. Comic books, strips, etc.—United States—History—20th century. 2. Cartooning—United States—History—20th century. 3. American wit and humor, Pictorial—History—20th century. I. Brunetti, Ivan.
NC1764.5.U6A58 2006
741.5'69—dc22 2006014095

A catalogue record for this book is available from the British Library.

The paper in this book meets the guidelines for permanence and durability of the Committee on Production Guidelines for Book Longevity of the Council on Library Resources.

10 9 8 7 6 5 4 3 2 1

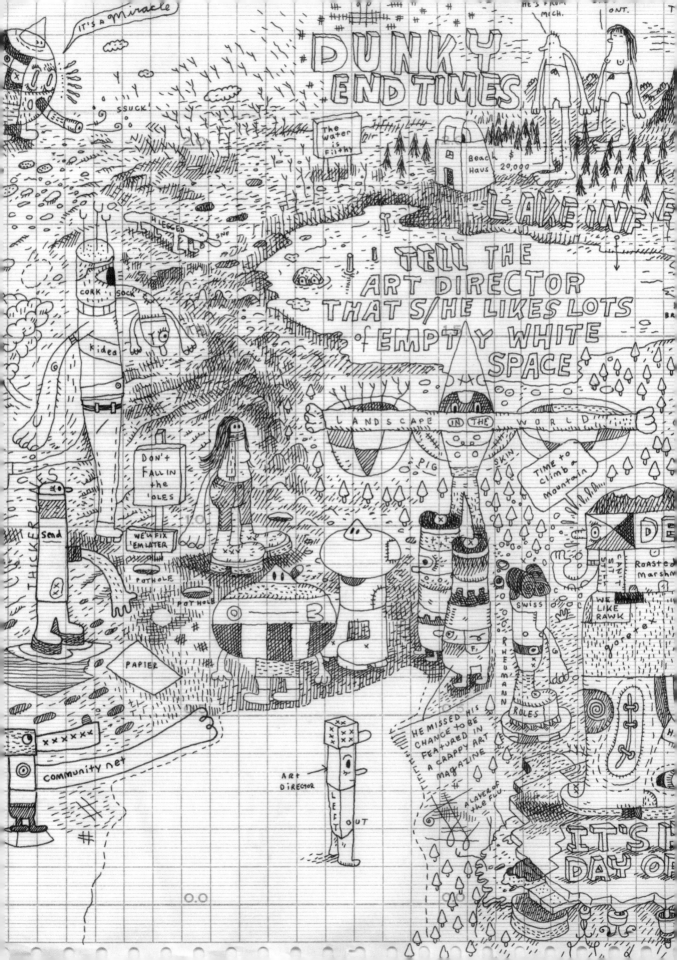

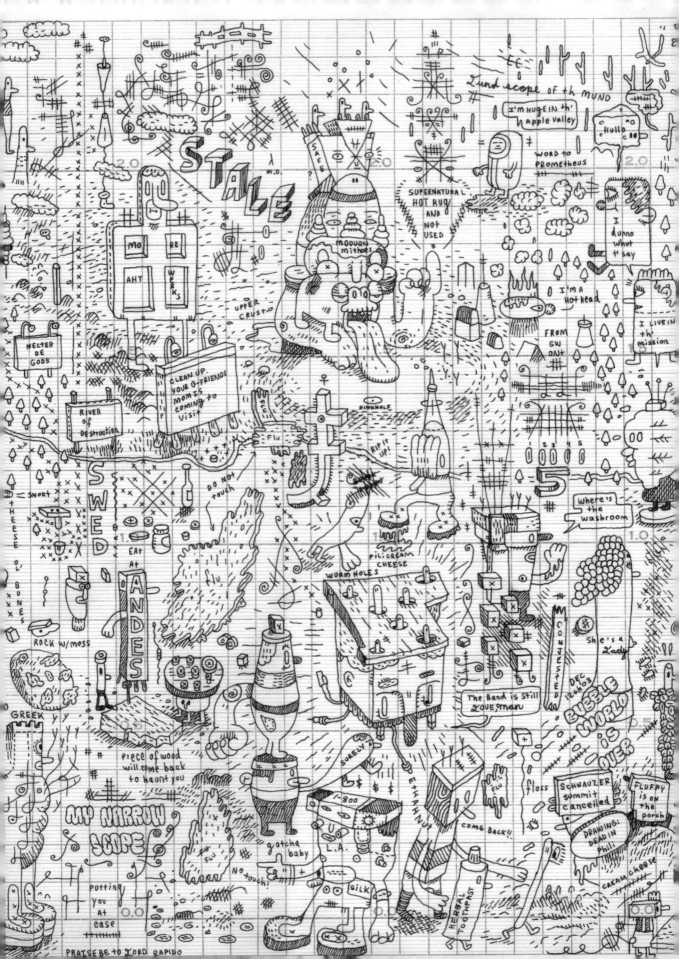

INTRODUCTION

Ivan Brunetti

As a cartoonist myself, and one plagued by an ever-present, crippling self-doubt and indecisiveness, it is nearly impossible to write anything objective, much less a mini-treatise. Cartooning is a relatively young art form, its many branches still evolving and bifurcating. The absolutist statements jotted in my notebooks furiously contradict themselves, sometimes line by line. Just when I think I've stumbled upon some philosophical truth, I remember at least one favorite cartoonist whose work violates whatever blustery principle I may have just posited.

Nevertheless, as editor of this volume, it behooves me to articulate some sense of my aesthetics and methodology. These, it should be noted, I base solely on my own struggles as a "practitioner" (as we are condescendingly known in scholarly circles) of this art.

Cartooning is a peculiar art form, a "convergence of seeing and reading," as has been pointed out by Chris Ware. While it involves a kind of writing and a kind of drawing, it is neither and yet both simultaneously.

It is helpful to think of the doodle as the fundament of cartooning. Yes, the humble doodle. Of course, everything starts out as a doodle, a scribble, a scrawl: masterful paintings, complex architecture, and models of the universe begin with the simplest concrete visual representations. But cartooning is perhaps the one art form that most embraces everything the doodle represents: the fresh spontaneity, the linear clarity, the beautiful simplicity, the direct and unfiltered transfer of thought from mind to paper, the spark of creativity itself. The very genesis of the cartoon, paradoxically, is its own end goal.

Art Spiegelman has demonstrated that cartooning is "writing with pictures," and I would wholeheartedly agree with this elegant assessment. Here we are using "picture" in the broadest sense of the term. In comics, words and pictures are not a mix-

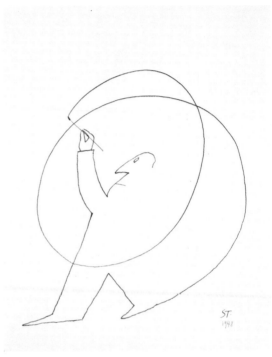

Saul Steinberg, Untitled, *1948*
Ink on paper, 14¼ x 11¼ in.
Beinecke Rare Book and Manuscript Library, Yale University
© The Saul Steinberg Foundation/Artists Rights Society
 (ARS), New York

ture, but an emulsion. Perhaps calligraphy might be a more apt, if still incomplete, metaphor. The cartoonist uses his own particular set of marks (or "visual handwriting") to establish a consistent visual vocabulary in which to communicate experience, memory, and imagination—in short, the stuff of narratives.

When we merely *look* at comics, they seem to exist as architectural entities, static aggregates of geometric and organic forms. But when we begin to *read* them, we enter their world, so to speak, and suddenly characters, situations, and emotions are seemingly animated in our mind's eye.

7

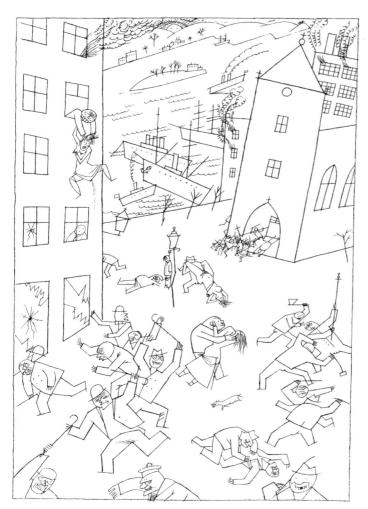

George Grosz, Riot of the Insane, *1915*

We can see this process at work even within a single panel; for example, let us consider George Grosz, who is sometimes referred to in the stuffier art texts as artist and cartoonist (as if the two were mutually exclusive). In *Riot of the Insane* (1915) he is unequivocally *cartooning,* and not simply because he uses the "hollow," unmodeled figures so characteristic of the medium.

Note that the calligraphy and the composition create the narrative. Grosz's "knife-hard" pen line cuts a satirical swath through a crumbling society spiraling into chaos; moreover, the off-kilter perspective suggests a scenario that is more internally felt than directly observed. If we "read" the image, the stability of the vertical lines of the leftmost building (and its implied "correct" perspective) gives way to "wrong," jagged, warring, more densely clustered diagonals as the eye travels to

the right and then downward through the composition. The church quite literally seems to be toppling over. The disturbing "action" is composed such that the entire image swirls around the light post in the center.

The contrasting stillness of the "de-pantsed" hanged man not only acts as a darkly comic counterpoint to the surrounding madness, but also solidifies the physical space. The eye is directed toward this central image of despair; could it be a stand-in for the artist imagining this scene? An entry point for the reader's empathy? With just a few well-placed scratchy lines on a blank page, the artist escorts us through an uninviting parallel world and asks us to consider if it is ultimately all that dissimilar from our own.

At first glance, the orderly composition and clean line of Ernie Bushmiller's *Nancy* page (1958)

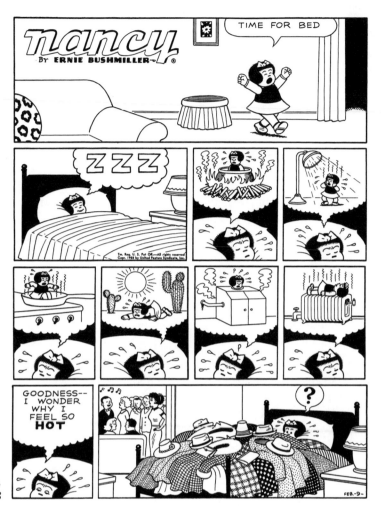

Ernie Bushmiller, Nancy,
Sunday page, February 9, 1958

would appear to be the diametrical opposite of the Grosz cartoon; however, if we set aside the obvious differences in sociopolitical intent, they actually have a key element in common: both constructions are deceptively simple.

Nancy "works" because "the simplicity is a carefully designed function of a complex amalgam of formal rules laid out by the designer." (This is from the witty and perceptive essay "How to Read Nancy," by Mark Newgarden and Paul Karasik.) The formal brilliance of the strip is transparent—not as in obvious, but as in invisible. Note the algebraically balanced composition, the visual rhythms of Nancy's head in the third tier, the easily distinguishable scales of the "real" and "dream" worlds, the economy and efficiency of line and texture, and the graphic clarity of the pile of coats in the last panel, which in lesser hands could have turned into a gray,

undifferentiated mush. Clutter was never depicted so unclutteredly.

At the purest level, comics are not an assembled *series* of images, but intuitively constructed *sequences* of images. Panels on a page (and even within an entire story) are connected into a unified whole, and each panel seems to exist in a latent state inside all of the other panels. The cartoonist creates—one might almost say discovers—these sequences, a process of communicating how he or she sees the internal and external world, the passage and interconnectedness of time. Cartooning is a "transmittal of thought and soul" through a codified, highly refined system of, essentially, doodles.

Or, as Saul Steinberg more poetically put it, "Doodling is the brooding of the hand." Even better is David Collier's observation, "There can be no hid-

Milt Gross, Nize Baby, *1926*

ing for the cartoonist. The state of his mind is apparent to the reader on first glimpse of his drawing."

Think of it this way: we can be aware of the structure encompassing the complexity of life, yet at the same time we can only exist "in the moment." So it is with the comics page, as perfect a metaphor as any for the unity of macrocosm and microcosm, and the utter folly of even thinking about things in such a highfalutin' way. Humor is the salt of life, after all, and the work in this book reflects this fact, no matter how dark, unfrivolous, dry, or bittersweet that humor might be.

With this anthology, I seek to offer a vibrant sampling of the vital, highly personal work that is currently being produced in contemporary "art comics," along with a few classic comic strips and other historical material that have retained a "modern" sensibility accessible to today's reader. The artists represented here intelligently use, and have helped develop, the unique word-picture language that is particular to the comics form.

Ultimately, my criteria were simple: these are comics that I savor and often revisit. They move, in every sense of that word: they come alive and elicit tears, laughter, and sometimes indescribable emotions. For brevity's sake, I limited myself to North American artists (with the exception of Grosz and Frans Masereel, their wordless pages needing no translation). This compilation is by no means comprehensive; I can think of at least 50 cartoonists, off the top of my head, that I wish I had room to include.

The visual and thematic connections between stories, I hope, will be apparent. After much deliberation, I have chosen to arrange the work so that it flows smoothly, unobstructed by strict chronology. I prefer to see cartooning as a continuum, albeit one

with many divergent lineages; thus, I've allowed the past and present to intermingle freely in this book.

A word about the overall structure of the book: the organization is intended to mirror the process of cartooning itself, which itself reflects the inexorable march of life. We begin with the infancy of the doodle, often cute and quick to develop its individuality, and then we move on to the baby steps of the single panel, where the comics stumble and take their shape, as their true personality emerges. From there, the far-reaching, core patterns of childhood establish themselves in the four-panel strips. As these sequences awkwardly grow into the full page, they begin to take on some of the self-consciousness typical of the adolescent. Soon the confidence of the twenties asserts itself, and we see short stories of several pages. By the time comics reach their thirties, they are more mature and ready to take on the multilayered complexity of longer stories. And this, in my opinion, is where comics are today: the equivalent of an adult of about thirty-five years.

Hopefully, the perspicacity that comes with middle age will be seen in the comics created in the years to come; or perhaps we are already living in this very period, which would imply that comics may be on the verge of an unsightly mid-life crisis. Of course, there's also the eventual calcification and decay of old age, not to mention the inevitability of death, so it may be best not to further belabor this fragile, shaky metaphor, wholly unfounded as it is.

Finally, an apology is in order for the unwieldy and perhaps tawdry-sounding moniker "graphic fiction." This is a catch-all term used to encompass all comics, or cartooning, if we may be even more democratic. The comics collected here represent many genres, such as the essay, fiction, nonfiction, autobiography, biography, journalism, and the uncategorizable, and they cover the entire spectrum of "brow," from "high" to "low" and all points in between. Some cartoonists favor slices of everyday life, and some seem to exist solely in their own insular world, but most fall somewhere within these extremes and comfortably accommodate both their external and internal "eyes."

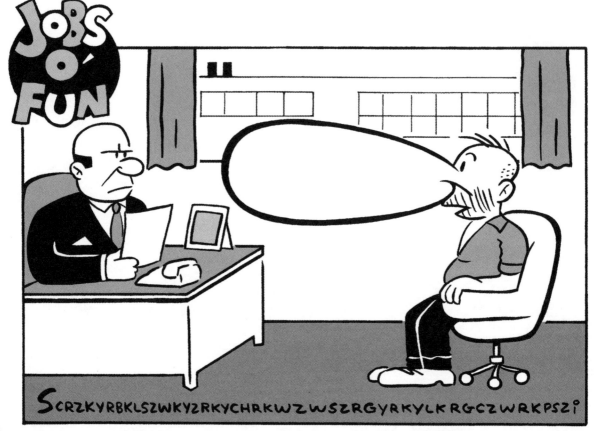

"Well yes, I am looking for an entry-level position. One with little intelligence required. I want something menial where I don't have to think very hard or at all, even. That would be nice. One where I'm only a marginal cog in a vast corporate machine whose ultimate function I could never begin to comprehend, let alone relate to. I want to be used, taken advantage of, beaten down, dicked around, given the shaft, exploited unmercifully and after a career of soul breaking monotony I want to be flung away like an obsolete piece of plumbing. I want to be paid as close to minimum wage as feasible. I don't want any benefits, medical coverage or even a nurse on duty if I cut off my thumb. I surely don't want any challenges. I want to spend my time in this world laboring anonymously, consuming in misery with little hope of anything beyond. I also wouldn't mind something with potential health hazards, possibly something carcinogenic. And I'd like my meager intelligence regularly insulted -- that's important. In fact, I'd be interested in regular on-the-job harassment -- racial, sexual or otherwise. And if it's not too much to ask, I'd really appreciate a position on the verge of obsolescence, something where I'd stand a good chance of being replaced by a computer circuit or a third-world child, or a genetically mutated member of the mandrill family within six years. In short, Mr. Shorin, I'm not looking for anything special."

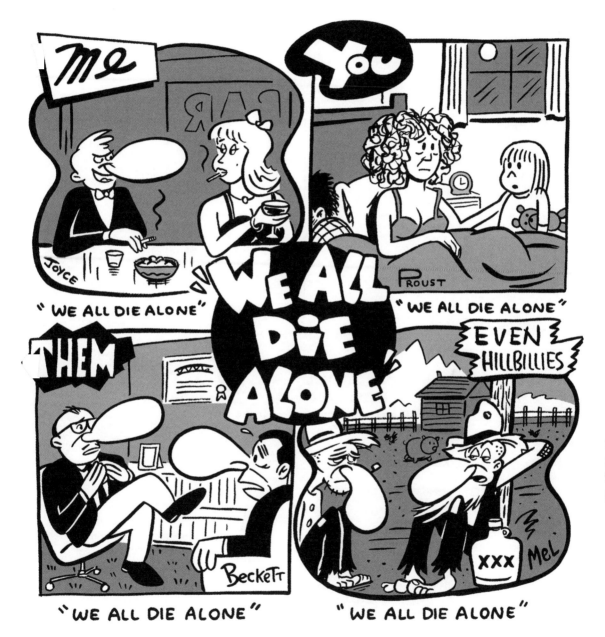

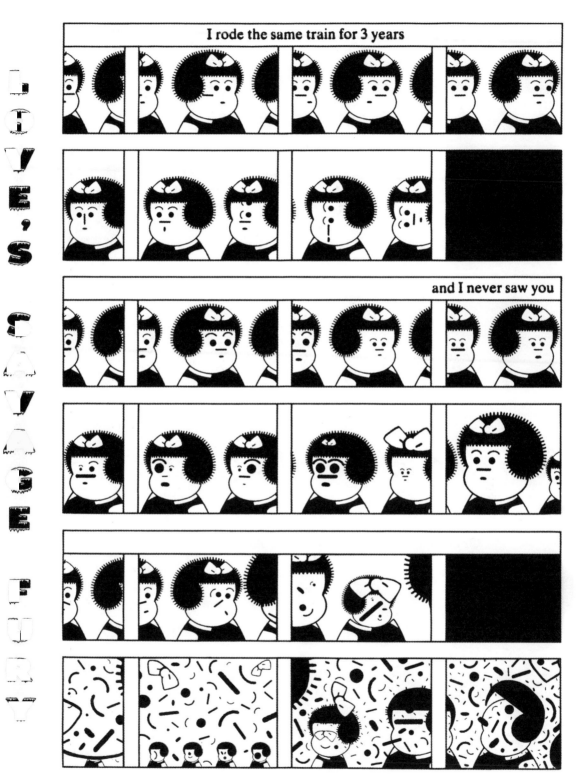

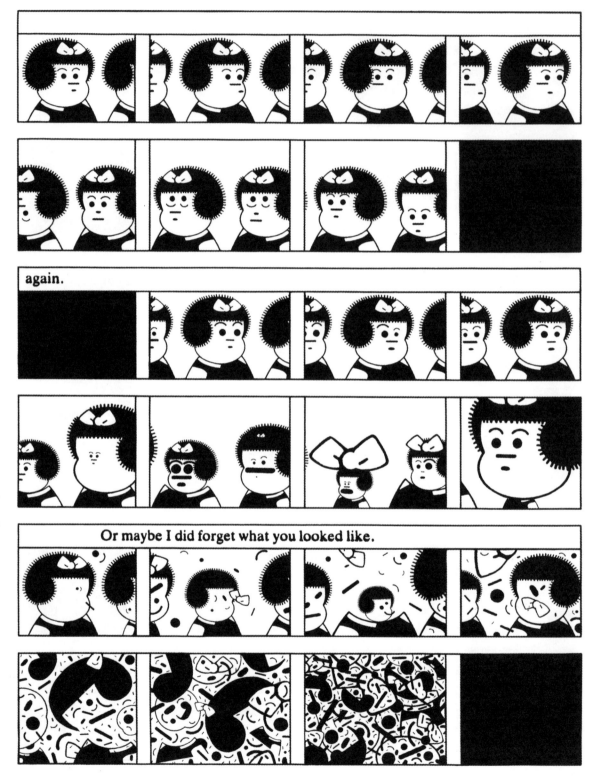

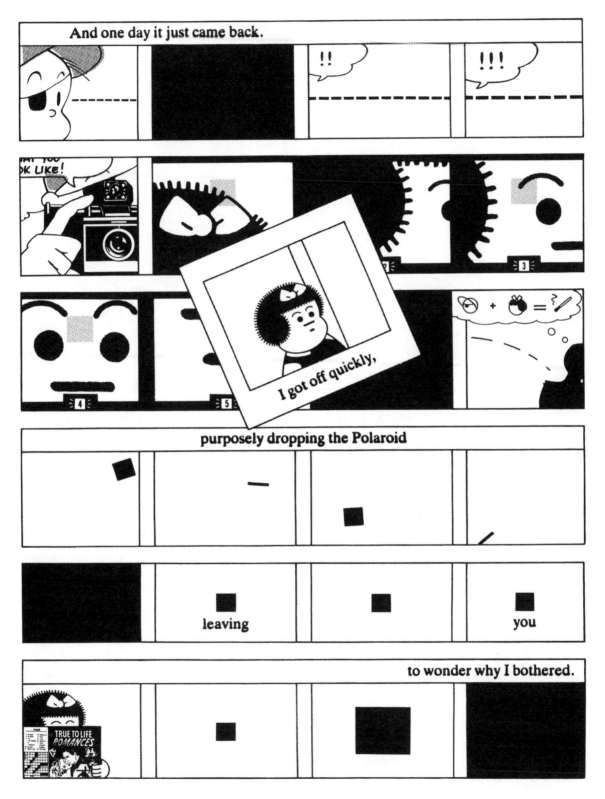

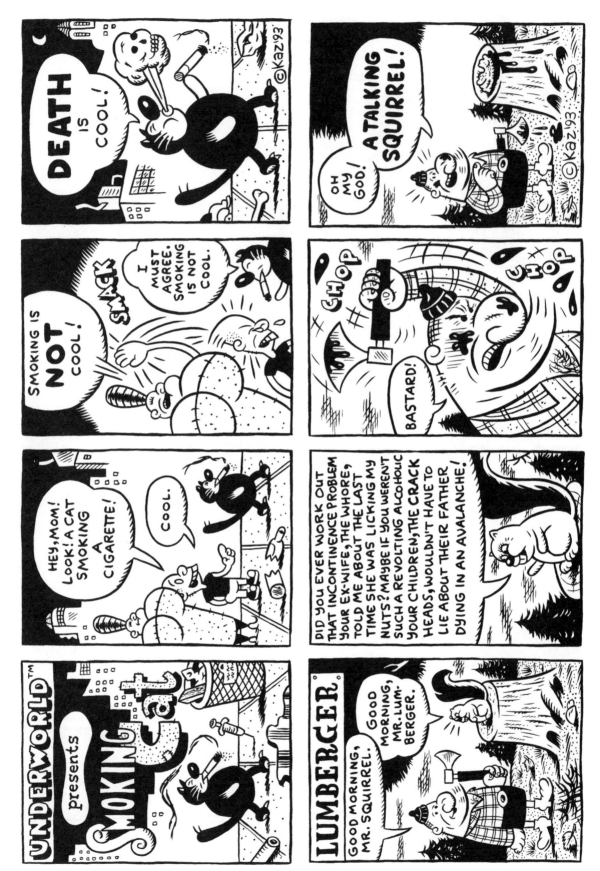

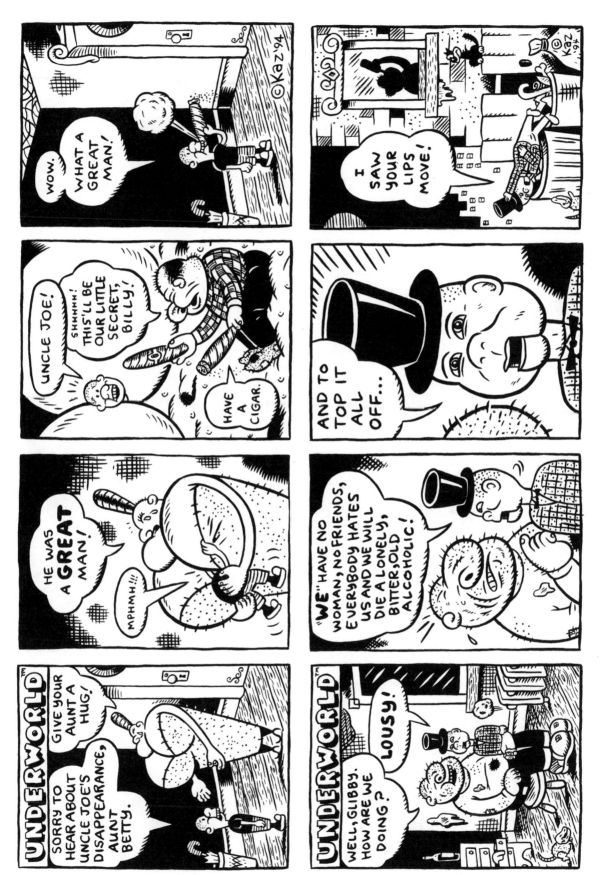

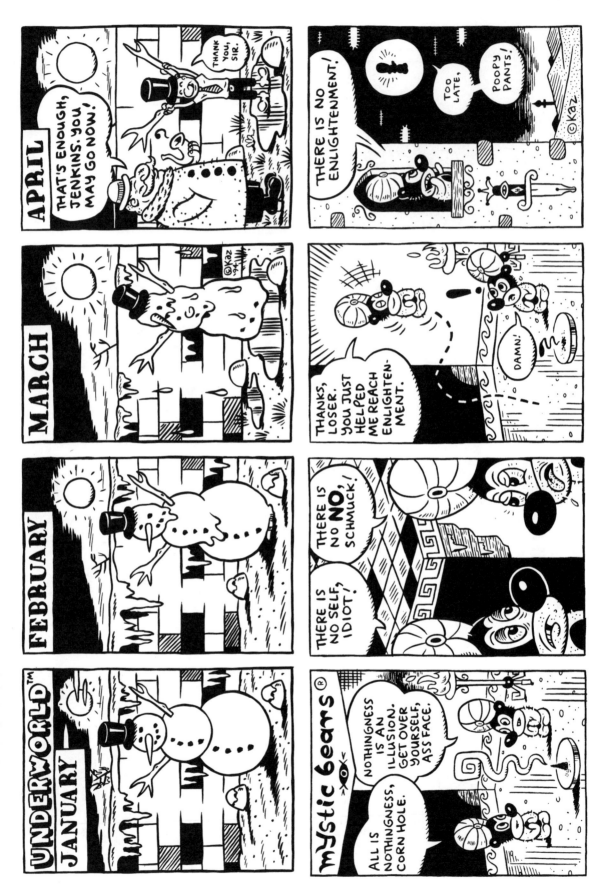

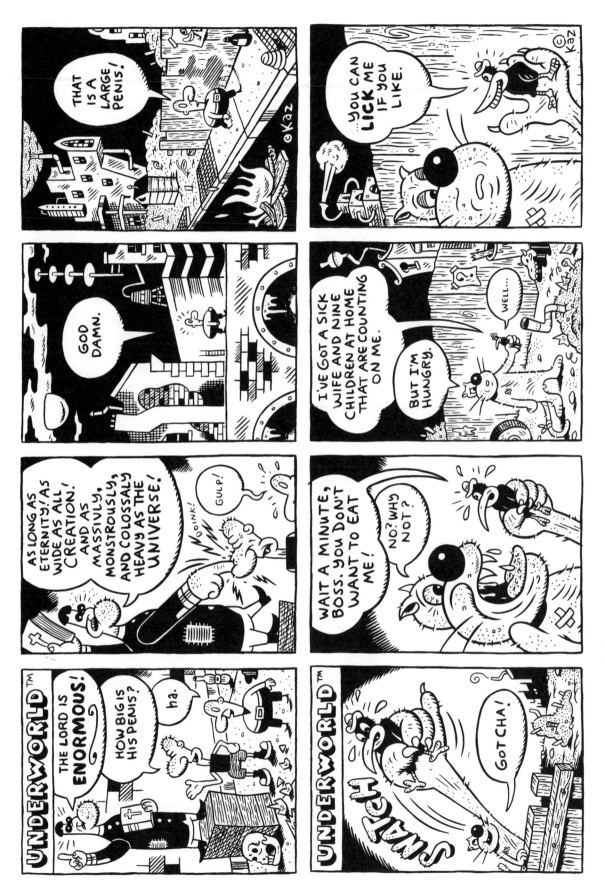

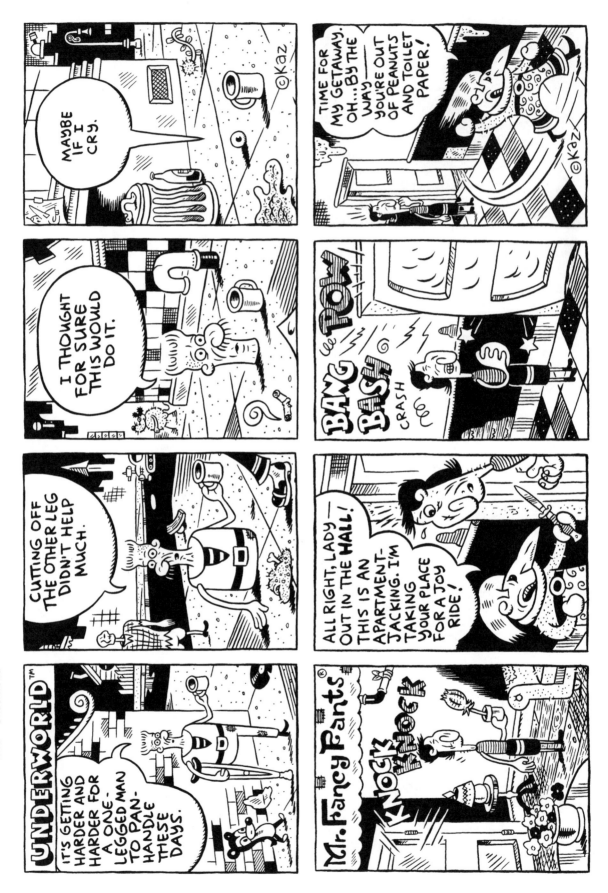

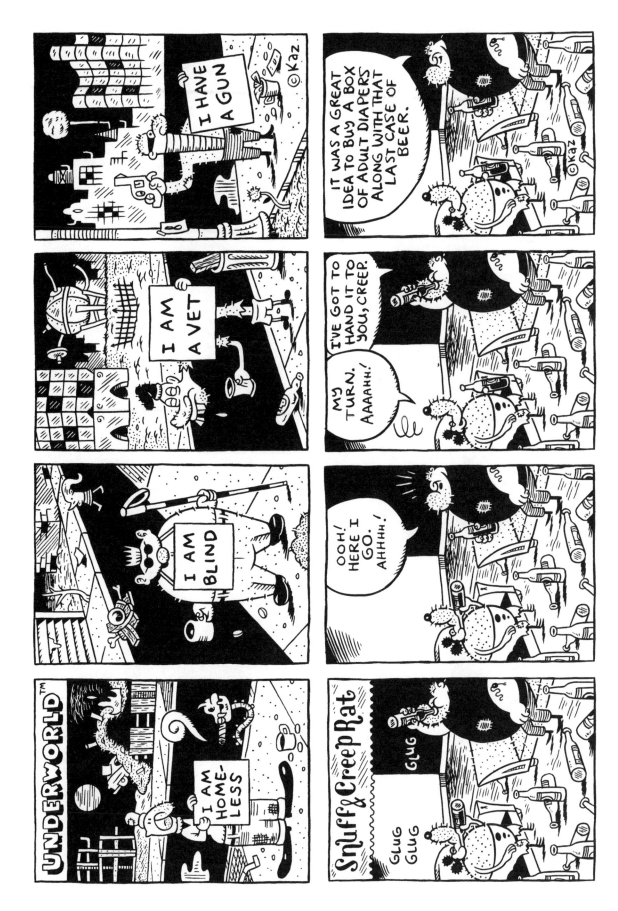

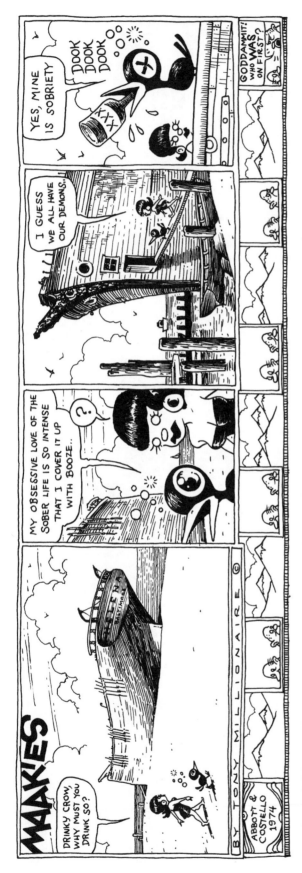

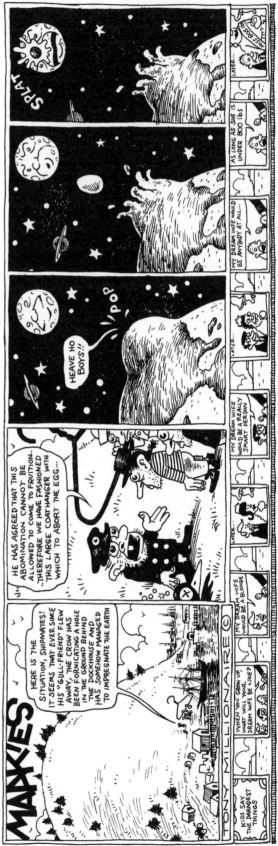

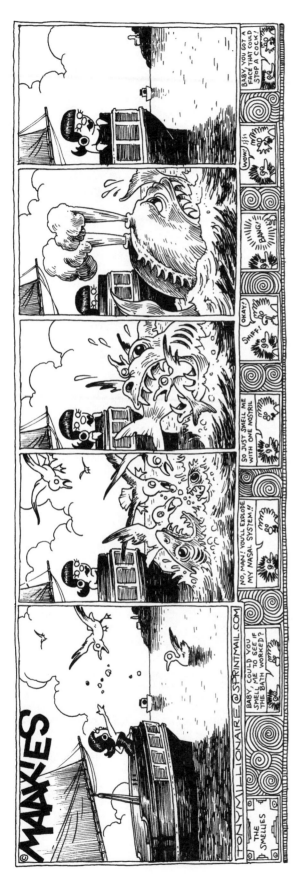
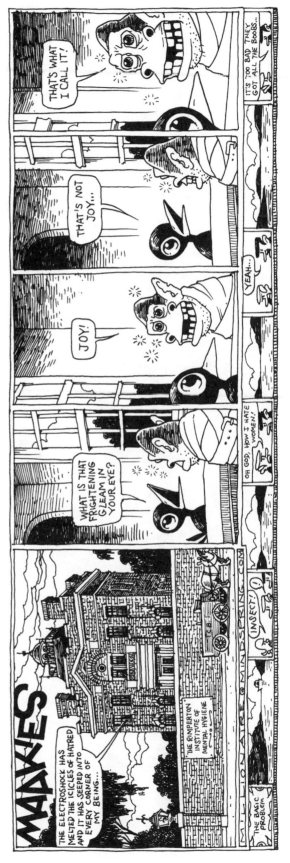

TONY MILLIONAIRE Maakies

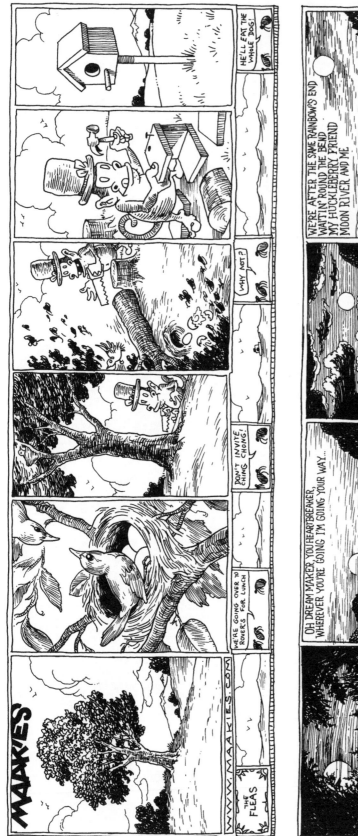

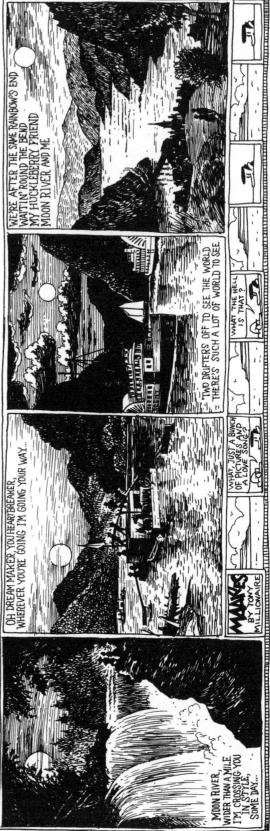

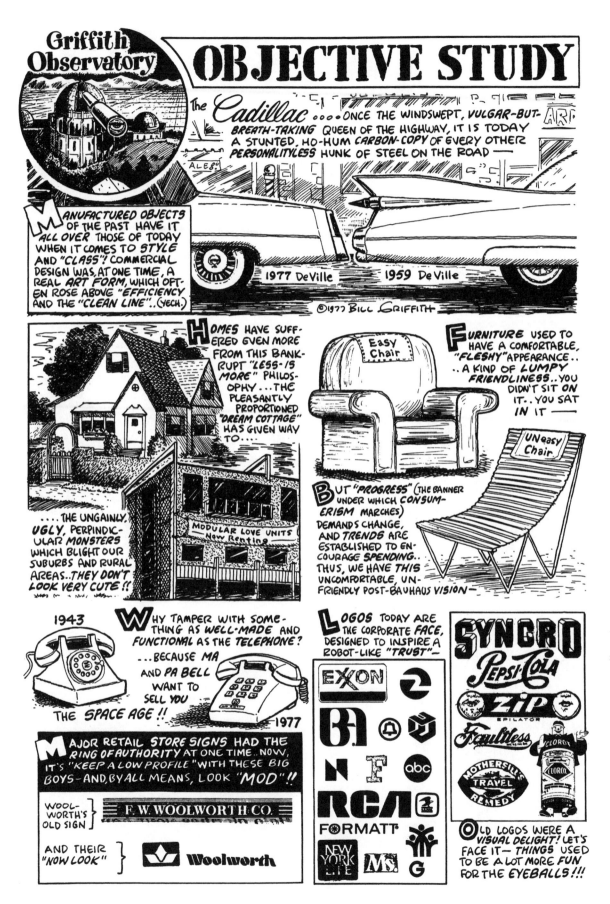

Griffith Observatory

OBJECTIVE STUDY

The Cadillac.....once the windswept, *vulgar-but-breath-taking* queen of the highway, it is today a stunted, ho-hum *carbon-copy* of every other *personalityless* hunk of steel on the road—

Manufactured objects of the past have it all over those of today when it comes to *style* and *"class"!* commercial design was, at one time, a real *art form*, which often rose above *"efficiency"* and the *"clean line"..*(yech.)

1977 DeVille 1959 DeVille

©1977 Bill Griffith

Homes have suffered even more from this bankrupt *"less-is more"* philosophy...the pleasantly proportioned *"dream cottage"* has given way to....

.... the ungainly, *ugly*, perpindicular monsters which blight our suburbs and rural areas..*they don't look very cute !!*

MODULAR LOVE UNITS Now Renting

Easy Chair

Furniture used to have a comfortable, *"fleshy"* appearance.. ..a kind of *lumpy friendliness*..you didn't sit on it..you sat *in* it—

UNeasy Chair

But *"progress"* (the banner under which *consumerism* marches) demands change, and *trends* are established to encourage *spending*.. thus, we have *this* uncomfortable, unfriendly post-bauhaus vision—

1943

Why tamper with something as *well-made* and *functional* as the *telephone?* ...because *ma* and *pa* bell want to sell *you* the *space age !!*

1977

Major retail *store signs* had the *ring of authority* at one time.. now, it's "keep a low profile" with these big boys—and, by all means, look *"mod"!!*

WOOLWORTH'S OLD SIGN } F.W.WOOLWORTH CO.

AND THEIR "NOW LOOK" } ◈ Woolworth

Logos today are the corporate *face*, designed to inspire a robot-like *"trust"*—

EXXON
B.
N
RCA
FORMATT
NEW YORK LIFE Ms.
abc
G

SYNCRO
Pepsi-Cola
ZIP EPILATOR
Faultless
MOTHERSILL'S TRAVEL REMEDY
CLOROX

Old logos were a *visual delight!* let's face it— *things* used to be a lot more *fun* for the eyeballs !!!

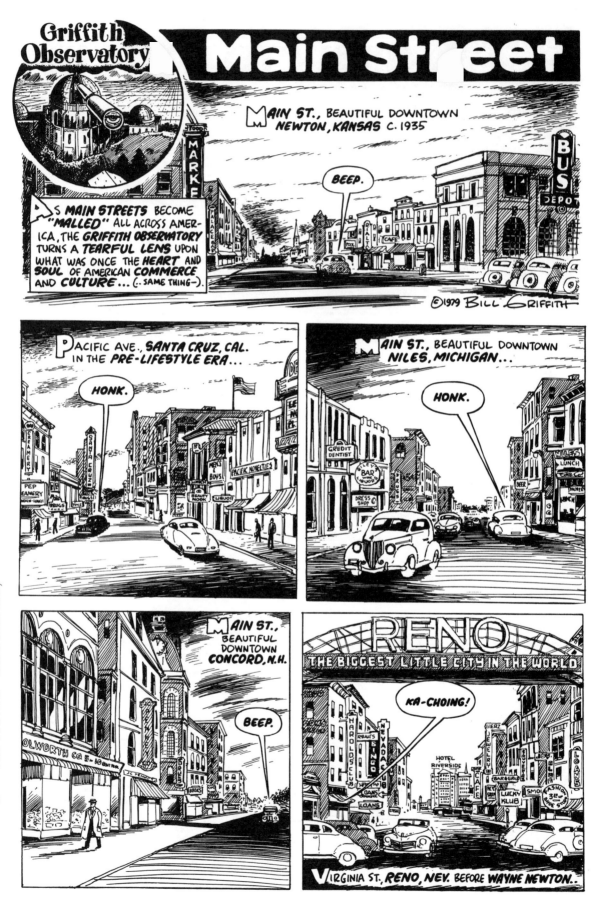

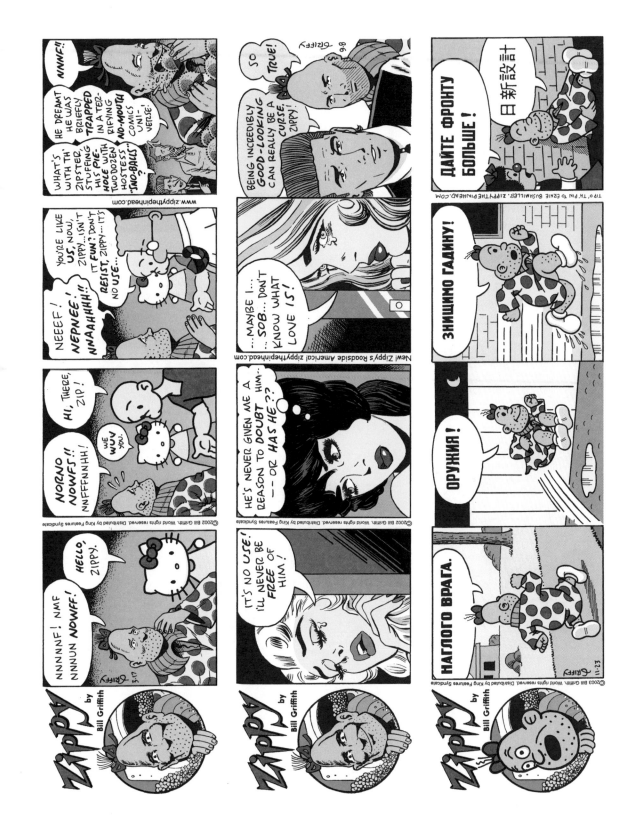

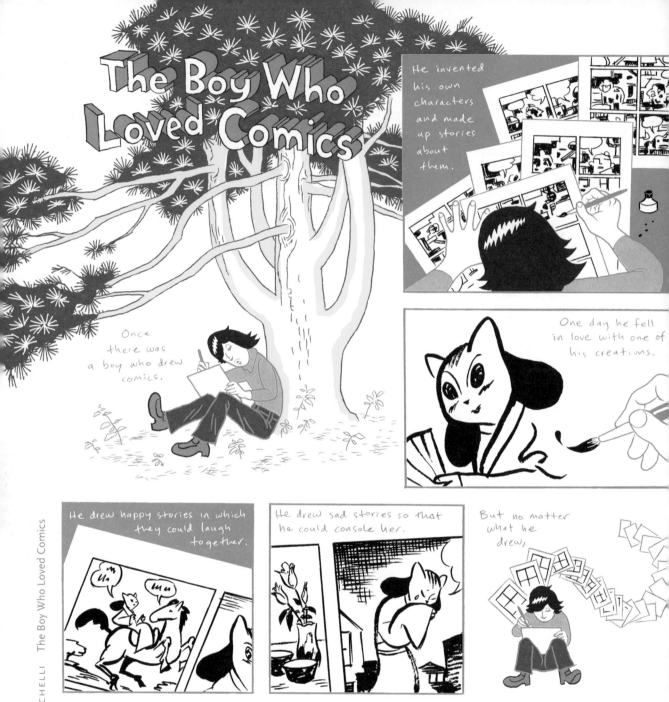

The Boy Who Loved Comics

He invented his own characters and made up stories about them.

Once there was a boy who drew comics.

One day he fell in love with one of his creations.

He drew happy stories in which they could laugh together.

He drew sad stories so that he could console her.

But no matter what he drew,

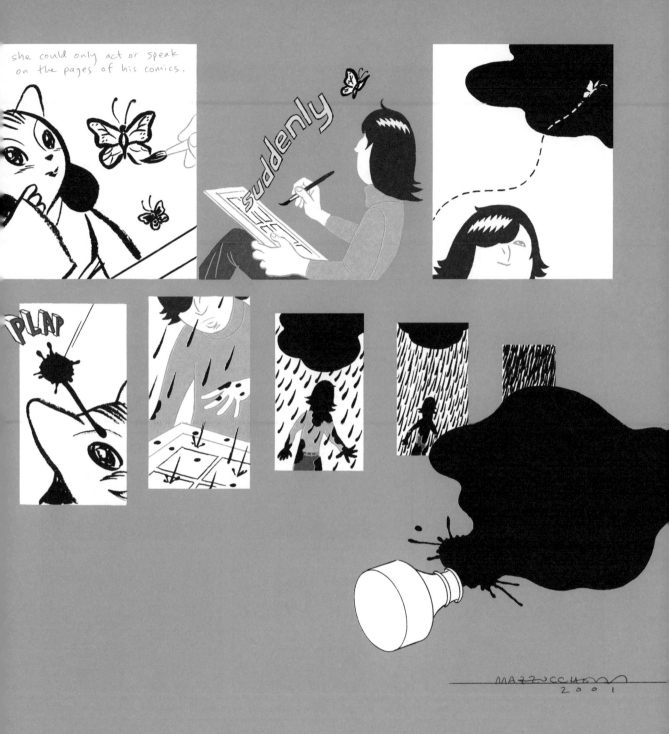

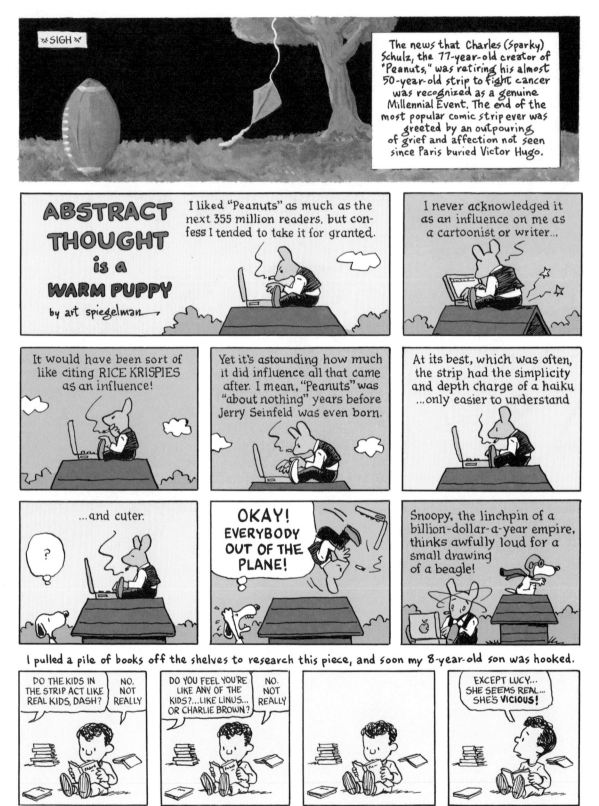

Out of the blue, I got a friendly letter from Charles Schulz inviting me to meet him sometime. Determining that it wasn't a hoax, I visited #1 Snoopy Place, in Santa Rosa, last August and was soon engaged in a theological conversation.

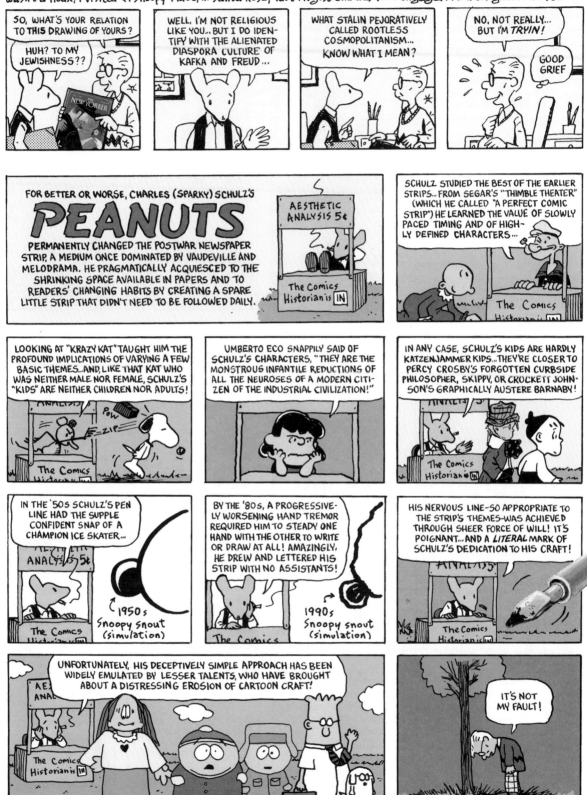

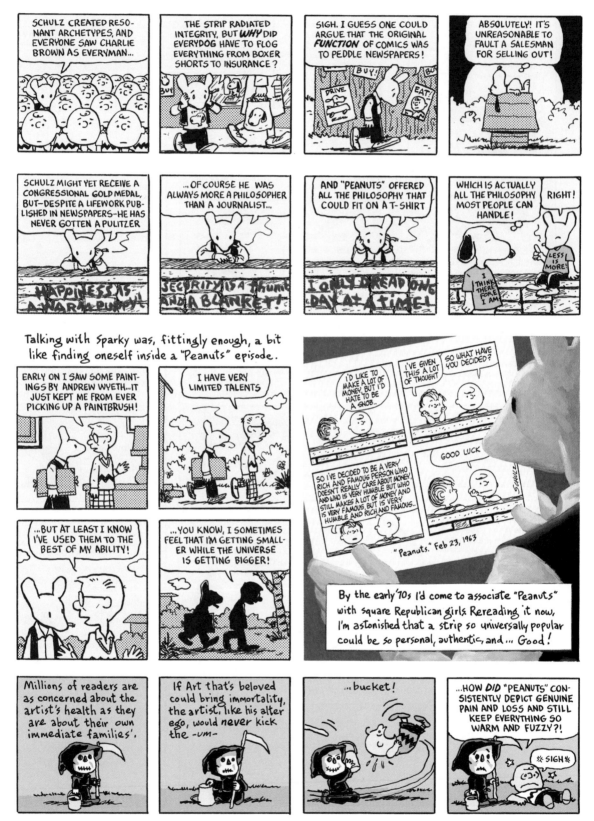

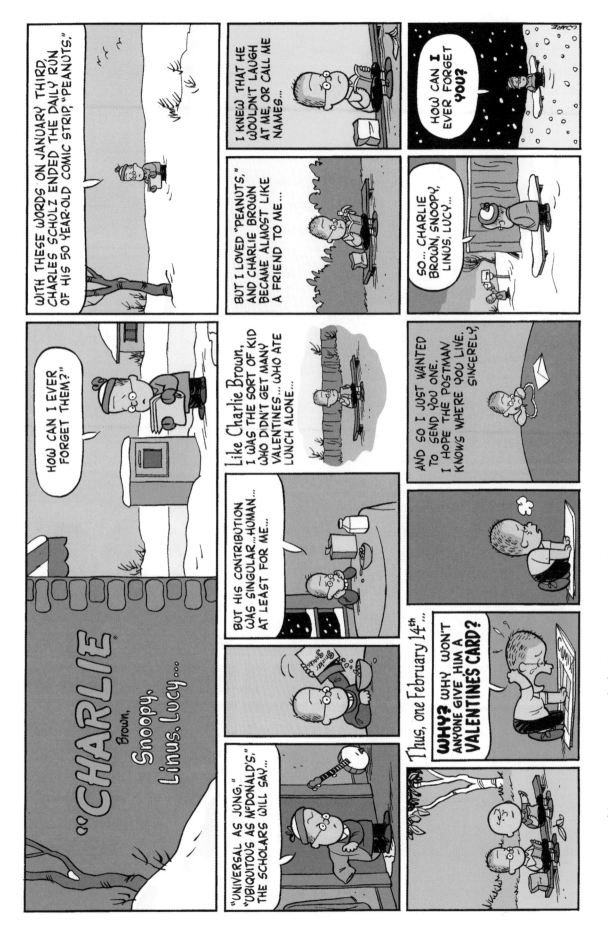

CHRIS WARE Charlie Brown, Snoopy, Linus, Lucy . . .

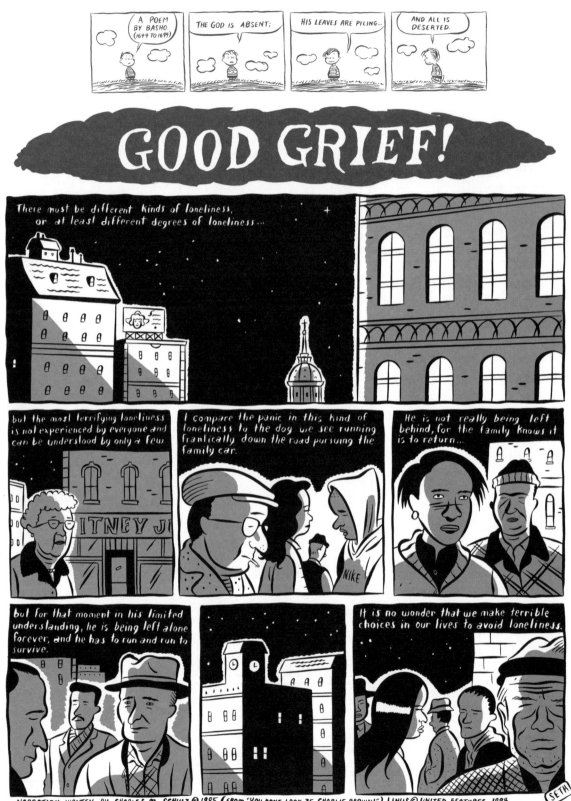

DEVELOPING A COMIC STRIP

Charles M. Schulz

A Peanuts *panel at the size it was drawn.*

One of the hardest things for a beginner to do is merely to get started on his first set of comic strips. It is strange that most people who have ambitions in the cartoon field are not willing to put in the great amount of work that many other people do in comparable fields. Most people who have comic-strip ambition wish to be able to draw only two or three weeks' material and then have it marketed. They are not willing to go through many years of apprenticeship. Now, by this I do not mean that they are unwilling to serve the so-called "minor markets" of cartooning, but they are unwilling to draw the many, many cartoons that

are necessary even before one can approach these minor markets.

It is strange that people in other areas of art are willing to paint and draw for the fun of it and for the experience involved, but that very few cartoonists are willing to draw set after set of comic strips just for the experience. We seem to have a tendency to believe that all we have to do is perfect our lettering, our figure drawing, and our rendering, and then we are all set to go. Nothing could be further from the truth.

There is an area of thought training that has to be worked out. I think the beginner should reconcile

Charlie Brown demonstrates a certain amount of arrogance, here with Snoopy.

himself to the fact that he is going to have to spend probably five to ten years developing his powers of observation and his sense of humor before he is able to venture into the professional side of the business.

Here, of course, I am speaking particularly of the humor strips. However, the same can be said of the adventure strips. The men who write adventure strips are trained storytellers, and they did not arrive at this ability overnight. What, then, can we do to make our beginnings?

One of the main things to avoid is thinking too far ahead of yourself. Almost all of us have ideas which we think would be great for a comic-strip series, but when we attempt to break down these general ideas into daily episodes, we find it extremely difficult. This is where I think we should begin. Try to think of your daily episodes without concentrating too heavily on the overall theme of your comic feature. While you are concentrating on these daily episodes, trying to get the most humorous idea you can out of each episode, you will also be developing the personalities of your characters. You will find that ideas will begin to come from these personalities.

As your ideas develop personalities and as your personalities develop more ideas, the overall theme of your feature then will begin to take form. This re-

ally is the only practical way to develop a good solid comic-strip feature.

If you go about it in the reverse manner, you are going to end up with weak ideas. You are going to be thinking so much about the general theme of your strip that your daily ideas will become diluted.

The system that I have recommended will also assure you of going in whichever direction your thoughts tend to take you. In these initial days of comic-strip work and practice, you must not confine yourself to any particular ideas. You must be in constant search for the characters and ideas that will eventually lead you to your best areas of work.

The characters that you start out to draw today may not be the same characters that you will end up drawing a month or year from now. New personalities will come along that you never thought of creating at the beginning, and frequently these new personalities will take you to completely different places. In regard to the characters themselves, it is not advisable to worry too much about their development. Let them grow with your ideas.

Remember, the one thing, above all, to avoid is the idea that you can think about this whole business for a long time and then suddenly one day sit down and draw 12 or 24 strips, send them in and expect to make your fortune. Some of the things about which I have been talking can be illustrated in the four strips that have been reproduced here. The ideas in each one of these depend upon the developed personalities of the characters involved. Right from the very beginning, we had established that Snoopy was a dog who could understand all of the things that the children were saying to him. He also has a very highly developed sense of intelligence and frequently resents the things that the children say about him. He definitely has a mind of his own and expresses it in thoughts and action.

Charlie Brown's personality goes in several directions. Most of the time he is quite depressed because of the feelings of other people about him, but at the

Generally, however, he is wholly struck down by the remarks of the other characters, especially Lucy.

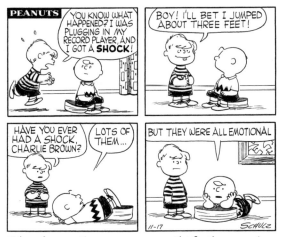

Schroeder sometimes serves as an outlet for the expressions of his friends, the way he is doing here for Charlie Brown.

Schulz enjoyed working with Linus because he liked injecting the naïve things that Linus frequently comes up with.

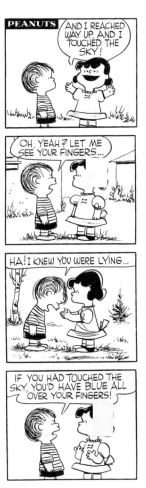

same time he has a certain amount of arrogance. This is demonstrated in the strip concerning him and Snoopy. Generally, however, he is wholly struck down by the remarks of the other characters, especially Lucy. She represents all of the cold-blooded, self-sufficient people in this world who do not feel that it is at all necessary ever to say anything kind about anyone.

Schroeder is a rather innocent sort of fellow who is completely devoted to Beethoven and can sometimes serve as an outlet for the expressions of his friends, the way he is doing here for Charlie Brown.

I have always enjoyed working with Linus, who is Lucy's smaller brother, because I like to inject the naïve things that he frequently comes up with. None of these characters could have done or said any of the things in these four strips when it first began, for it took many months (and, in some cases, years) for them to develop these personalities. This is what I mean when I say you must be patient in developing your strip, and not try to look too far ahead. Be perfectly content to work on the single strip that is now in place on your drawing board.

Students always seem interested in some of the practical points of reproduction that are involved in various comic strips, so I feel that I might comment somewhat on these. *Peanuts* always is drawn with four equal panels so that a newspaper editor can reproduce it in three different forms. He can run it horizontally, or he may drop one panel beneath another and run it vertically. Also, he may drop the last two

panels beneath the first two and run the strip in the form of a square. Each one of the panels in these *Peanuts* strips is drawn 5½ inches high by 6½ inches wide in the original. This makes for quite a large panel, but I need the working space to be able to get the proper expressions and to make my lettering clear. *Peanuts* has a very great reduction and I have to work large in order that the pen lines can be made bold enough to stand this reduction.

I work exclusively with the pen and use the brush only to place the dark areas, such as we find here on the dog's ears, the brick wall, and Lucy's hair.

I think that design plays a very important part in the drawing of comic strips. Design involves not only the composition of the characters and their place in each individual panel, but it involves the proper drawing of the other elements within the strip. I have tried to do this in the drawing of the brick wall by making the wall itself interesting and by varying the size and color of the bricks or stones in the wall. I have also tried to do this in the little bit of drapery that shows in the strip where Charlie Brown and Schroeder are talking. There is also a rather modernistic painting placed on the wall in order to give the strip a little extra design.

In the last strip, we have a corner of a house and the corner of a garage jutting into the panel to break up the square into pleasing areas. We also have the introduction of a little birch tree and a very small pine tree, which are good items because of their interesting designs. This is the sort of thing that you search for all of your life, trying to develop to the highest degree.

CHARLES M. SCHULZ Developing a Comic Strip

39

This essay was originally published in 1959 by Art Instruction, Inc., and reprinted in The Comics Journal No. 250 *in 2003. Reprinted here with permission from Jean Schulz.*

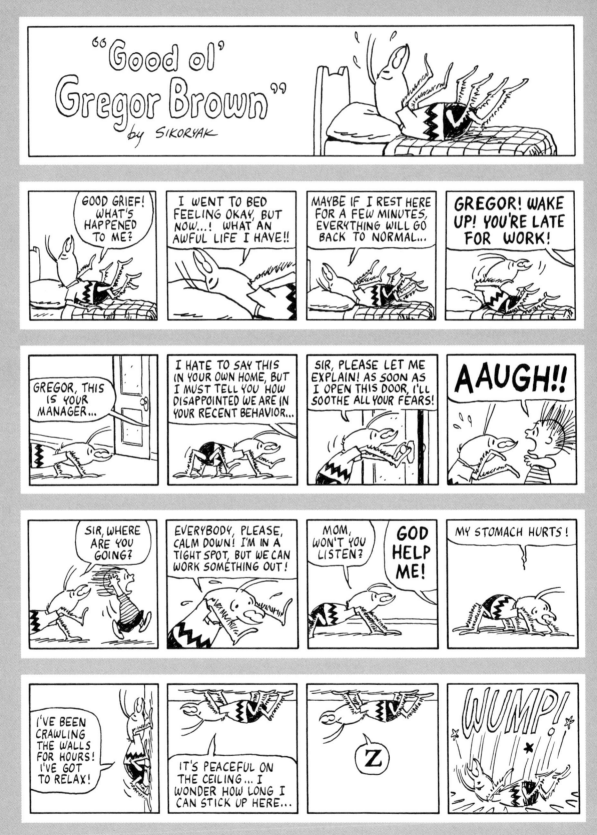

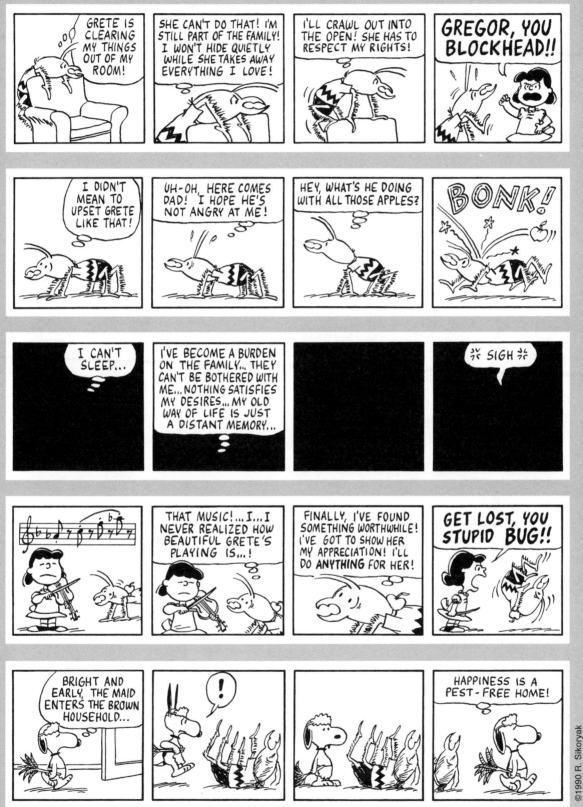

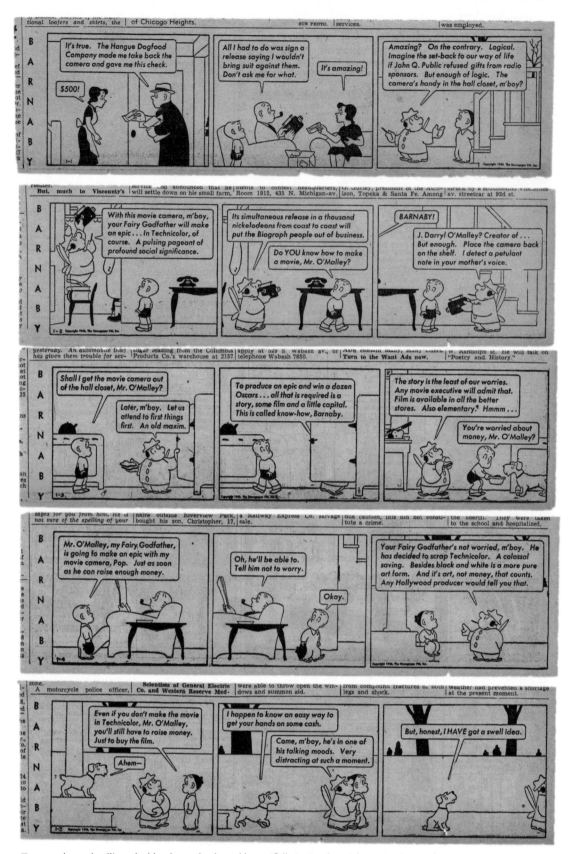

CROCKETT JOHNSON Barnaby

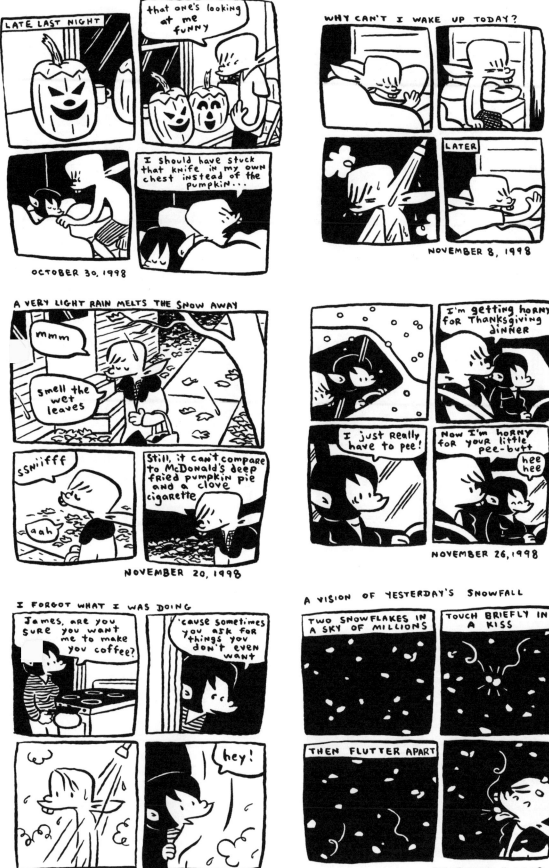

JAMES KOCHALKA *excerpts from The Sketchbook Diaries*

DECEMBER 14, 1998

DECEMBER 15, 1998

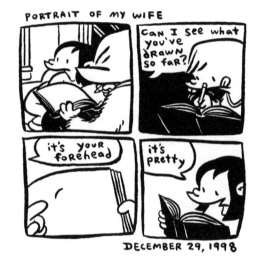

DECEMBER 29, 1998

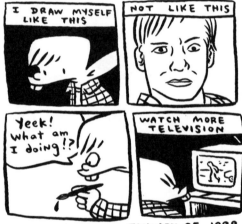

JANUARY 25, 1999

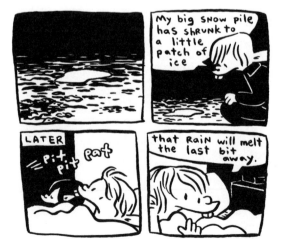

APRIL 4, 1999

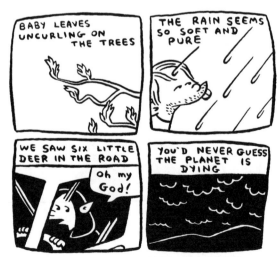

MAY 5, 1999

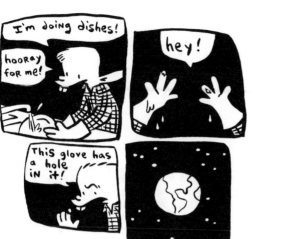

May 13, 1999

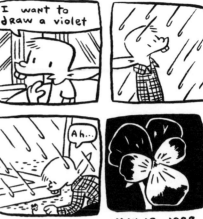

MAY 19, 1999

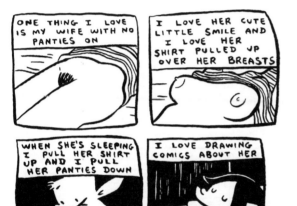

MAY 29, 1999

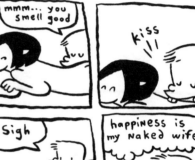
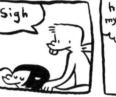
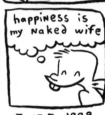

JUNE 5, 1999

JULY 8, 1999

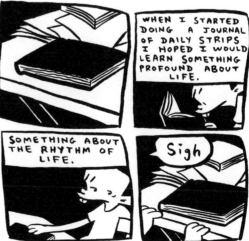

JULY 30, 1999

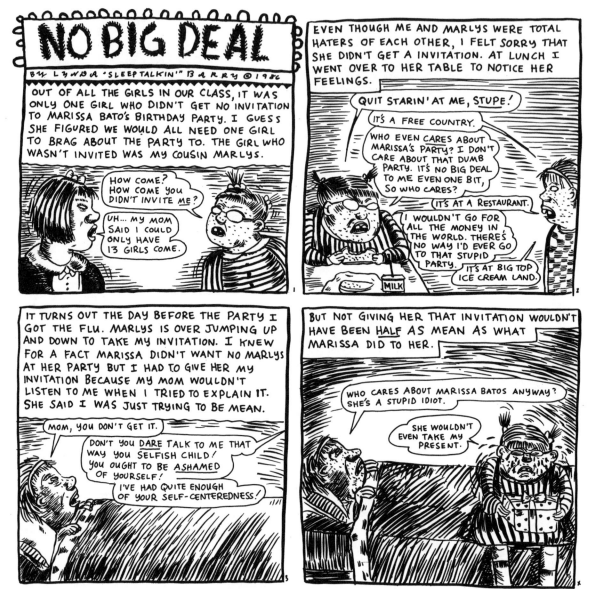

NO BIG DEAL

BY LYNDA "SLEEPTALKIN'" BARRY © 1986

OUT OF ALL THE GIRLS IN OUR CLASS, IT WAS ONLY ONE GIRL WHO DIDN'T GET NO INVITATION TO MARISSA BATO'S BIRTHDAY PARTY. I GUESS SHE FIGURED WE WOULD ALL NEED ONE GIRL TO BRAG ABOUT THE PARTY TO. THE GIRL WHO WASN'T INVITED WAS MY COUSIN MARLYS.

HOW COME? HOW COME YOU DIDN'T INVITE ME?

UH... MY MOM SAID I COULD ONLY HAVE 13 GIRLS COME.

EVEN THOUGH ME AND MARLYS WERE TOTAL HATERS OF EACH OTHER, I FELT SORRY THAT SHE DIDN'T GET A INVITATION. AT LUNCH I WENT OVER TO HER TABLE TO NOTICE HER FEELINGS.

QUIT STARIN' AT ME, STUPE!

IT'S A FREE COUNTRY.

WHO EVEN CARES ABOUT MARISSA'S PARTY? I DON'T CARE ABOUT THAT DUMB PARTY. IT'S NO BIG DEAL TO ME EVEN ONE BIT, SO WHO CARES?

IT'S AT A RESTAURANT.

I WOULDN'T GO FOR ALL THE MONEY IN THE WORLD. THERE'S NO WAY I'D EVER GO TO THAT STUPID PARTY.

IT'S AT BIG TOP ICE CREAM LAND.

MILK

IT TURNS OUT THE DAY BEFORE THE PARTY I GOT THE FLU. MARLYS IS OVER JUMPING UP AND DOWN TO TAKE MY INVITATION. I KNEW FOR A FACT MARISSA DIDN'T WANT NO MARLYS AT HER PARTY BUT I HAD TO GIVE HER MY INVITATION BECAUSE MY MOM WOULDN'T LISTEN TO ME WHEN I TRIED TO EXPLAIN IT. SHE SAID I WAS JUST TRYING TO BE MEAN.

MOM, YOU DON'T GET IT.

DON'T YOU DARE TALK TO ME THAT WAY YOU SELFISH CHILD! YOU OUGHT TO BE ASHAMED OF YOURSELF! I'VE HAD QUITE ENOUGH OF YOUR SELF-CENTEREDNESS!

BUT NOT GIVING HER THAT INVITATION WOULDN'T HAVE BEEN HALF AS MEAN AS WHAT MARISSA DID TO HER.

WHO CARES ABOUT MARISSA BATOS ANYWAY? SHE'S A STUPID IDIOT.

SHE WOULDN'T EVEN TAKE MY PRESENT.

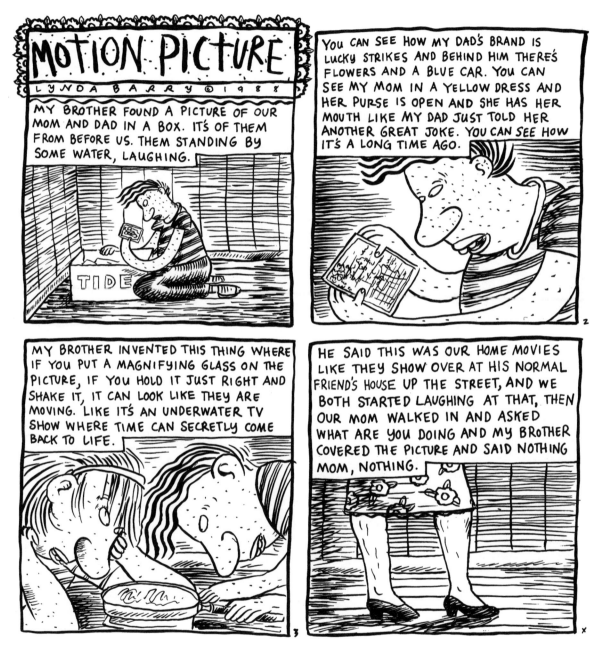

LYNDA BARRY Ernie Pook's Comeek

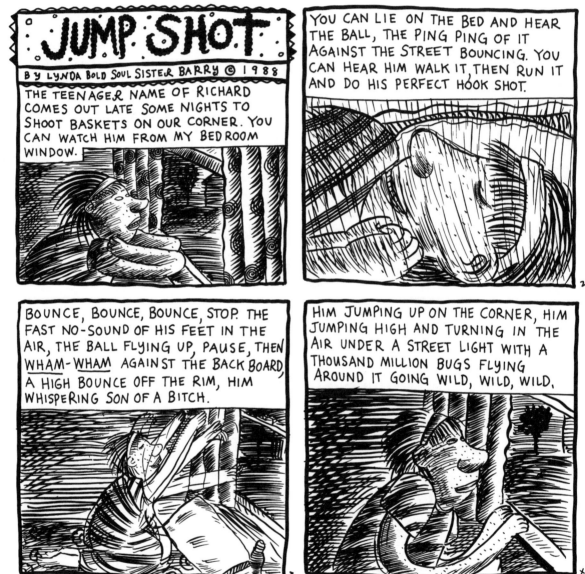

JUMP SHOT

BY LYNDA BOLD SOUL SISTER BARRY © 1988

THE TEENAGER NAME OF RICHARD COMES OUT LATE SOME NIGHTS TO SHOOT BASKETS ON OUR CORNER. YOU CAN WATCH HIM FROM MY BEDROOM WINDOW.

YOU CAN LIE ON THE BED AND HEAR THE BALL, THE PING PING OF IT AGAINST THE STREET BOUNCING. YOU CAN HEAR HIM WALK IT, THEN RUN IT AND DO HIS PERFECT HOOK SHOT.

BOUNCE, BOUNCE, BOUNCE, STOP. THE FAST NO-SOUND OF HIS FEET IN THE AIR, THE BALL FLYING UP, PAUSE, THEN WHAM-WHAM AGAINST THE BACK BOARD, A HIGH BOUNCE OFF THE RIM, HIM WHISPERING SON OF A BITCH.

HIM JUMPING UP ON THE CORNER, HIM JUMPING HIGH AND TURNING IN THE AIR UNDER A STREET LIGHT WITH A THOUSAND MILLION BUGS FLYING AROUND IT GOING WILD, WILD, WILD.

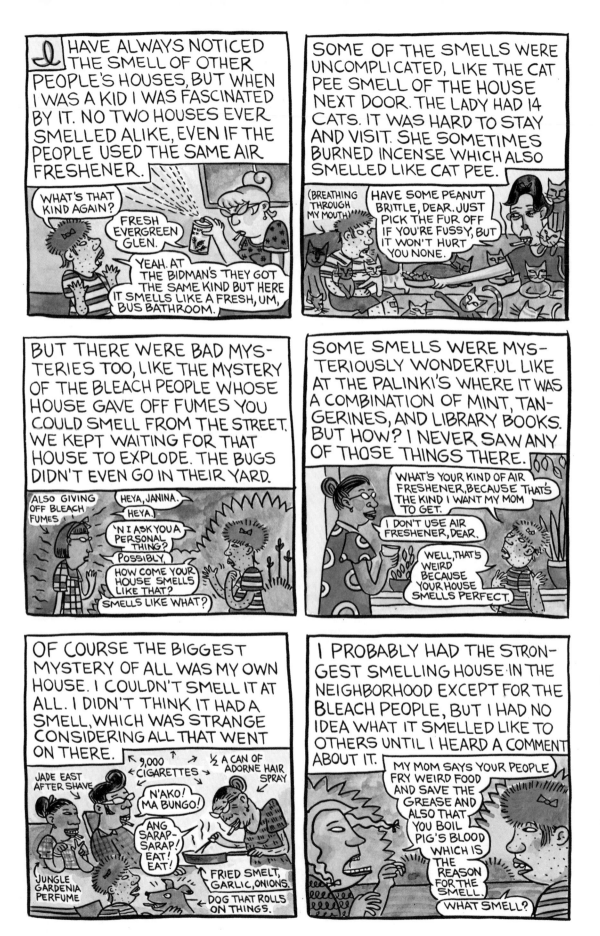

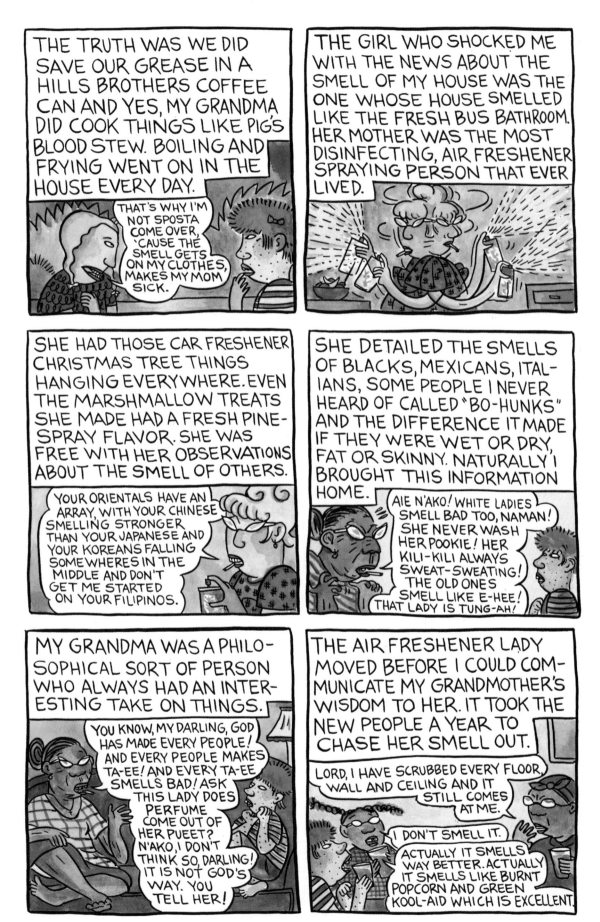

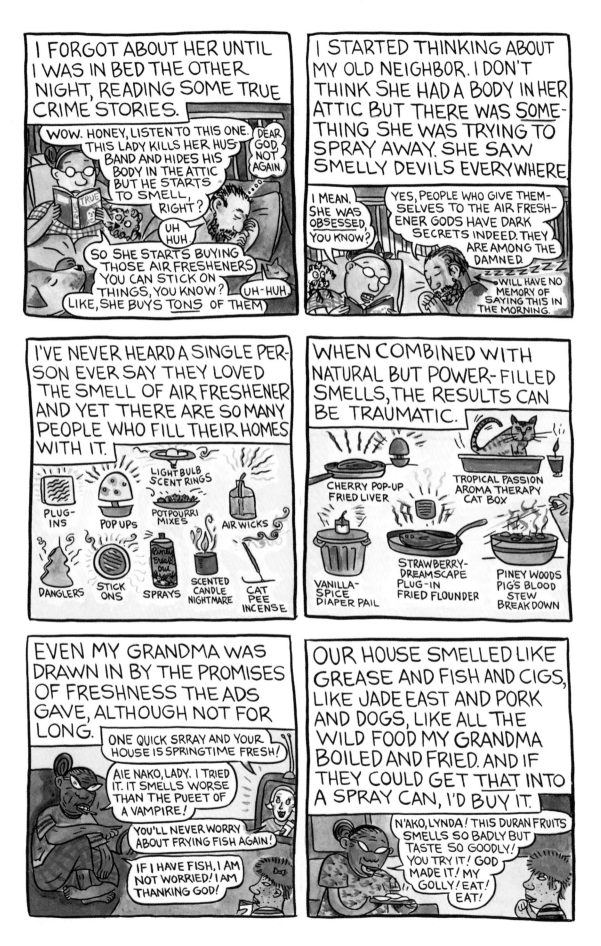

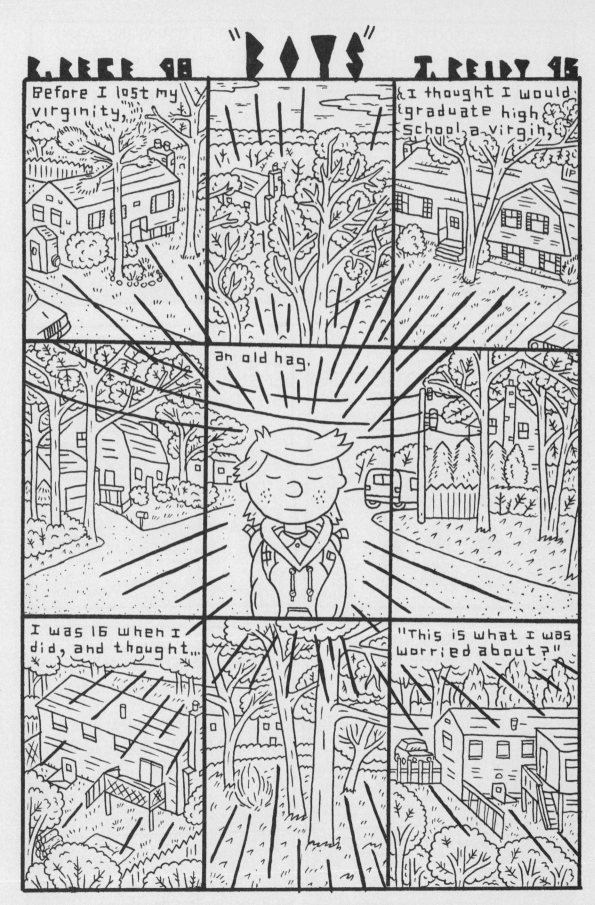

RON REGÉ, JR. (with JOAN REIDY) *excerpts from Boys*

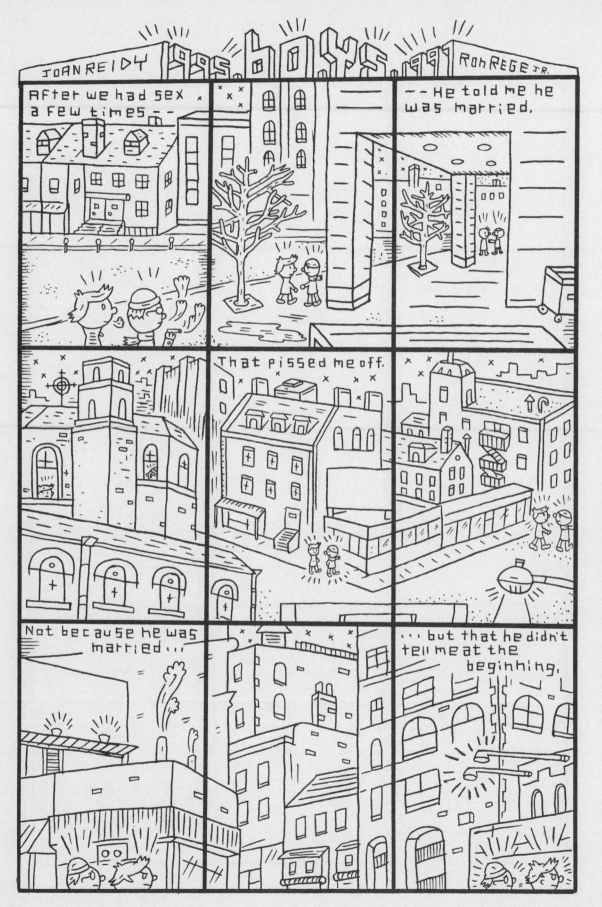

RON REGÉ, JR. (WITH JOAN REIDY) *excerpts from Boys*

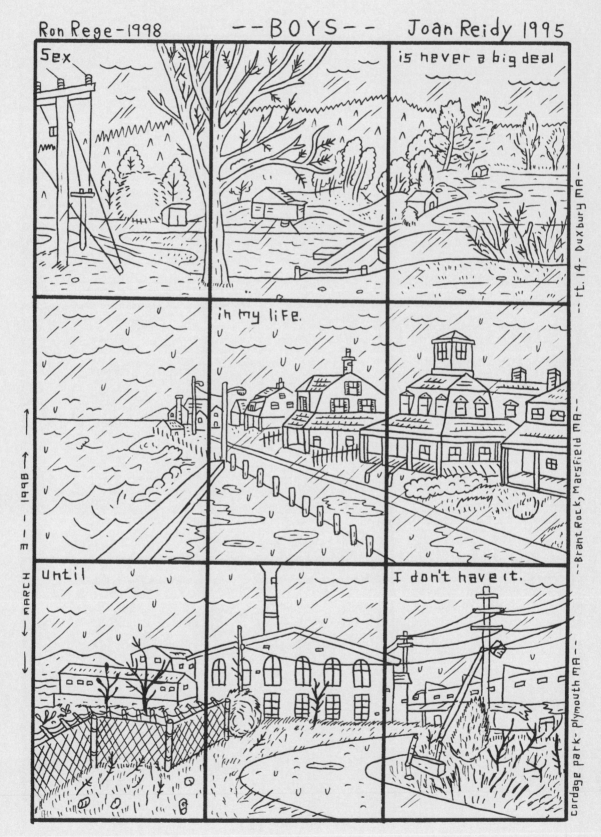

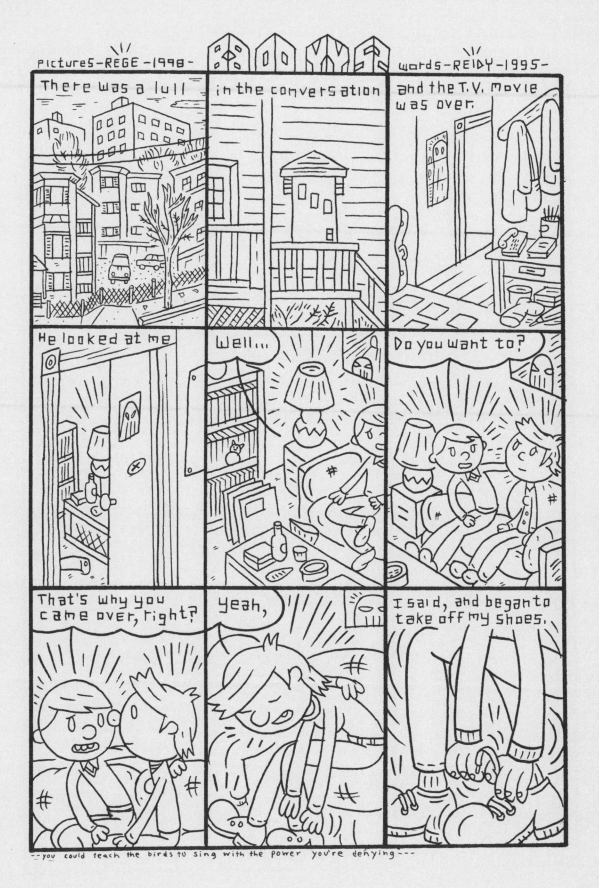

RON REGÉ, JR. (with JOAN REIDY) *excerpts from Boys*

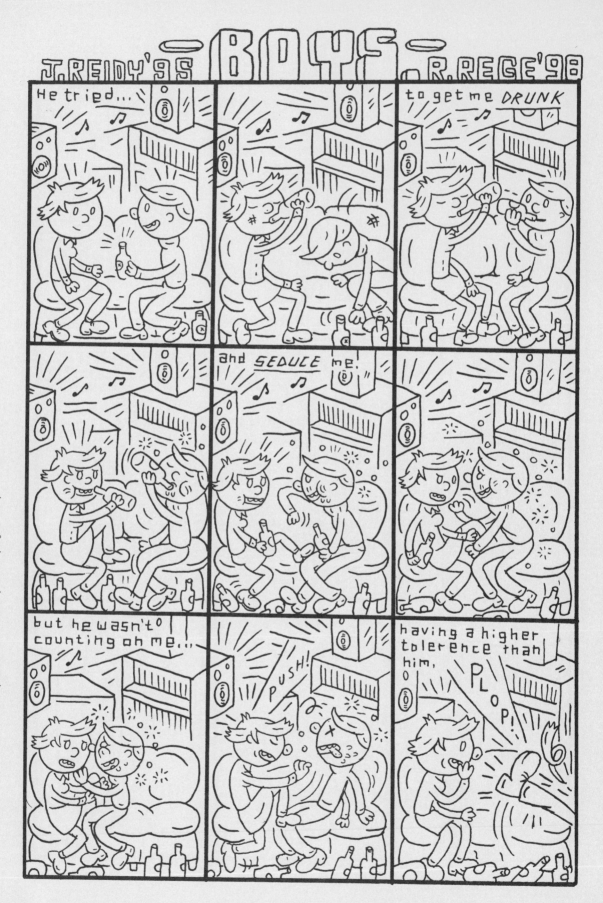

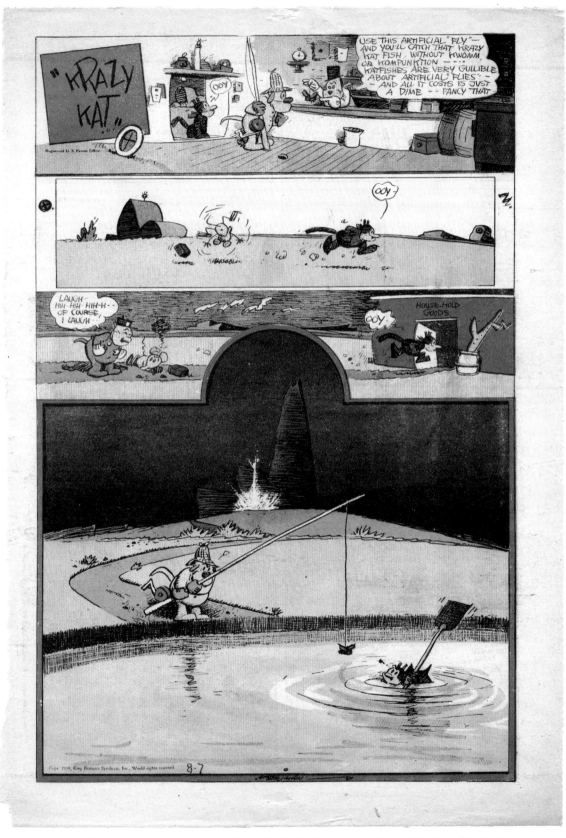

George Herriman, Krazy Kat, Sunday page, August 7, 1938. © King Features Syndicate. Collection of Chris Ware.

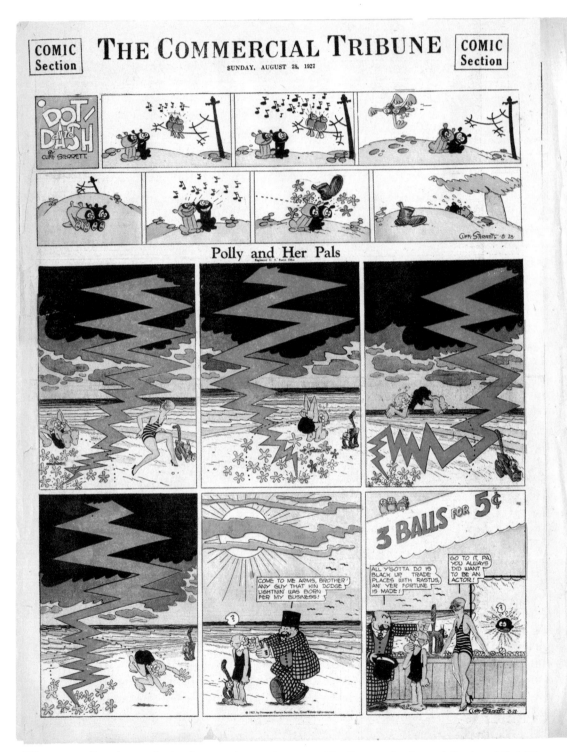

Cliff Sterrett, Polly and Her Pals, *Sunday page, August 28, 1927.* © *King Features Syndicate. Collection of Chris Ware.*

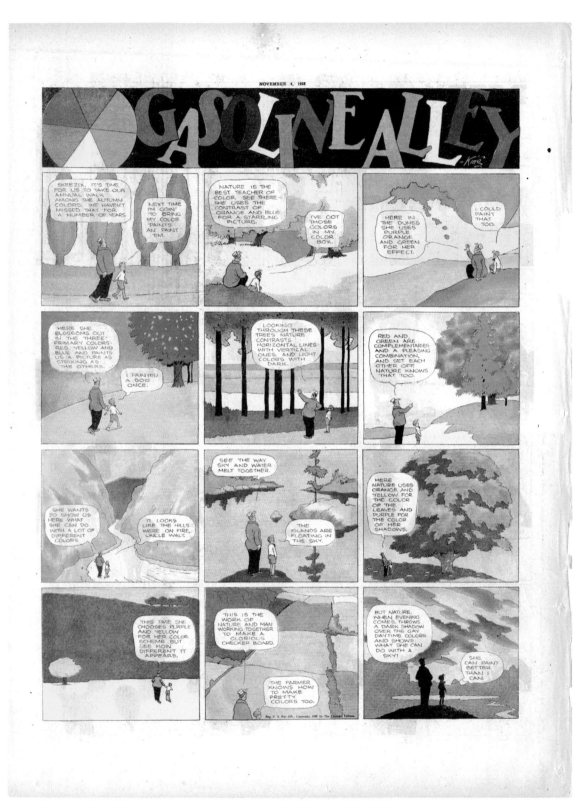

Frank King, Gasoline Alley, *Sunday page, November 4, 1928. Collection of Chris Ware.*

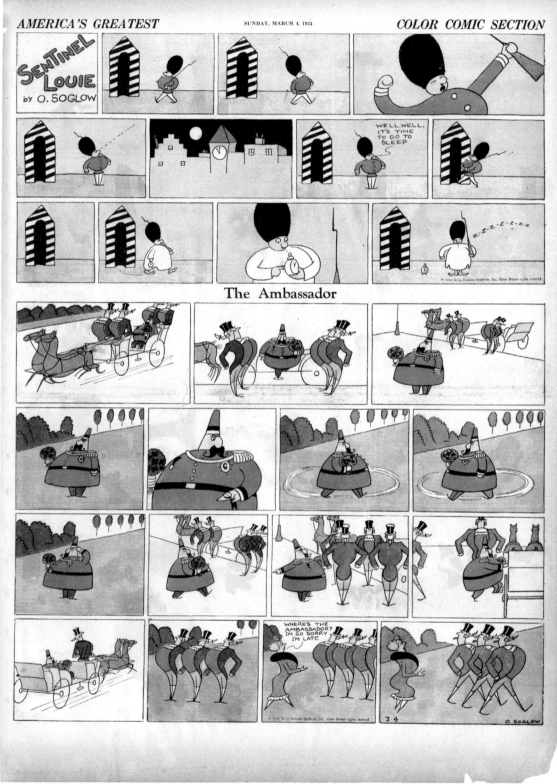

60

Otto Soglow, The Ambassador, *Sunday page, March 4, 1934. © King Features Syndicate. Collection of Chris Ware.*

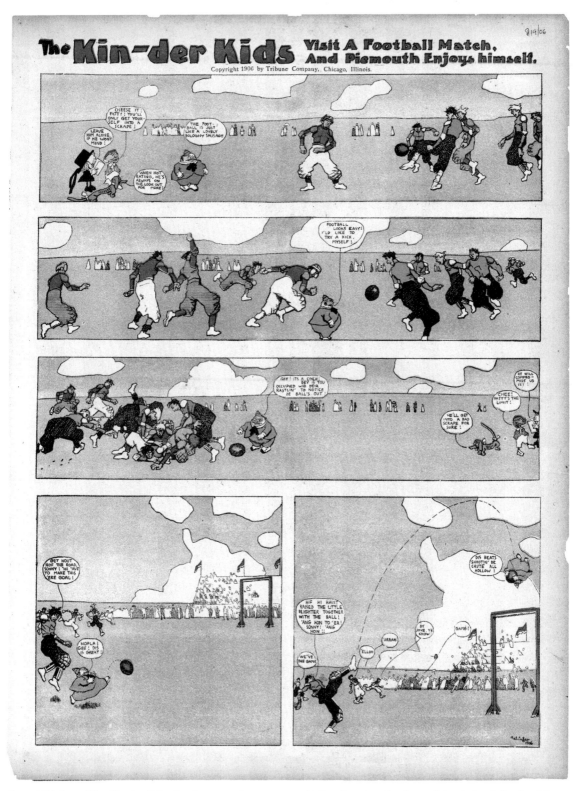

Lyonel Feininger, The Kin-der Kids, Sunday page, August 19, 1906. San Francisco Academy of Comic Art Collection, The Ohio State University Cartoon Research Library.

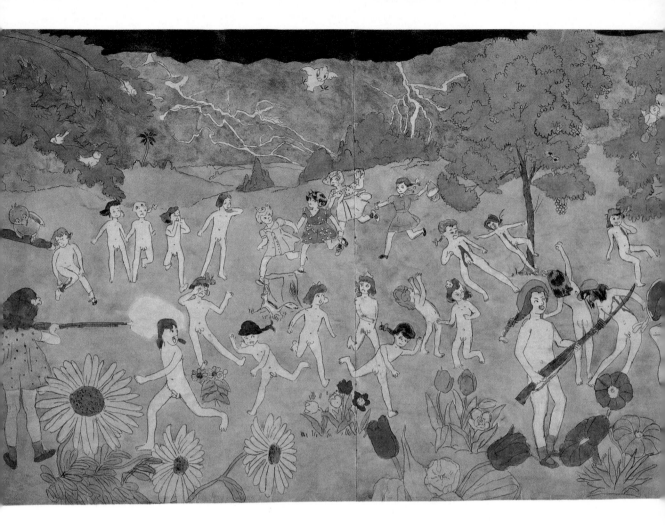

THE CHILD SLAVE REBELLION

When his landlord, photographer Nathan Lerner, entered Henry Darger's room in 1972, he was faced with mountains of the old man's scavengings accumulated over the 40 years he had lived there: crucifixes, broken toys and dolls, bundles of old magazines and comic books, piles of phone directories used to paste in complete runs of *Nancy* clipped from the daily paper, 88 pairs of broken eyeglasses, hundreds of empty bottles of Pepto Bismol, 500 pairs of dilapidated shoes, balls of twine that he had made from tying small pieces together; the list was endless. Henry Darger, who spent most of his adult life as an industrious janitor scrubbing Chicago's hospitals from 7 am to 8:30 pm, came home to create a fantastic world collaged from the debris of popular culture in the privacy of his own never-cleaned room.

In 1916, at age 24, Darger began typing what turned into a 19,000-page epic: *The Adventures of the Vivian Girls in What is Known as the Realms of the Unreal or the Glandelinian War Storm or the Glandico-Abiennian Wars, as caused by the Child Slave Rebellion*. It is the story of a planet (of which our earth is a moon) where all the countries are Catholic. But one, Glandelinia, turns against the faith and enslaves, tortures, mutilates, and murders its children. The beautiful Vivian Girls eventually save them with the help of the Hero, Jack Evans. Darger handbound each of the 13 volumes and inscribed the title in gold leaf. To illustrate the story, he painted 87 wall-size paintings on both sides of cheap paper, glued into two-by-eight-foot sheets. The illustrations are traced and collaged from children's books, coloring books, and comics. His writing "collages" and paraphrases the books that shaped his imagination: dime novels and the Bible.

[A few passages] from the first couple of hundred pages of his autobiography, written in the last six years of his life when illness forced him to retire, give us virtually the only information we have about

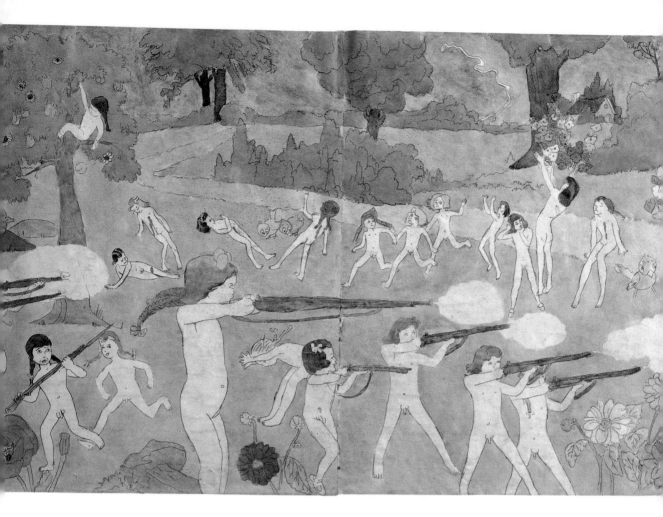

Henry, the orphan boy. The rest of his autobiography is consumed by a 1,500-page description of a twister in Countybrown, Illinois, witnessed when he was 21. Darger was obsessed with Catholicism, fires, tortured children, mythical demons . . . and weather. Convinced that the weather was God's domain, he was deeply upset by the idea that men would attempt to predict it. He kept a daily journal, *Weather Report of Cold and Warm, Also Summer Heats and Cool Spells, Storms and Fair or Cloudy Days, Contrary to What the Weatherman Says, And Also True Too*, noting every night for nine years what the day's forecast had been and what had actually happened.

At the age of 80, Darger's increasing lameness forced him to ask his landlord to take him to the Little Sisters of the Poor's home. He died six months later.

This essay is reprinted from RAW, *Volume 2, Number 2 (1990), edited by Art Spiegelman and Françoise Mouly.*

Chris Ware noticed a striking similarity between the long horizontal panels of the Lyonel Feininger comic strip (on page 61) and some of Henry Darger's compositions. Could Darger have seen Feininger's work in the Chicago Tribune? *In any case, Darger's distinct, rich palette and his structural use of color have an affinity with the Sunday comics; moreover, standing before one of Darger's immense watercolors, one can easily empathize with a young boy dwarfed by the unwieldy broadsheet of a Sunday comic supplement from the early part of the 20th century.*

63

MUCH THANX TO GARY ARLINGTON

R. HAYES

ALINE KOMINSKY-CRUMB Of What Use Is a Bunch?

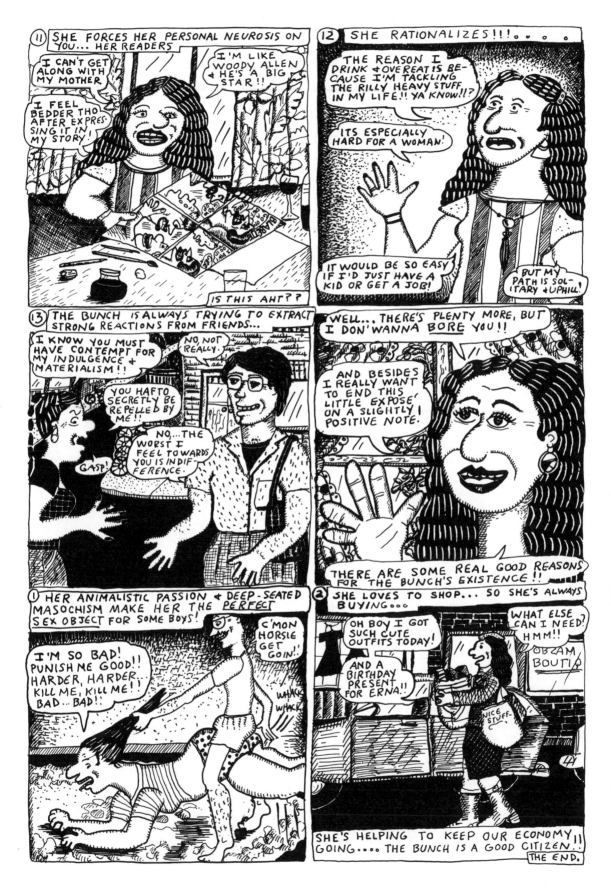

Right margin, rotated text: ALINE KOMINSKY-CRUMB Of What Use Is a Bunch?

67

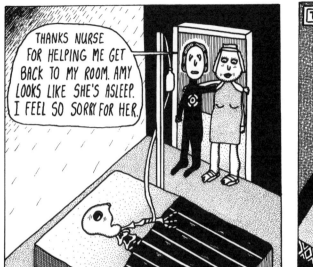

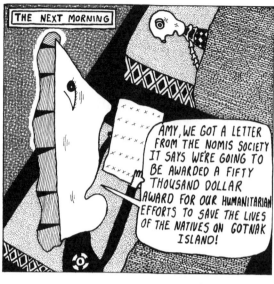

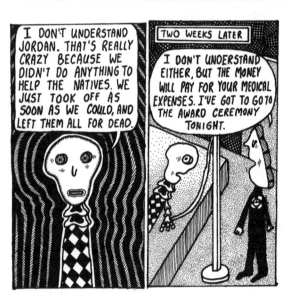

68

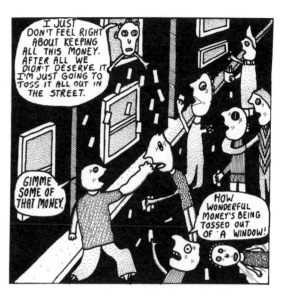

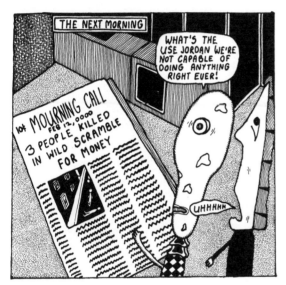

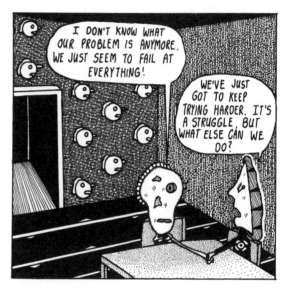

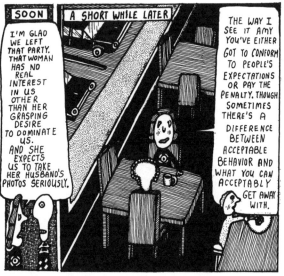

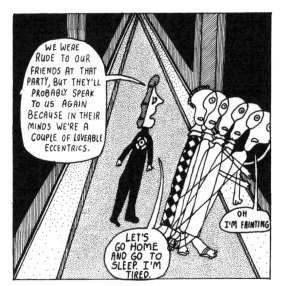

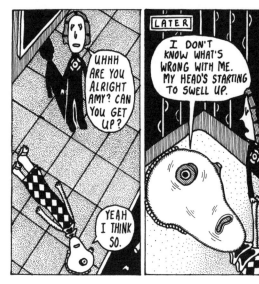

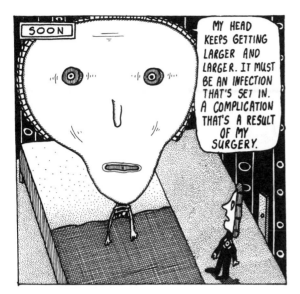

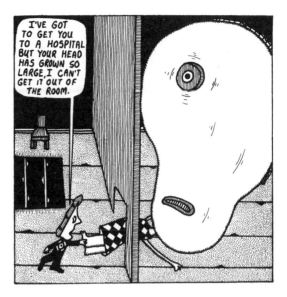

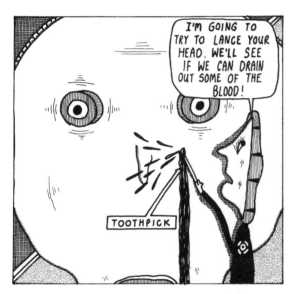

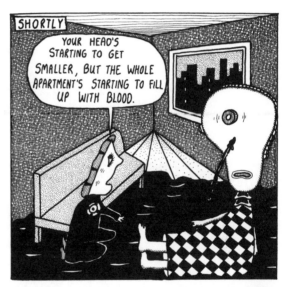

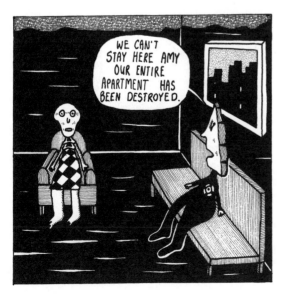

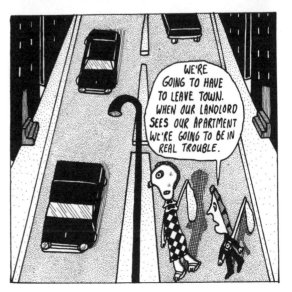

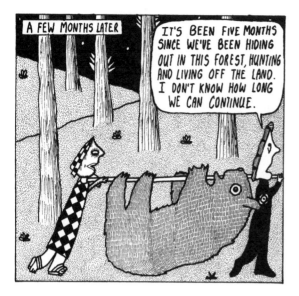

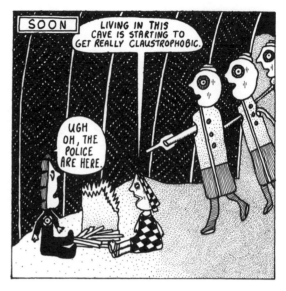

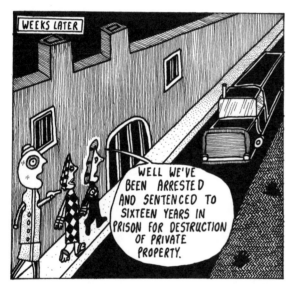

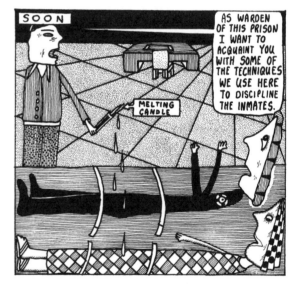



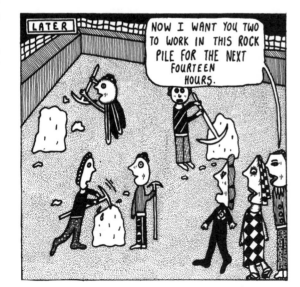

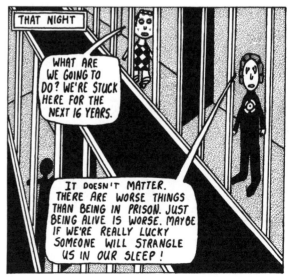



MARK BEYER *excerpt from Agony*

72

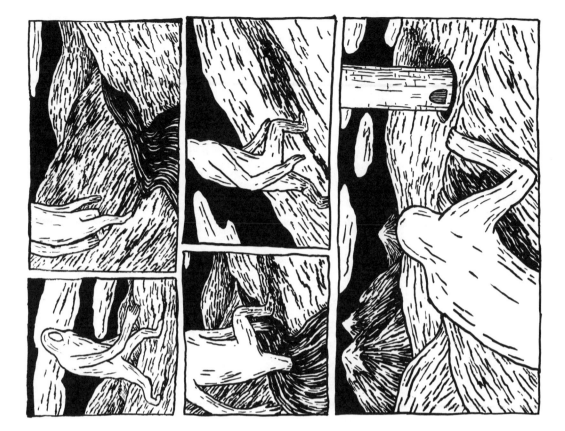

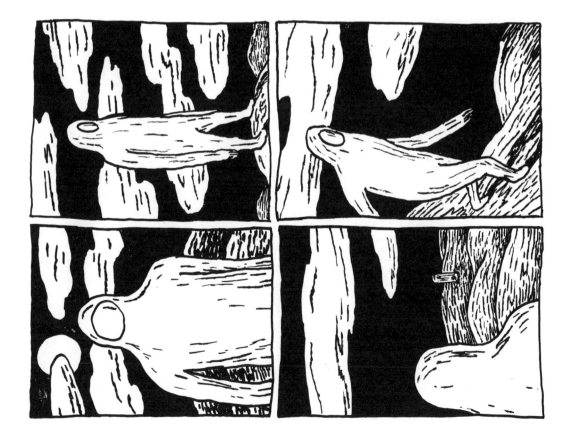

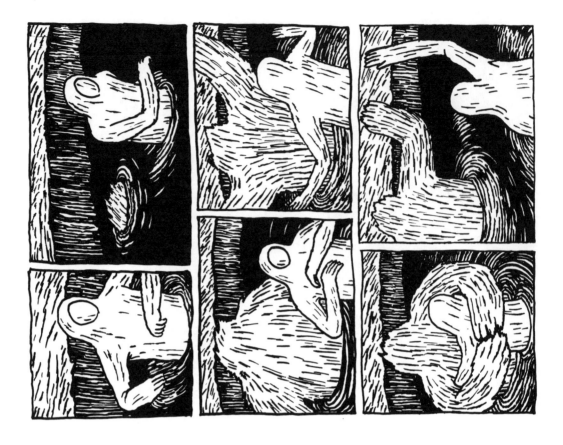

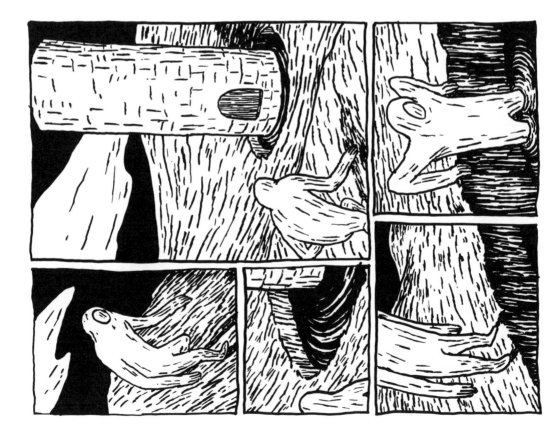

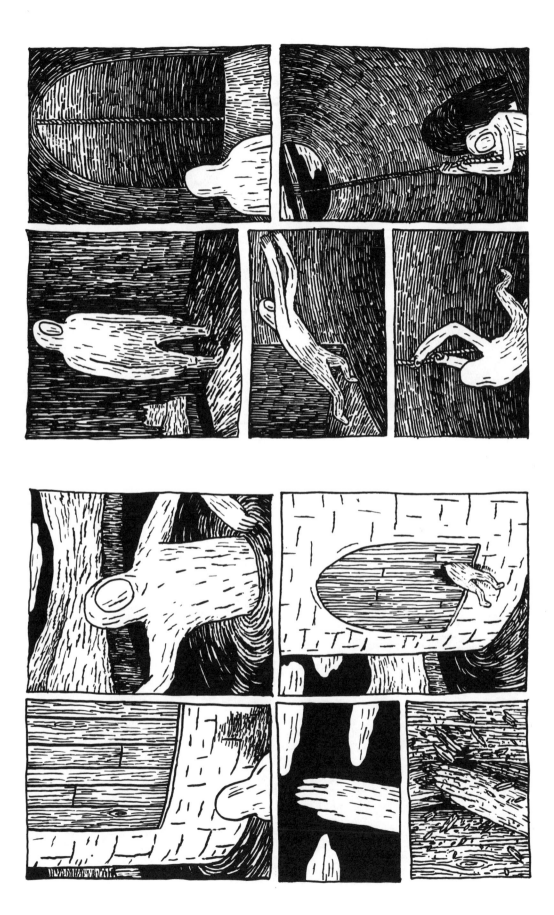

75

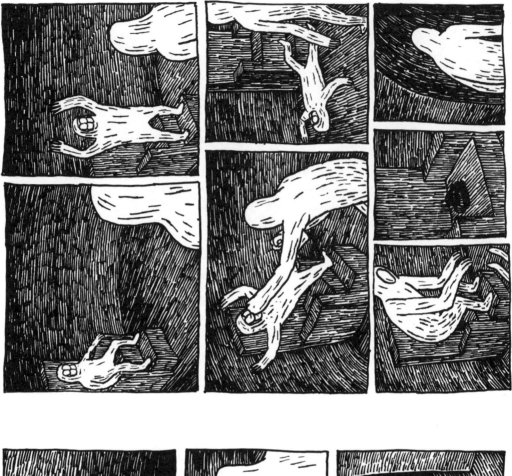

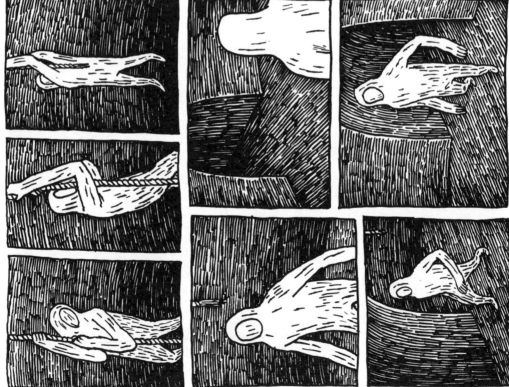

76

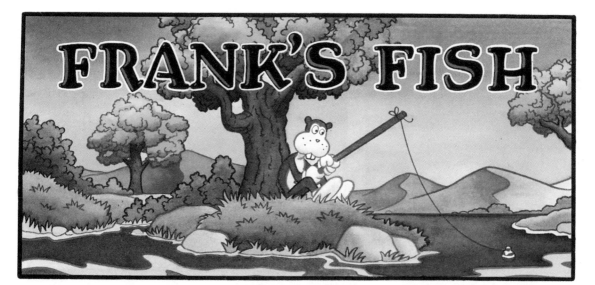

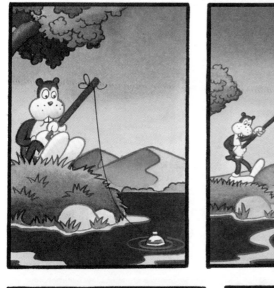

JIM WOODRING Frank's Fish

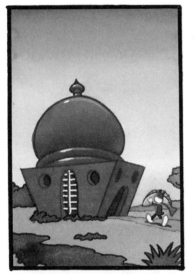
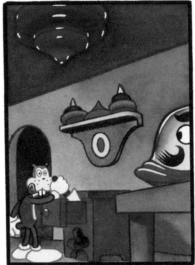
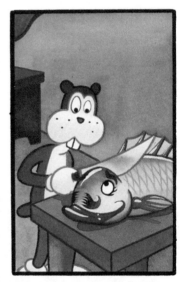
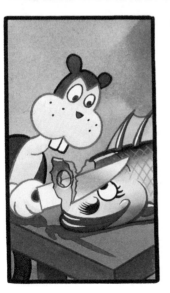
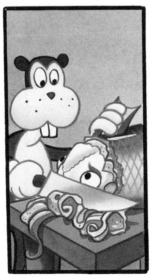
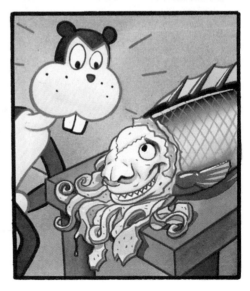

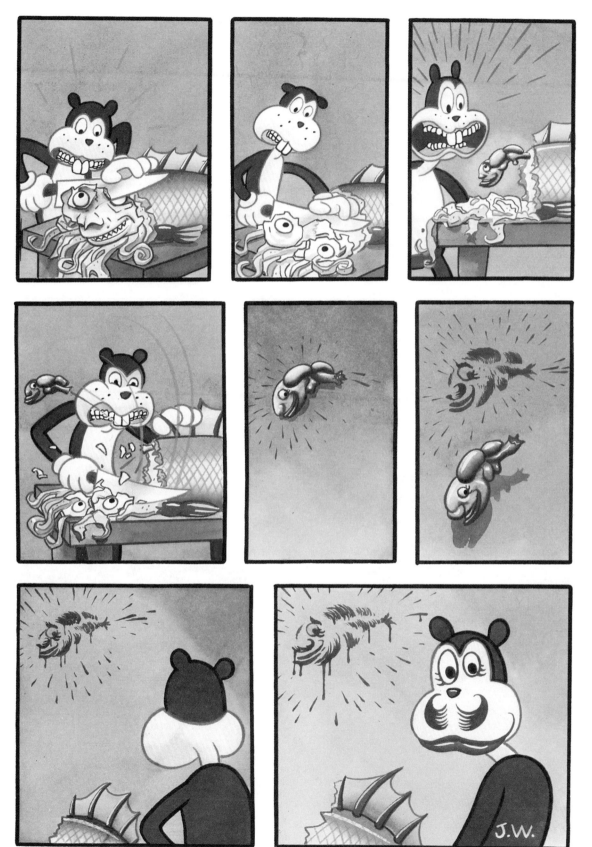

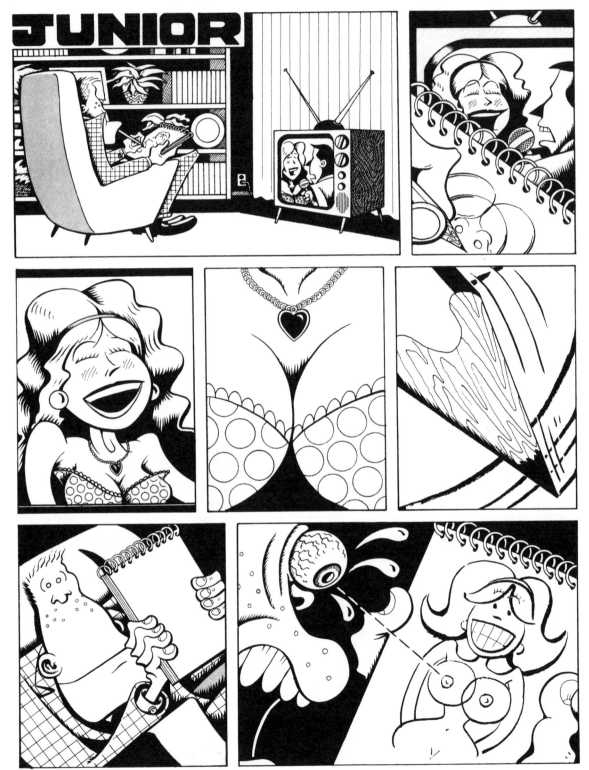

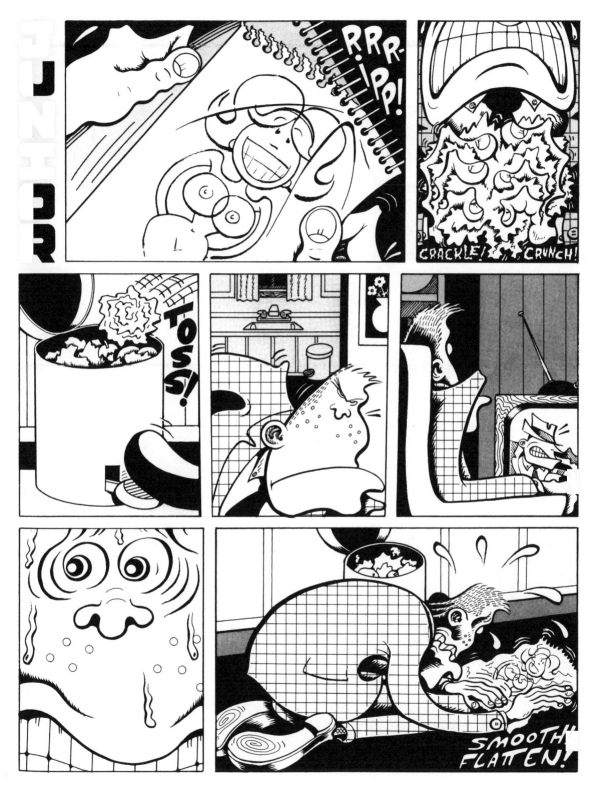

PETER BAGGE *excerpt from Oedipus Junior*

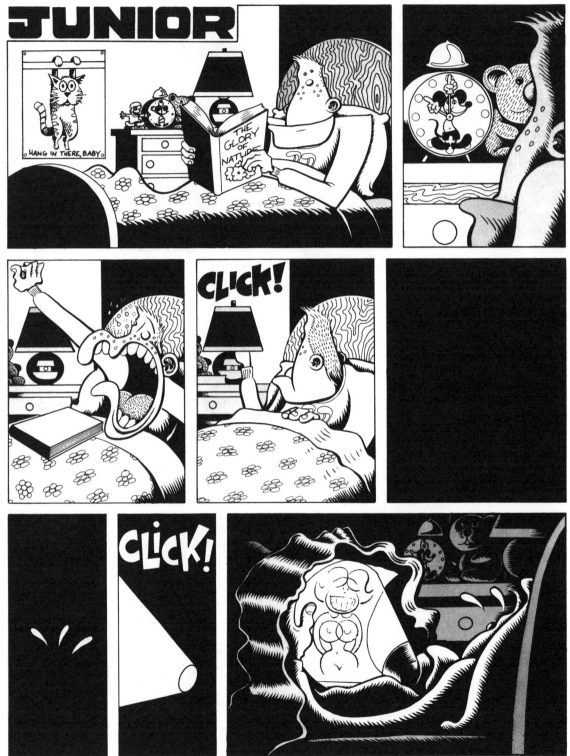

© '89 P. BAGGE

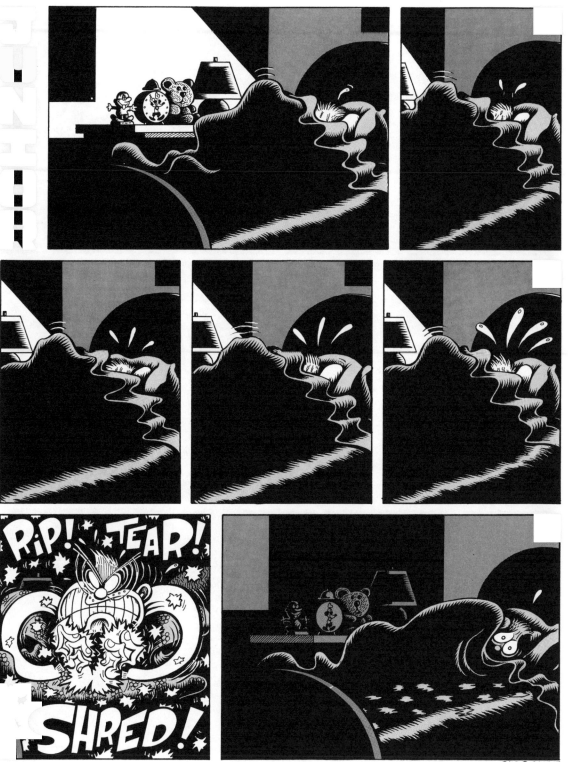

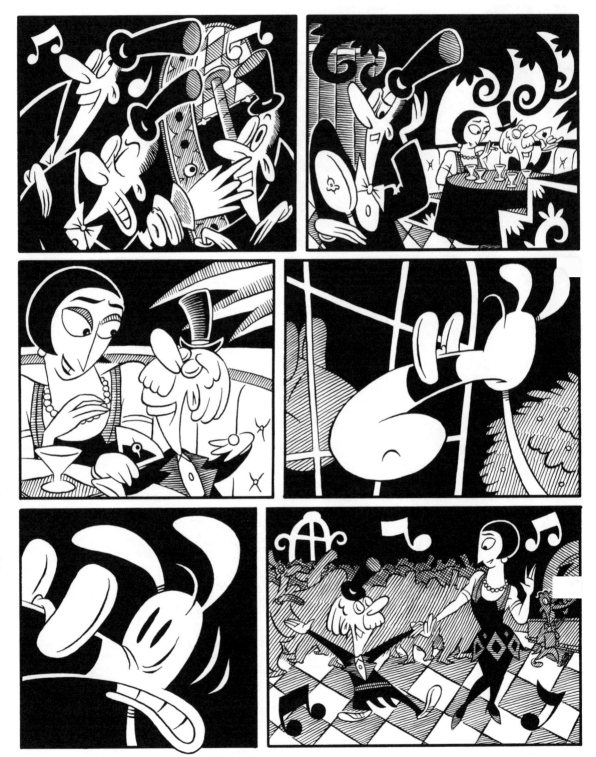

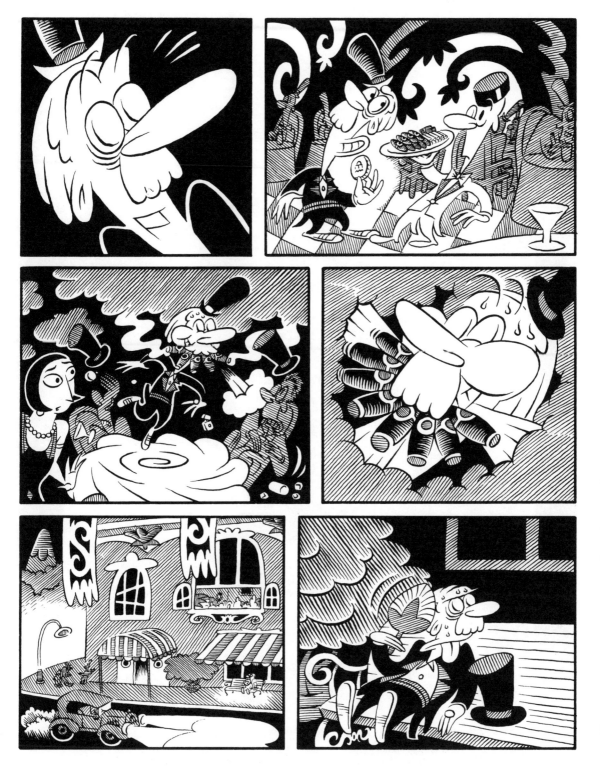

WALT HOLCOMBE *excerpt from The King of Persia*

85

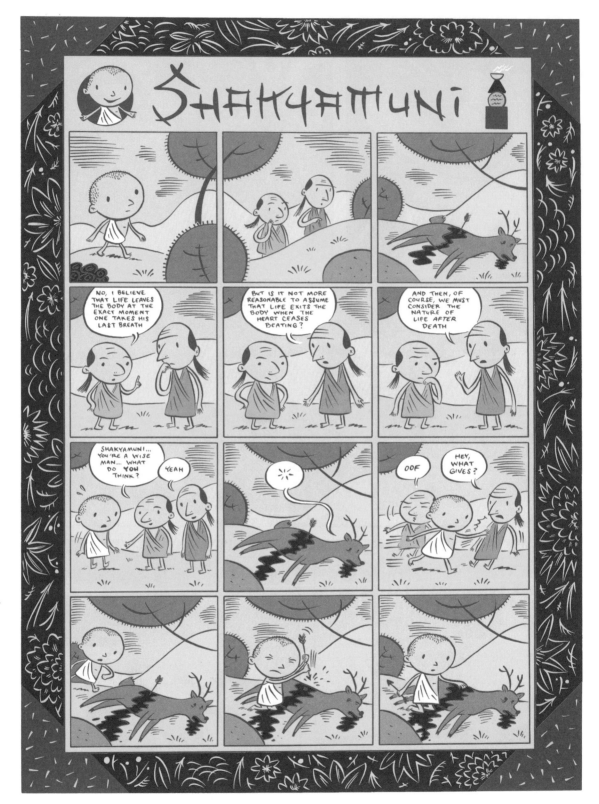

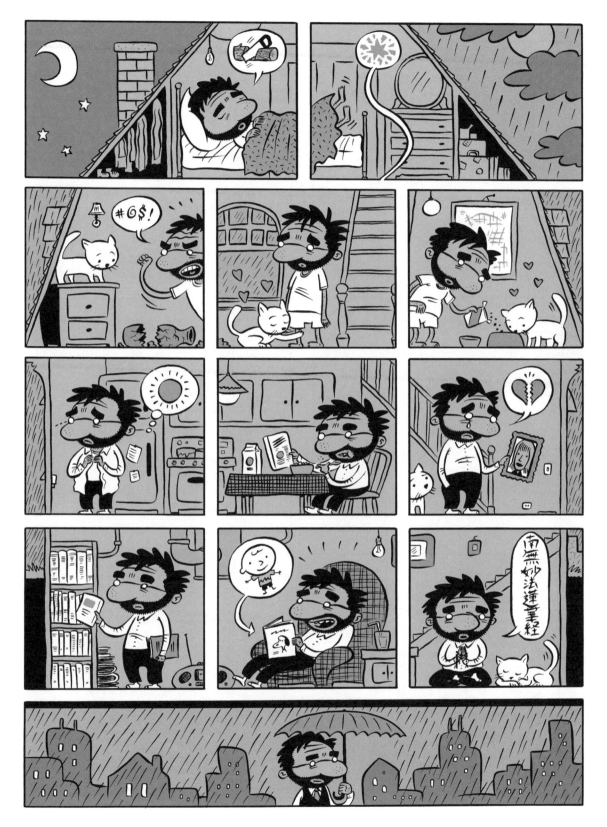

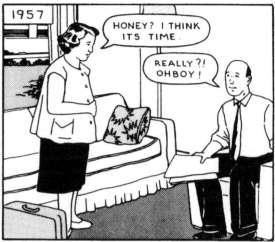

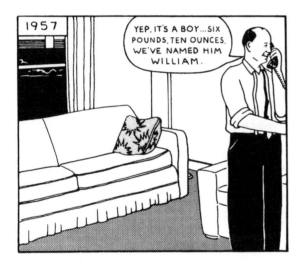

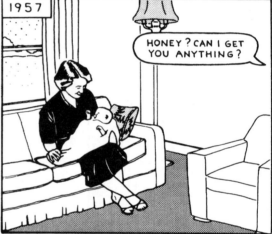

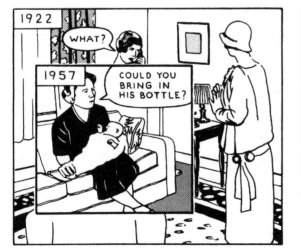

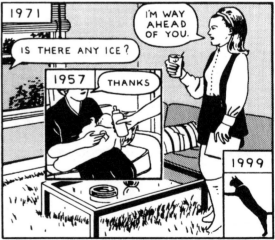

RICHARD McGUIRE Here

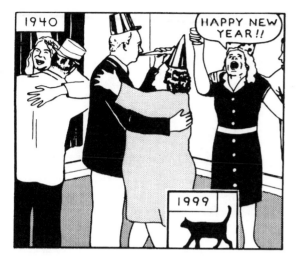
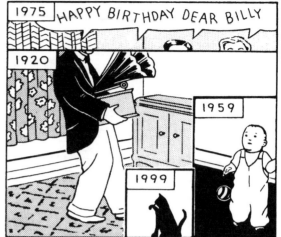
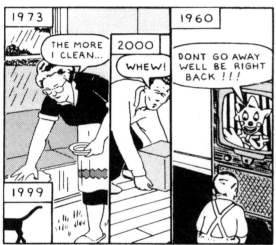
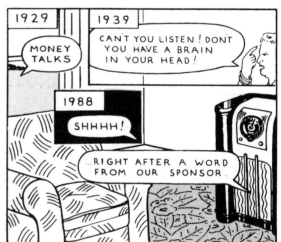
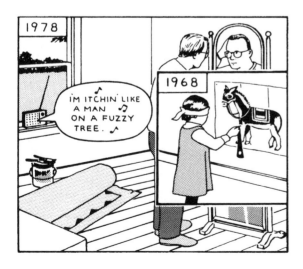
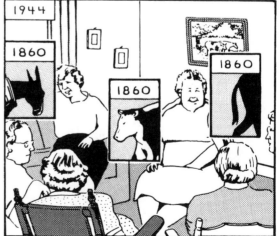

RICHARD McGUIRE Here

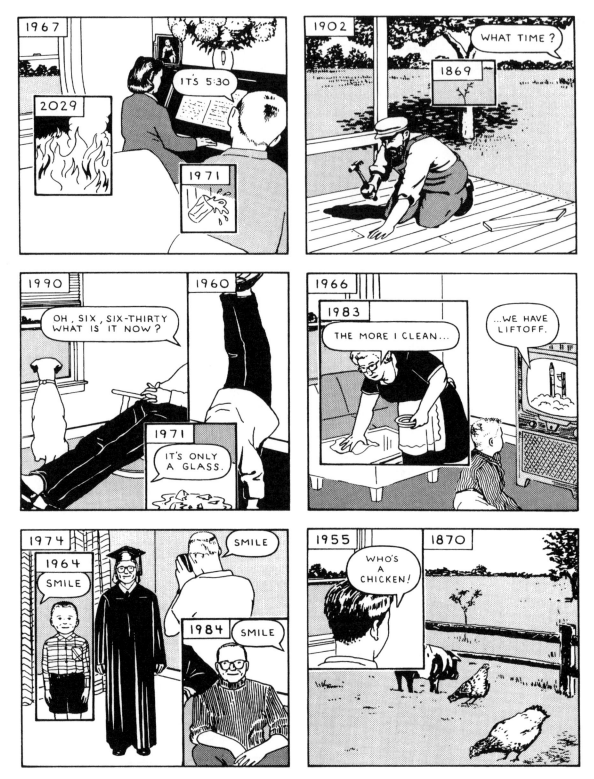

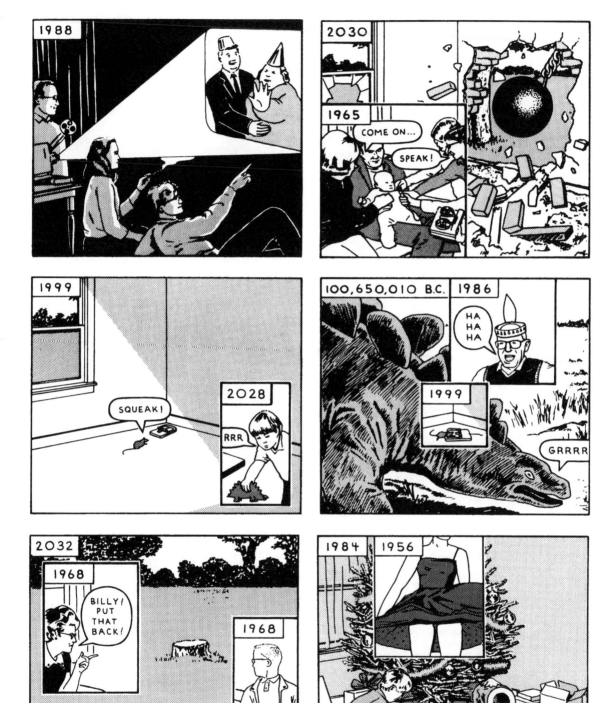

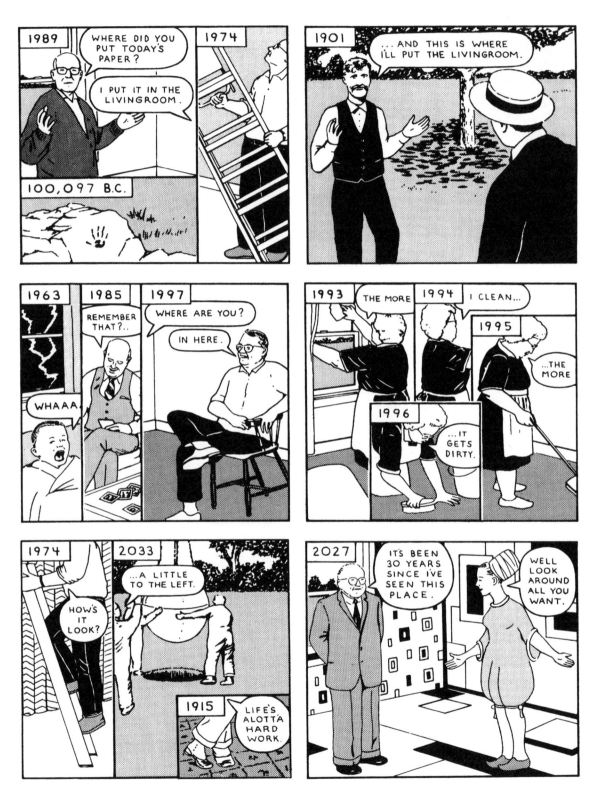

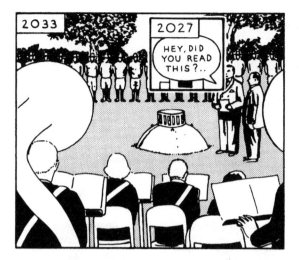

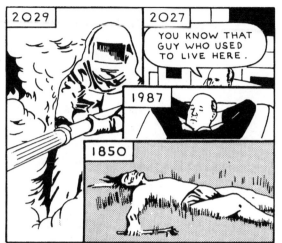

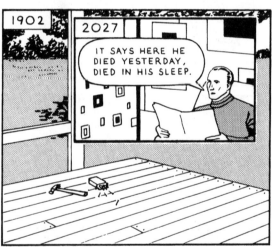

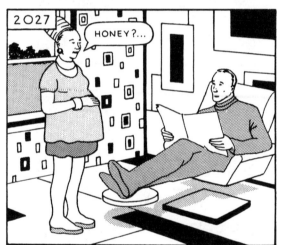

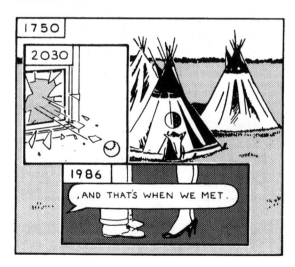

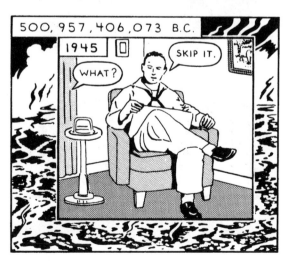

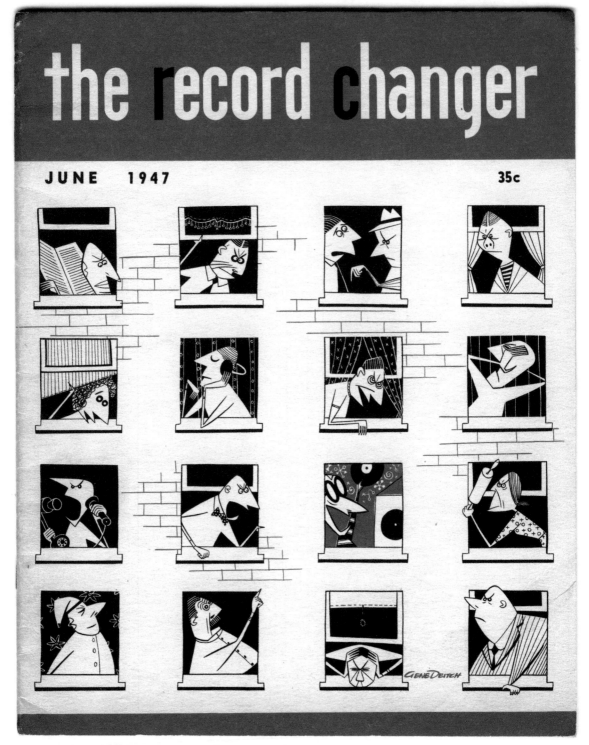

the record changer

GENE DEITCH The Record Changer

JUNE 1947 35c

Gene Deitch, cover for the June 1947 issue of The Record Changer.

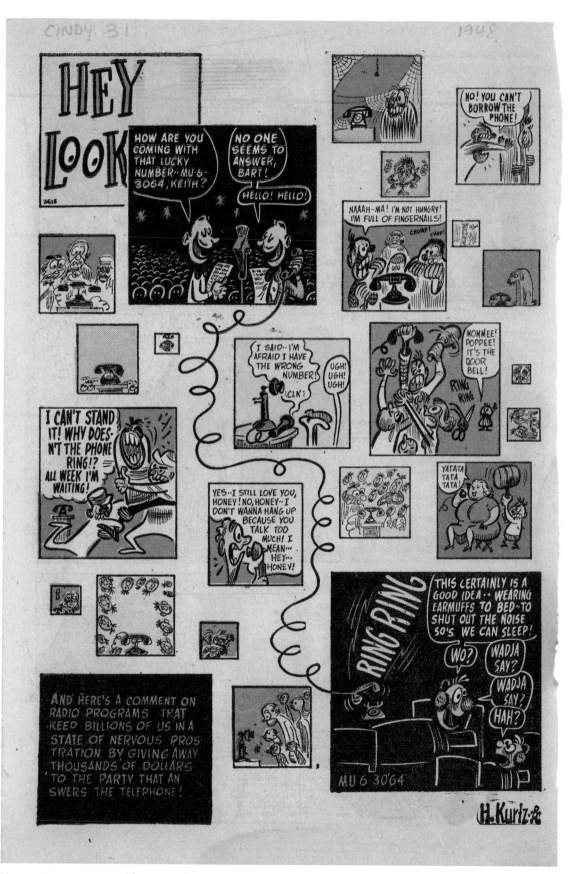

Harvey Kurtzman, Hey Look! From Cindy No. 31, 1948. Collection of Glenn Bray. Copyright © Harvey Kurtzman Estate and used by permission of Denis Kitchen Art Agency.

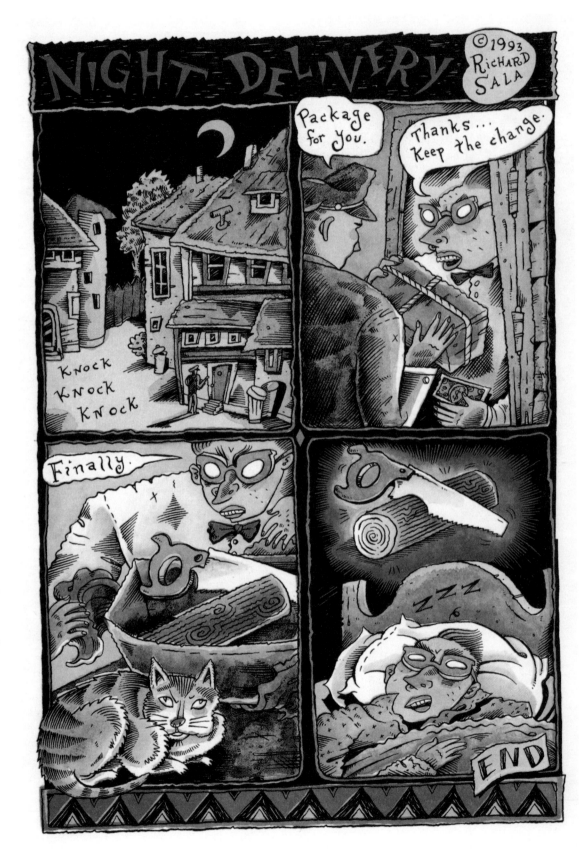

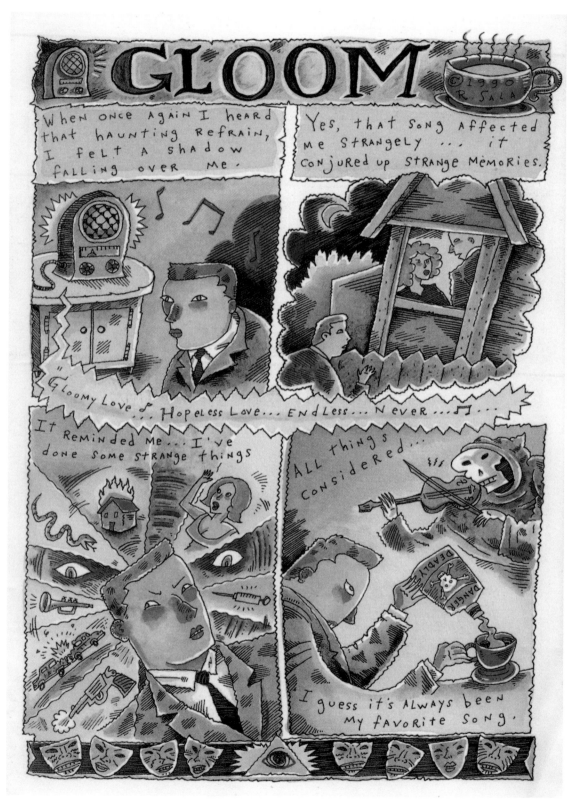

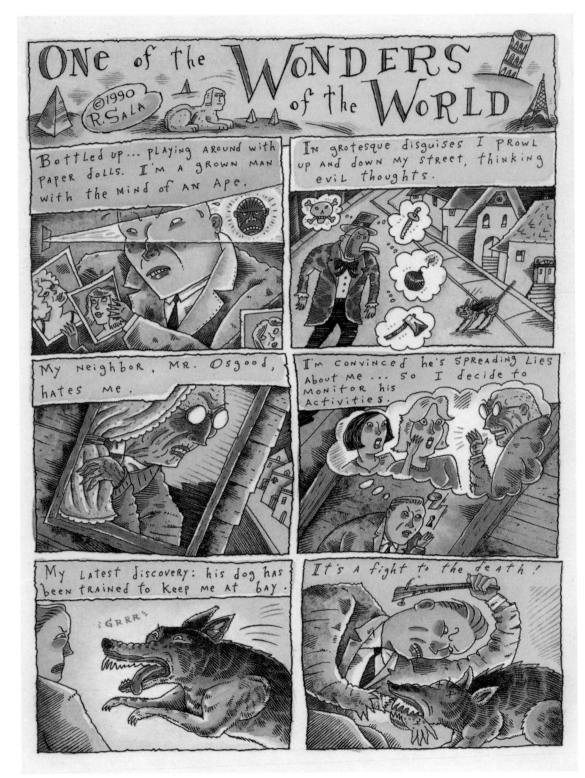

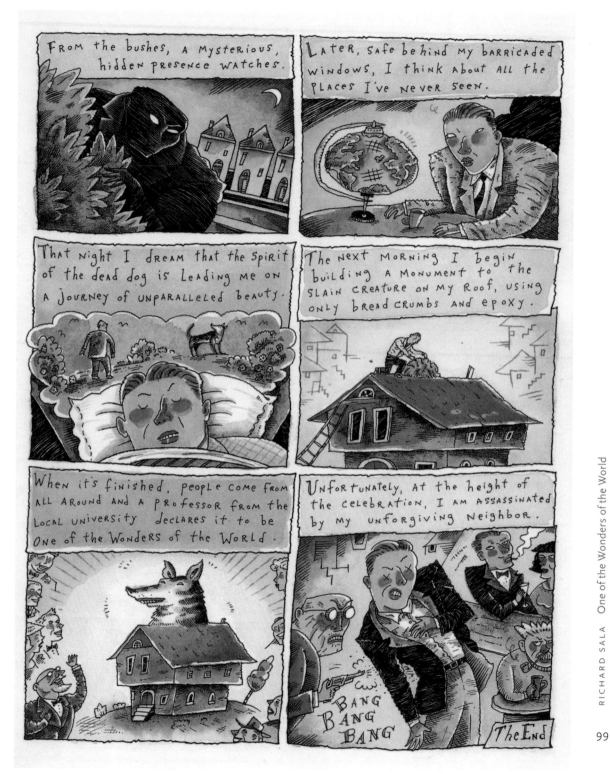

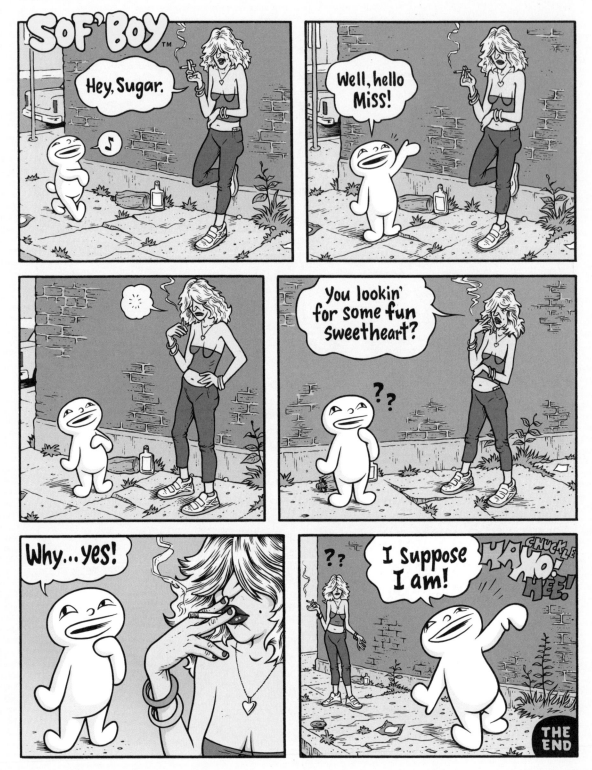

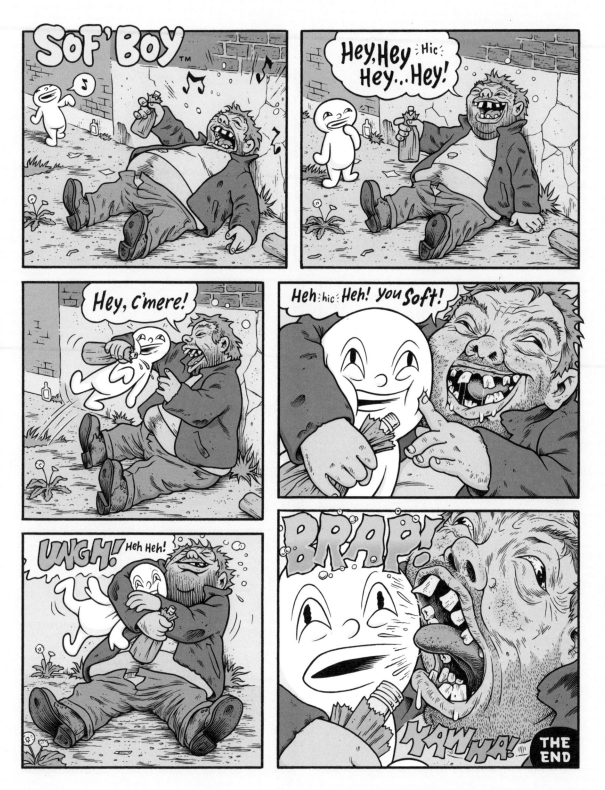

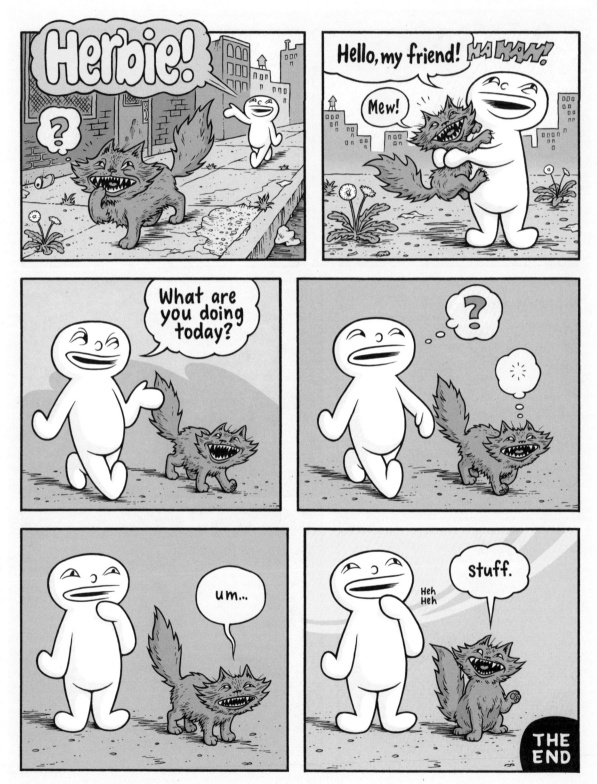

ARCHER PREWITT Sof' Boy

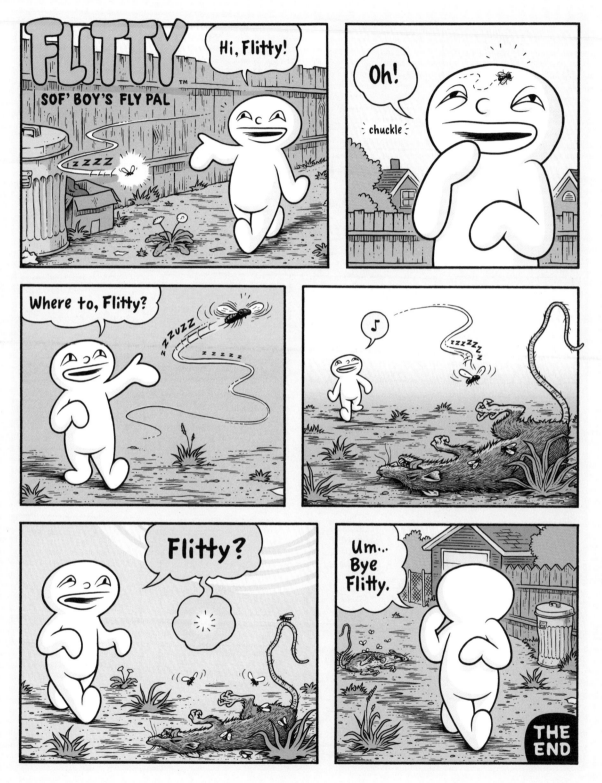

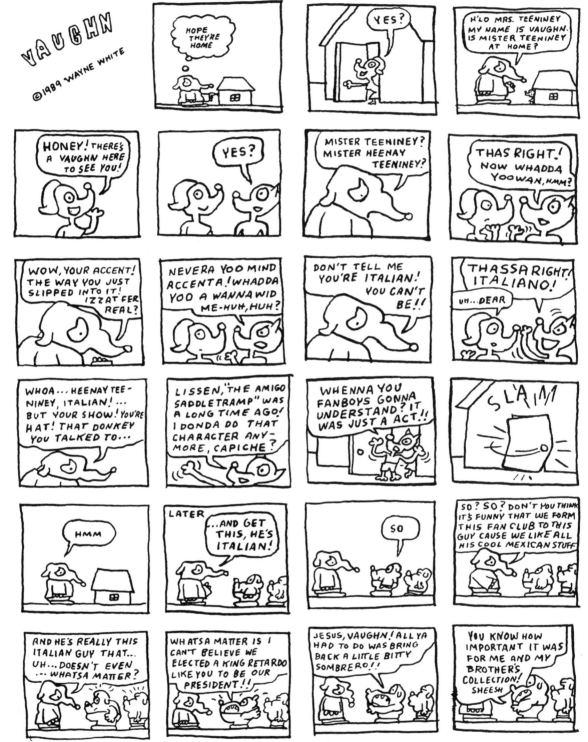

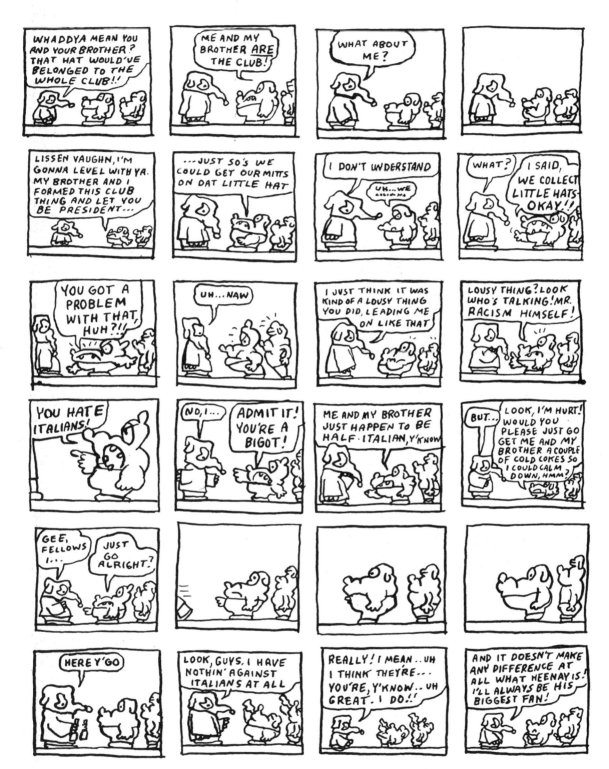

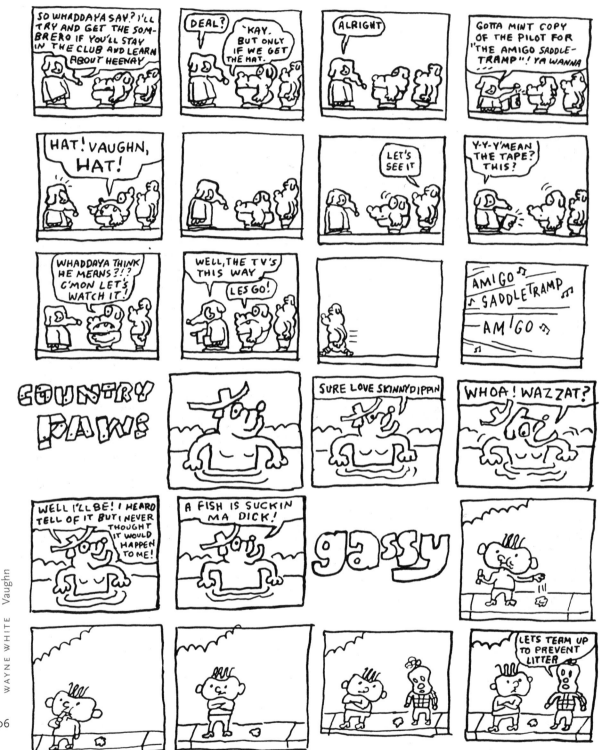

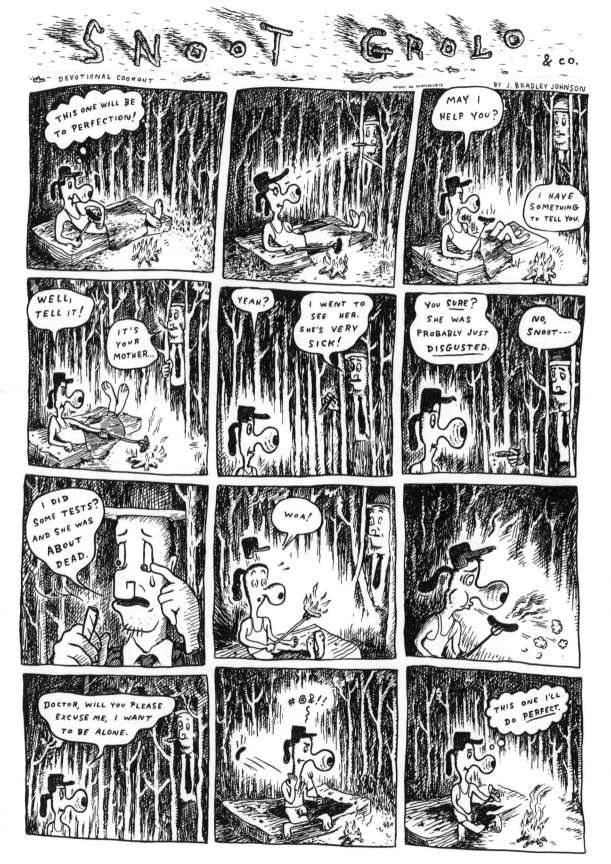

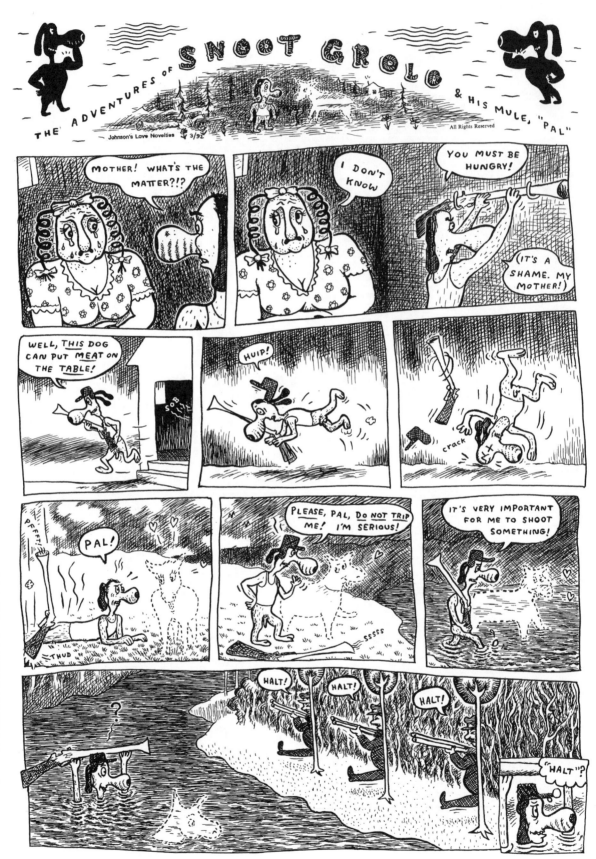

108

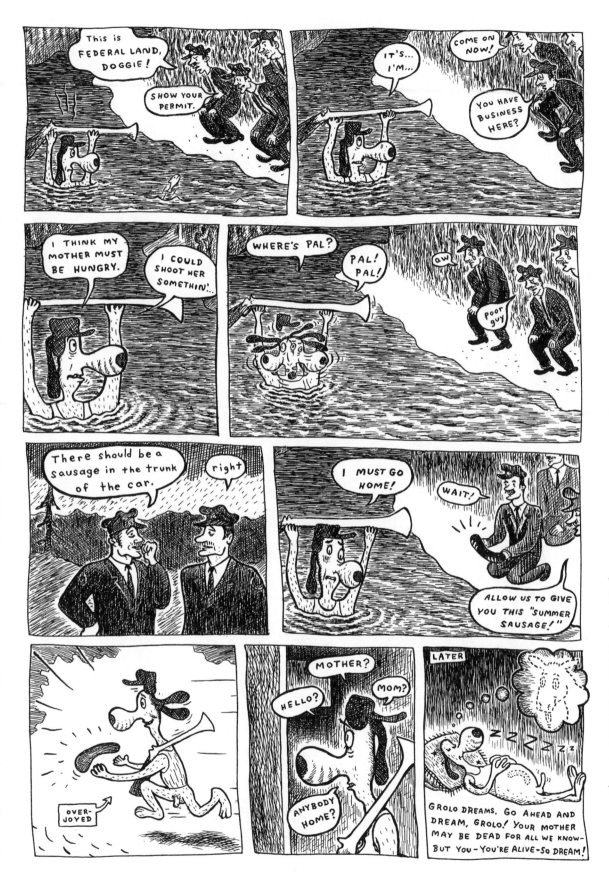

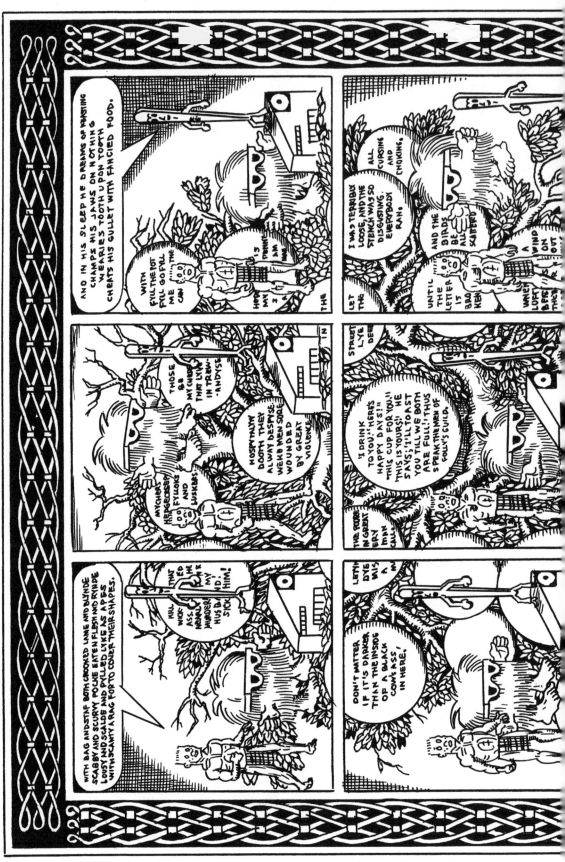

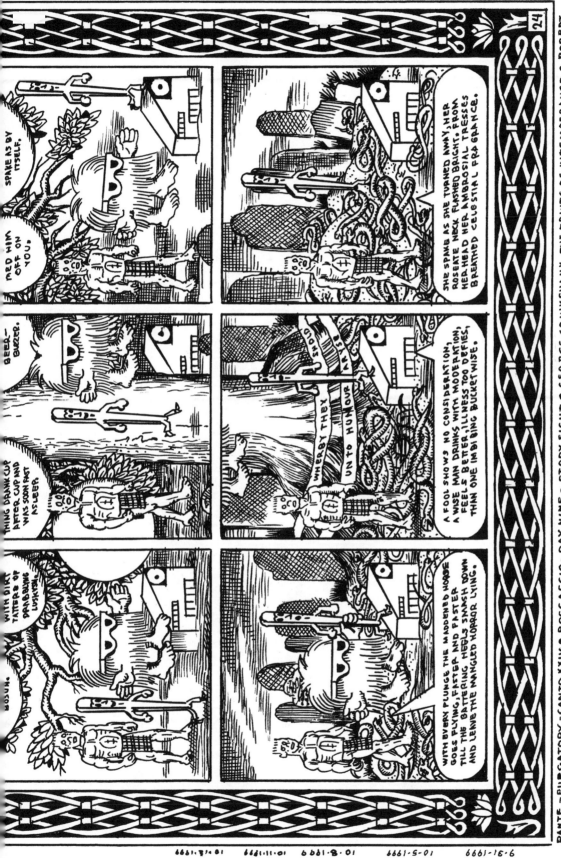

111 GARY PANTER *excerpt from Jimbo in Purgatory*

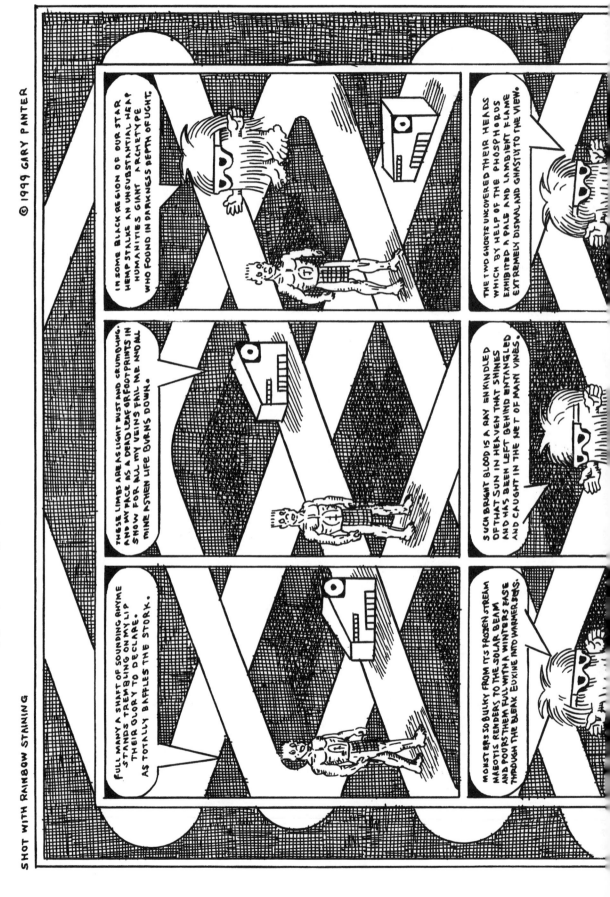

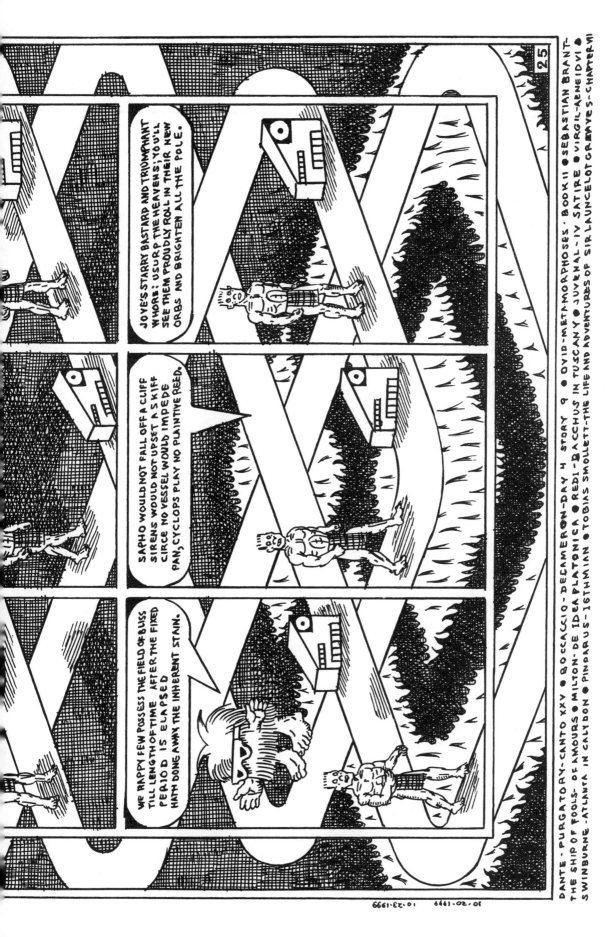

GARY PANTER *excerpt from* Jimbo in Purgatory

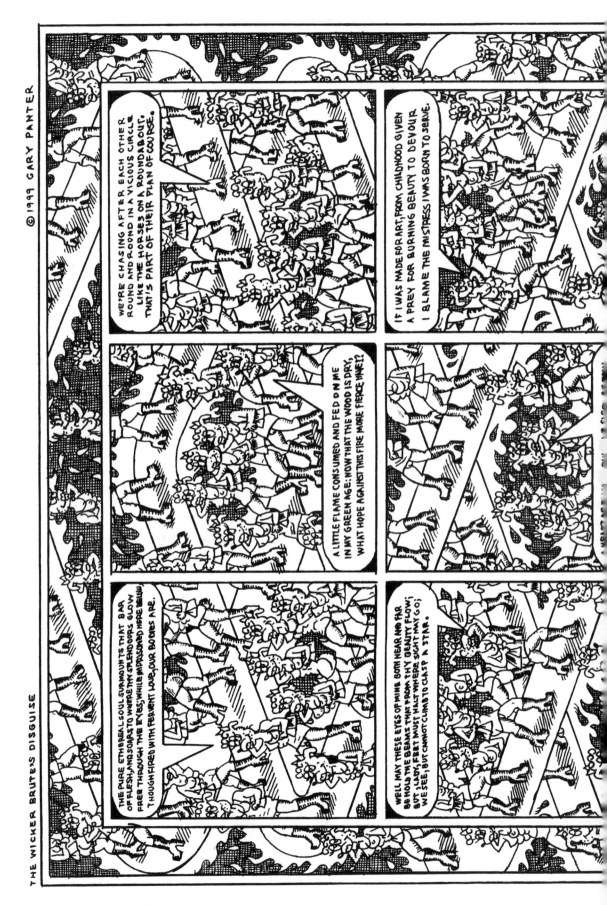

© 1999 GARY PANTER

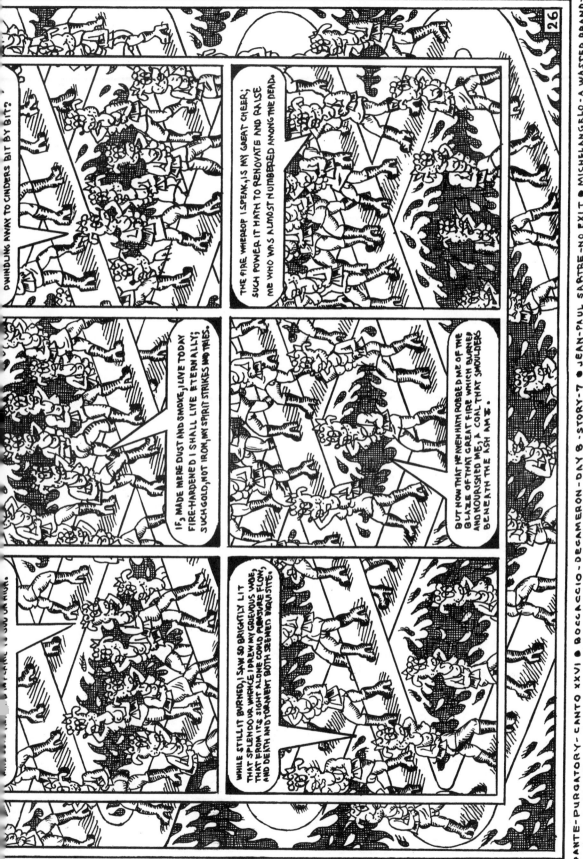

DANTE – PURGATORY – CANTO XXVI ● BOCCACCIO – DECAMERON – DAY 8 – STORY–7 ● JEAN-PAUL SARTRE–NO EXIT ● MICHELANGELO–A WASTED BRAND– –LOVE'S FURNACE–LOVE'S FLAME DOTH FEED ON AGE–LOVE AND DEATH–LOVE IS A REFINER'S FIRE–FLESH AND SPIRIT ●

GARY PANTER *excerpt from* Jimbo in Purgatory

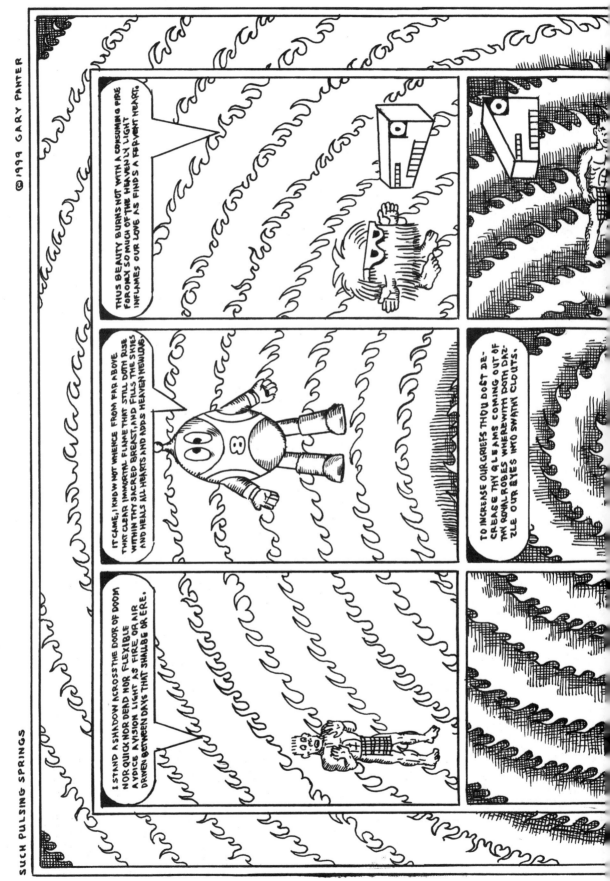

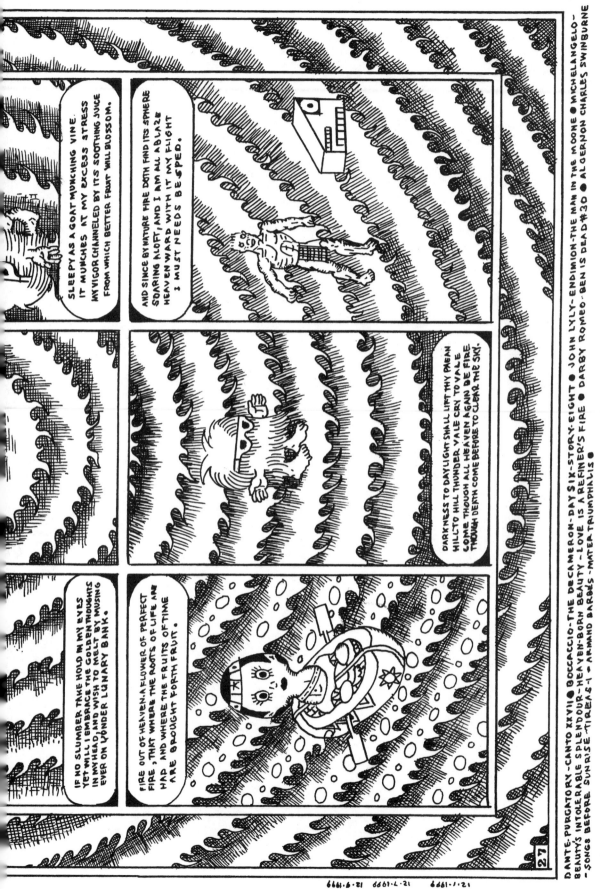

GARY PANTER · excerpt from Jimbo in Purgatory

117

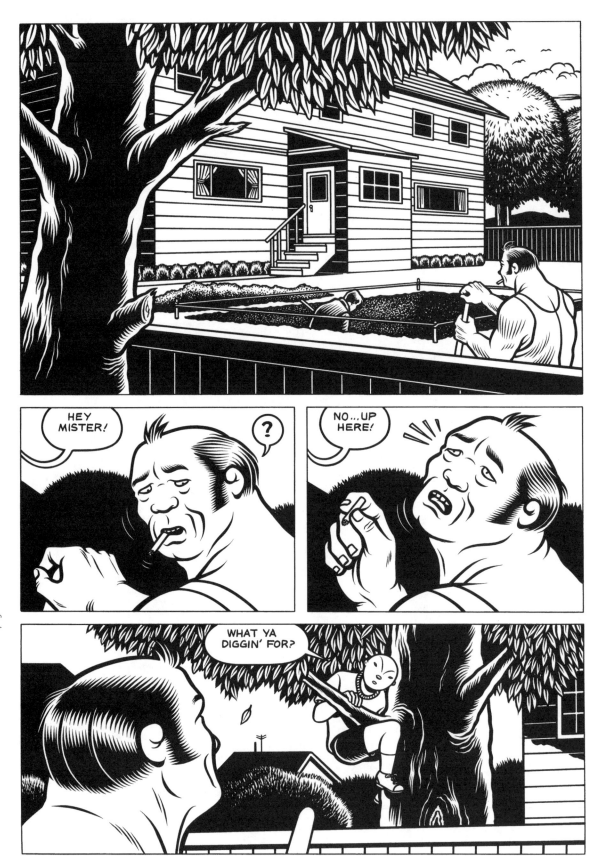

CHARLES BURNS *excerpt from Curse of the Molemen*

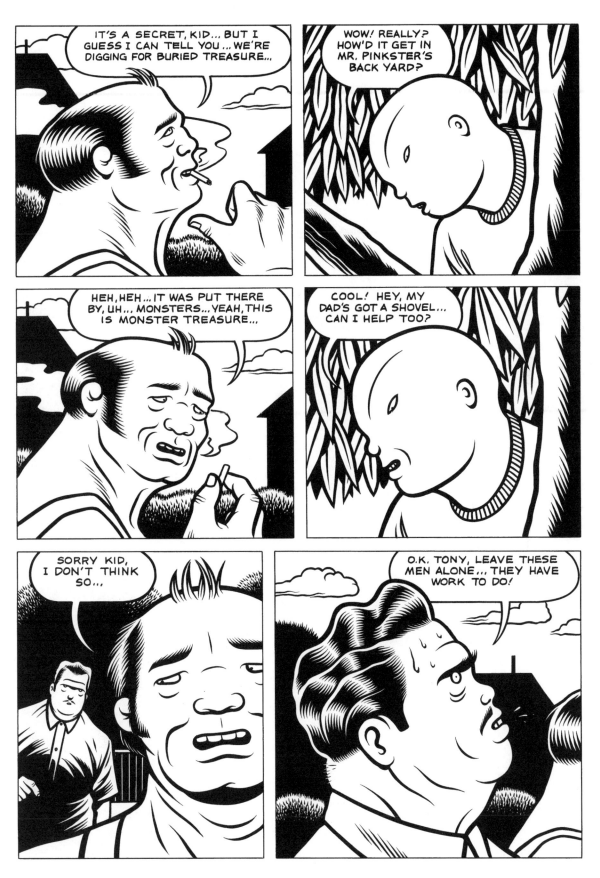

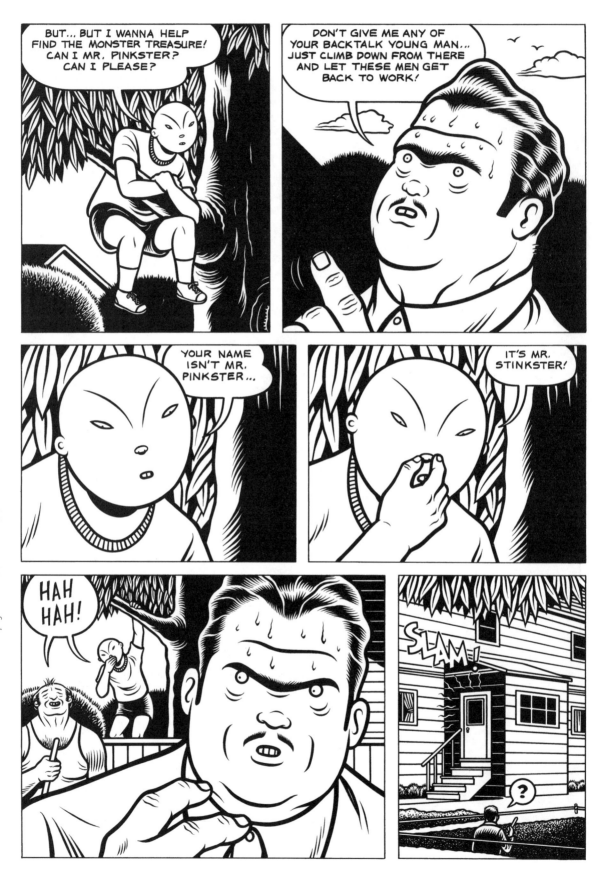

CHARLES BURNS *excerpt from Curse of the Molemen*

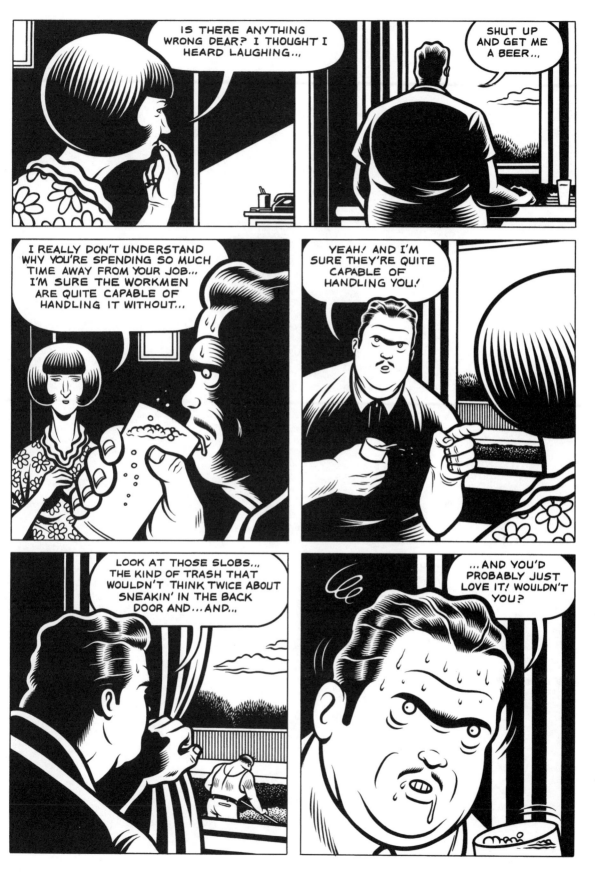

CHARLES BURNS *excerpt from Curse of the Molemen*

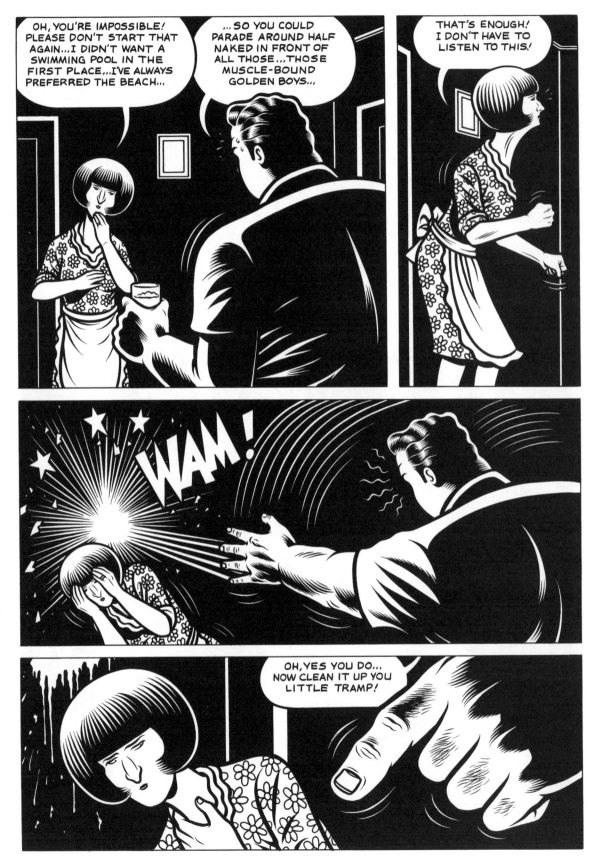

CHARLES BURNS *excerpt from* Curse of the Molemen

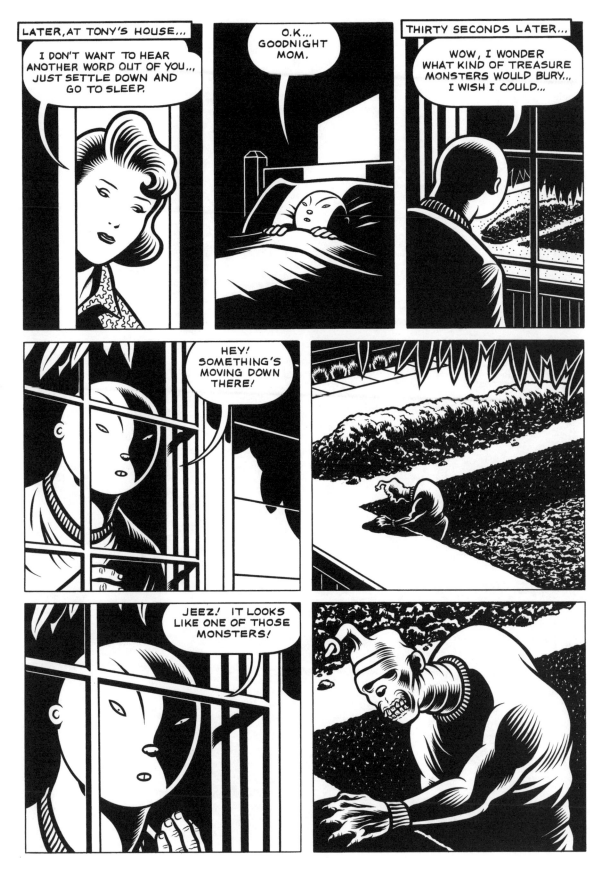

CHARLES BURNS *excerpt from Curse of the Molemen*

123

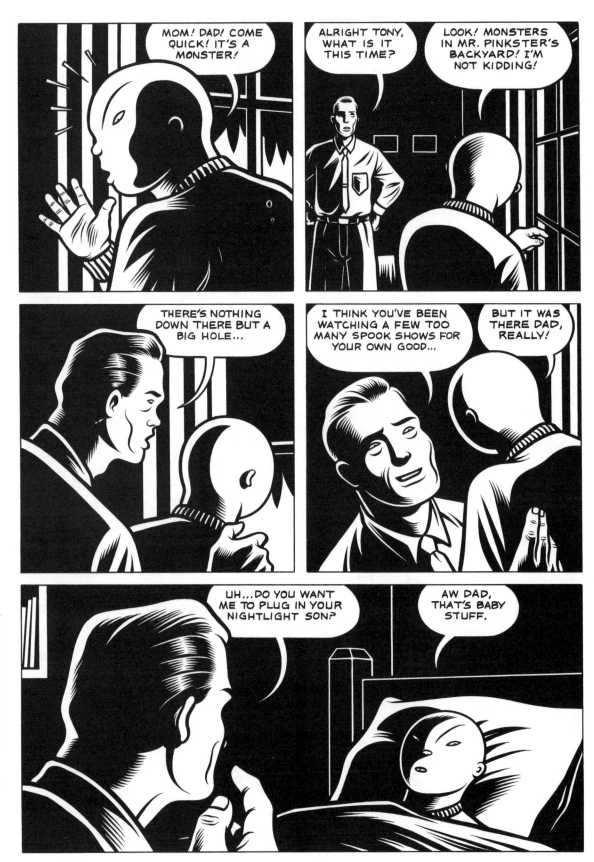

CHARLES BURNS *excerpt from Curse of the Molemen*

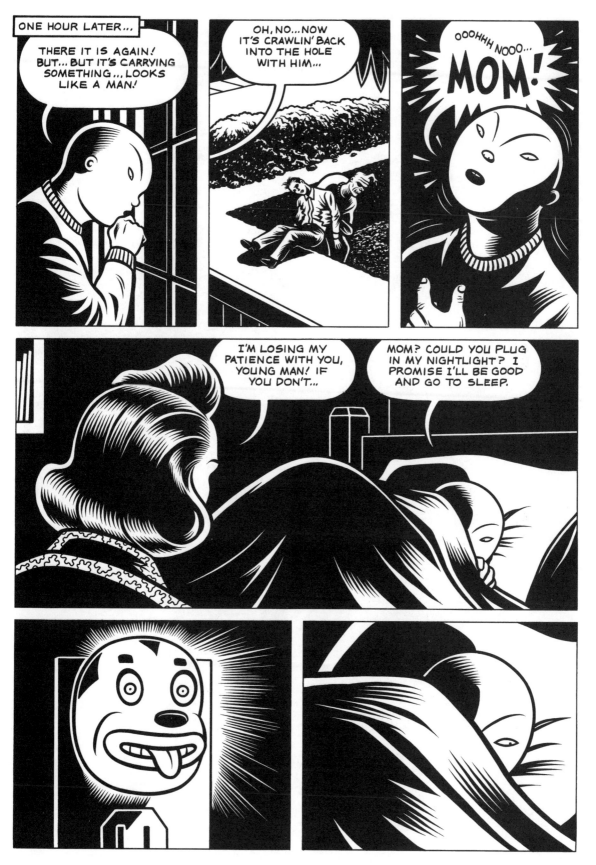

CHARLES BURNS *excerpt from Curse of the Molemen*

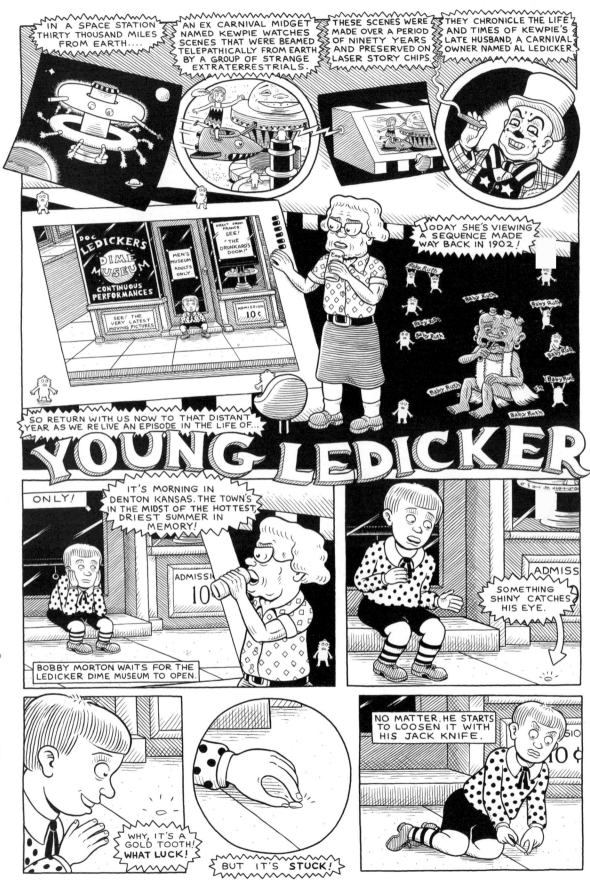

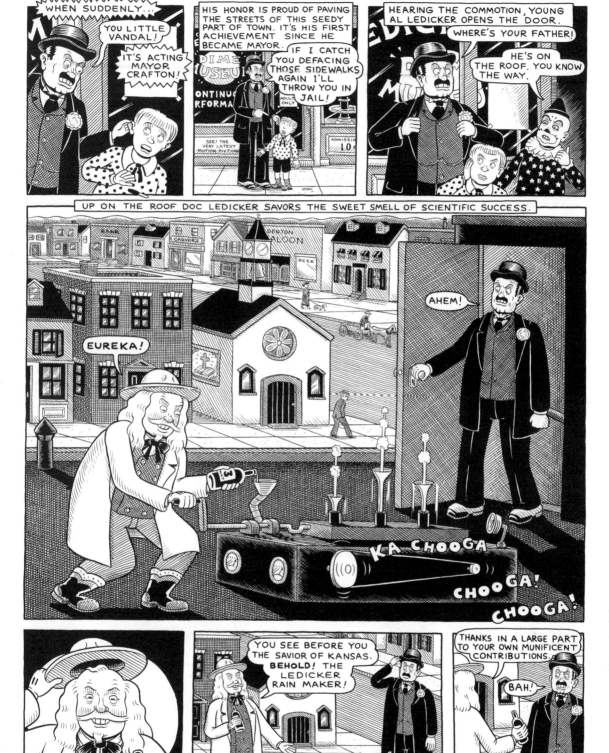

KIM DEITCH Young Ledicker

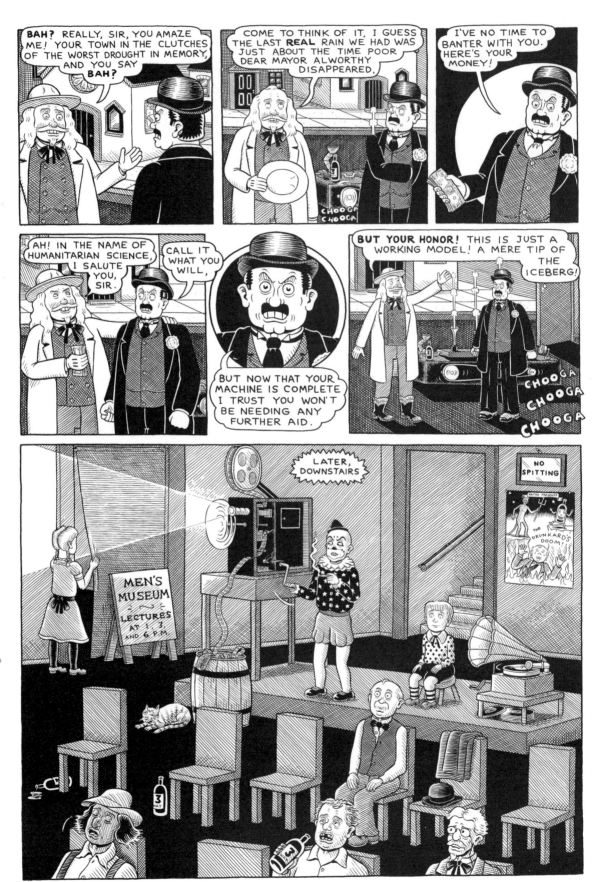

KIM DEITCH Young Ledicker

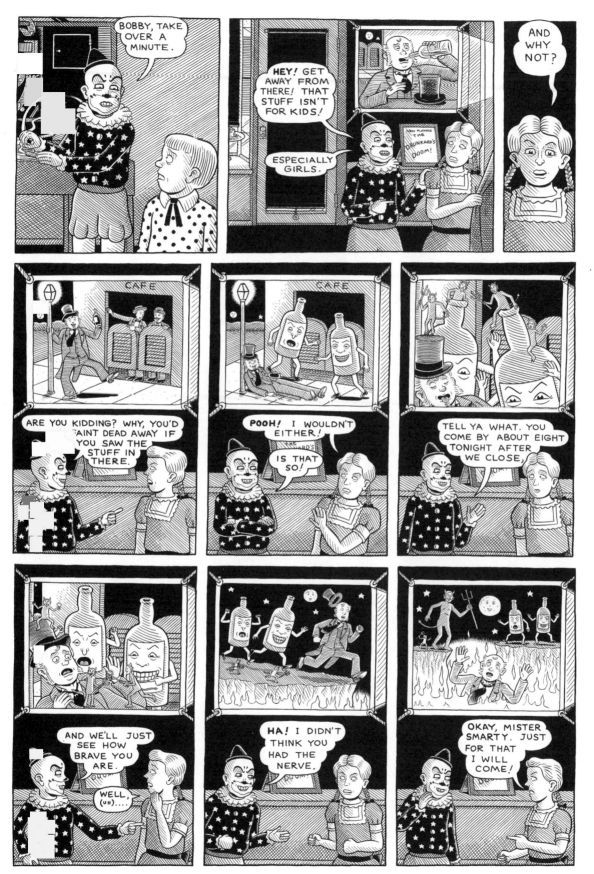

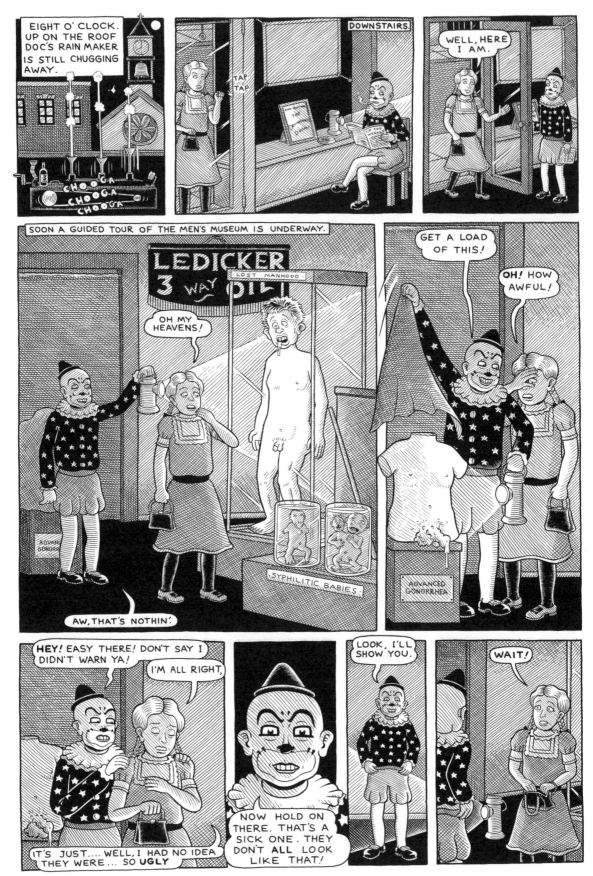

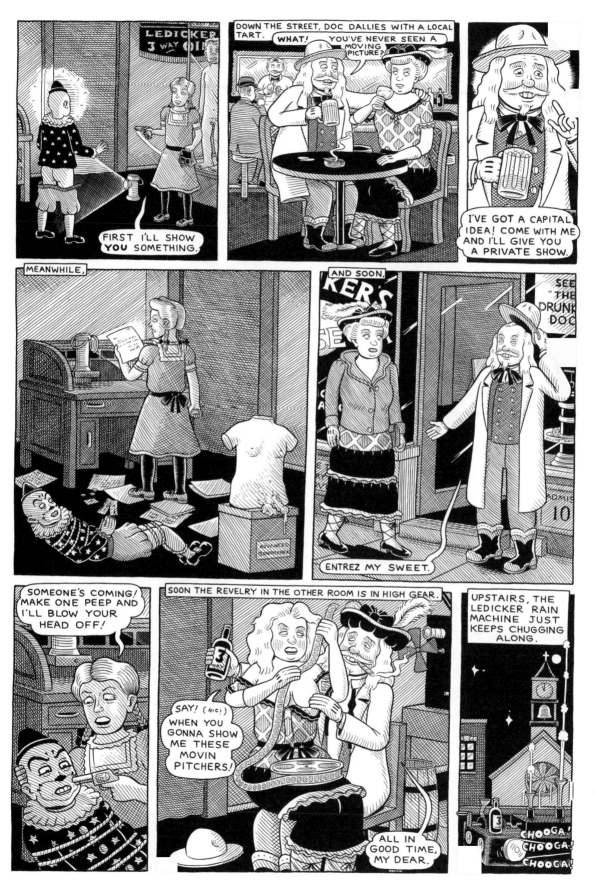

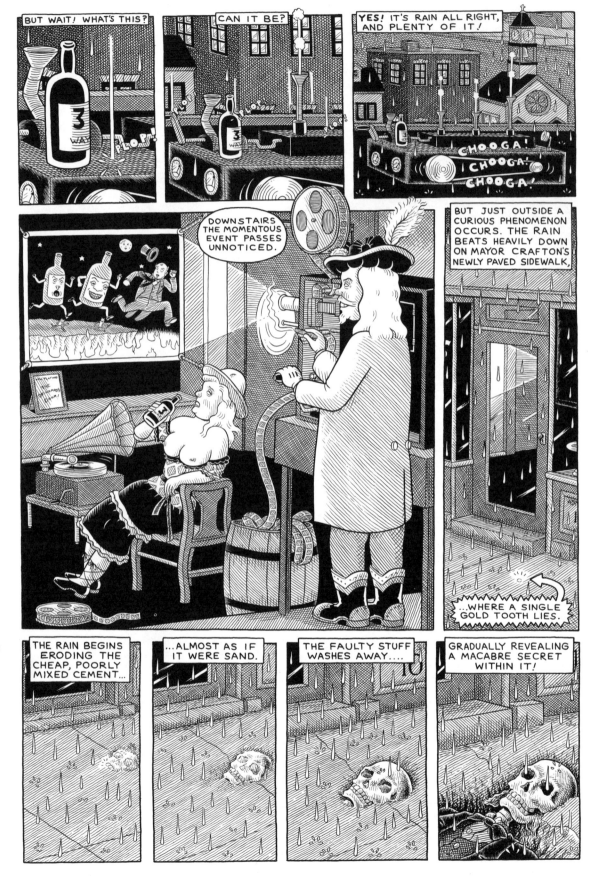

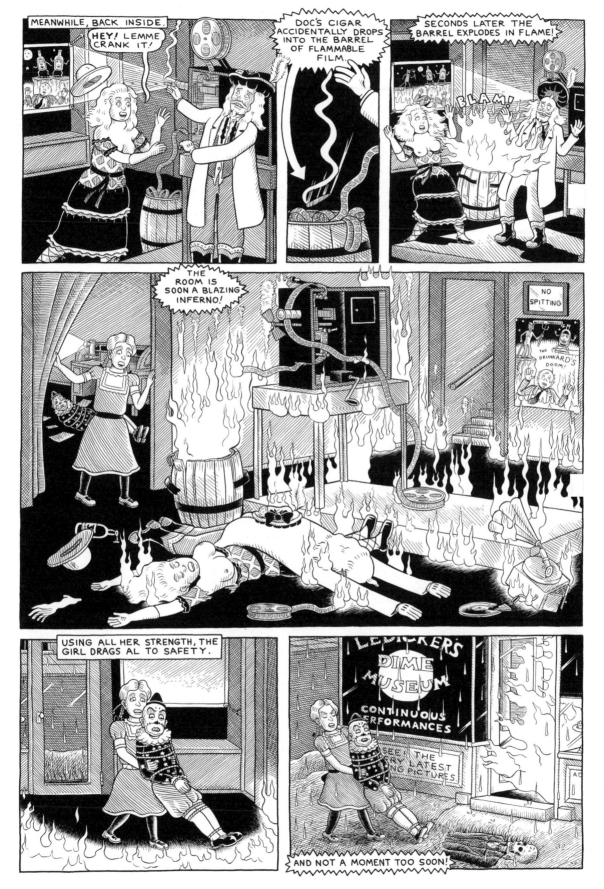

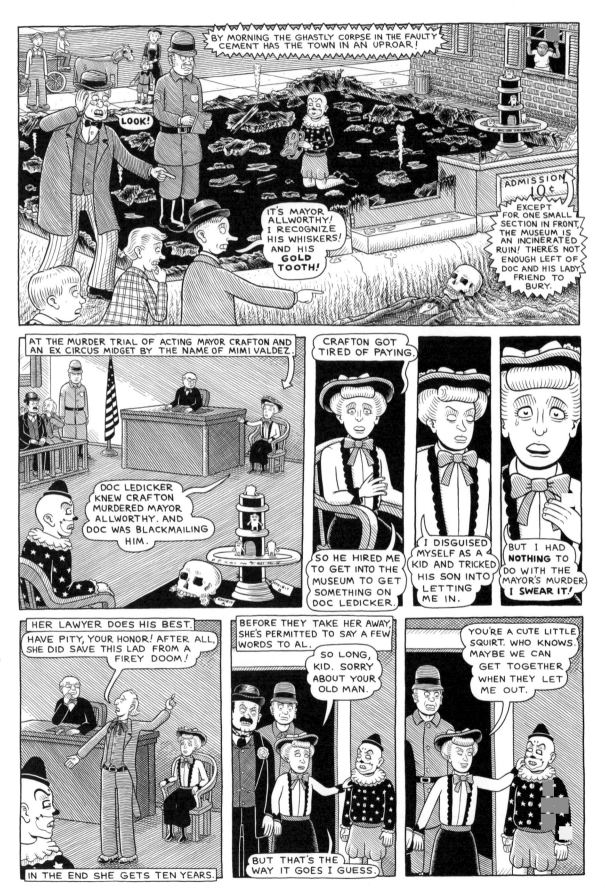

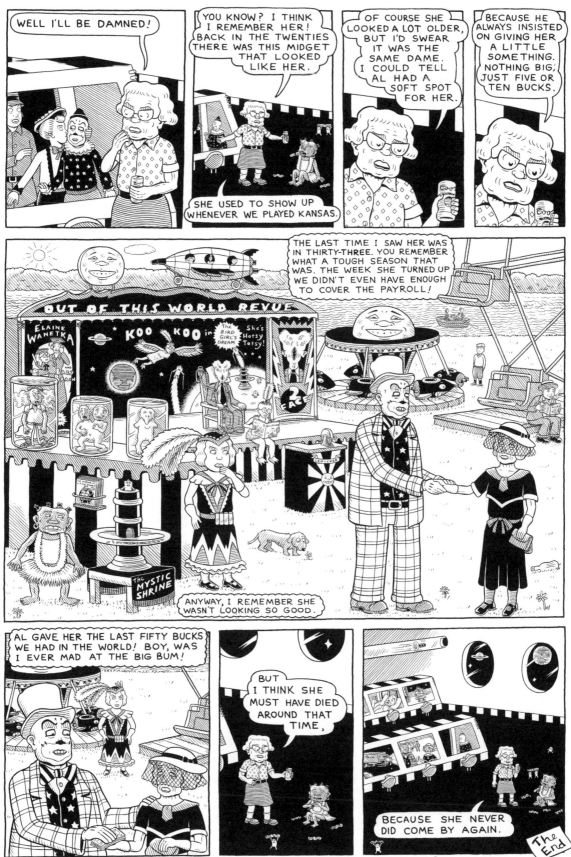

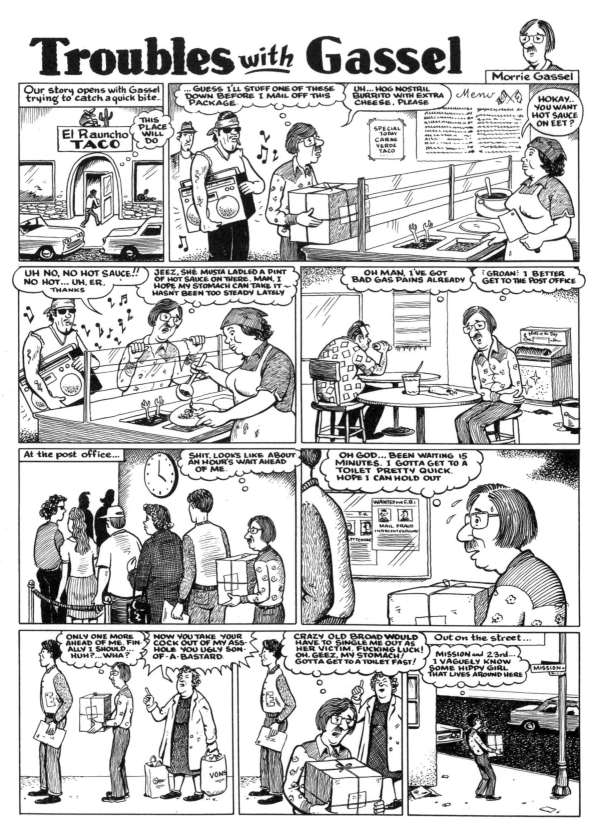

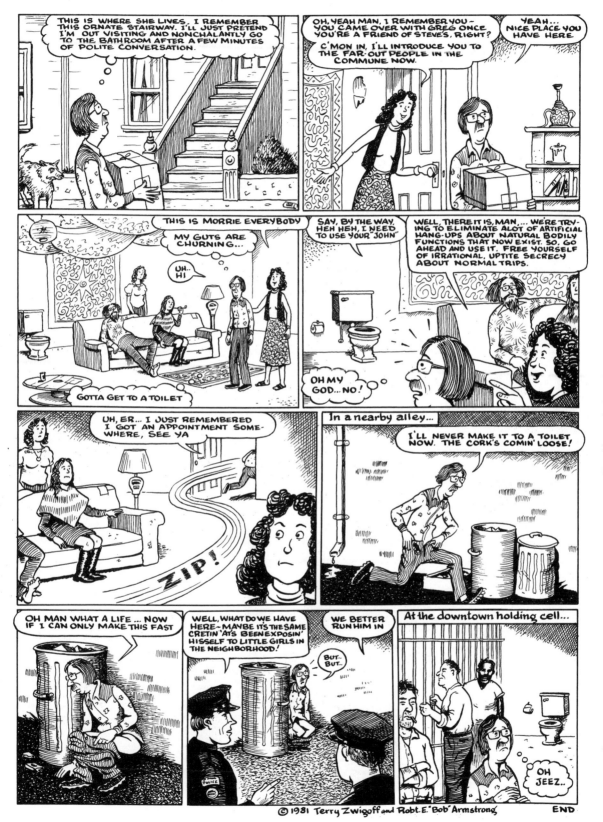

Jack Survives

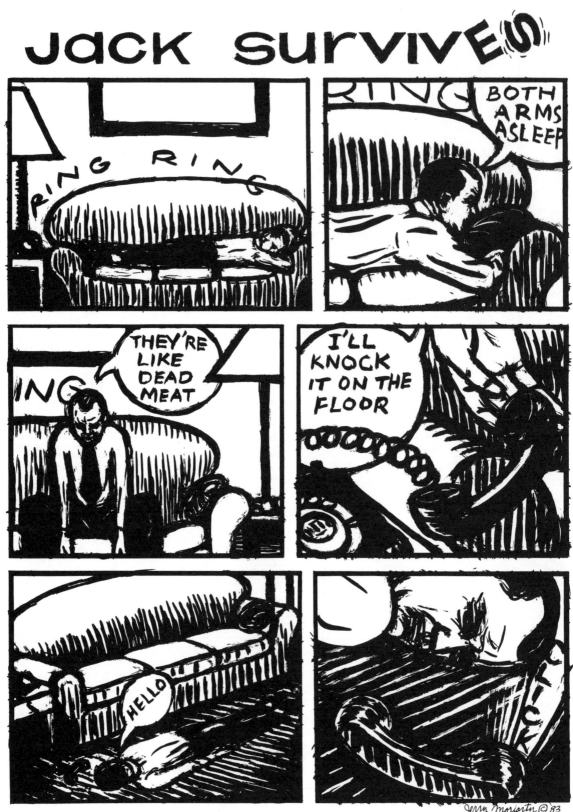

Jerry Moriarty © 83

JACK SURVIVES

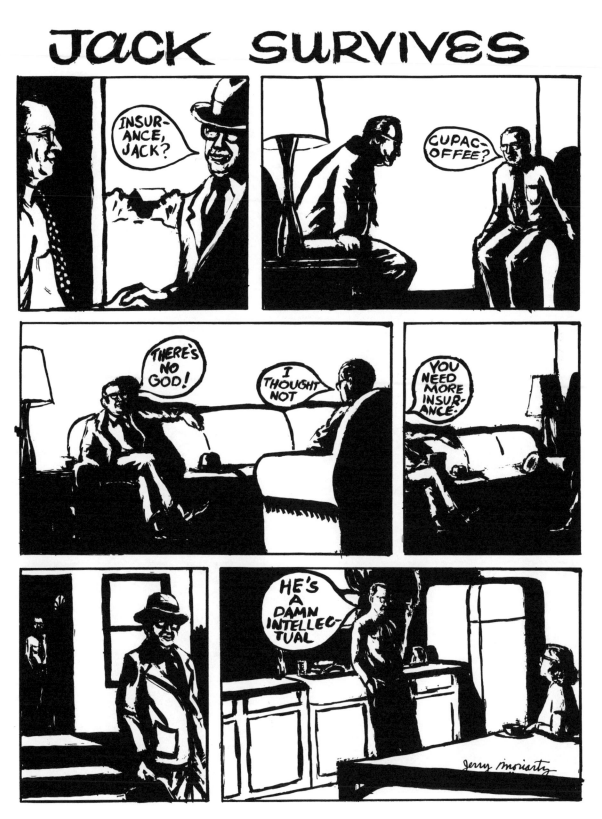

JERRY MORIARTY *excerpts from Jack Survives*

JACK SURVIVES

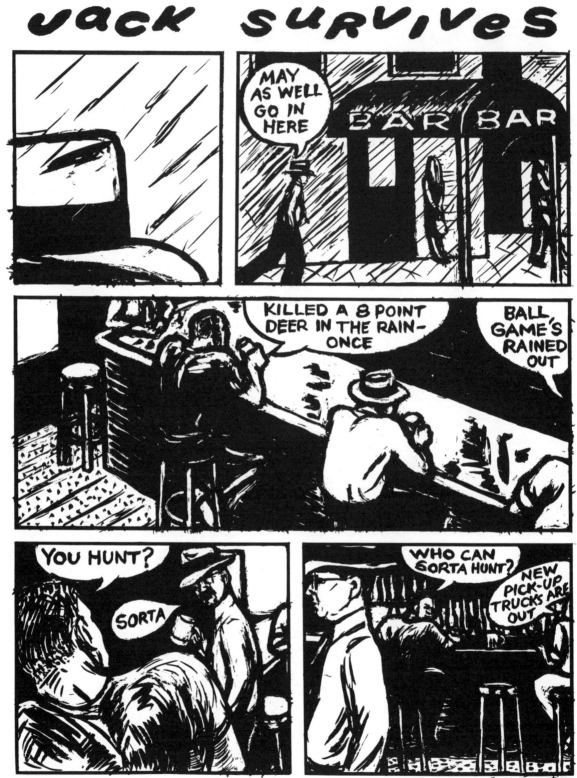

JERRY MORIARTY *excerpts from Jack Survives*

Jerry Moriarty ©83

His answering machine is always full.

"A ten...story building on Jubal Ave....I need some photographs"

As he is one of the few men onto this racket...

SUN
EARTH
THE CREEPING SHADOW

"In a few minutes) the shadows will just be right"

Mr. Knipl must quell his memory of what previously stood on this site.

"Here, number 156. It was the Goulash Building"

JULIUS KNIPL
REAL ESTATE
PHOTOGRAPHER
WO2-3465
3, VESEY ST

"I still have a couple hours good light"

"Souvenir!? Take a photo home for the family! only five dollars!"

"No thanks"

An idle onlooker terrifies Mr. Knipl.

And then bemoans the closing of his favorite dairy cafeteria.

CAFETERIA

Thinks of what he'll do with the money from this job.

A cold borscht.

He returns a phone call.

"Please, I don't want, I don't you, to meet me. just give me your address and I'll send you the pictures"

BEN KATCHOR *excerpts from* Cheap Novelties

141

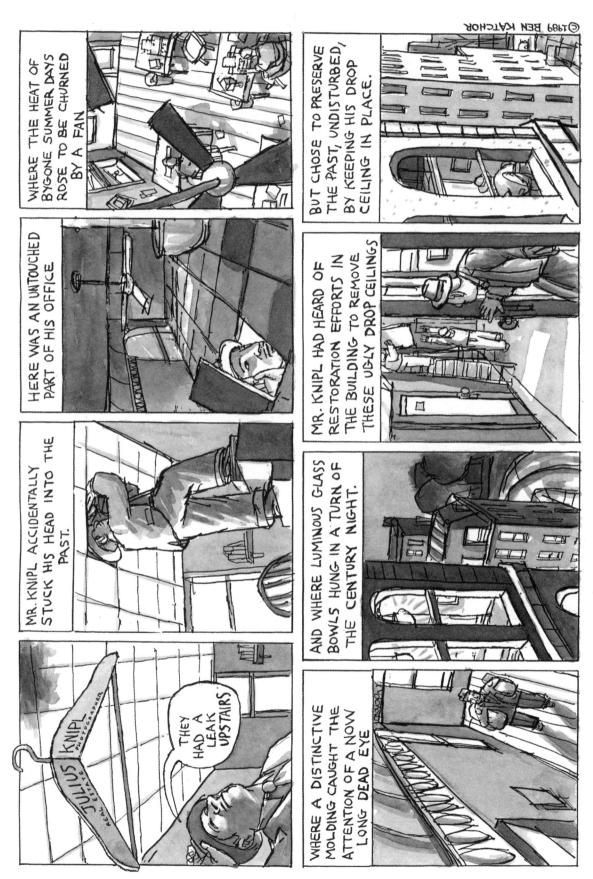

WHERE THE HEAT OF BYGONE SUMMER DAYS ROSE TO BE CHURNED BY A FAN

HERE WAS AN UNTOUCHED PART OF HIS OFFICE

MR. KNIPL ACCIDENTALLY STUCK HIS HEAD INTO THE PAST.

JULIUS KNIPL REAL ESTATE PHOTOGRAPHER

THEY HAD A LEAK UPSTAIRS

BUT CHOSE TO PRESERVE THE PAST, UNDISTURBED, BY KEEPING HIS DROP CEILING IN PLACE.

MR. KNIPL HAD HEARD OF RESTORATION EFFORTS IN THE BUILDING TO REMOVE THESE UGLY DROP CEILINGS

AND WHERE LUMINOUS GLASS BOWLS HUNG IN A TURN OF THE CENTURY NIGHT.

WHERE A DISTINCTIVE MOLDING CAUGHT THE ATTENTION OF A NOW LONG DEAD EYE

BEN KATCHOR *excerpts from* Cheap Novelties

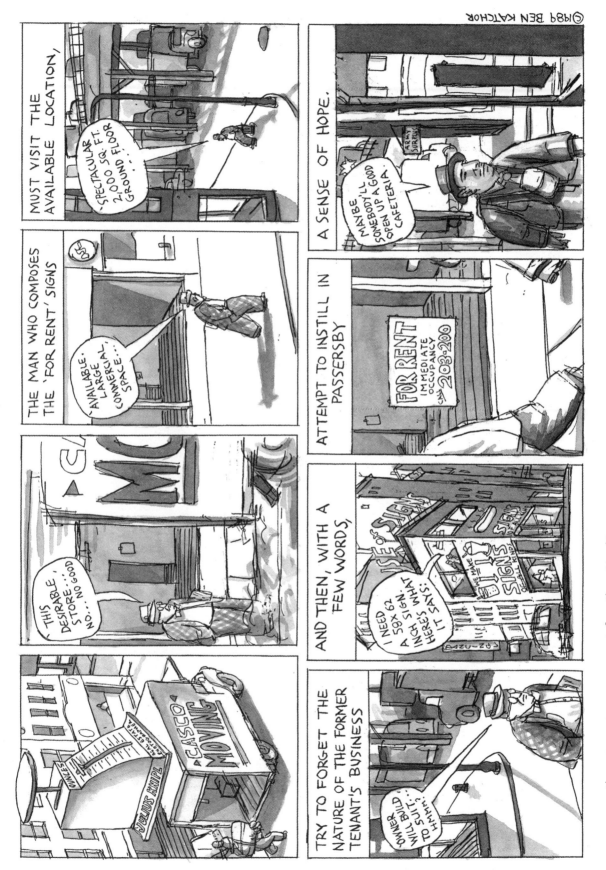

BEN KATCHOR *excerpts from Cheap Novelties*

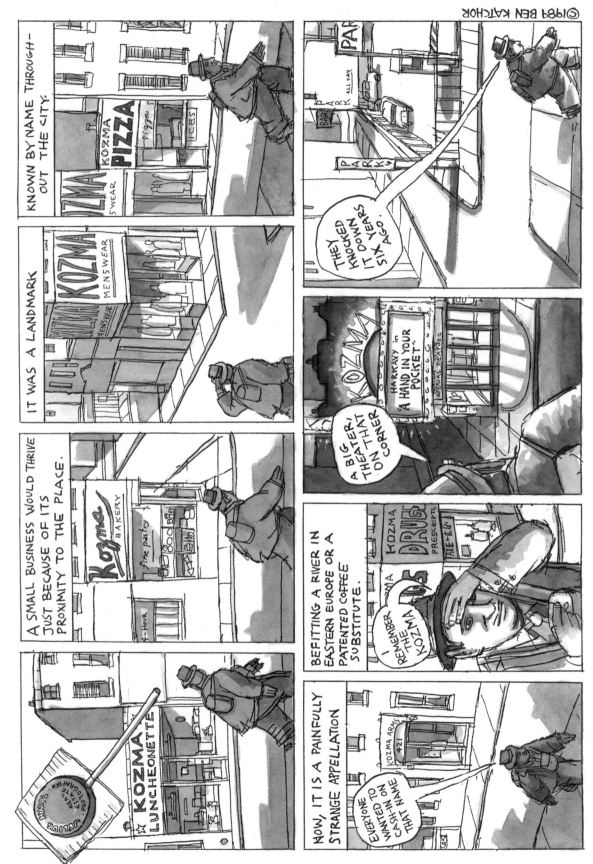

BEN KATCHOR *excerpts from Cheap Novelties*

© 1984 BEN KATCHOR

KNOWN BY NAME THROUGH—OUT THE CITY.

IT WAS A LANDMARK

A SMALL BUSINESS WOULD THRIVE JUST BECAUSE OF ITS PROXIMITY TO THE PLACE.

THEY KNOCKED IT DOWN SIX YEARS AGO.

A BIG THEATER THAT ON THAT CORNER

BEFITTING A RIVER IN EASTERN EUROPE OR A PATENTED COFFEE SUBSTITUTE.

I REMEMBER THE KOZMA

NOW, IT IS A PAINFULLY STRANGE APPELLATION

EVERYONE WANTED TO CASH-IN ON THAT NAME

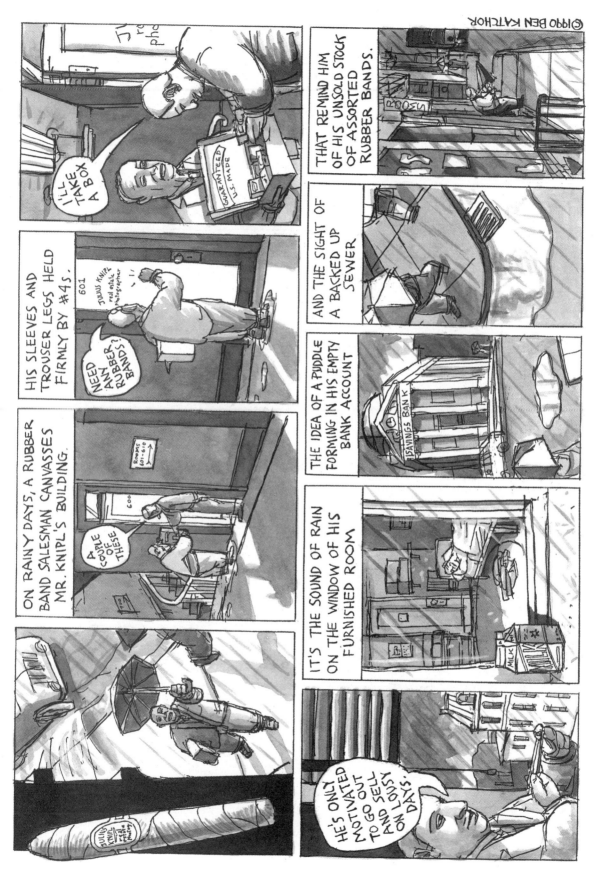

BEN KATCHOR *excerpts from* Cheap Novelties

145

BEN KATCHOR *excerpts from Cheap Novelties*

MR. KNIPL MEETS A MAN IN THE 'GOING OUT OF BUSINESS' TRADE.

"I GO OUT OF BUSINESS! SIGNS, LOUDSPEAKERS, HANDBILLS! 'EVERYTHING MUST GO!'"

"REGULAR PRICES ... NO BARGAINS. MAYBE A COUPLE TOURISTS WANDER IN. THEN, AFTER A FEW WEEKS ..."

"AND FILL IT WITH ALL KINDS OF CAMERAS AND ELECTRONIC ITEMS"

"I RENT A STORE ON A BUSY STREET"

"IT'S ALWAYS A TERRIBLE BLOW TO MY FAMILY."

"I WANDER THE STREETS FOR WEEKS, IN A DAZE LOOKING FOR A NEW LOCATION ... A FRESH START."

"BY THAT TIME, EVERY-ONE'S SEEN IT, IT'S PLAYED OUT AND YOU CAN CLOSE UP QUIETLY, FOR REAL."

"MY LAST STORE WENT OUT OF BUSINESS FOR THREE YEARS."

"PEOPLE CAN'T RESIST IT."

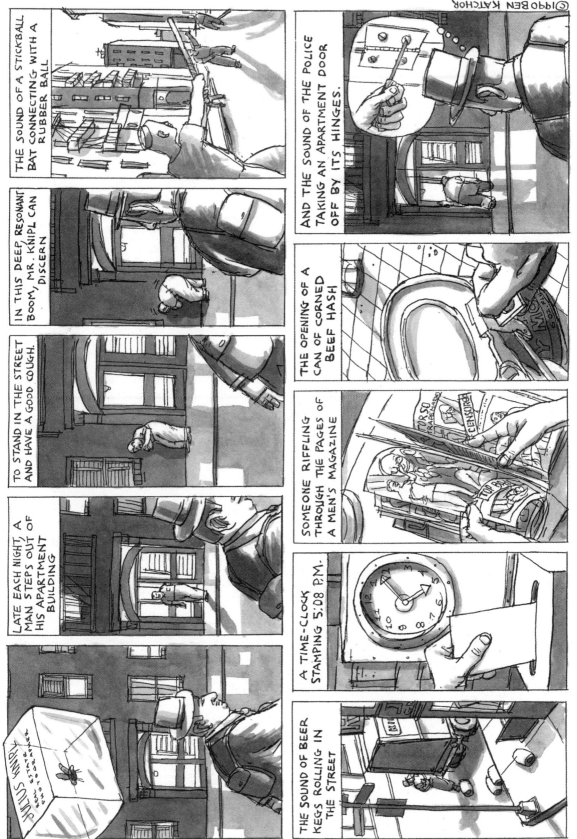

THE SOUND OF A STICKBALL BAT CONNECTING WITH A RUBBER BALL

IN THIS DEEP RESONANT BOOM, MR. KNIPL CAN DISCERN

TO STAND IN THE STREET AND HAVE A GOOD COUGH.

LATE EACH NIGHT, A MAN STEPS OUT OF HIS APARTMENT BUILDING

AND THE SOUND OF THE POLICE TAKING AN APARTMENT DOOR OFF BY ITS HINGES.

THE OPENING OF A CAN OF CORNED BEEF HASH

SOMEONE RIFFLING THROUGH THE PAGES OF A MEN'S MAGAZINE

A TIME-CLOCK STAMPING 5:08 P.M.

THE SOUND OF BEER KEGS ROLLING IN THE STREET

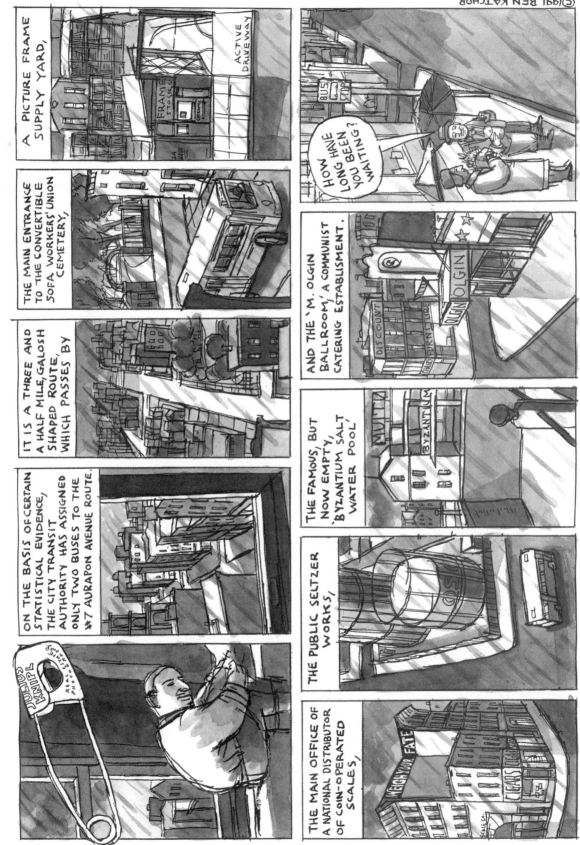

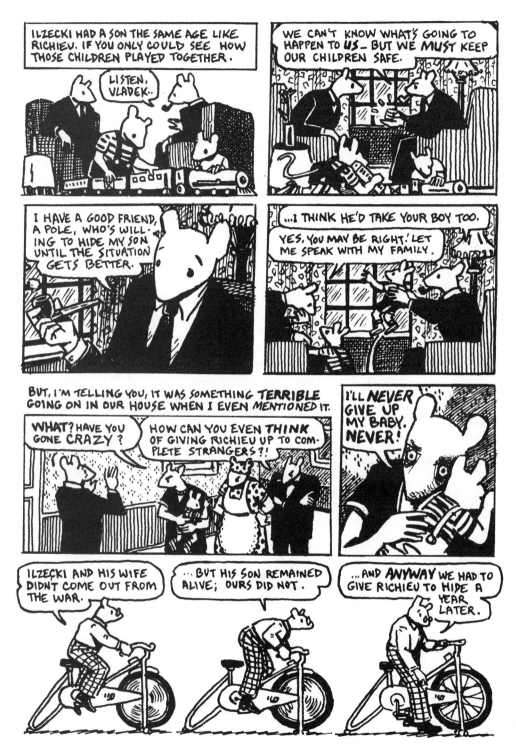

ART SPIEGELMAN *excerpt from MAUS*

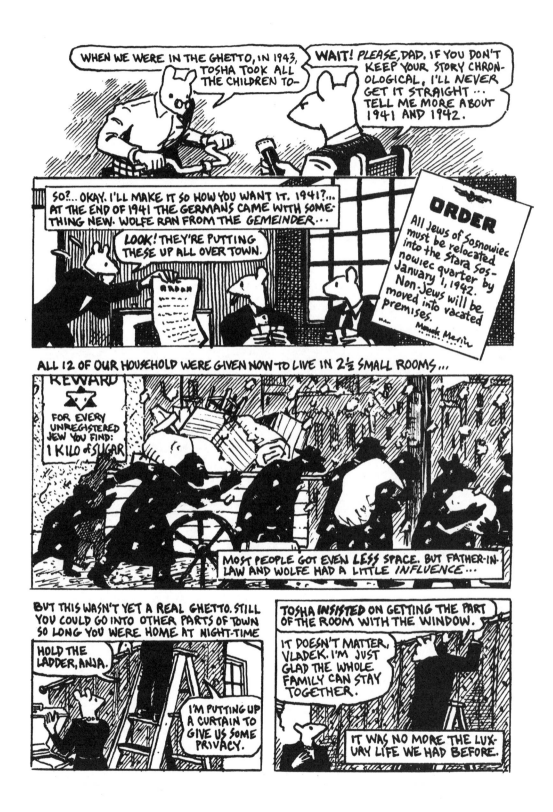

ART SPIEGELMAN *excerpt from MAUS*

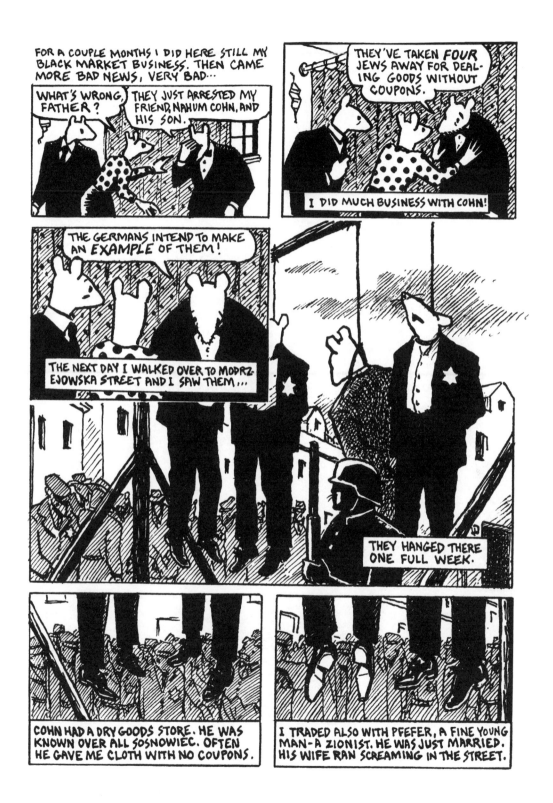

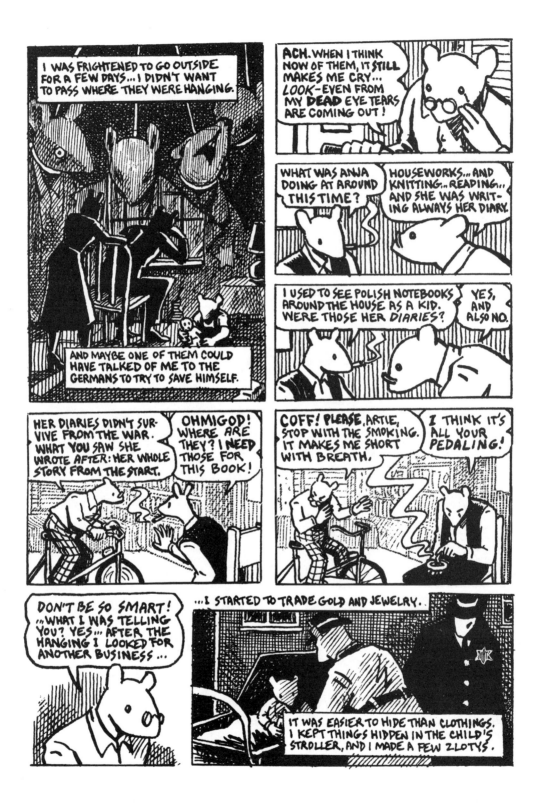

ART SPIEGELMAN *excerpt from MAUS*

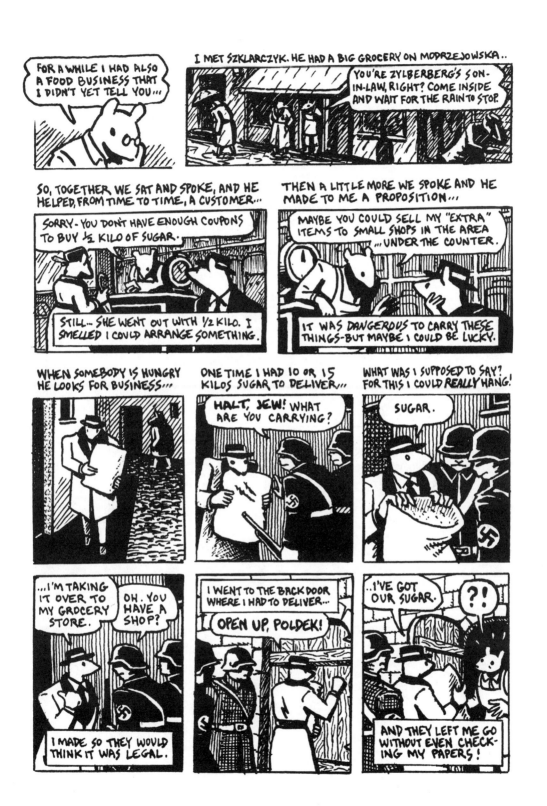

FOR A WHILE I HAD ALSO A FOOD BUSINESS THAT I DIDN'T YET TELL YOU...

I MET SZKLARCZYK. HE HAD A BIG GROCERY ON MODRZEJOWSKA...

YOU'RE ZYLBERBERG'S SON-IN-LAW, RIGHT? COME INSIDE AND WAIT FOR THE RAIN TO STOP.

SO, TOGETHER WE SAT AND SPOKE, AND HE HELPED, FROM TIME TO TIME, A CUSTOMER...

SORRY - YOU DON'T HAVE ENOUGH COUPONS TO BUY ½ KILO OF SUGAR.

STILL... SHE WENT OUT WITH ½ KILO. I SMELLED I COULD ARRANGE SOMETHING.

THEN A LITTLE MORE WE SPOKE AND HE MADE TO ME A PROPOSITION...

MAYBE YOU COULD SELL MY "EXTRA" ITEMS TO SMALL SHOPS IN THE AREA ... UNDER THE COUNTER.

IT WAS DANGEROUS TO CARRY THESE THINGS - BUT MAYBE I COULD BE LUCKY.

WHEN SOMEBODY IS HUNGRY HE LOOKS FOR BUSINESS...

ONE TIME I HAD 10 OR 15 KILOS SUGAR TO DELIVER...

HALT, JEW! WHAT ARE YOU CARRYING?

WHAT WAS I SUPPOSED TO SAY? FOR THIS I COULD REALLY HANG!

SUGAR.

...I'M TAKING IT OVER TO MY GROCERY STORE.

OH. YOU HAVE A SHOP?

I MADE SO THEY WOULD THINK IT WAS LEGAL.

I WENT TO THE BACK DOOR WHERE I HAD TO DELIVER...

OPEN UP, POLDEK!

..I'VE GOT OUR SUGAR.

?!

AND THEY LEFT ME GO WITHOUT EVEN CHECK-ING MY PAPERS!

ART SPIEGELMAN *excerpt from MAUS*

153

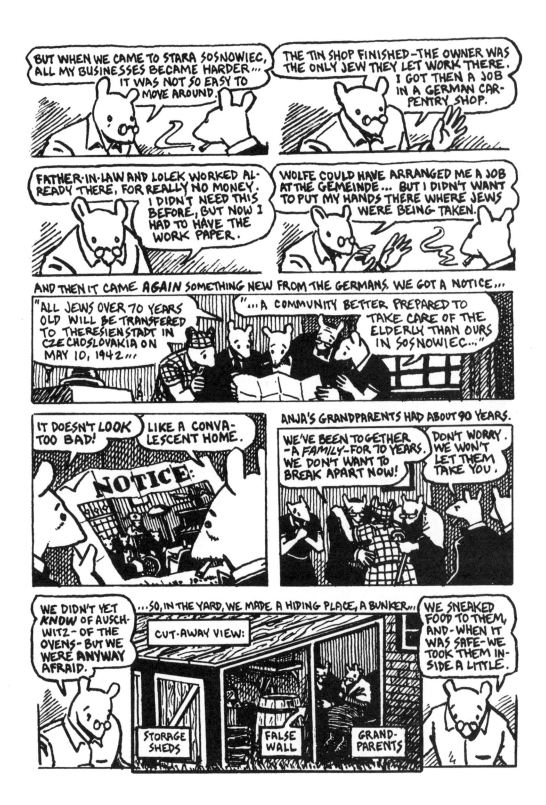

ART SPIEGELMAN *excerpt from MAUS*

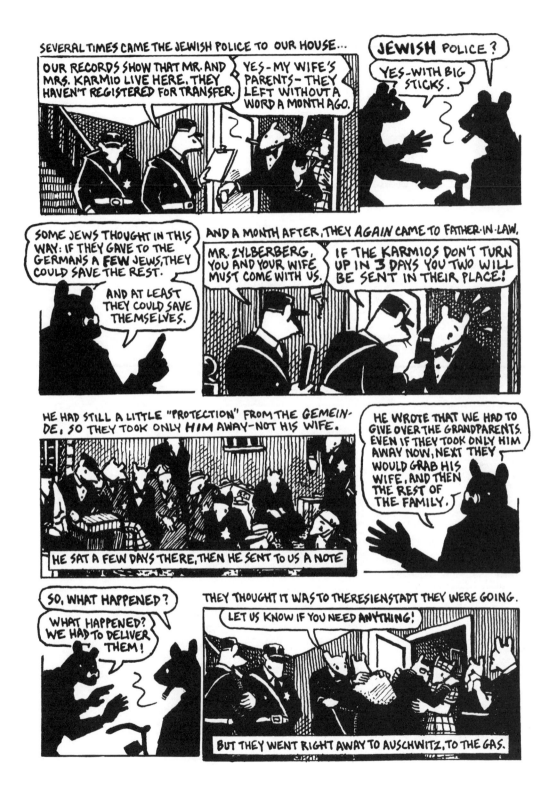

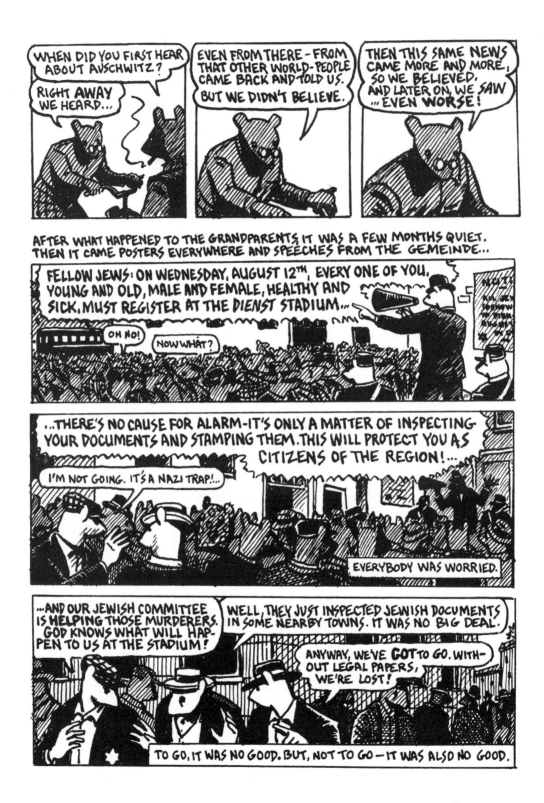

ART SPIEGELMAN *excerpt from MAUS*

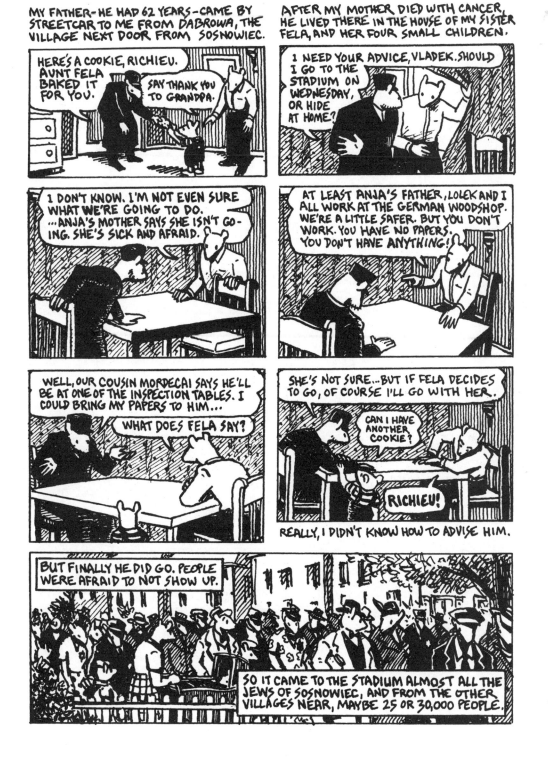

MY FATHER—HE HAD 62 YEARS—CAME BY STREETCAR TO ME FROM DABROWA, THE VILLAGE NEXT DOOR FROM SOSNOWIEC.

AFTER MY MOTHER DIED WITH CANCER, HE LIVED THERE IN THE HOUSE OF MY SISTER FELA, AND HER FOUR SMALL CHILDREN.

HERE'S A COOKIE, RICHIEU. AUNT FELA BAKED IT FOR YOU.

SAY THANK YOU TO GRANDPA.

I NEED YOUR ADVICE, VLADEK. SHOULD I GO TO THE STADIUM ON WEDNESDAY, OR HIDE AT HOME?

I DON'T KNOW. I'M NOT EVEN SURE WHAT WE'RE GOING TO DO. ...ANJA'S MOTHER SAYS SHE ISN'T GOING. SHE'S SICK AND AFRAID.

AT LEAST ANJA'S FATHER, LOLEK AND I ALL WORK AT THE GERMAN WOODSHOP. WE'RE A LITTLE SAFER. BUT YOU DON'T WORK. YOU HAVE NO PAPERS. YOU DON'T HAVE ANYTHING!

WELL, OUR COUSIN MORDECAI SAYS HE'LL BE AT ONE OF THE INSPECTION TABLES. I COULD BRING MY PAPERS TO HIM...

WHAT DOES FELA SAY?

SHE'S NOT SURE...BUT IF FELA DECIDES TO GO, OF COURSE I'LL GO WITH HER.

CAN I HAVE ANOTHER COOKIE?

RICHIEU!

REALLY, I DIDN'T KNOW HOW TO ADVISE HIM.

BUT FINALLY HE DID GO. PEOPLE WERE AFRAID TO NOT SHOW UP.

SO IT CAME TO THE STADIUM ALMOST ALL THE JEWS OF SOSNOWIEC, AND FROM THE OTHER VILLAGES NEAR, MAYBE 25 OR 30,000 PEOPLE.

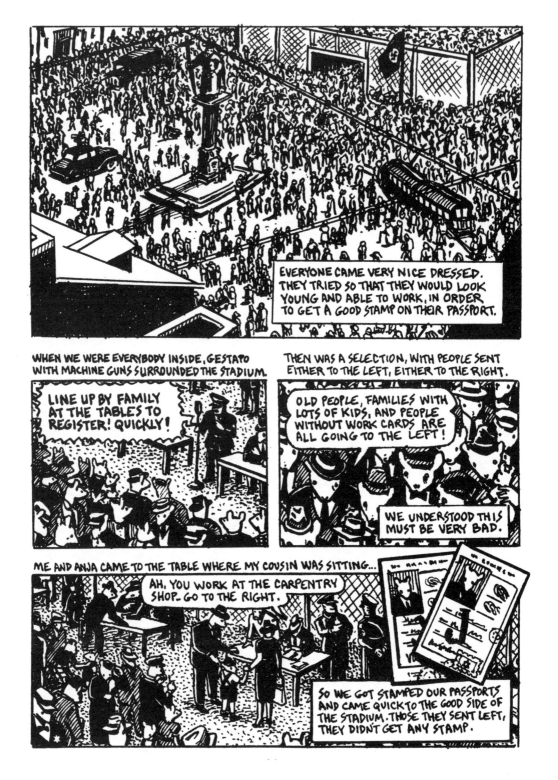

ART SPIEGELMAN *excerpt from MAUS*

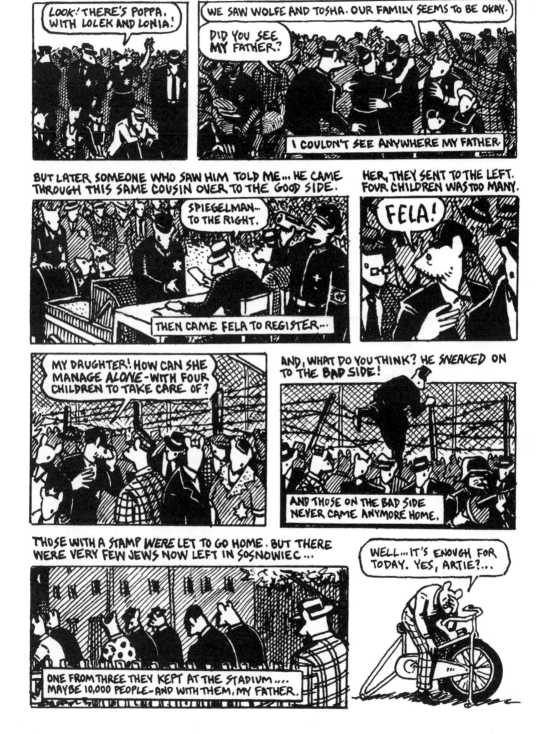

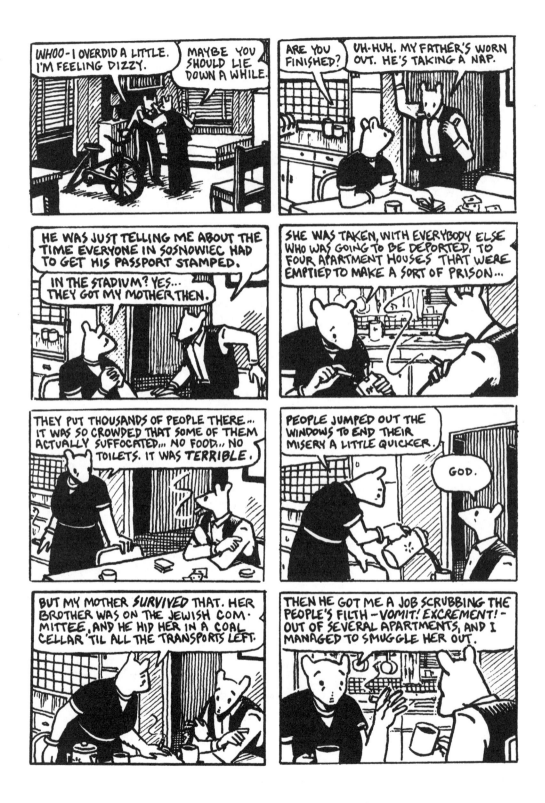

ART SPIEGELMAN *excerpt from MAUS*

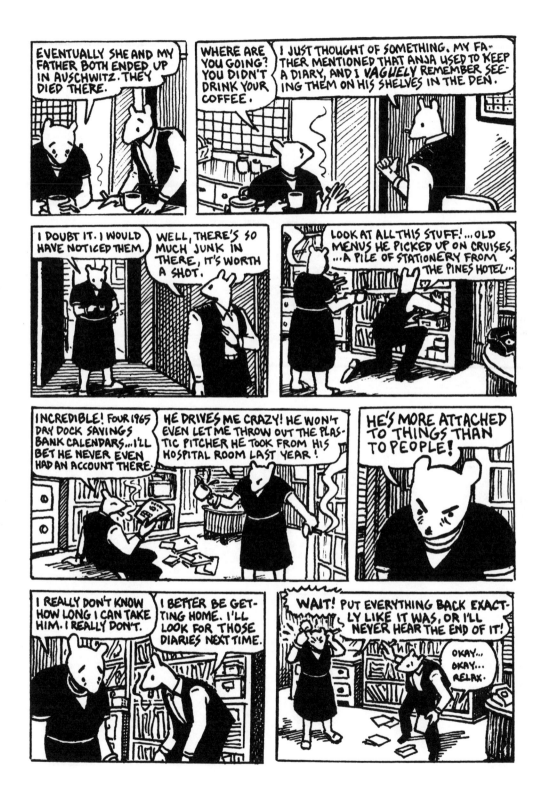

ART SPIEGELMAN *excerpt from MAUS*

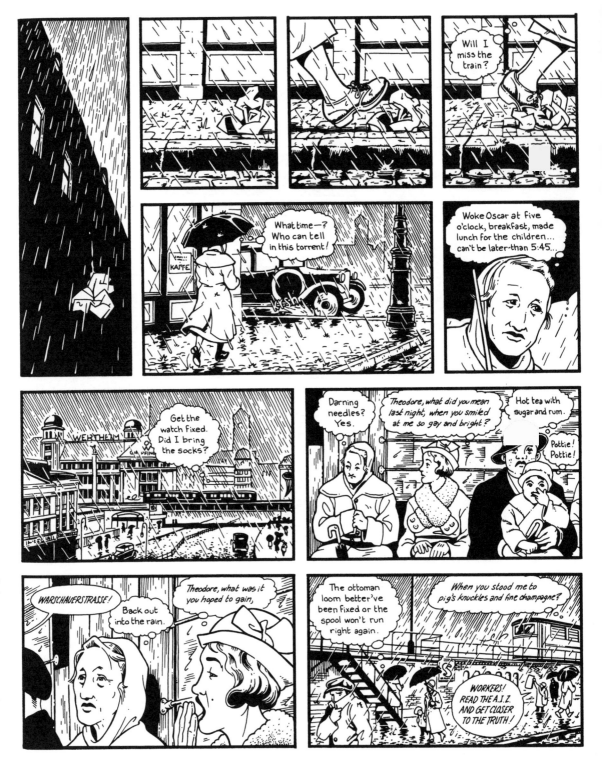

JASON LUTES *excerpt from Berlin*

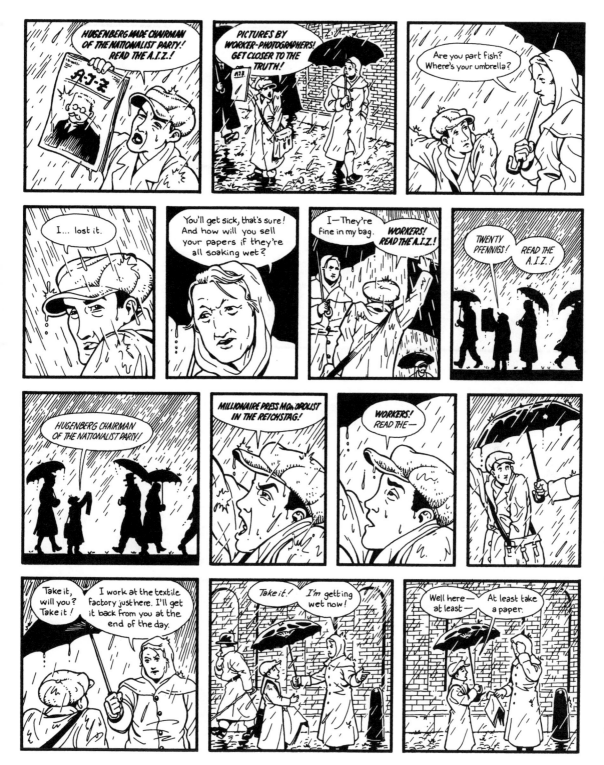

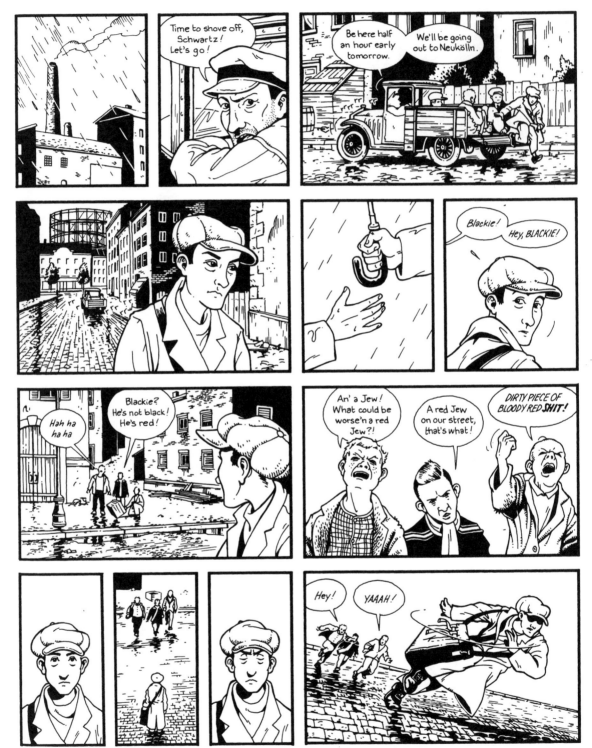

JASON LUTES *excerpt from Berlin*

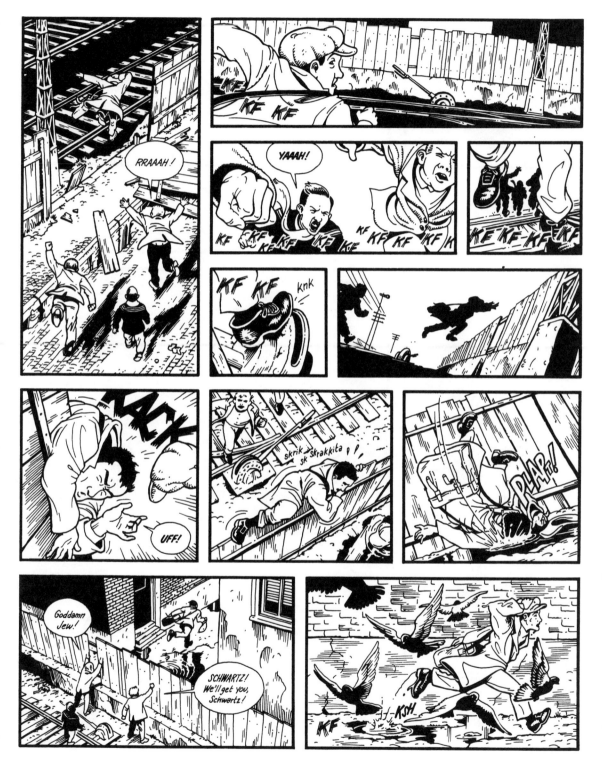

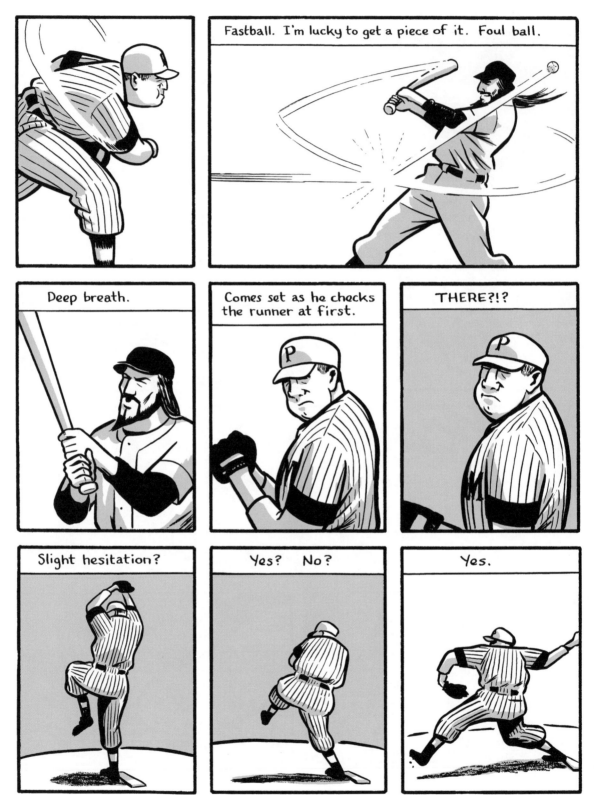

JAMES STURM *excerpt from* The Golem's Mighty Swing

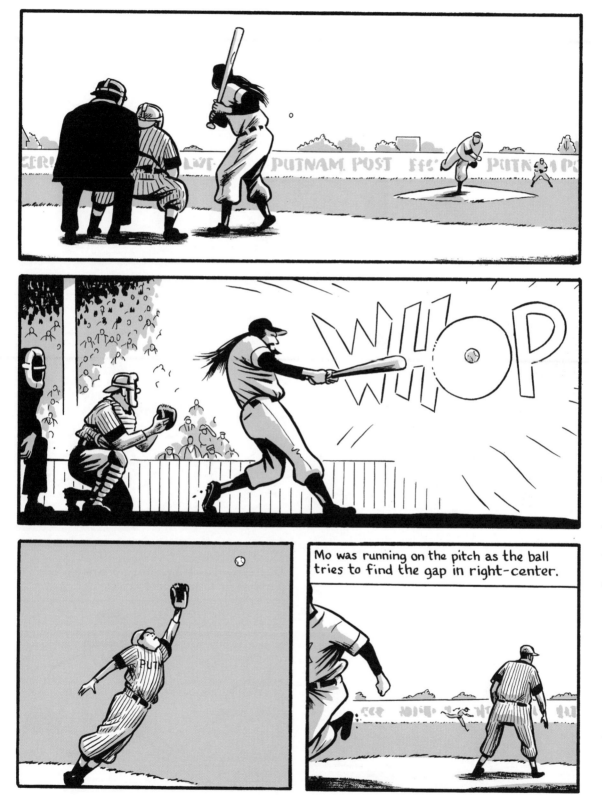

Centerfielder stops the ball before it reaches the wall.

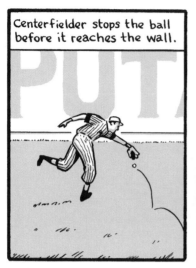

Mo scores on a high throw up the line. He pays a price—the catcher gives him a hard spike to his thigh.

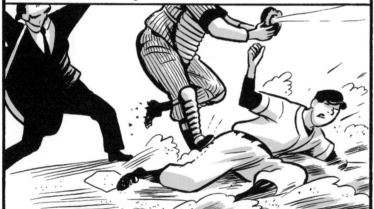

If Mo's hurt he's not showing it. He's scored a run off Mickey McFadden.

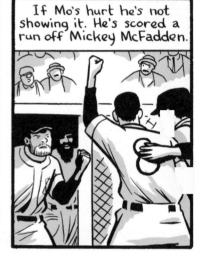

McFadden is irate. He walks off the mound screaming into his glove.

Due to my knees I remain at first. Our clean-up hitter approaches the plate. The crowd becomes eerily quiet.

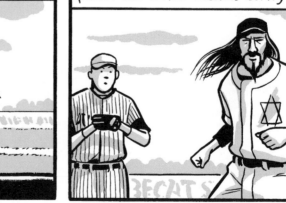

JAMES STURM excerpt from The Golem's Mighty Swing

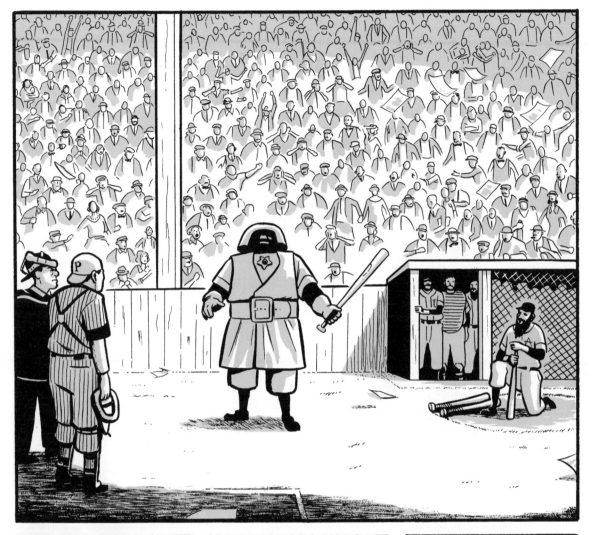

JAMES STURM *excerpt from The Golem's Mighty Swing*

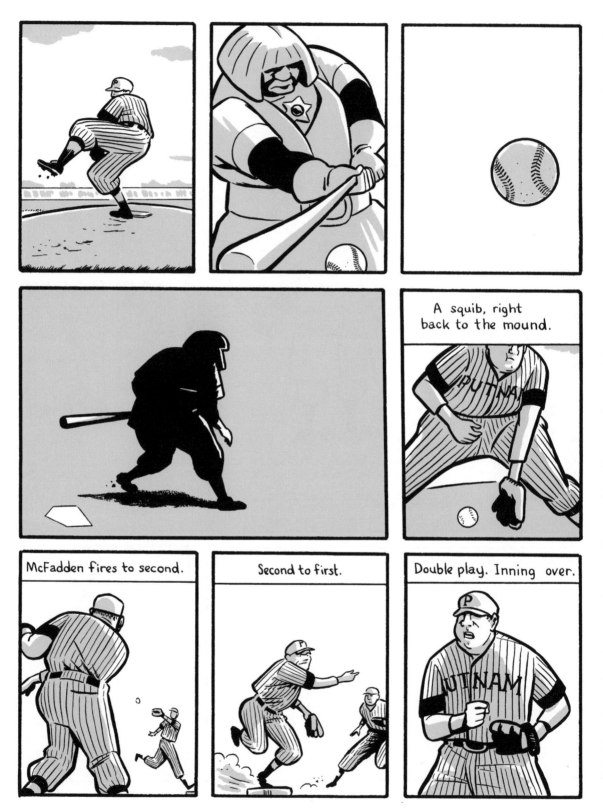

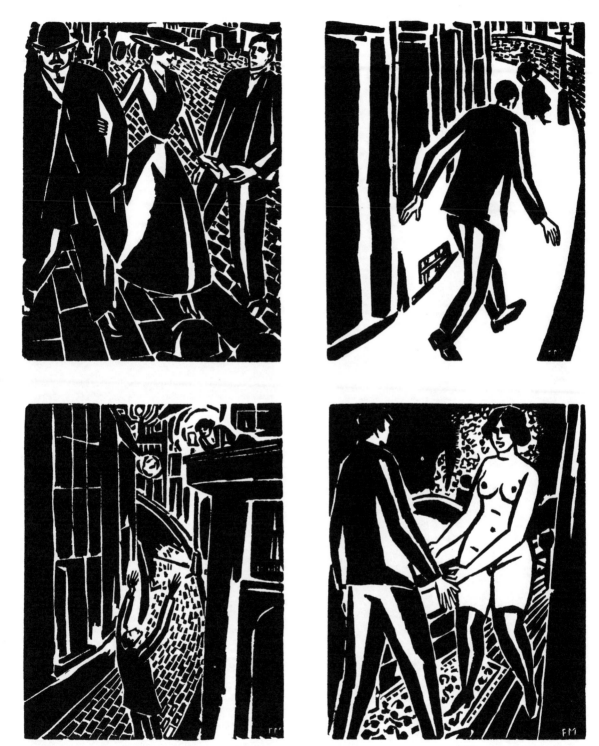

Frans Masereel's Passionate Journey: A Novel in 165 Woodcuts, *was originally published in 1919. The story is told entirely in pictures and is meant to be read one panel per page. Note how the flow of images is not merely illustrative but rather creates and visually drives the narrative. From Thomas Mann's introduction to the 1926 edition: "Seldom has raciness so blended with conviction as here in the contrast between a fundamentally old and traditional technique and the sharpness and contemporary boldness of the things it expresses." Would it be far-fetched to call this a truly "graphic novel"?*

FRANS MASEREEL *excerpt from Passionate Journey*

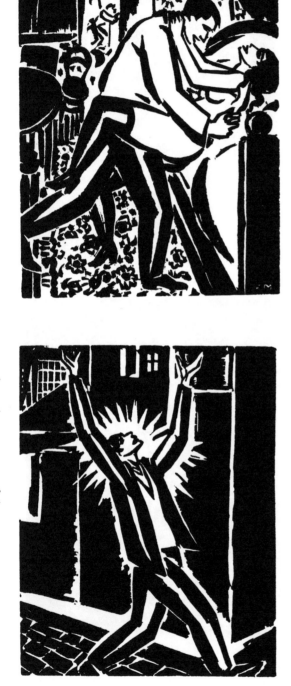
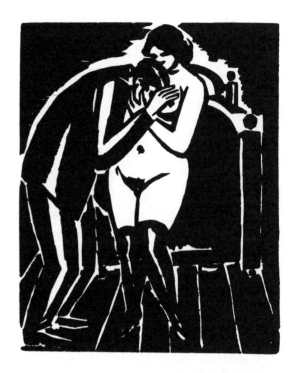
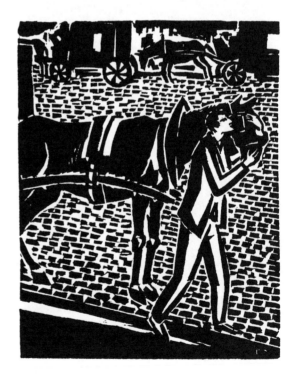

FRANS MASEREEL *excerpt from* Passionate Journey

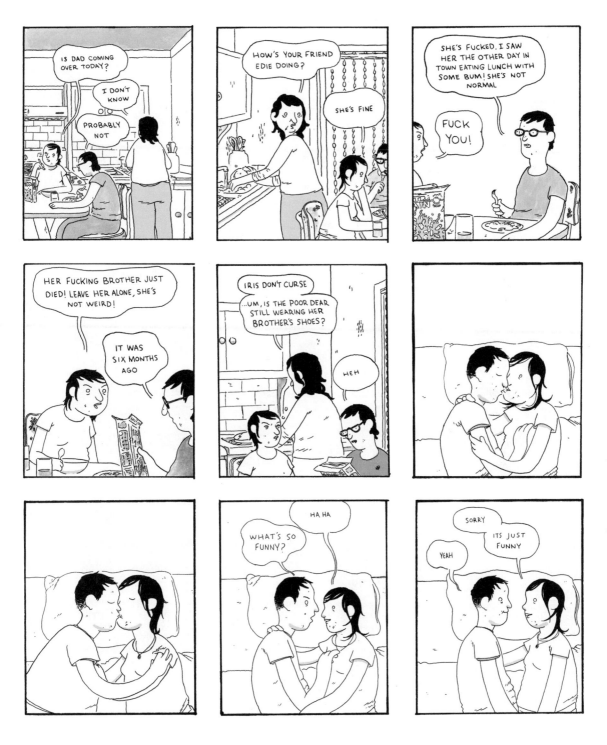

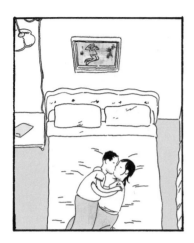
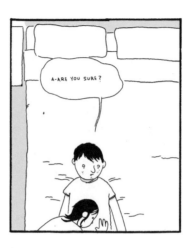

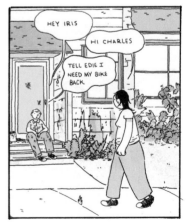

174

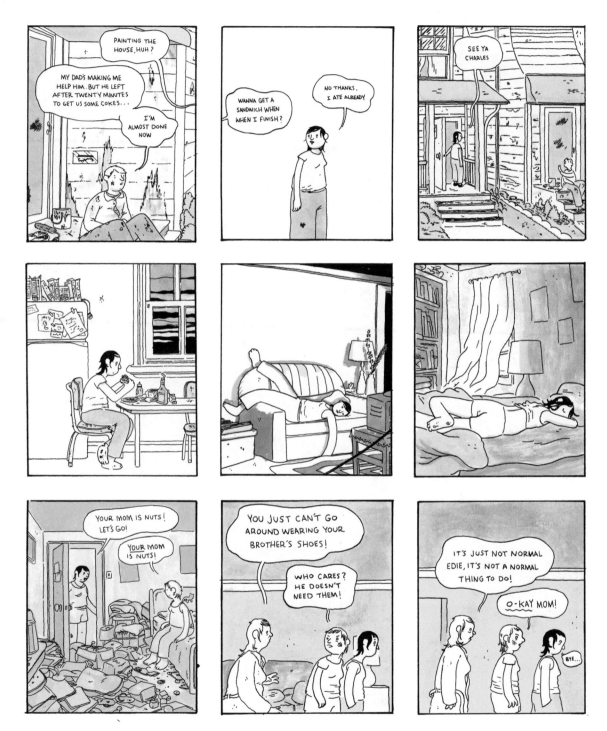

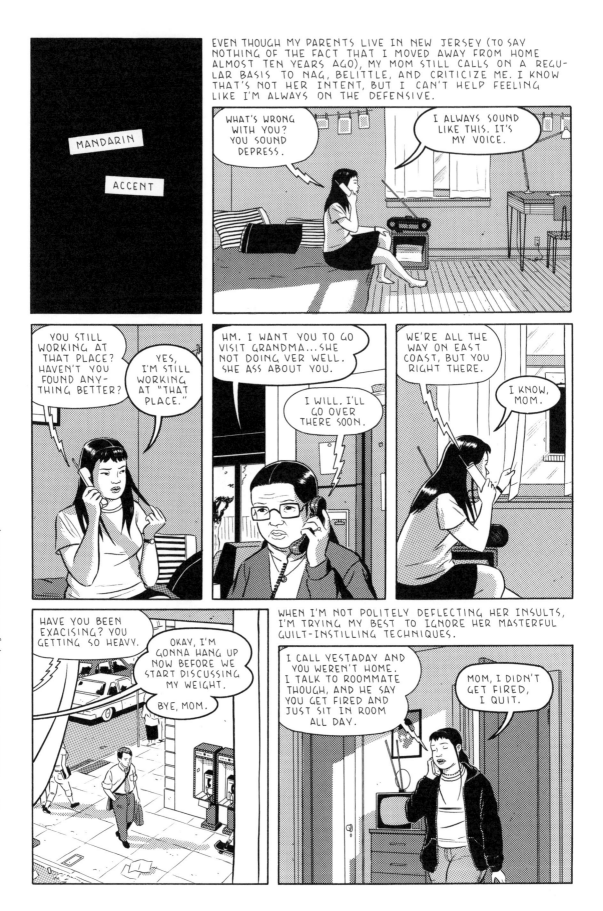

EVEN THOUGH MY PARENTS LIVE IN NEW JERSEY (TO SAY NOTHING OF THE FACT THAT I MOVED AWAY FROM HOME ALMOST TEN YEARS AGO), MY MOM STILL CALLS ON A REGULAR BASIS TO NAG, BELITTLE, AND CRITICIZE ME. I KNOW THAT'S NOT HER INTENT, BUT I CAN'T HELP FEELING LIKE I'M ALWAYS ON THE DEFENSIVE.

MANDARIN

ACCENT

WHAT'S WRONG WITH YOU? YOU SOUND DEPRESS.

I ALWAYS SOUND LIKE THIS. IT'S MY VOICE.

YOU STILL WORKING AT THAT PLACE? HAVEN'T YOU FOUND ANYTHING BETTER?

YES, I'M STILL WORKING AT "THAT PLACE."

HM. I WANT YOU TO GO VISIT GRANDMA...SHE NOT DOING VER WELL. SHE ASS ABOUT YOU.

I WILL. I'LL GO OVER THERE SOON.

WE'RE ALL THE WAY ON EAST COAST, BUT YOU RIGHT THERE.

I KNOW, MOM.

WHEN I'M NOT POLITELY DEFLECTING HER INSULTS, I'M TRYING MY BEST TO IGNORE HER MASTERFUL GUILT-INSTILLING TECHNIQUES.

HAVE YOU BEEN EXACISING? YOU GETTING SO HEAVY.

OKAY, I'M GONNA HANG UP NOW BEFORE WE START DISCUSSING MY WEIGHT.

BYE, MOM.

I CALL YESTADAY AND YOU WEREN'T HOME. I TALK TO ROOMMATE THOUGH, AND HE SAY YOU GET FIRED AND JUST SIT IN ROOM ALL DAY.

MOM, I DIDN'T GET FIRED, I QUIT.

ADRIAN TOMINE *excerpt from Hawaiian Getaway*

176

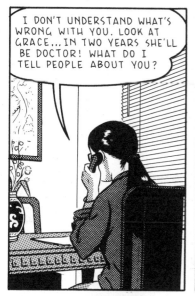

I DON'T UNDERSTAND WHAT'S WRONG WITH YOU. LOOK AT GRACE...IN TWO YEARS SHE'LL BE DOCTOR! WHAT DO I TELL PEOPLE ABOUT YOU?

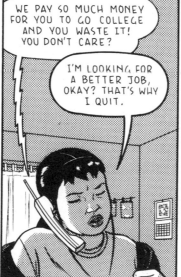

WE PAY SO MUCH MONEY FOR YOU TO GO COLLEGE AND YOU WASTE IT! YOU DON'T CARE?

I'M LOOKING FOR A BETTER JOB, OKAY? THAT'S WHY I QUIT.

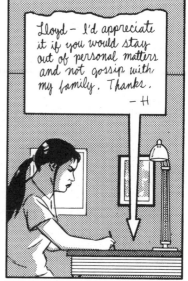

Lloyd — I'd appreciate it if you would stay out of personal matters and not gossip with my family. Thanks.
— H

EVEN WHEN I WAS A KID, MY MOM WAS ABLE TO ABSOLUTELY PARALYZE ME WITH GUILT.

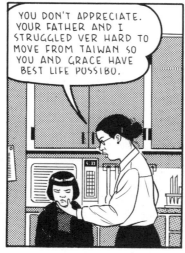

YOU DON'T APPRECIATE. YOUR FATHER AND I STRUGGLED VER HARD TO MOVE FROM TAIWAN SO YOU AND GRACE HAVE BEST LIFE PUSSIBU.

I FELT LIKE I COULDN'T LEGITIMATELY COMPLAIN ABOUT ANYTHING, AND THAT I'D NEVER BE ABLE TO REPAY THE DEBT I OWED MY PARENTS.

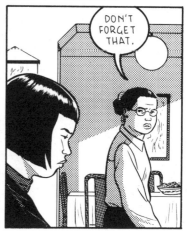

DON'T FORGET THAT.

THAT'S PROBABLY WHY I EVEN WENT TO COLLEGE AT ALL: TO DEFER THEIR INEVITABLE DISAPPOINTMENT IN ME ANOTHER FOUR YEARS.

RECENTLY, MY MOM PUSHED MY TOLERANCE TOO FAR, AND FOR THE FIRST TIME SINCE HIGH SCHOOL, I REALLY FLIPPED OUT AND LASHED BACK AT HER.

OF COURSE, AS SOON AS I SLAMMED THE PHONE DOWN, I FELT GUILTIER THAN EVER. WHETHER MY MOM KNOWS IT OR NOT, SHE GOT THE LAST LAUGH.

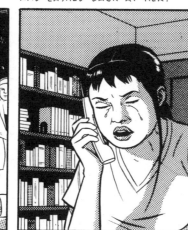

ADRIAN TOMINE *excerpt from Hawaiian Getaway*

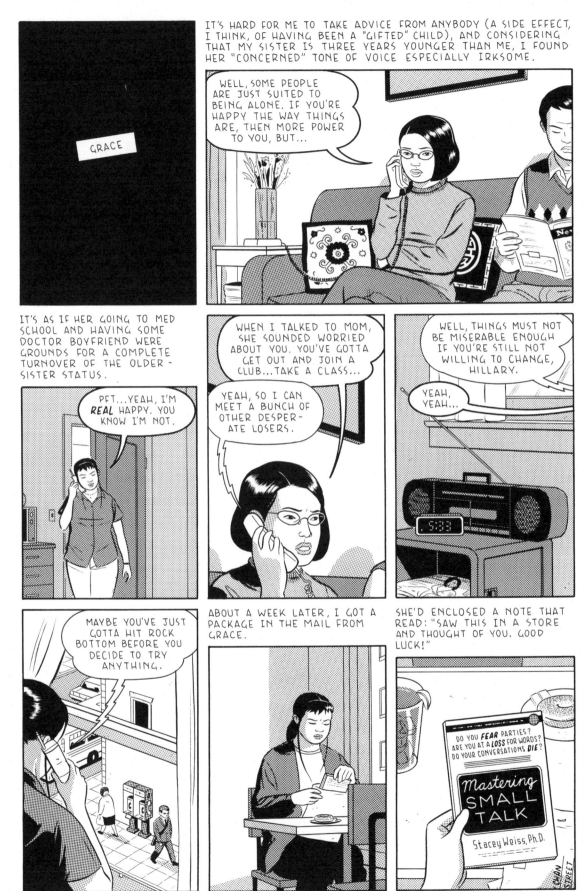

ADRIAN TOMINE *excerpt from Hawaiian Getaway*

DESPITE MY RESISTANT ATTITUDE, GRACE WASN'T TELLING ME ANYTHING I DIDN'T ALREADY KNOW. SEVERAL MONTHS EARLIER, I HAD MADE THE EXACT TYPE OF "EFFORT" THAT SHE (AND OUR MOM) WOULD HAVE LOVED TO SEE.

SIT

BACK

AND

WATCH

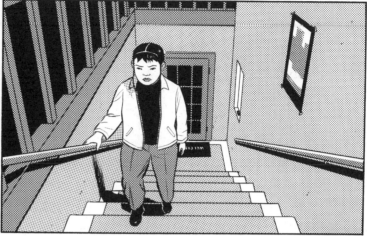

IT WAS ANOTHER PHONE OPERATOR'S BIRTHDAY, SO SHE THREW A BIG PARTY FOR HERSELF AND INVITED EVERYONE FROM WORK.

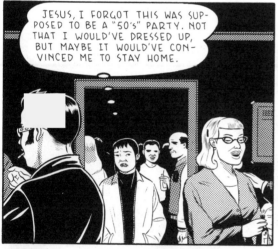

JESUS, I FORGOT THIS WAS SUP- POSED TO BE A "50's" PARTY. NOT THAT I WOULD'VE DRESSED UP, BUT MAYBE IT WOULD'VE CON- VINCED ME TO STAY HOME.

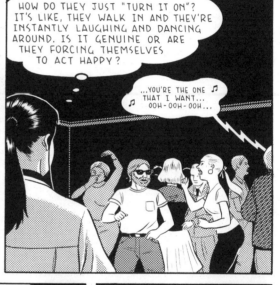

HOW DO THEY JUST "TURN IT ON"? IT'S LIKE, THEY WALK IN AND THEY'RE INSTANTLY LAUGHING AND DANCING AROUND. IS IT GENUINE OR ARE THEY FORCING THEMSELVES TO ACT HAPPY?

...YOU'RE THE ONE THAT I WANT... OOH-OOH-OOH...

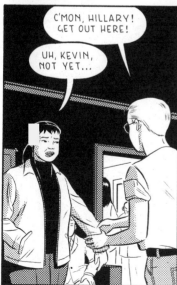

C'MON, HILLARY! GET OUT HERE!

UH, KEVIN, NOT YET...

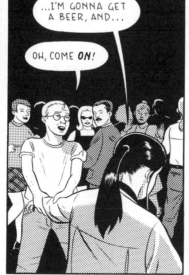

...I'M GONNA GET A BEER, AND...

OH, COME ON!

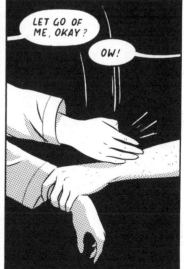

LET GO OF ME, OKAY?

OW!

ADRIAN TOMINE *excerpt from Hawaiian Getaway*

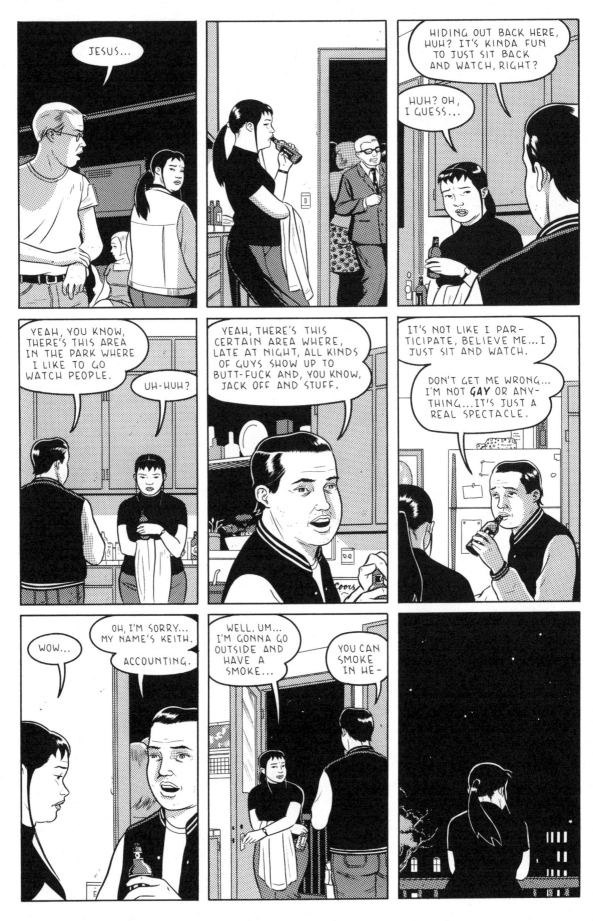

ADRIAN TOMINE *excerpt from Hawaiian Getaway*

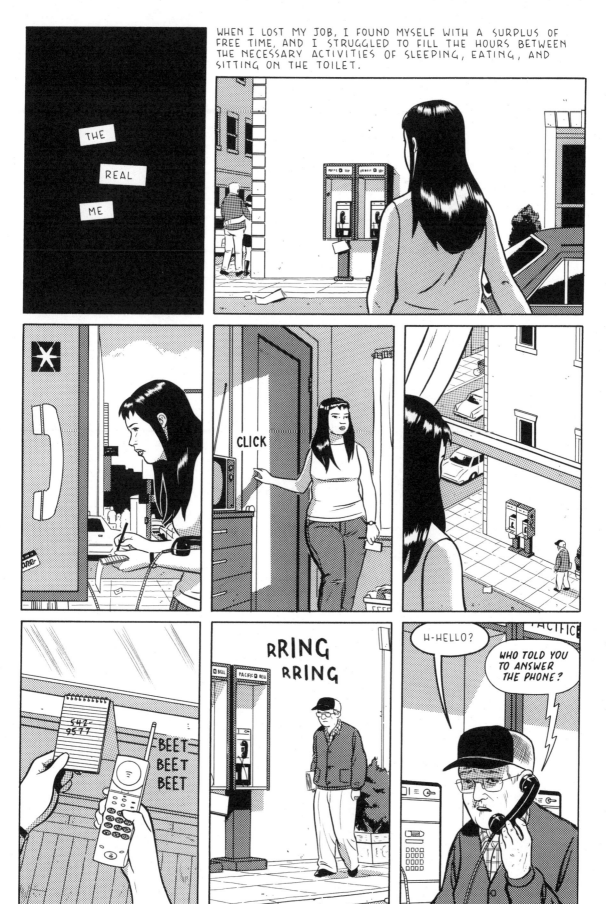

WHEN I LOST MY JOB, I FOUND MYSELF WITH A SURPLUS OF FREE TIME, AND I STRUGGLED TO FILL THE HOURS BETWEEN THE NECESSARY ACTIVITIES OF SLEEPING, EATING, AND SITTING ON THE TOILET.

THE
REAL
ME

CLICK

RRING
RRING

BEET
BEET
BEET

H-HELLO?

WHO TOLD YOU TO ANSWER THE PHONE?

ADRIAN TOMINE excerpt from Hawaiian Getaway

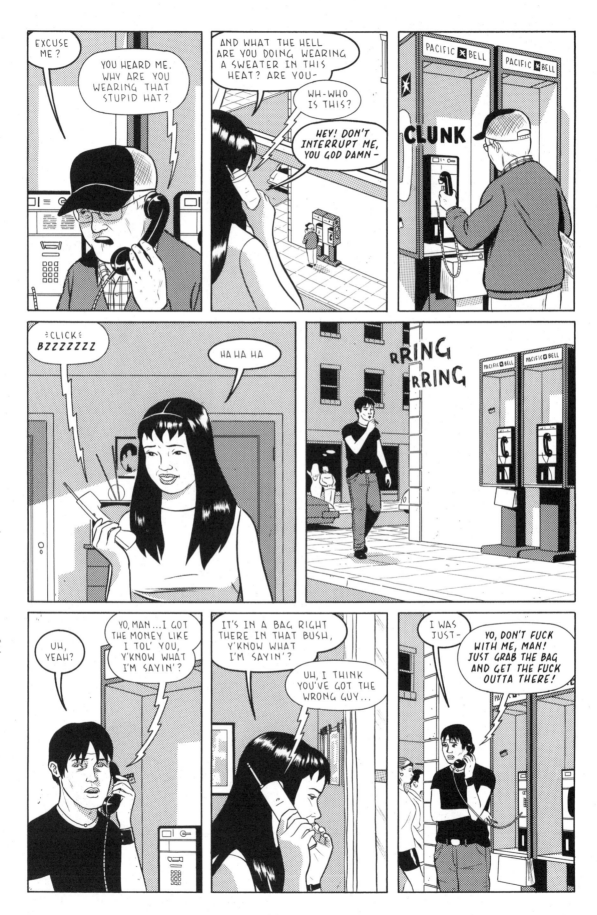

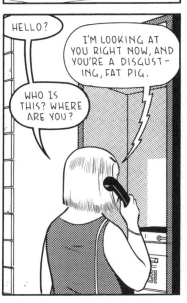

HA HA

LATER, WHEN IT SEEMED LIKE EVERYTHING WAS FALLING APART, THE NATURE OF MY LITTLE PAS- TIME BEGAN TO CHANGE.

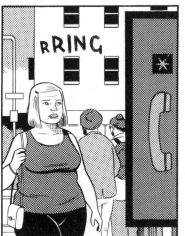

rRING

HELLO?

WHO IS THIS? WHERE ARE YOU?

I'M LOOKING AT YOU RIGHT NOW, AND YOU'RE A DISGUST- ING, FAT PIG.

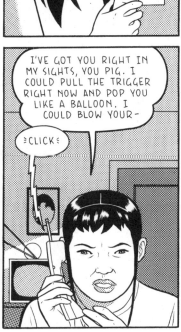

I'VE GOT YOU RIGHT IN MY SIGHTS, YOU PIG. I COULD PULL THE TRIGGER RIGHT NOW AND POP YOU LIKE A BALLOON. I COULD BLOW YOUR—

≥CLICK≤

I KEPT THE PHONE TO MY EAR, LISTENING TO THE DIAL TONE. I FELT LIKE I WAS SOME OTHER PERSON, AND THAT THE REAL ME WAS SITTING ACROSS THE ROOM, WATCHING IN DISBELIEF.

ADRIAN TOMINE *excerpt from* Hawaiian Getaway

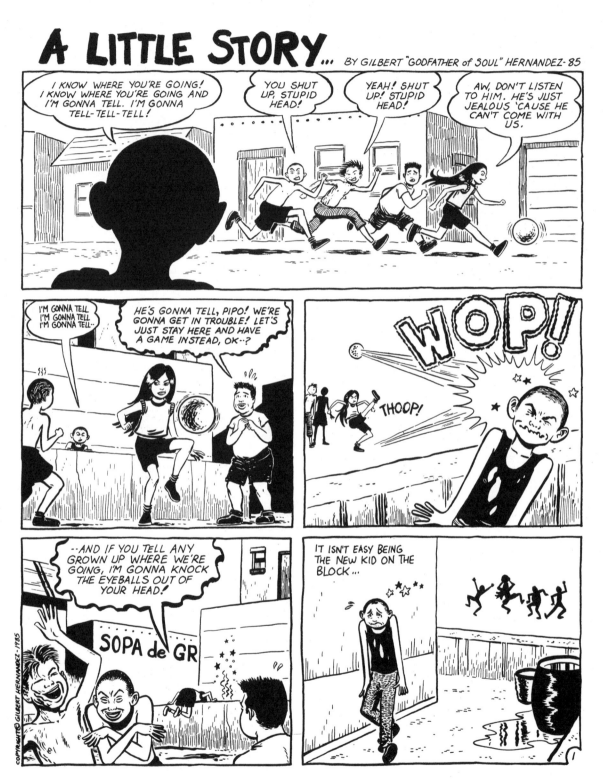

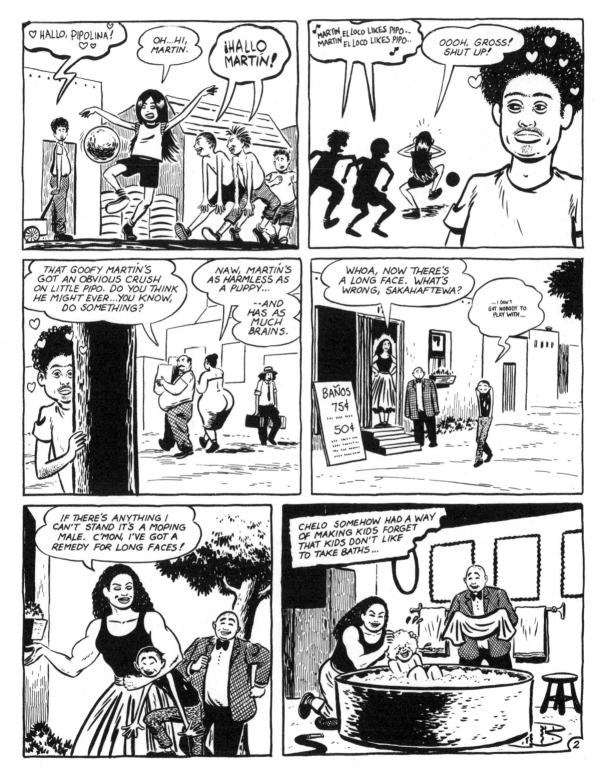

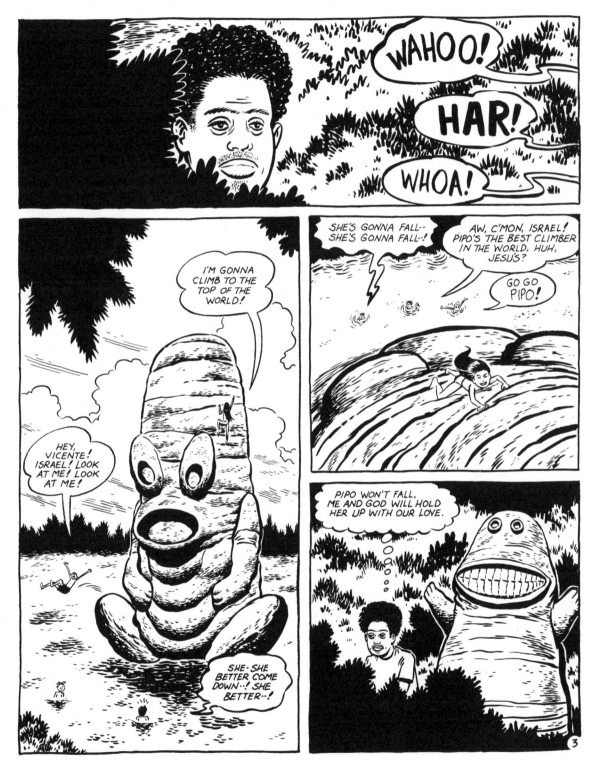

GILBERT HERNANDEZ A Little Story

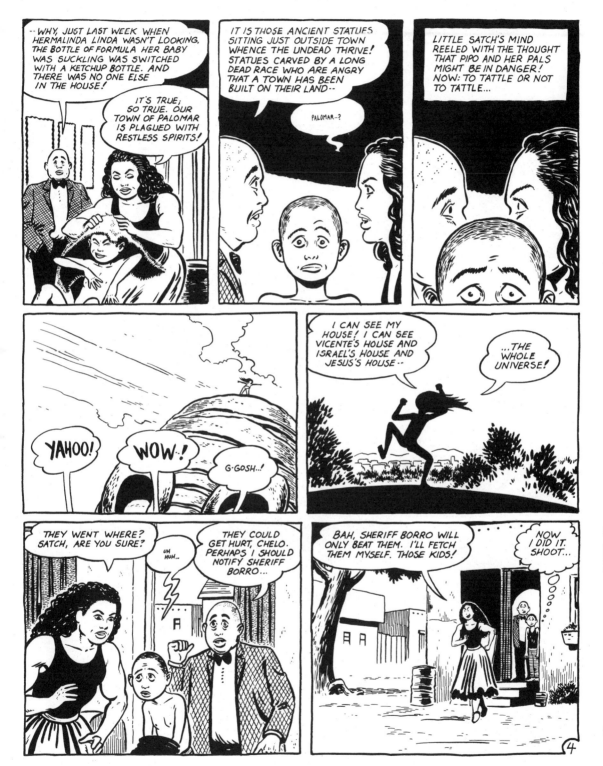

GILBERT HERNANDEZ A Little Story

GILBERT HERNANDEZ A Little Story

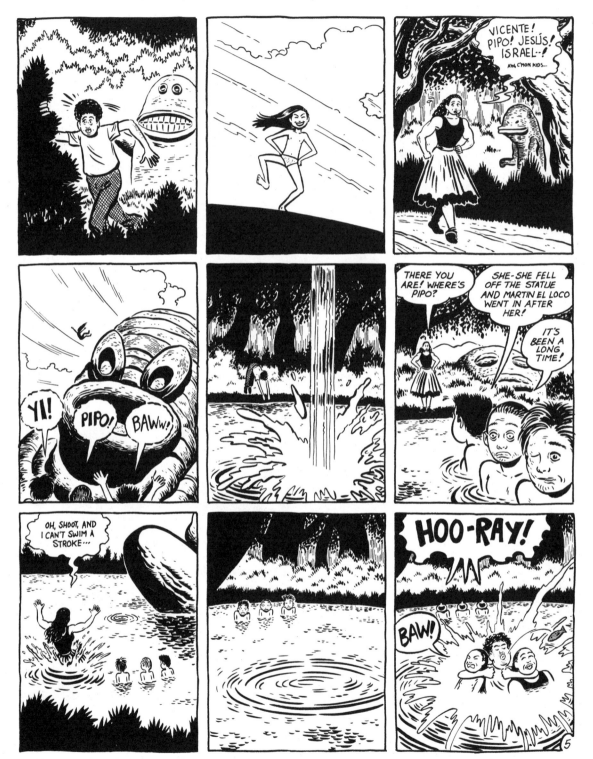

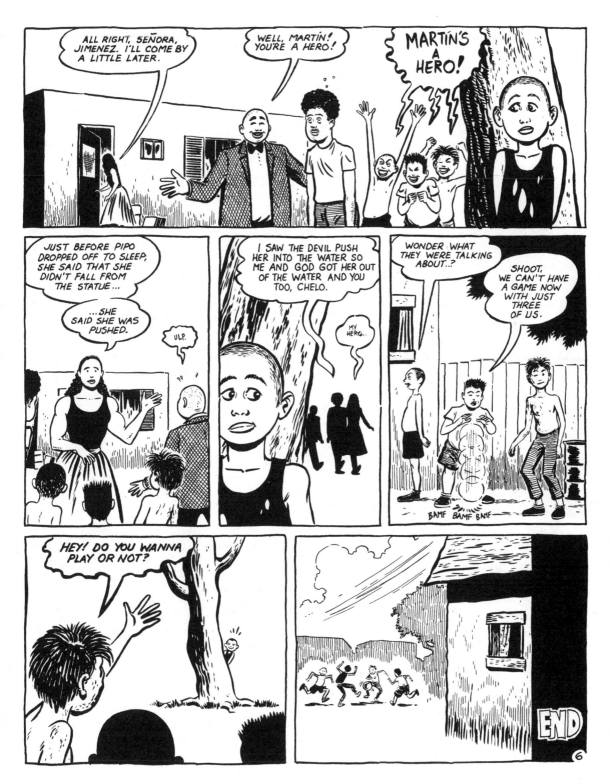

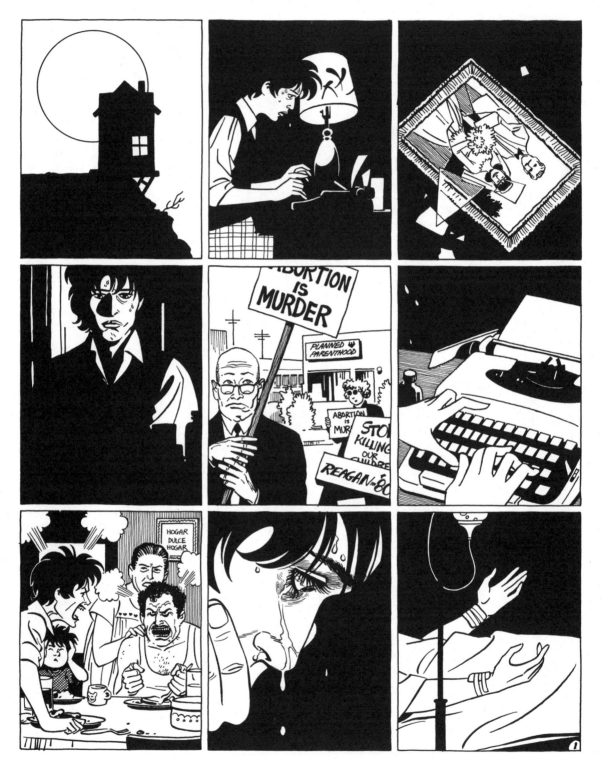

flies on
the ceiling

THE STORY OF ISABEL IN MEXICO

Xaime 88-89

JAIME HERNANDEZ Flies on the Ceiling

JAIME HERNANDEZ Flies on the Ceiling

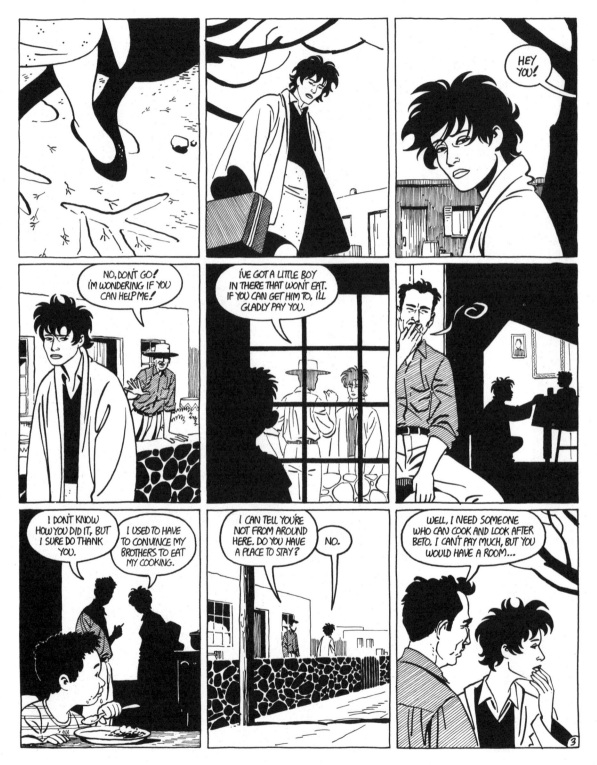

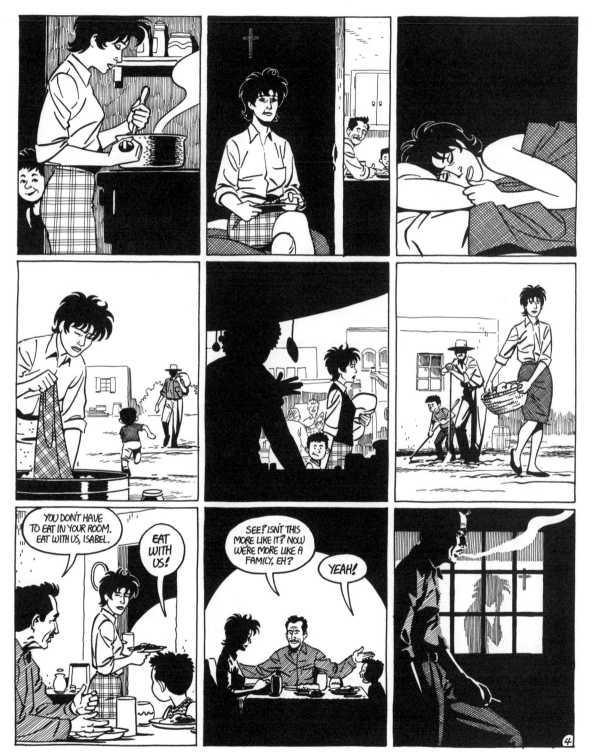

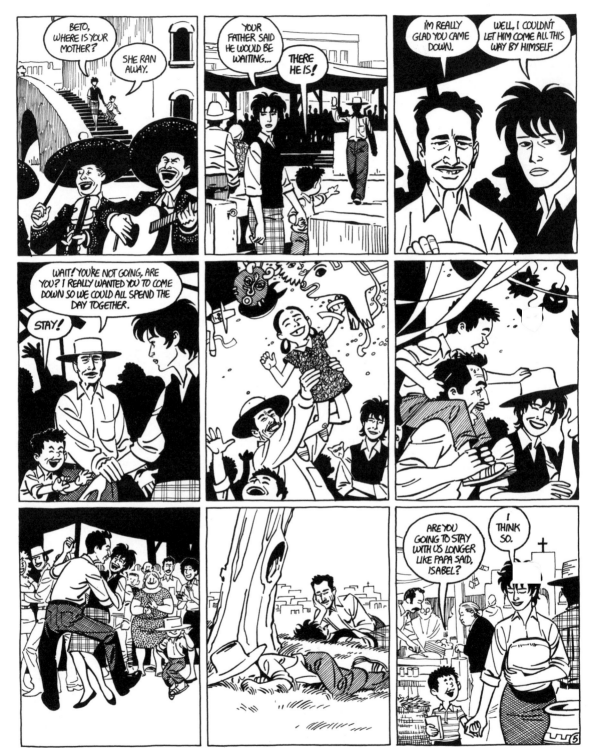

JAIME HERNANDEZ Flies on the Ceiling

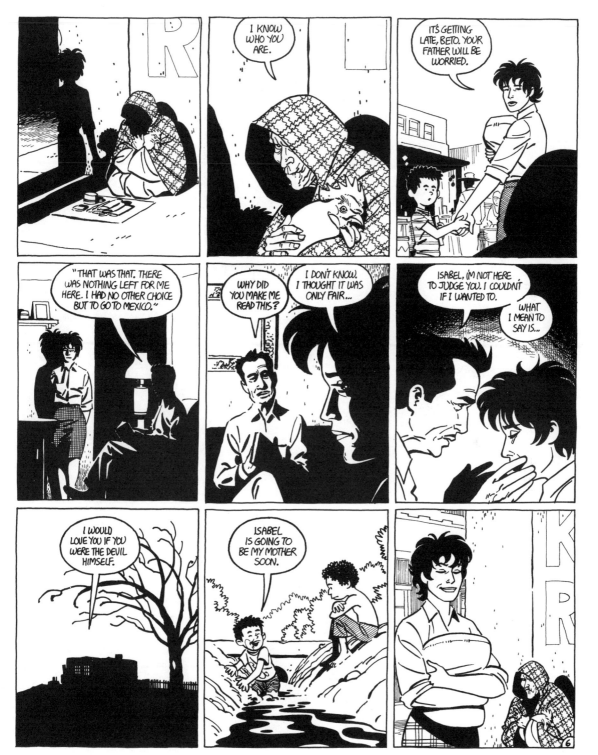

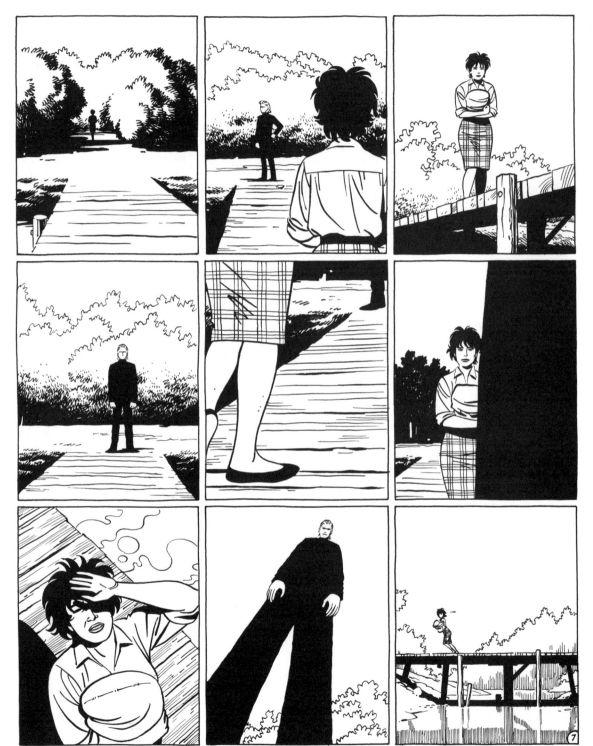

JAIME HERNANDEZ Flies on the Ceiling

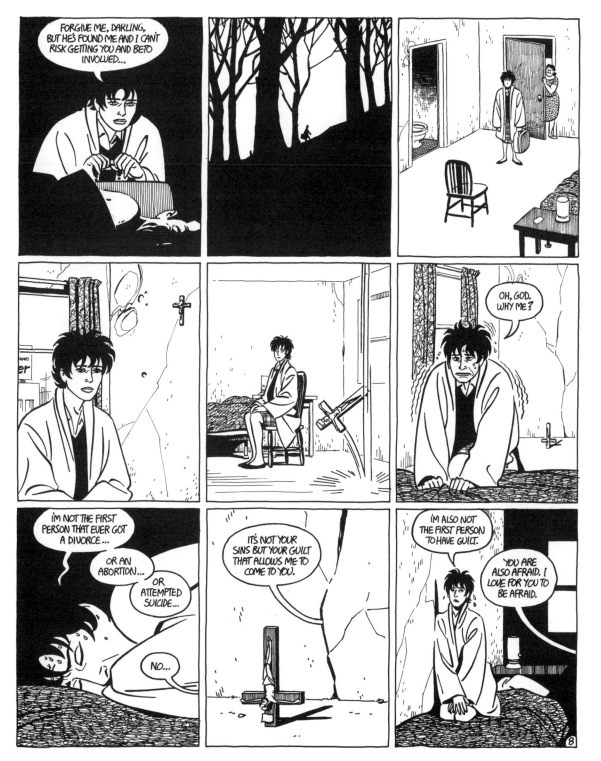

JAIME HERNANDEZ Flies on the Ceiling

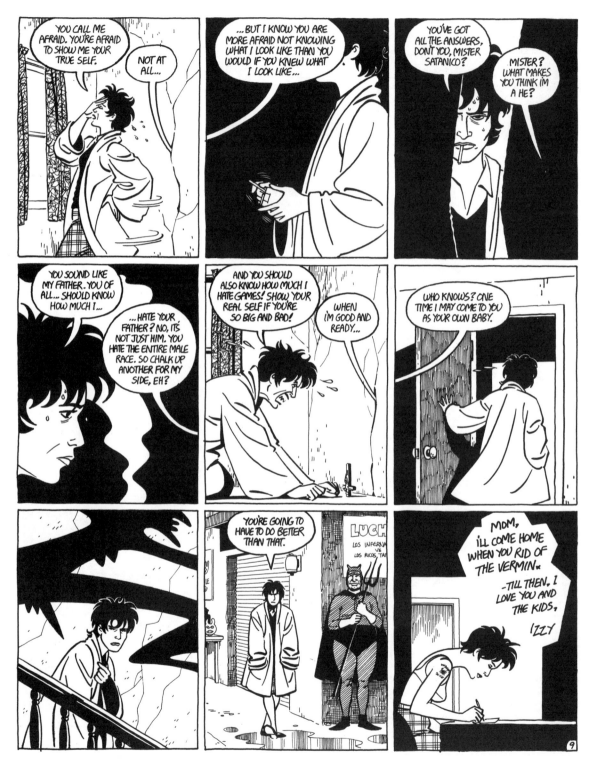

JAIME HERNANDEZ Flies on the Ceiling

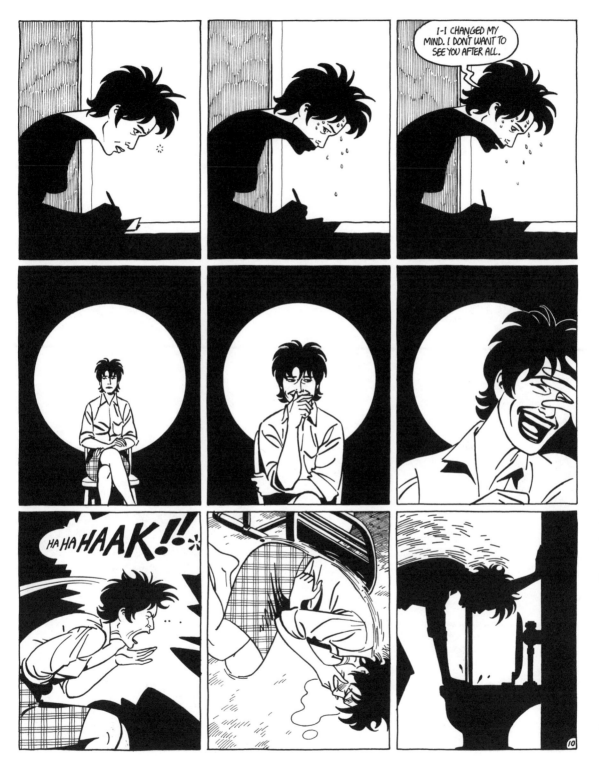

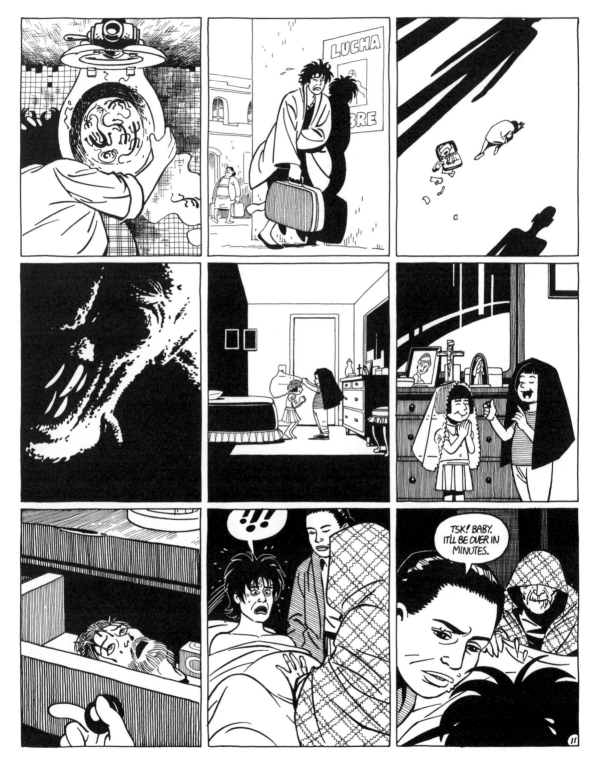

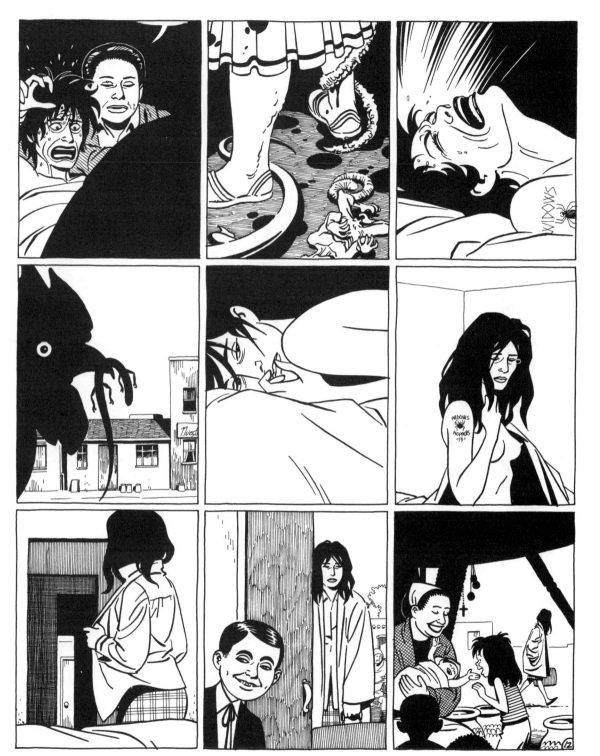

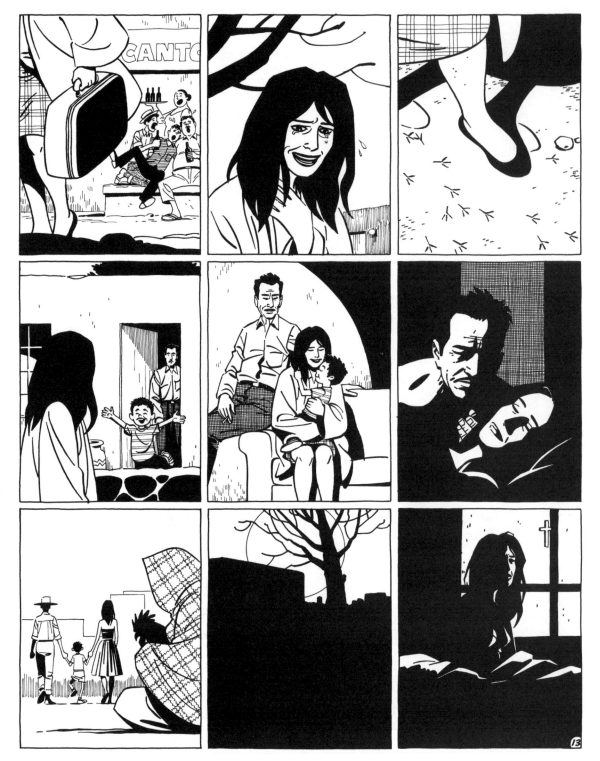

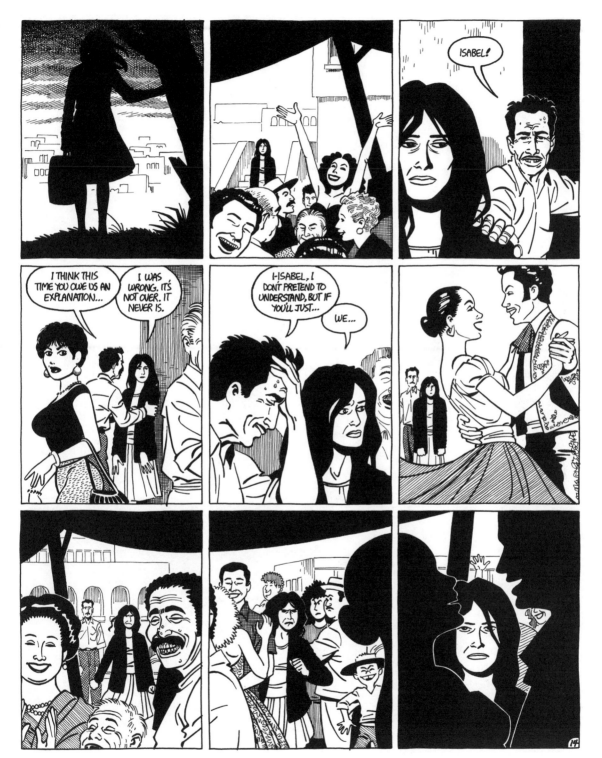

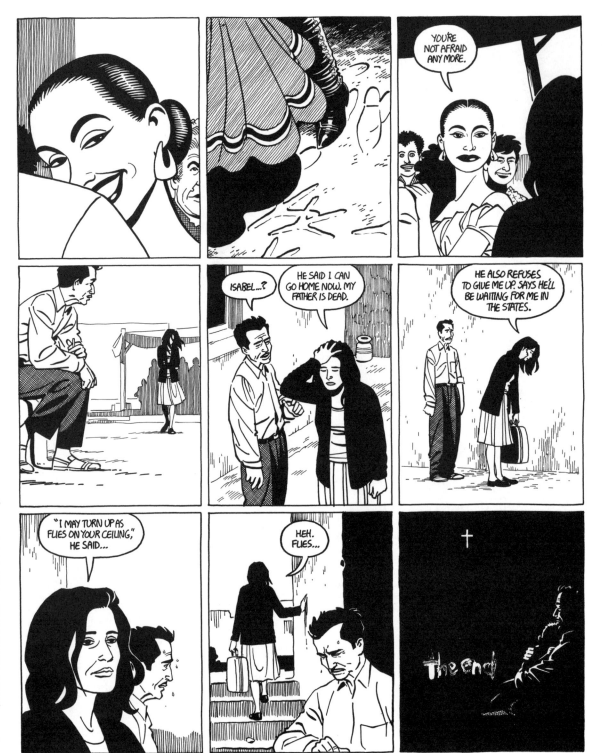

JAIME HERNANDEZ Flies on the Ceiling

Once upon a time...

JUSTIN GREEN *excerpt from Binky Brown Meets the Holy Virgin Mary*

JUSTIN GREEN *excerpt from Binky Brown Meets the Holy Virgin Mary*

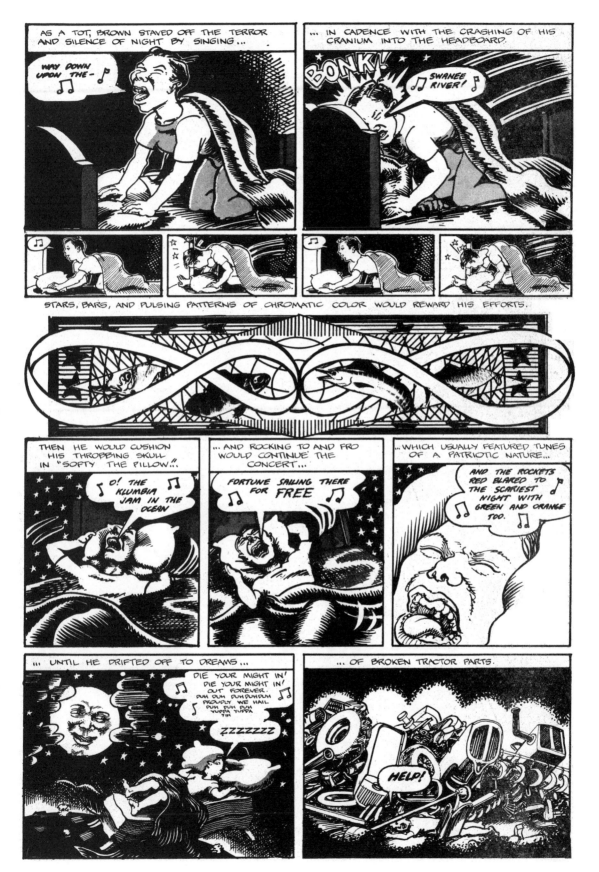

JUSTIN GREEN *excerpt from* Binky Brown Meets the Holy Virgin Mary

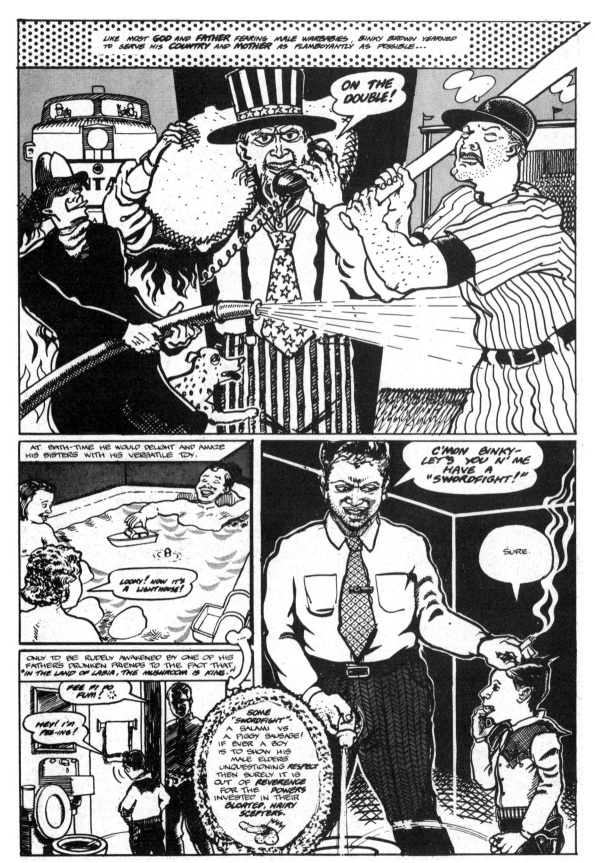

JUSTIN GREEN excerpt from Binky Brown Meets the Holy Virgin Mary

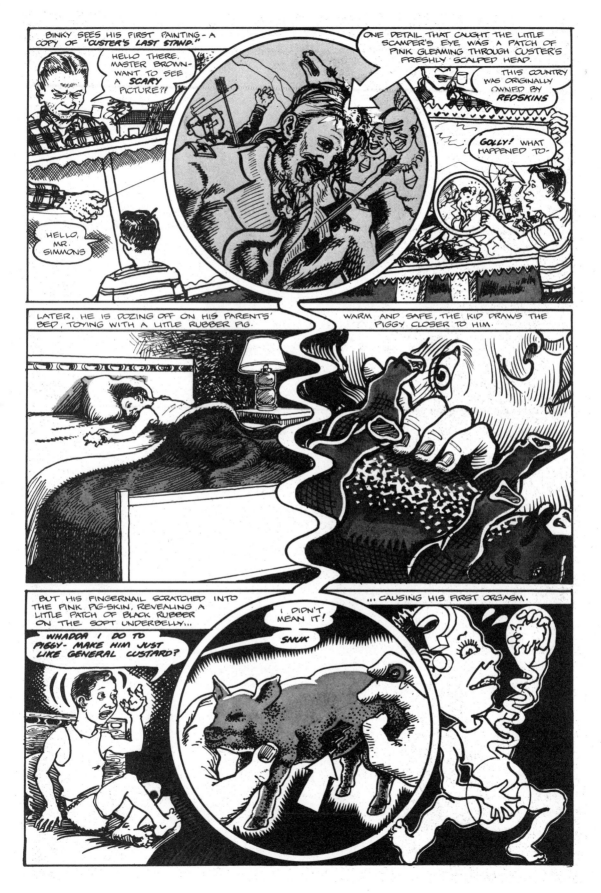

JUSTIN GREEN *excerpt from Binky Brown Meets the Holy Virgin Mary*

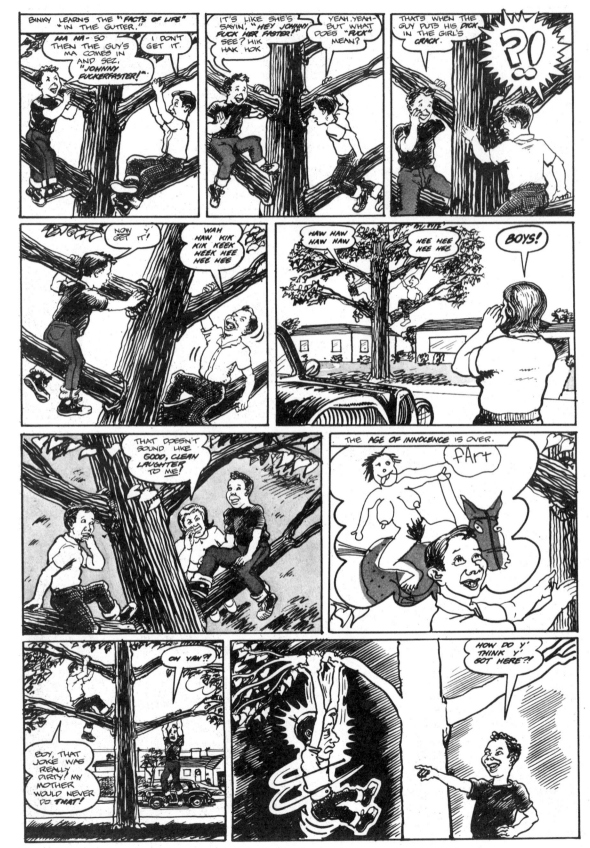

JUSTIN GREEN *excerpt from Binky Brown Meets the Holy Virgin Mary*

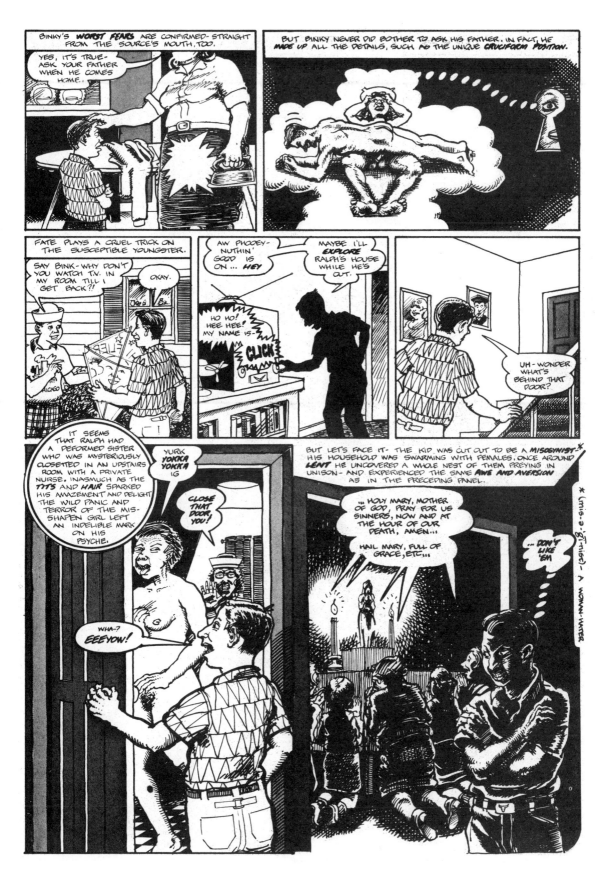

JUSTIN GREEN *excerpt from Binky Brown Meets the Holy Virgin Mary*

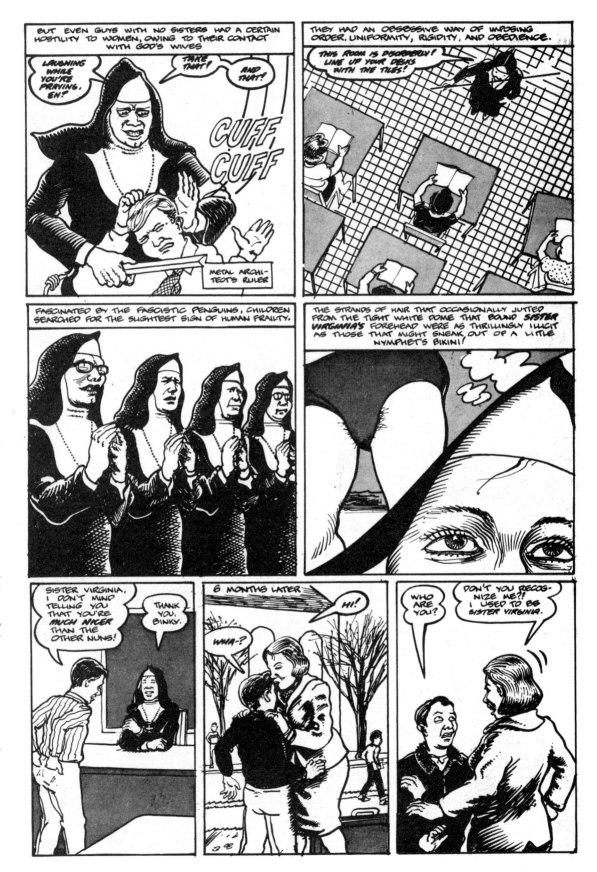

JUSTIN GREEN *excerpt from Binky Brown Meets the Holy Virgin Mary*

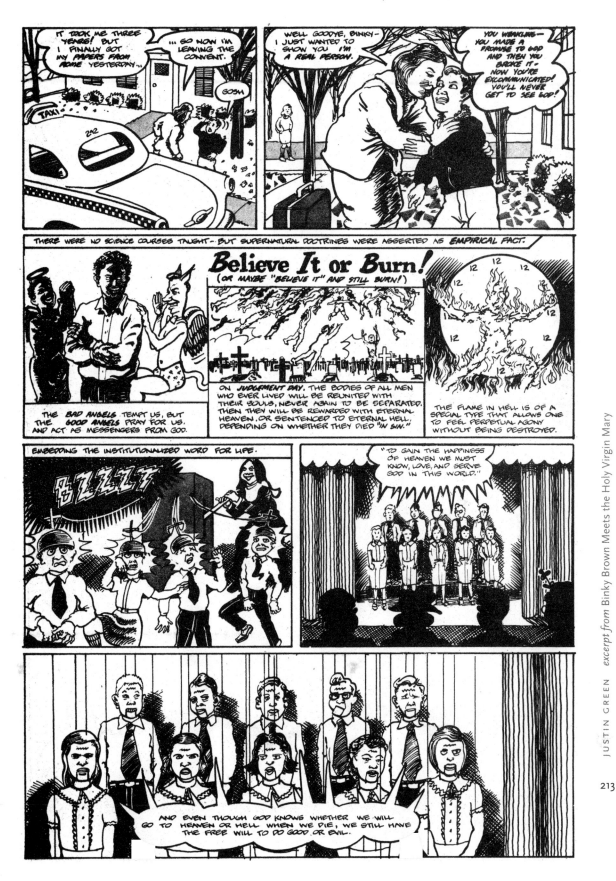

JUSTIN GREEN *excerpt from Binky Brown Meets the Holy Virgin Mary*

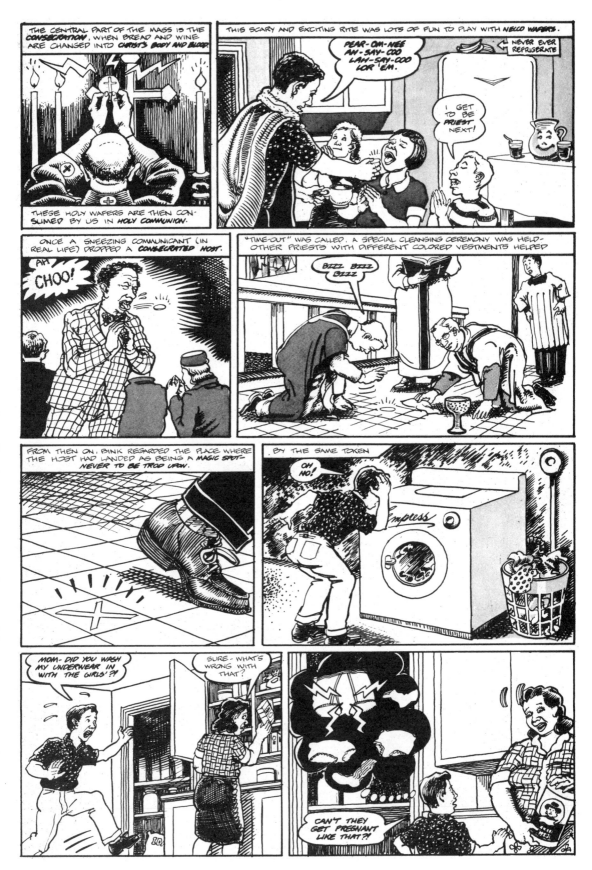

JUSTIN GREEN *excerpt from Binky Brown Meets the Holy Virgin Mary*

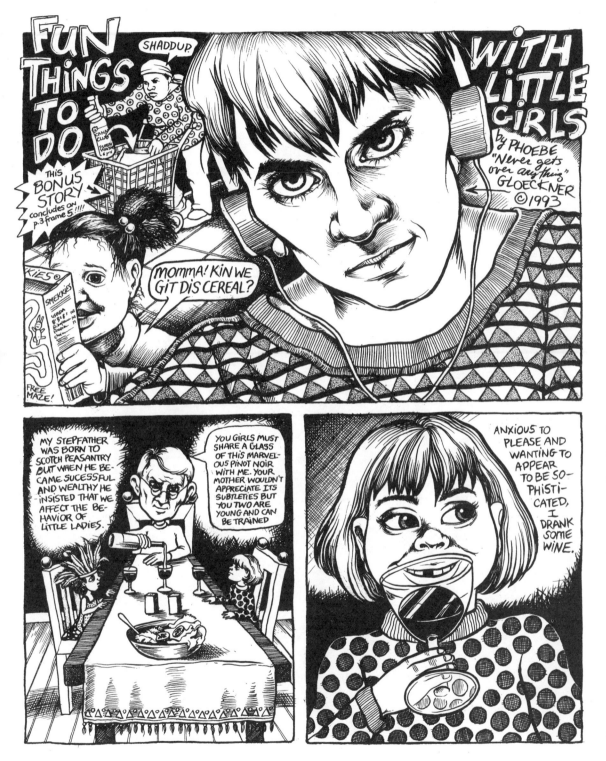

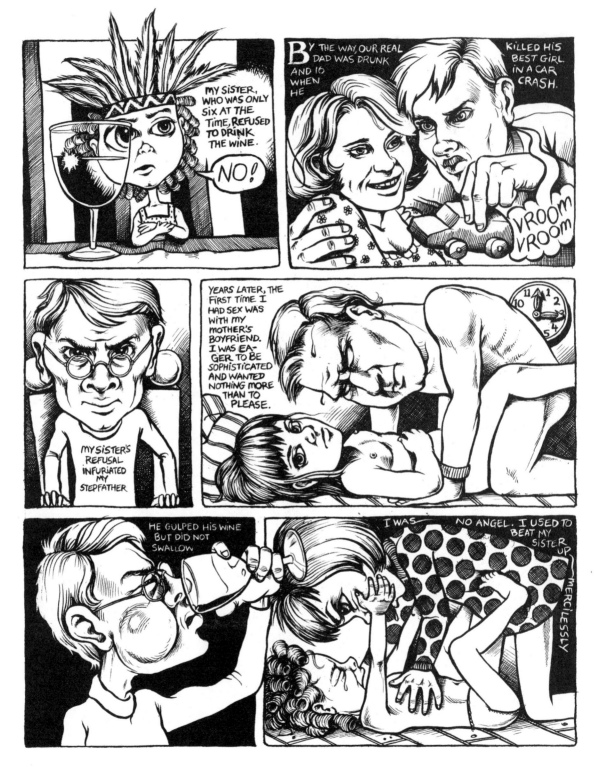

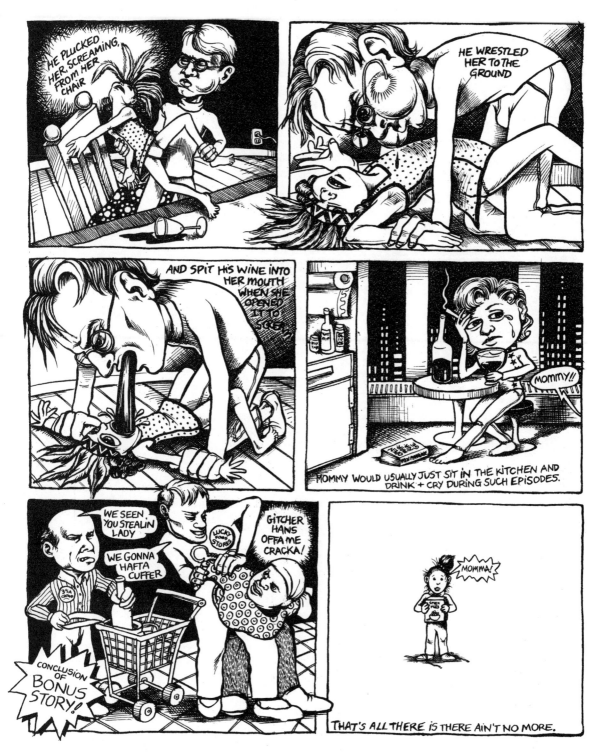

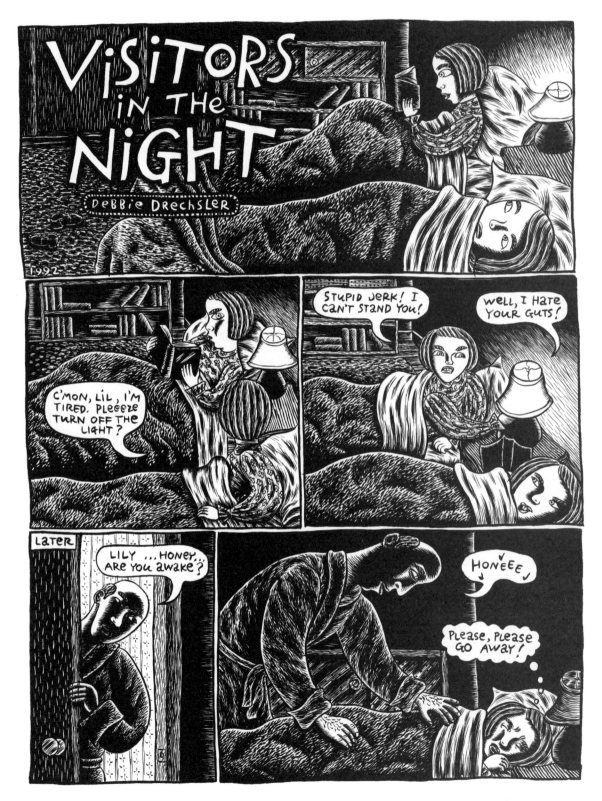

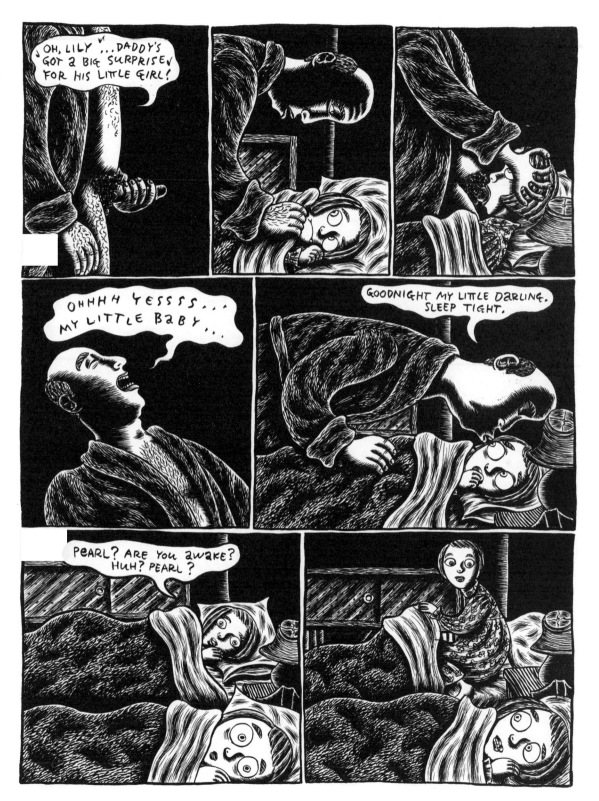

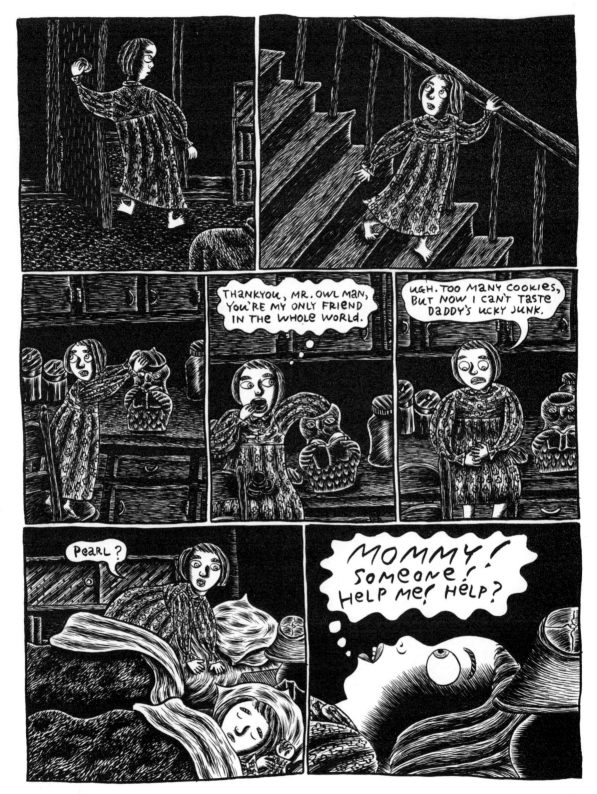

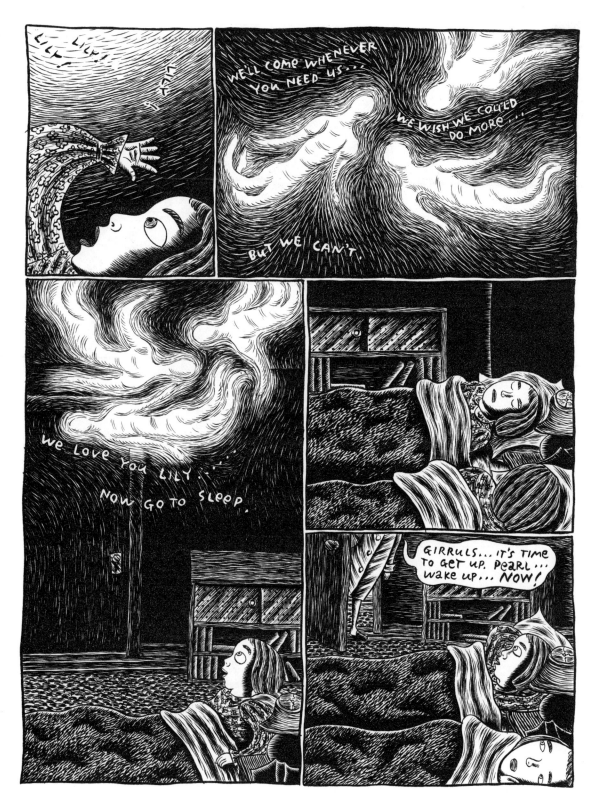

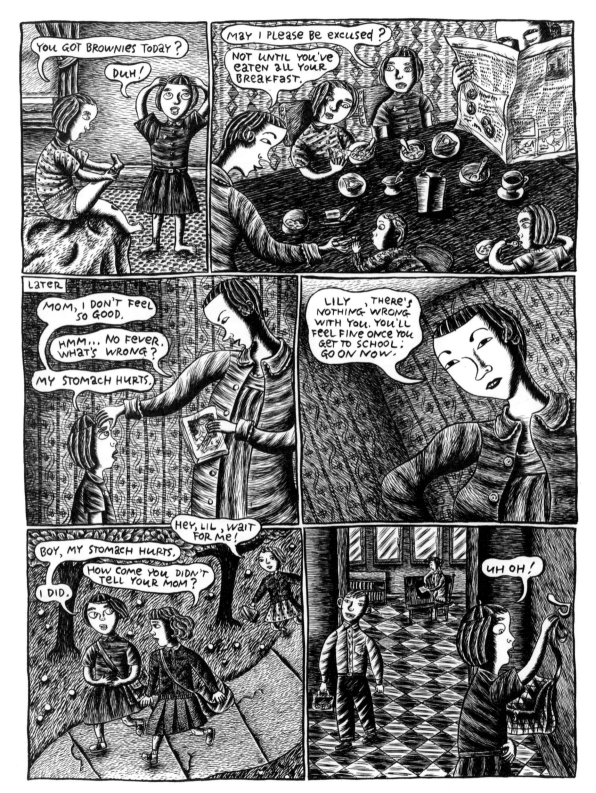

DEBBIE DRECHSLER Visitors in the Night

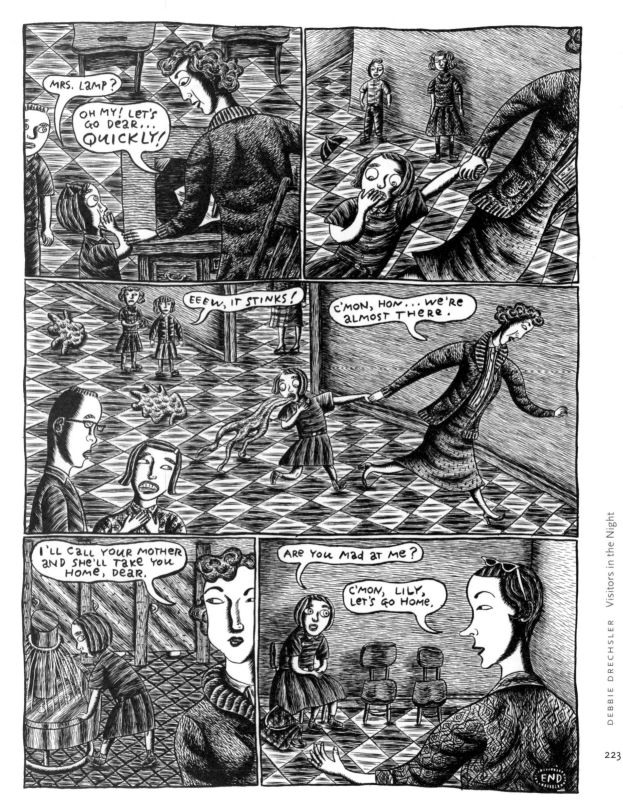

DEBBIE DRECHSLER Visitors in the Night

CHESTER BROWN *excerpt from* I Never Liked You

CHESTER BROWN *excerpt from* I Never Liked You

CHESTER BROWN *excerpt from* I Never Liked You

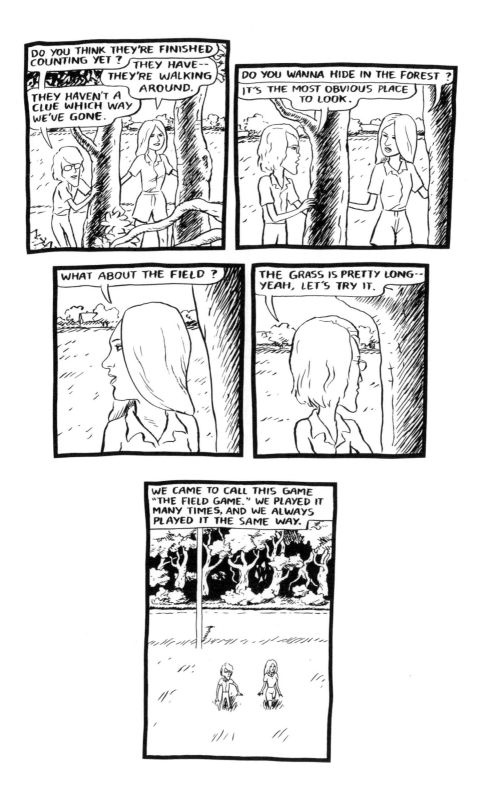

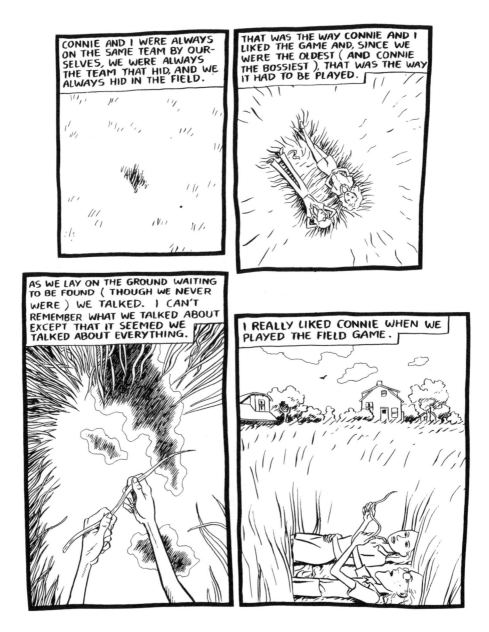

CONNIE AND I WERE ALWAYS ON THE SAME TEAM BY OUR-SELVES, WE WERE ALWAYS THE TEAM THAT HID, AND WE ALWAYS HID IN THE FIELD.

THAT WAS THE WAY CONNIE AND I LIKED THE GAME AND, SINCE WE WERE THE OLDEST (AND CONNIE THE BOSSIEST), THAT WAS THE WAY IT HAD TO BE PLAYED.

AS WE LAY ON THE GROUND WAITING TO BE FOUND (THOUGH WE NEVER WERE) WE TALKED. I CAN'T REMEMBER WHAT WE TALKED ABOUT EXCEPT THAT IT SEEMED WE TALKED ABOUT EVERYTHING.

I REALLY LIKED CONNIE WHEN WE PLAYED THE FIELD GAME.

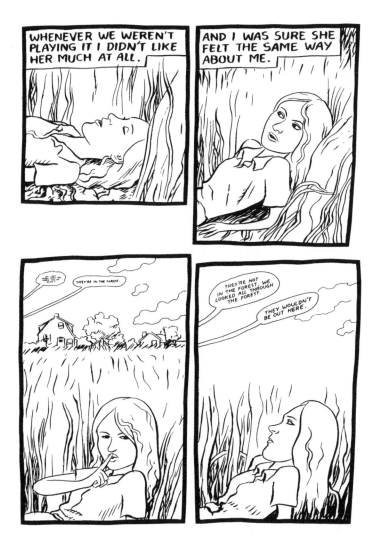

CHESTER BROWN *excerpt from* I Never Liked You

JOE MATT *excerpt from* The Poor Bastard

233

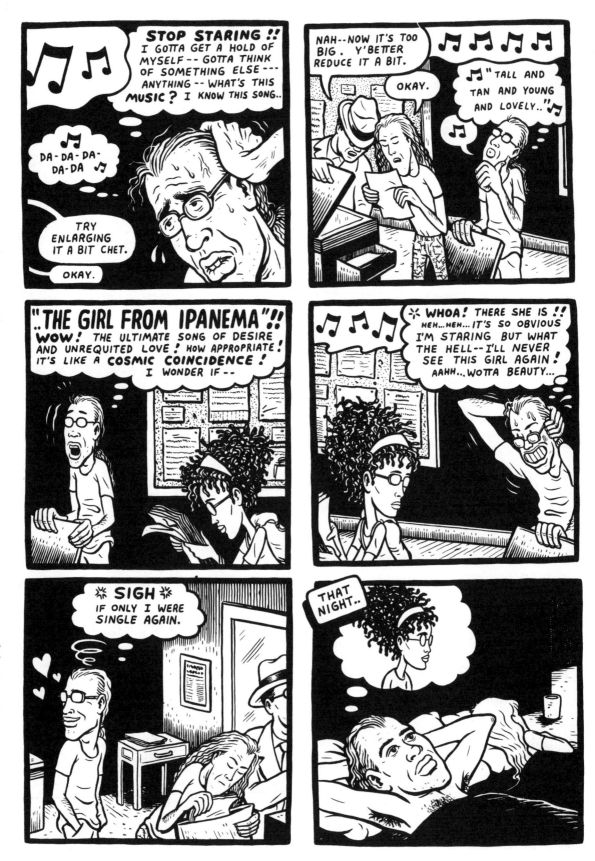

JOE MATT *excerpt from* The Poor Bastard

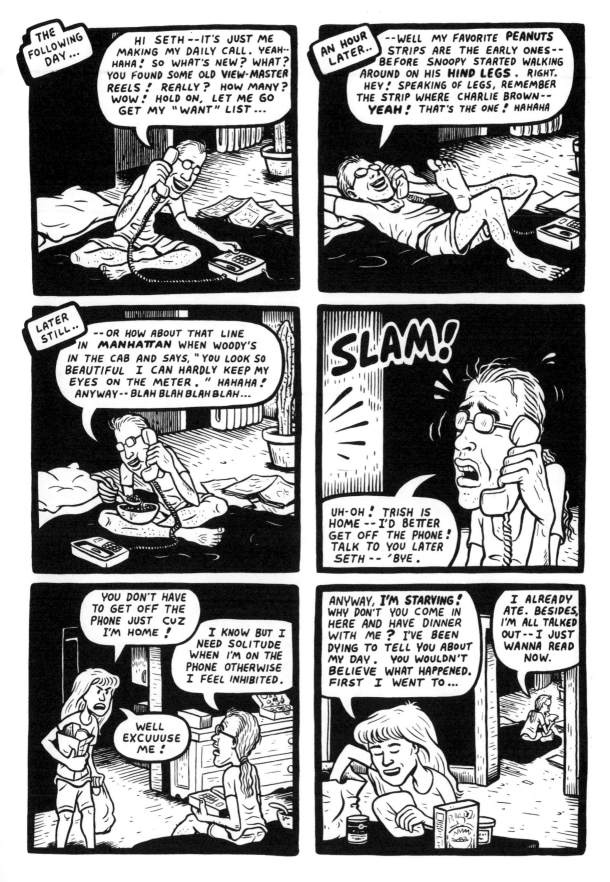

JOE MATT *excerpt from The Poor Bastard*

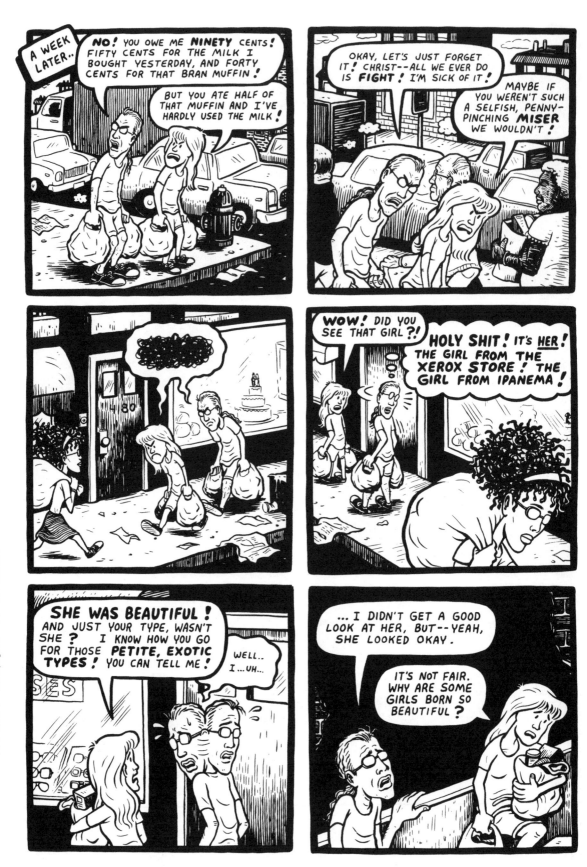

JOE MATT *excerpt from* The Poor Bastard

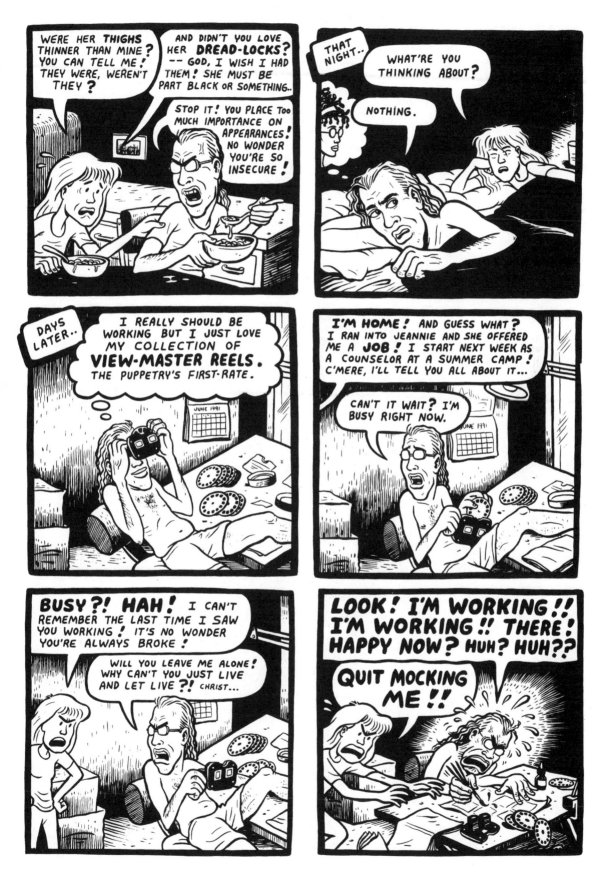

JOE MATT *excerpt from* The Poor Bastard

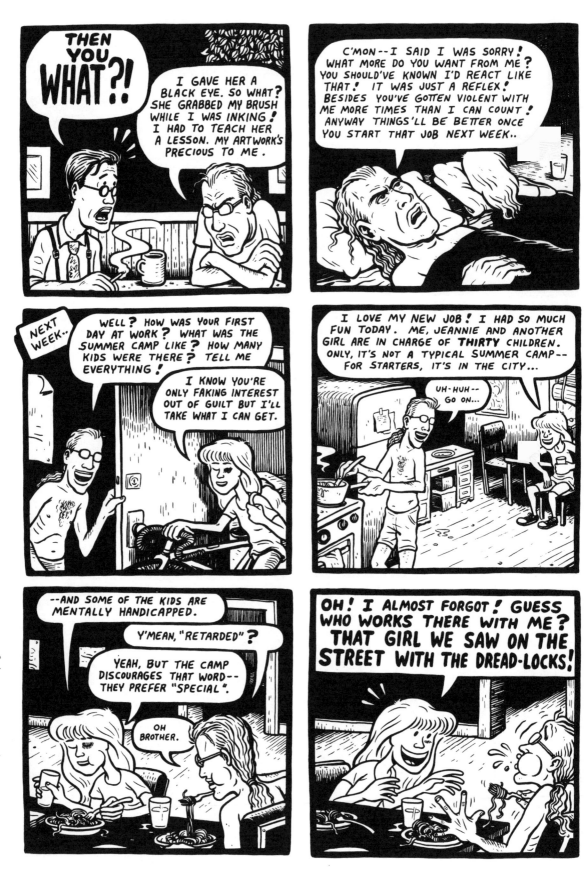

238

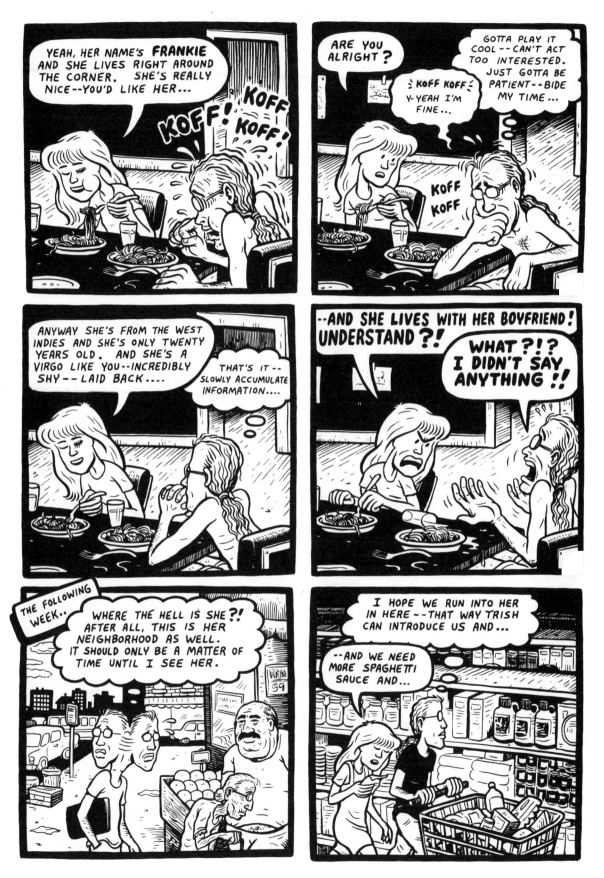

JOE MATT *excerpt from The Poor Bastard*

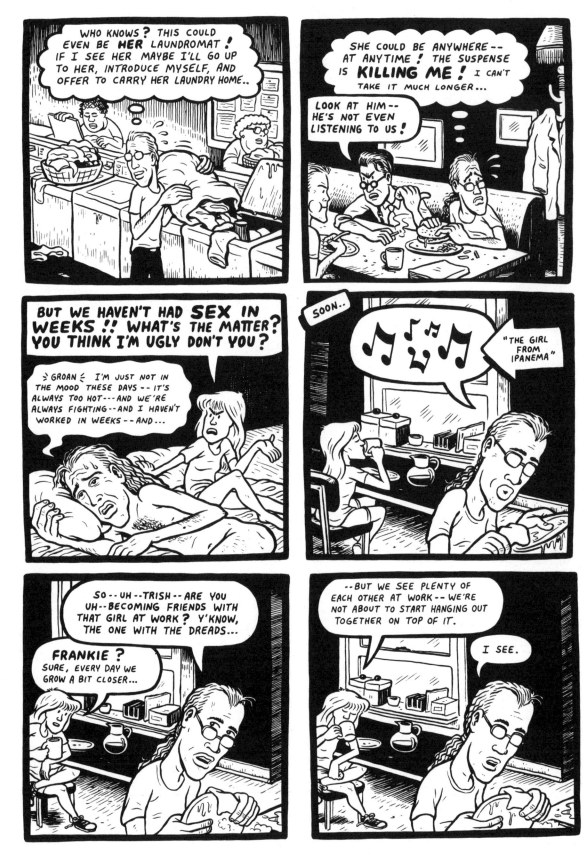

JOE MATT excerpt from The Poor Bastard

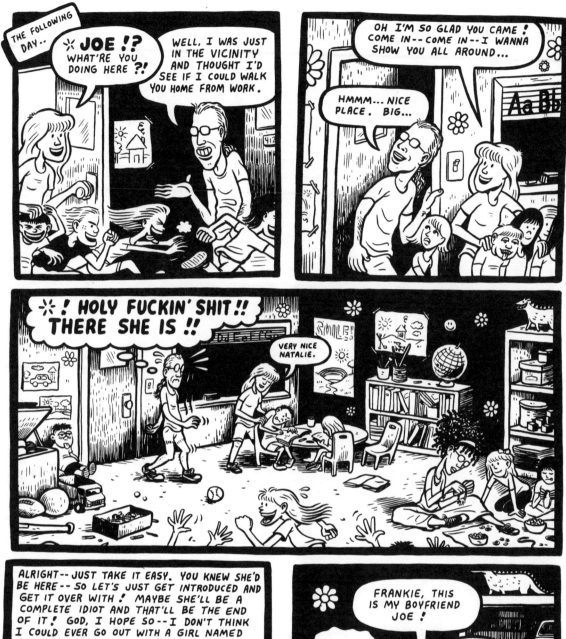

JOE MATT *excerpt from* The Poor Bastard

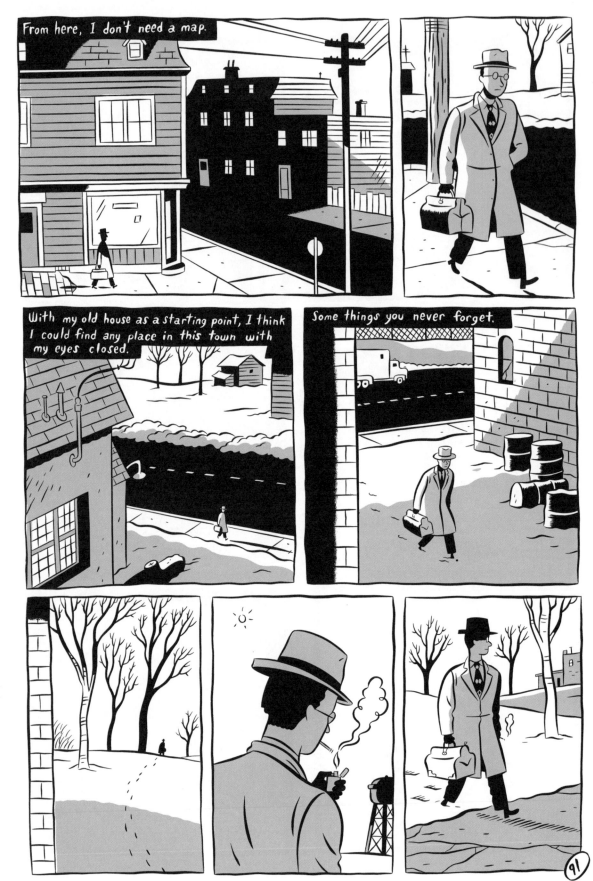

SETH *excerpt from* It's a Good Life If You Don't Weaken

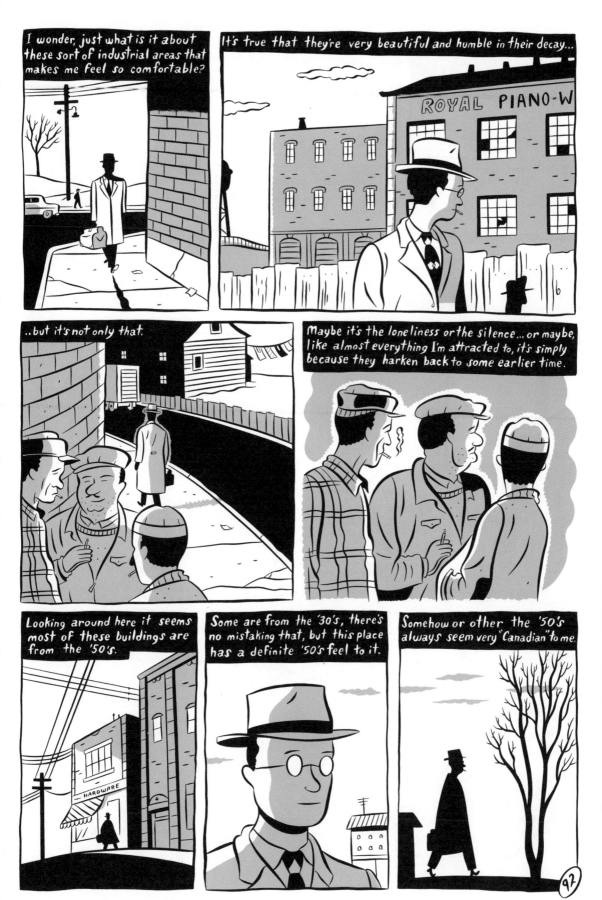

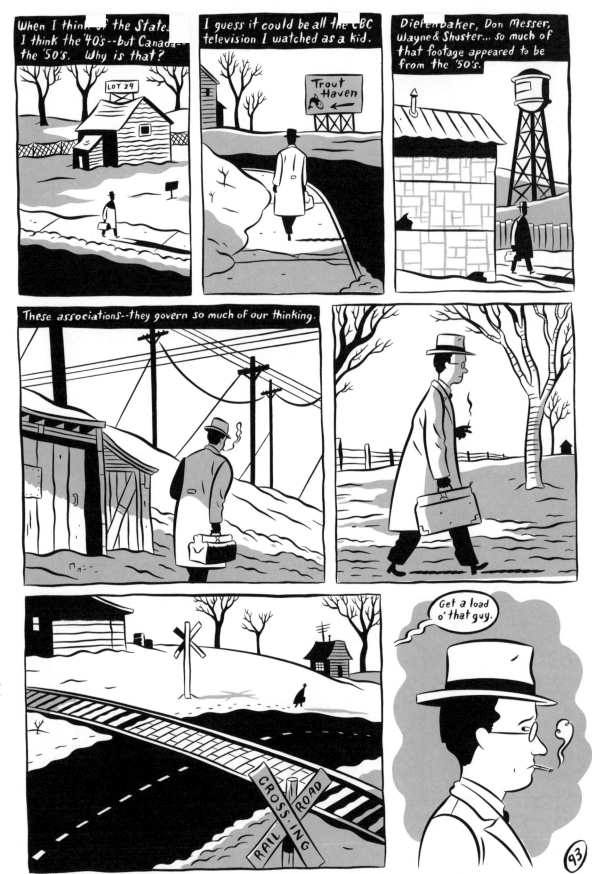

SETH *excerpt from* It's a Good Life If You Don't Weaken

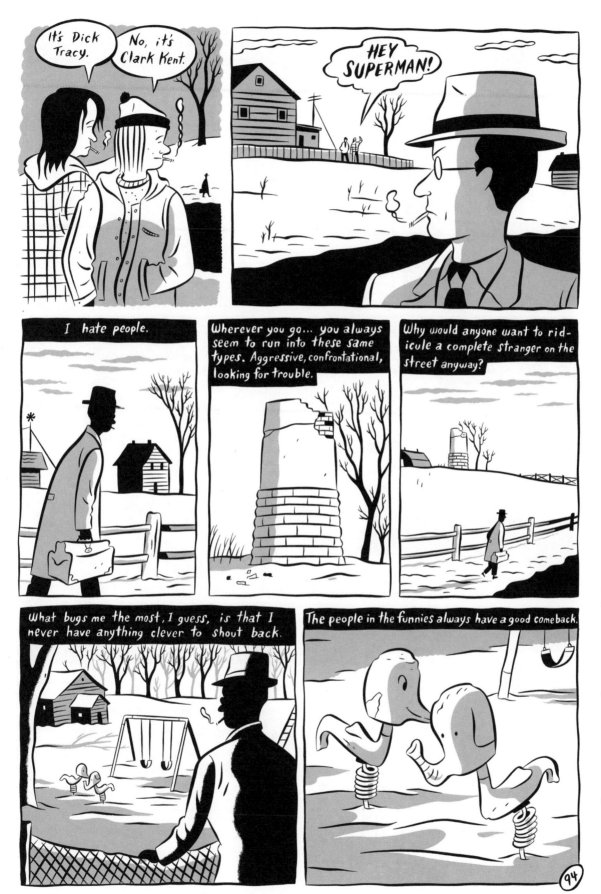

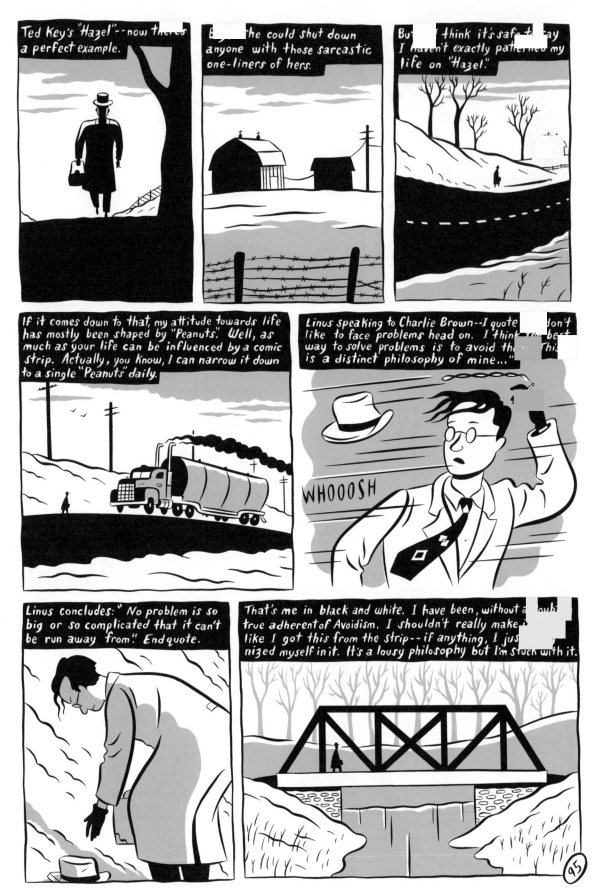

Ted Key's "Hazel"--now there's a perfect example.

B[...] he could shut down anyone with those sarcastic one-liners of hers.

But [...] think it's safe to say I haven't exactly patterned my life on "Hazel."

If it comes down to that, my attitude towards life has mostly been shaped by "Peanuts". Well, as much as your life can be influenced by a comic strip. Actually, you know, I can narrow it down to a single "Peanuts" daily.

Linus speaking to Charlie Brown--I quote [...] don't like to face problems head on. I think the best way to solve problems is to avoid the[...] This is a distinct philosophy of mine..."

WHOOOSH

Linus concludes: "No problem is so big or so complicated that it can't be run away from!" End quote.

That's me in black and white. I have been, without a doubt, true adherent of Avoidism. I shouldn't really make [...] like I got this from the strip--if anything, I jus[...] nized myself in it. It's a lousy philosophy but I'm stuck with it.

SETH *excerpt from It's a Good Life If You Don't Weaken*

246

95

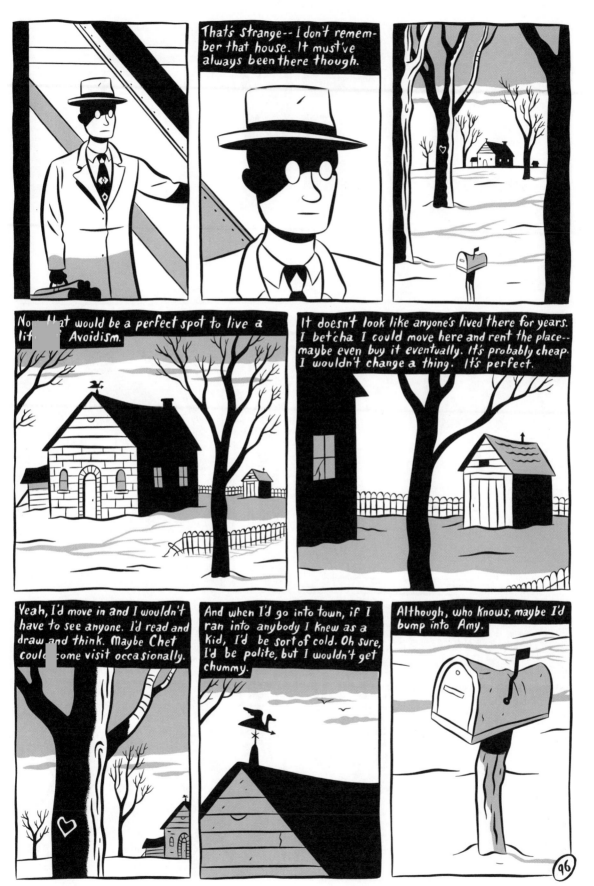

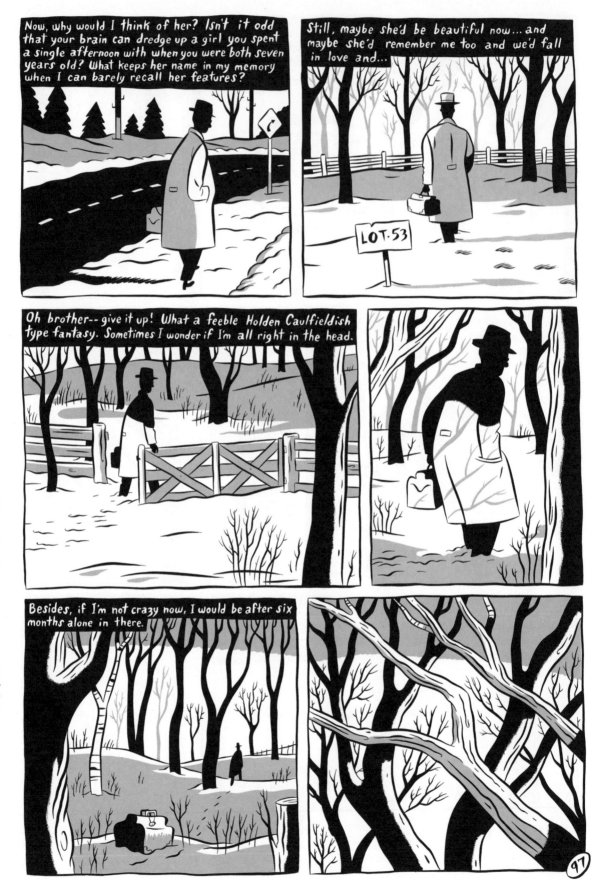

SETH *excerpt from* It's a Good Life If You Don't Weaken

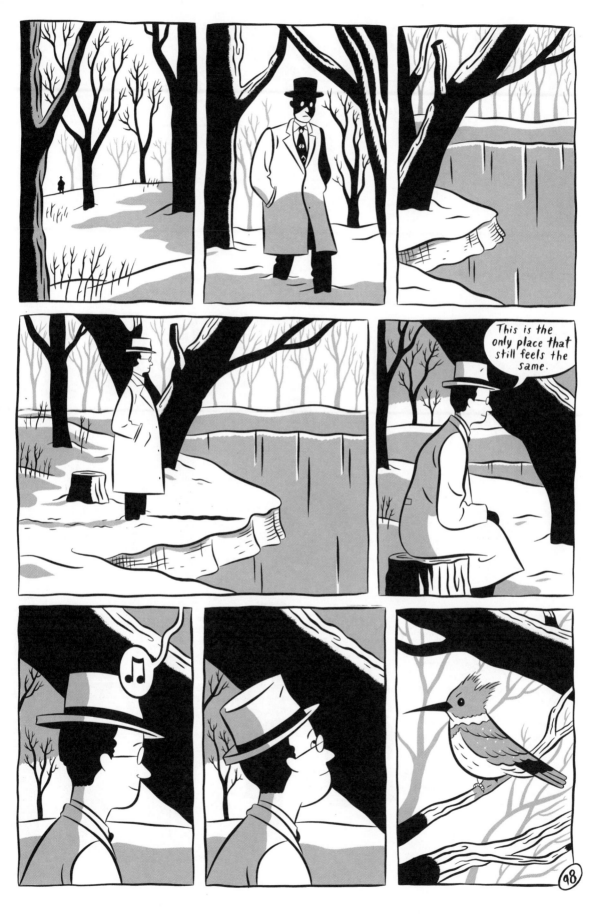

SETH *excerpt from* It's a Good Life If You Don't Weaken

249

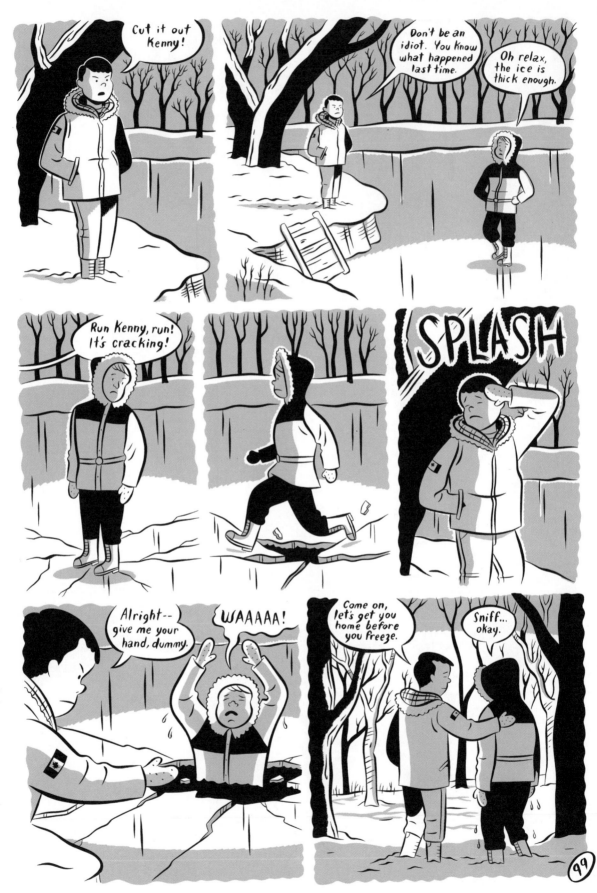

SETH *excerpt from* It's a Good Life If You Don't Weaken

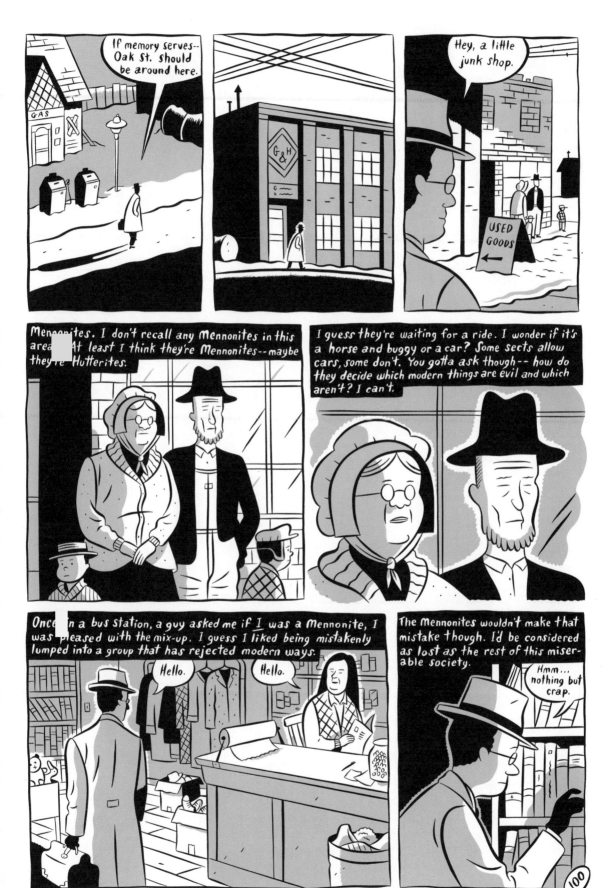

SETH *excerpt from* It's a Good Life If You Don't Weaken

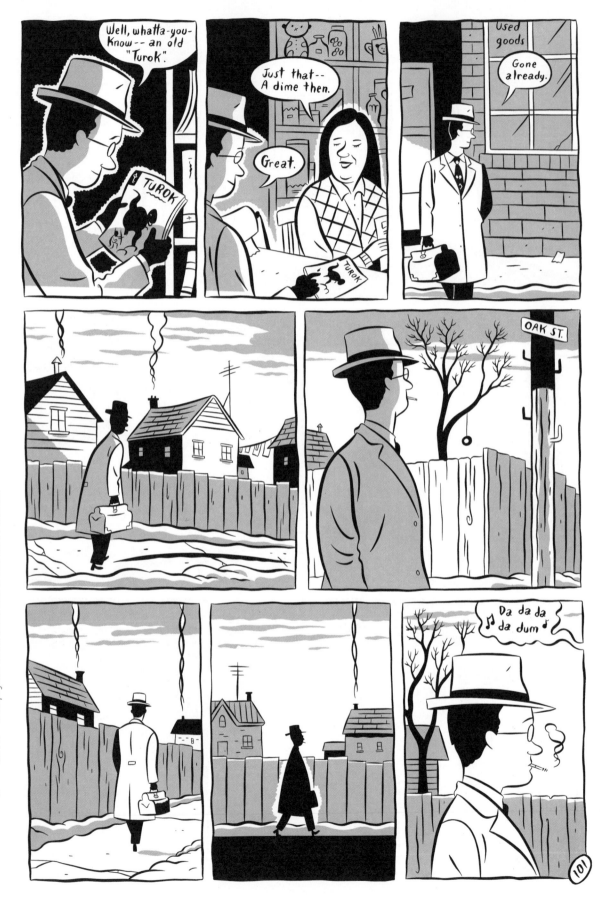

SETH *excerpt from* It's a Good Life If You Don't Weaken

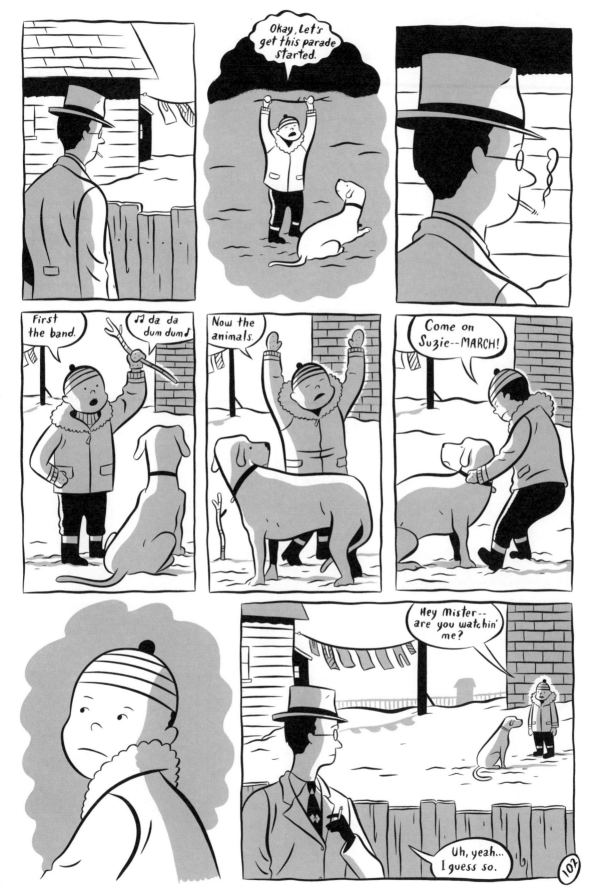

SETH *excerpt from* It's a Good Life If You Don't Weaken

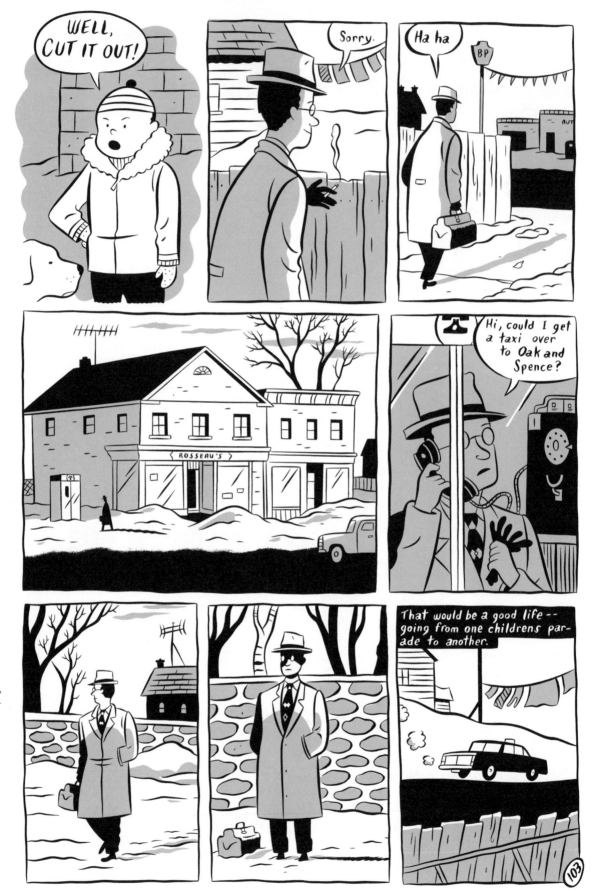

SETH *excerpt from* It's a Good Life If You Don't Weaken

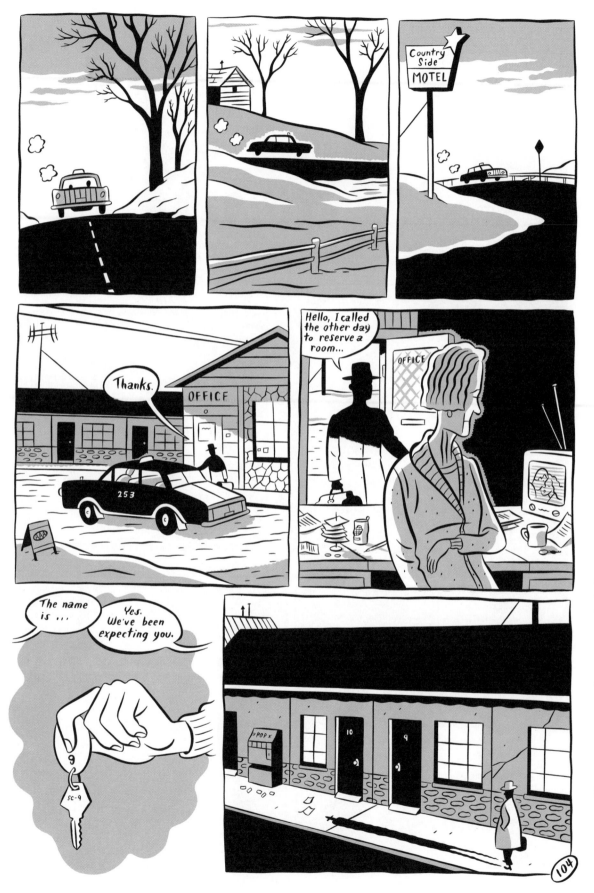

SETH *excerpt from* It's a Good Life If You Don't Weaken

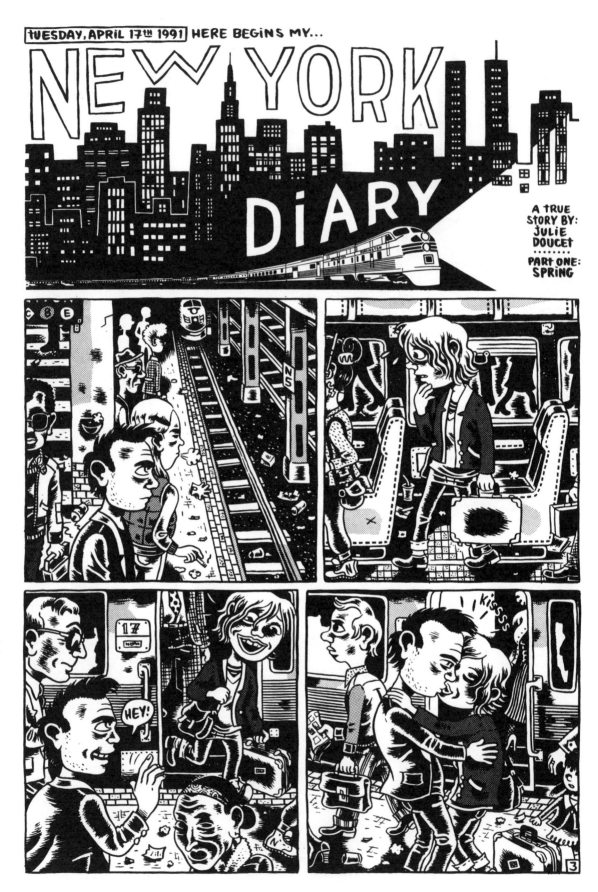

JULIE DOUCET *excerpt from My New York Diary*

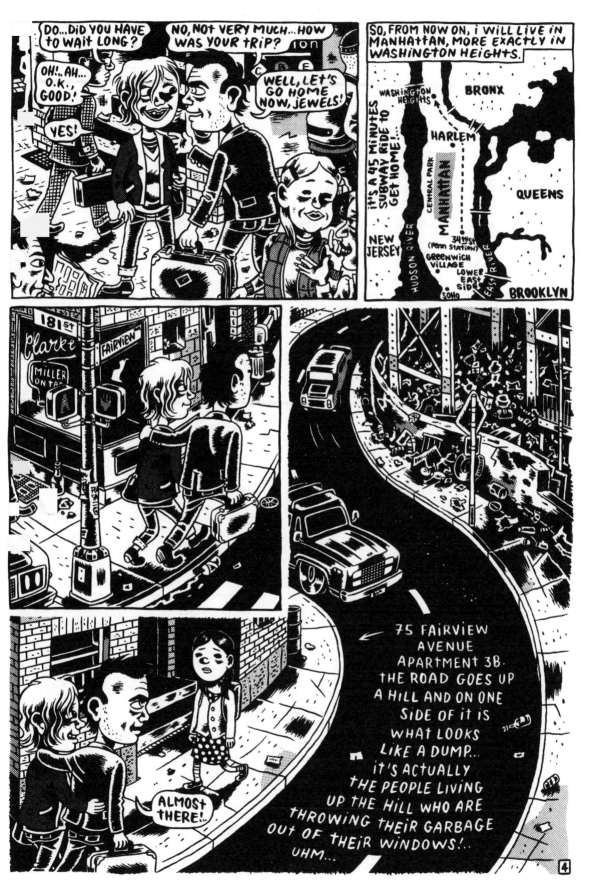

JULIE DOUCET *excerpt from My New York Diary*

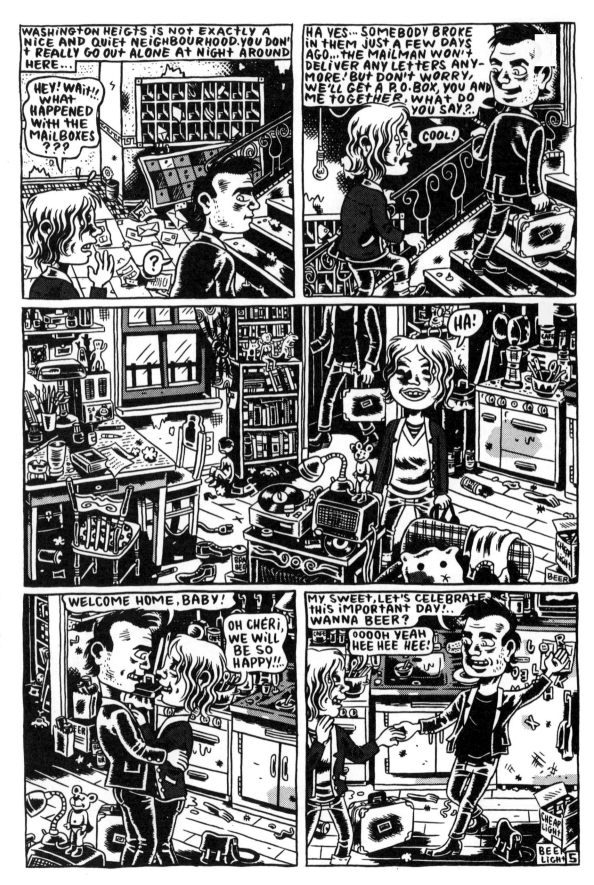

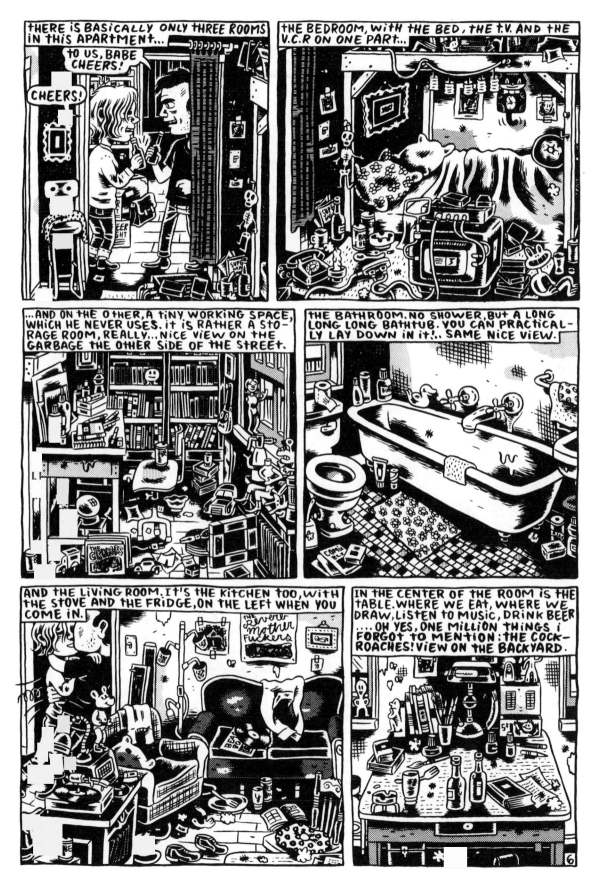

THERE IS BASICALLY ONLY THREE ROOMS IN THIS APARTMENT...

TO US, BABE CHEERS!

CHEERS!

THE BEDROOM, WITH THE BED, THE T.V. AND THE V.C.R ON ONE PART...

...AND ON THE OTHER, A TINY WORKING SPACE, WHICH HE NEVER USES. IT IS RATHER A STORAGE ROOM, REALLY... NICE VIEW ON THE GARBAGE THE OTHER SIDE OF THE STREET.

THE BATHROOM. NO SHOWER, BUT A LONG LONG LONG BATHTUB. YOU CAN PRACTICALLY LAY DOWN IN IT!.. SAME NICE VIEW.

AND THE LIVING ROOM. IT'S THE KITCHEN TOO, WITH THE STOVE AND THE FRIDGE, ON THE LEFT WHEN YOU COME IN.

IN THE CENTER OF THE ROOM IS THE TABLE. WHERE WE EAT, WHERE WE DRAW, LISTEN TO MUSIC, DRINK BEEROH YES, ONE MILLION THINGS I FORGOT TO MENTION: THE COCKROACHES! VIEW ON THE BACKYARD.

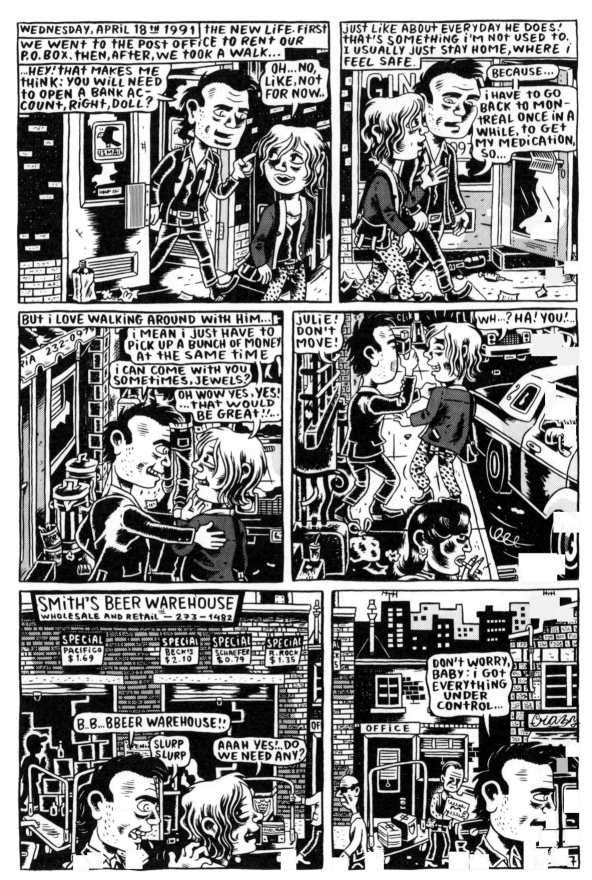

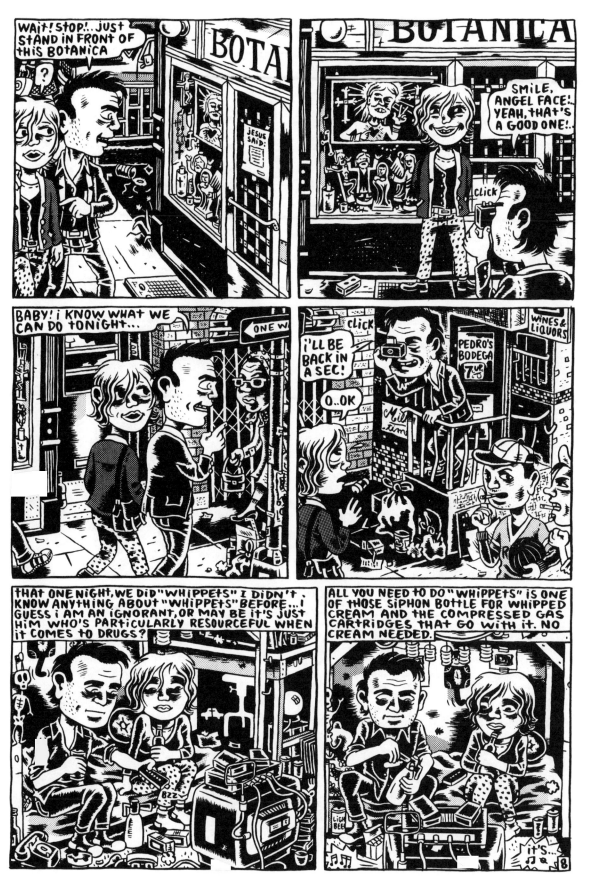

JULIE DOUCET *excerpt from My New York Diary*

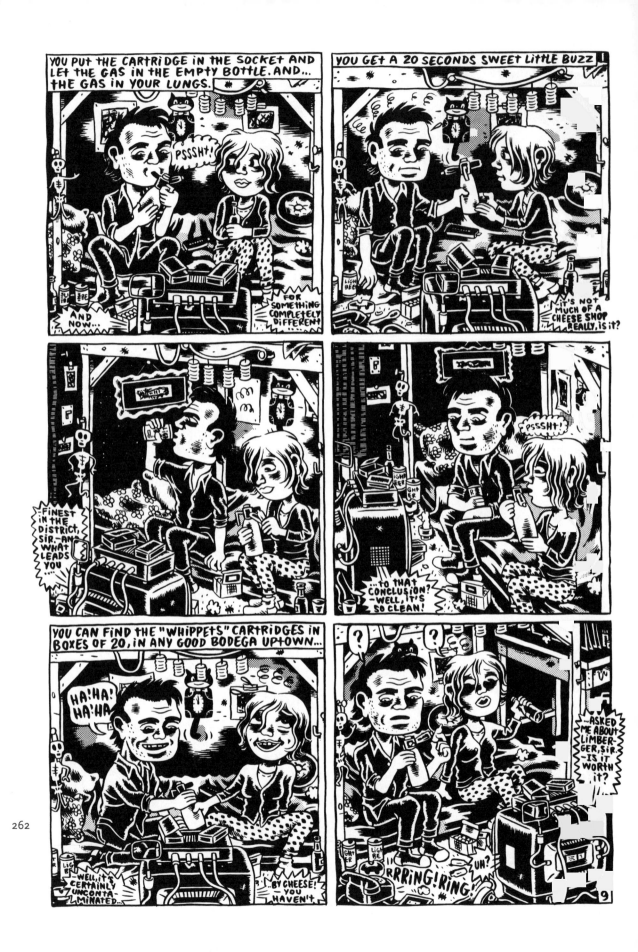

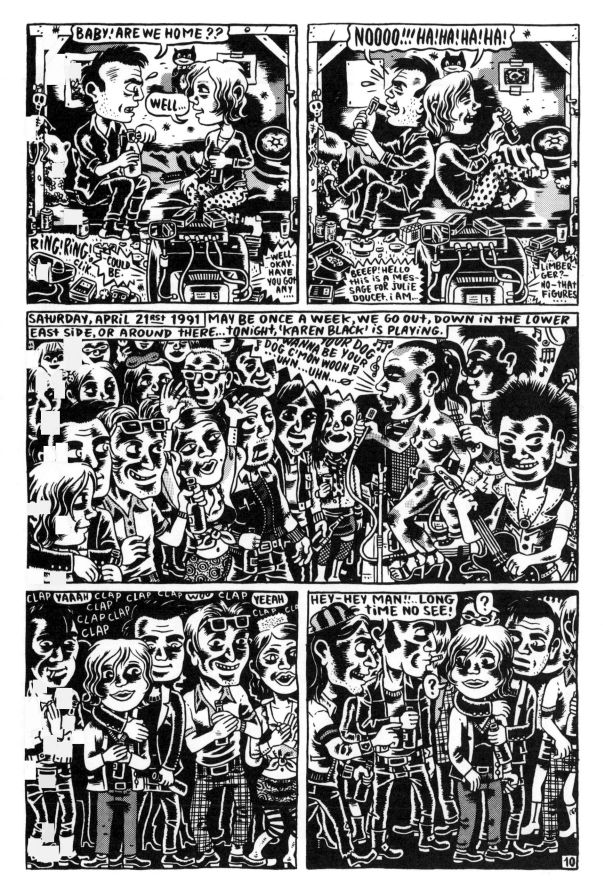

JEFFREY BROWN *excerpt from* Clumsy

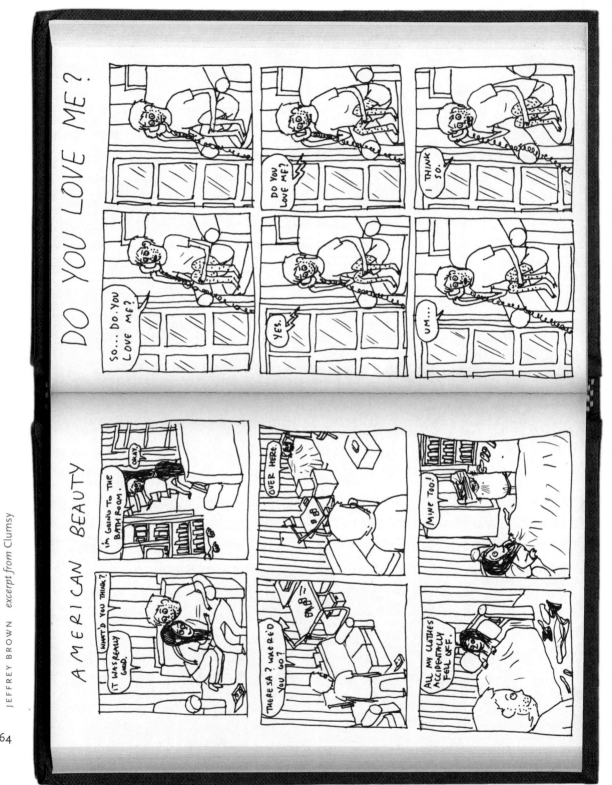

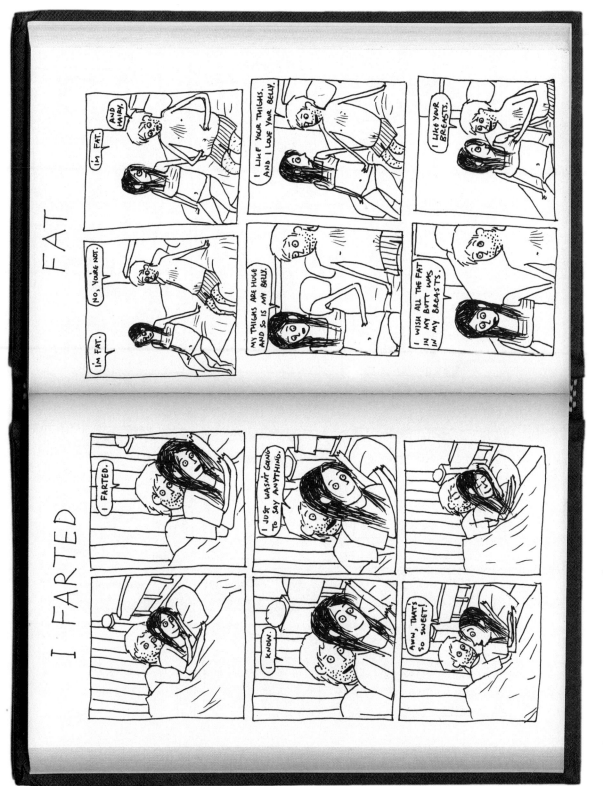

JEFFREY BROWN *excerpt from* Clumsy

JEFFREY BROWN *excerpt from* Clumsy

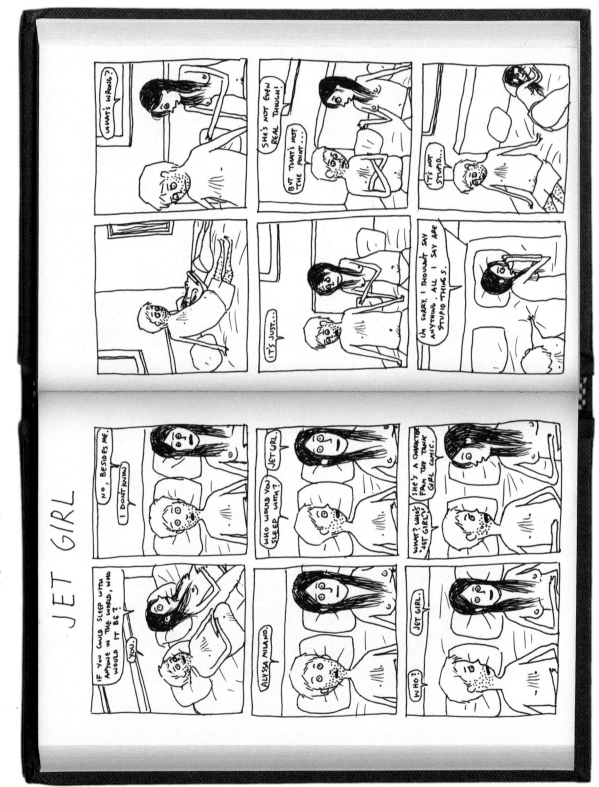

JET GIRL

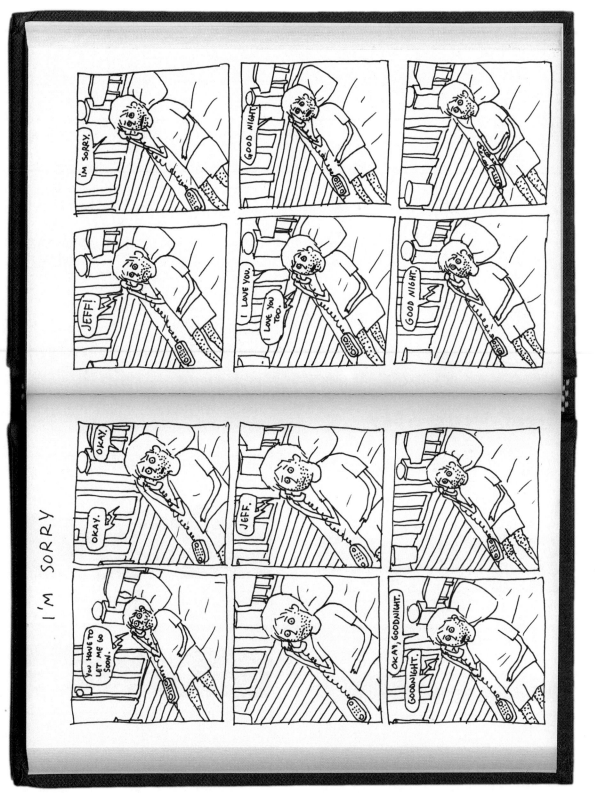

I'M SORRY

STUFF

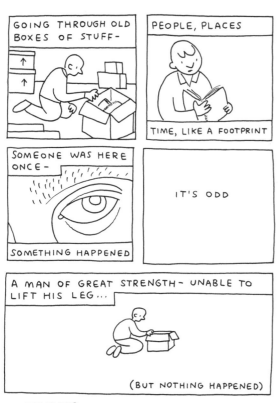

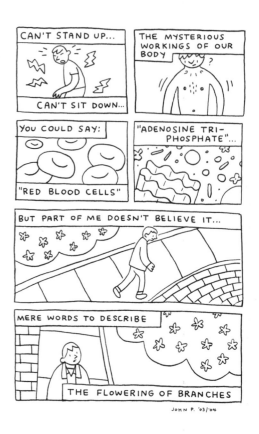

DEC. 24 2003
JAN. 21 2004

JOHN P. '03/'04

Great Western Sky

JOHN PORCELLINO *excerpts from King-Cat No. 63*

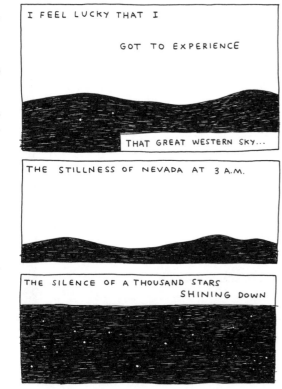

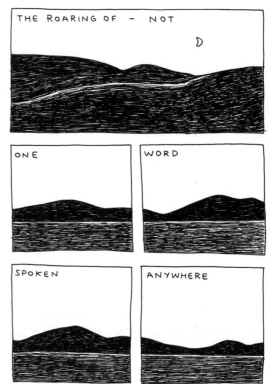

JULY 03 - FEB 04 J.P.

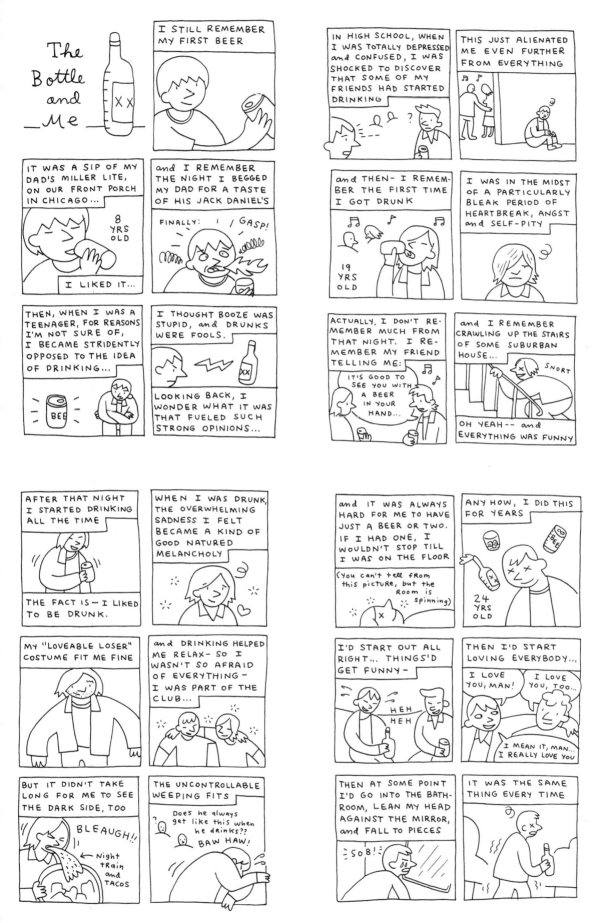

JOHN PORCELLINO *excerpts from King-Cat No. 63*

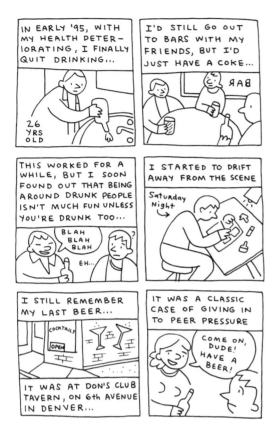

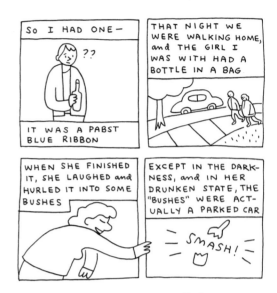

IT WAS AT THAT MOMENT I DECIDED NEVER TO DRINK AGAIN.

JOHN P. LOVE — WITH — FINISHED JULY 2004

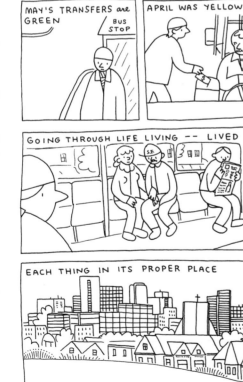

BARBERS I HAVE KNOWN

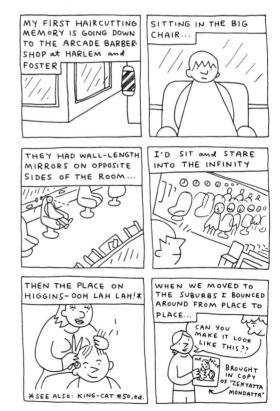

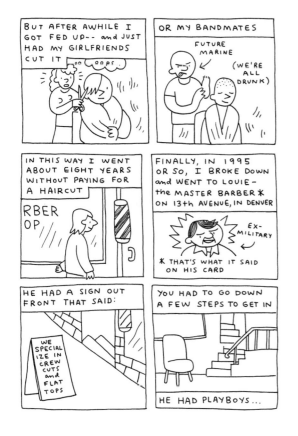

BUT AFTER AWHILE I GOT FED UP-- and JUST HAD MY GIRLFRIENDS CUT IT

OO OOPS

OR MY BANDMATES

FUTURE MARINE

(WE'RE ALL DRUNK)

IN THIS WAY I WENT ABOUT EIGHT YEARS WITHOUT PAYING FOR A HAIRCUT

RBER OP

FINALLY, IN 1995 OR SO, I BROKE DOWN and WENT TO LOUIE-the MASTER BARBER✱ ON 13th AVENUE, IN DENVER

EX-MILITARY

✱ THAT'S WHAT IT SAID ON HIS CARD

HE HAD A SIGN OUT FRONT THAT SAID:

WE SPECIAL IZE IN CREW CUTS and FLAT TOPS

YOU HAD TO GO DOWN A FEW STEPS TO GET IN

HE HAD PLAYBOYS...

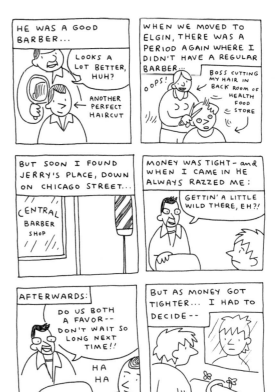

HE WAS A GOOD BARBER...

LOOKS A LOT BETTER, HUH?

ANOTHER PERFECT HAIRCUT

WHEN WE MOVED TO ELGIN, THERE WAS A PERIOD AGAIN WHERE I DIDN'T HAVE A REGULAR BARBER...

OOPS!

BOSS CUTTING MY HAIR IN BACK ROOM OF HEALTH FOOD STORE

BUT SOON I FOUND JERRY'S PLACE, DOWN ON CHICAGO STREET...

CENTRAL BARBER SHOP

MONEY WAS TIGHT- and WHEN I CAME IN HE ALWAYS RAZZED ME:

GETTIN' A LITTLE WILD THERE, EH?!

AFTERWARDS:

DO US BOTH A FAVOR-- DON'T WAIT SO LONG NEXT TIME!!

HA HA

BUT AS MONEY GOT TIGHTER... I HAD TO DECIDE--

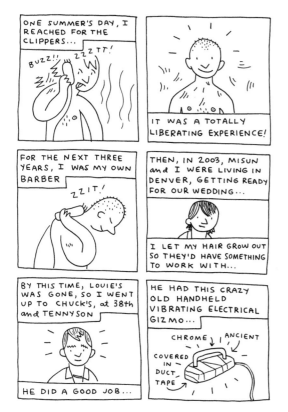

ONE SUMMER'S DAY, I REACHED FOR THE CLIPPERS...

BUZZ!! ZZTT!

IT WAS A TOTALLY LIBERATING EXPERIENCE!

FOR THE NEXT THREE YEARS, I WAS MY OWN BARBER

ZZIT!

THEN, IN 2003, MISUN and I WERE LIVING IN DENVER, GETTING READY FOR OUR WEDDING...

I LET MY HAIR GROW OUT SO THEY'D HAVE SOMETHING TO WORK WITH...

BY THIS TIME, LOUIE'S WAS GONE, SO I WENT UP TO CHUCK'S, at 38th and TENNYSON

HE DID A GOOD JOB...

HE HAD THIS CRAZY OLD HANDHELD VIBRATING ELECTRICAL GIZMO...

CHROME

ANCIENT

COVERED IN DUCT TAPE

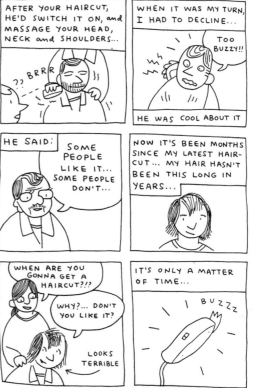

AFTER YOUR HAIRCUT, HE'D SWITCH IT ON, and MASSAGE YOUR HEAD, NECK and SHOULDERS...

BRRR

WHEN IT WAS MY TURN, I HAD TO DECLINE...

TOO BUZZY!!

HE WAS COOL ABOUT IT

HE SAID:

SOME PEOPLE LIKE IT... SOME PEOPLE DON'T...

NOW IT'S BEEN MONTHS SINCE MY LATEST HAIRCUT... MY HAIR HASN'T BEEN THIS LONG IN YEARS...

WHEN ARE YOU GONNA GET A HAIRCUT?!?

WHY?... DON'T YOU LIKE IT?

LOOKS TERRIBLE

IT'S ONLY A MATTER OF TIME...

BUZZZ

JOHN P. MAY 4th 2004

JOHN PORCELLINO excerpts from King-Cat No. 63

A PARAGRAPH BY SAUL BELLOW (1915–2005)

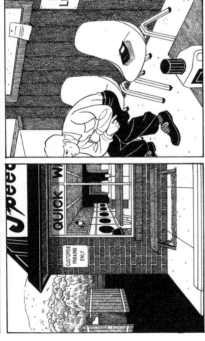

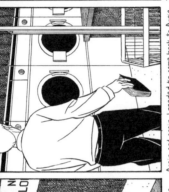

Ten years ago, I was a graduate student at Ohio University, studying English and teaching writing. One Sunday in October, I took a copy of Saul Bellow's *The Adventures of Augie March* to the laundromat. I read distractedly, mostly worrying about what to do with my writing class the next day.

Augie is an imposing book, easy to set aside, and I'd picked it up and put it down several times in the year since I moved from Westmont to Athens. But if a book has life, as Augie does, that book creates a need in the reader.

Again and again, I needed to come back to Augie, not so much for the fulsome plot as for the life in the prose. Often I'd skip back to passages I'd already read, and marvel anew at their color and rhythm. Invigorated by Bellow's writing, I seemed to notice more, think more numbly.

Then I'd put the book down, for one reason or another, and I'd be back in my everyday mind, suddenly less in love with thinking. But that is the core comedy of Bellow's fiction: having to think and live at the same time. To borrow the life of a book may also be to borrow a solitary release from living.

Again and again I came back to Augie, in Illinois and then in Ohio, over many months, even if it was just to revisit one particularly fine paragraph in which Augie sits on a bench by a courthouse, in the sun, and ponders the effect of fresh summer air on his being.

That paragraph, which is in no way essential to the plot but absolutely essential to the life of the book, always made me slightly dizzy, a little rapturous. The writing was like the very air Augie inhaled.

I first read that paragraph as I ate fish in Sarasota, where I bought the book. I read that paragraph aloud, mumbling it, in the Westmont Library. I thought about that paragraph later that October day in Athens, as I walked along the Hocking River.

I suddenly felt as if I'd been dropped there, in the Hocking Valley, in Ohio, on Earth, for no good reason. It was the feeling that comes between abandoning purpose and gathering commitments, in the pause after youth.

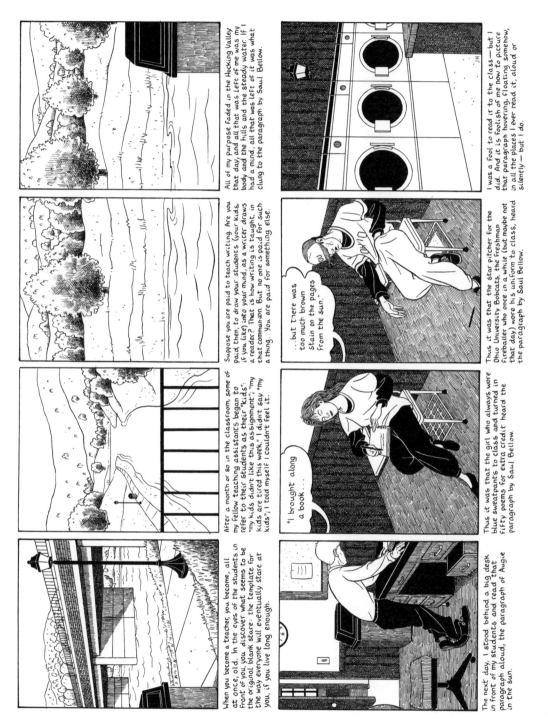

JOHN HANKIEWICZ A Paragraph by Saul Bellow (1915–2005)

JONATHAN BENNETT Torrential

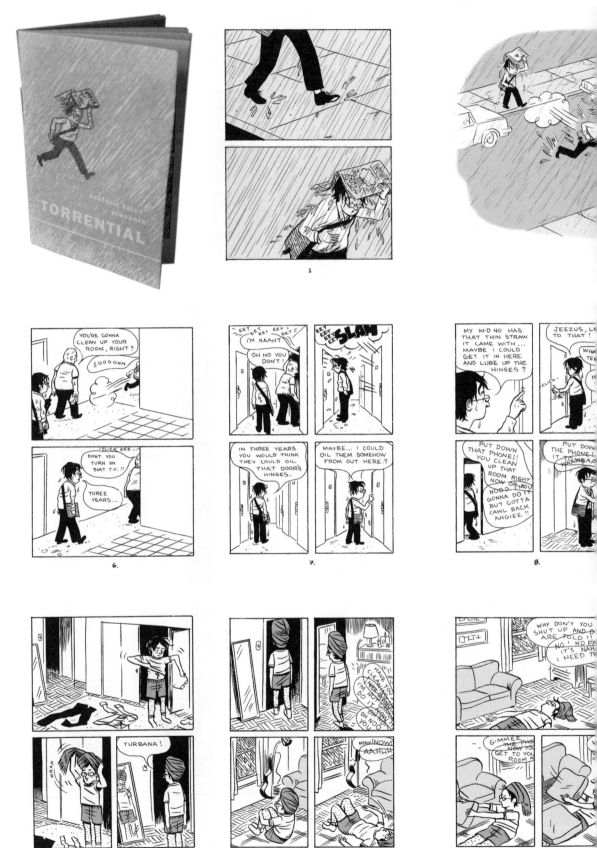

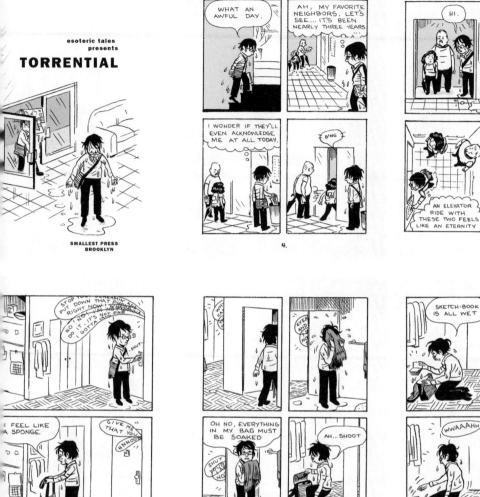

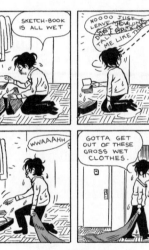

JONATHAN BENNETT Torrential

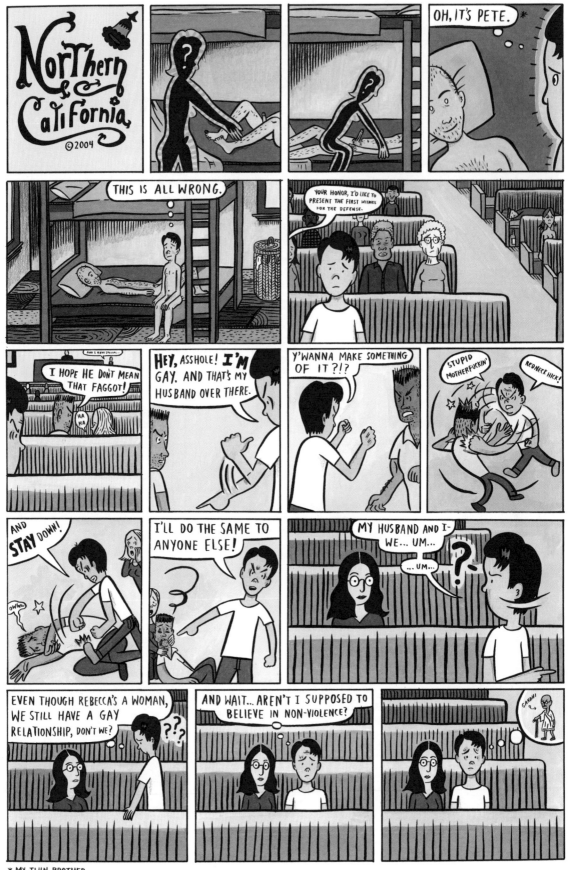

DAVID HEATLEY Northern California

* MY TWIN BROTHER

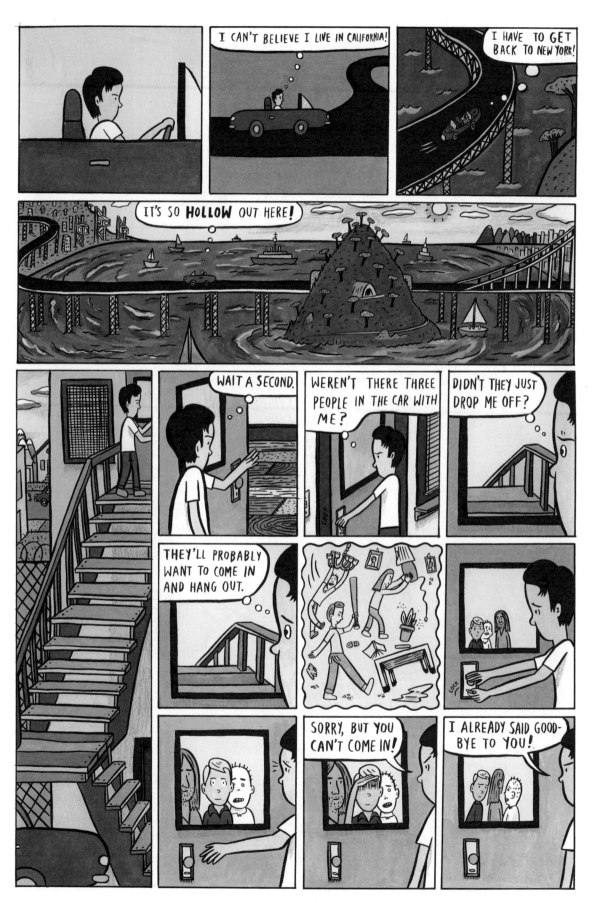

DAVID HEATLEY Northern California

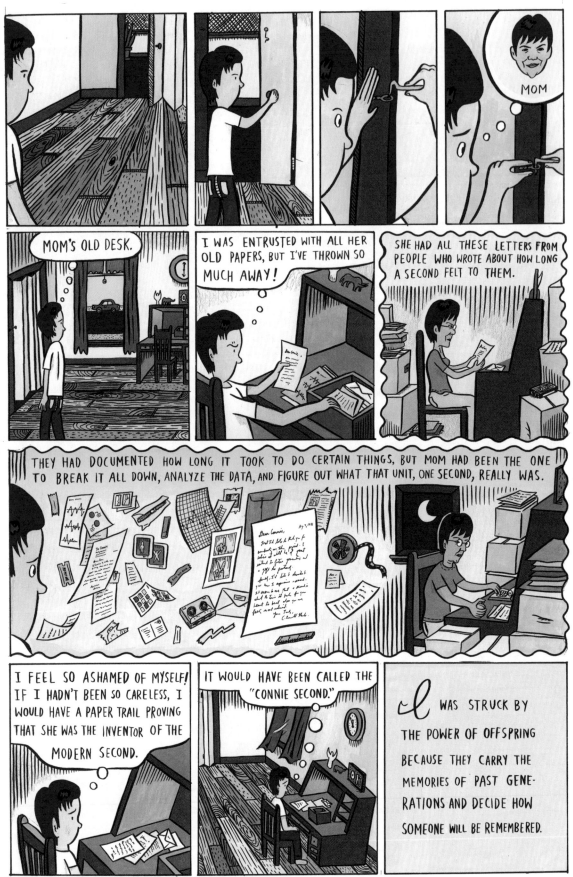

DREAMT DECEMBER 2002

CECIL AND JORDAN IN NEW YORK

By Gabrielle Bell March 2004

We arrived in Brooklyn on a snowy December night.

MAKE A RIGHT! I MEAN A LEFT! MAYBE WE SHOULD JUST STOP.

WE'RE NOT MOVING!

We stayed with our old high school friend Gladys, in her tiny, one-room studio. It was cluttered with furniture that all seemed to have been found on the street.

MY BOYFRIEND IS GOING TO BE STAYING HERE ON SATURDAY.

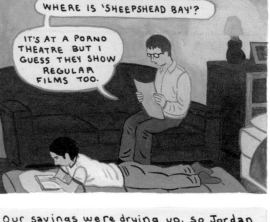

Jordan was able to get a couple of screenings for his film, but they didn't look promising.

WHERE IS 'SHEEPSHEAD BAY'?

IT'S AT A PORNO THEATRE BUT I GUESS THEY SHOW REGULAR FILMS TOO.

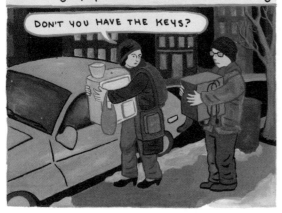

We've been at this for so long that all his shows mean to me anymore is that we'll be moving equipment at three in the morning.

DON'T YOU HAVE THE KEYS?

Our savings were drying up, so Jordan found seasonal work at a toy store, and I set about getting some temporary housing.

THERE'S A THOUSAND DOLLAR DEPOSIT, AND I TAKE OUT A HUNDRED FOR EACH THING YOU BREAK.

Until I could find an affordable place, I did my best to keep out of Gladys' way.

On the third day of the blizzard, the alternate side parking suspension was lifted, and all of the money we made on our tour went towards a parking ticket.

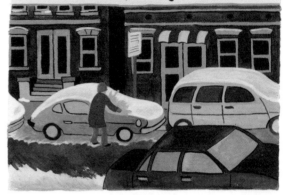

Jordan worked thirteen hour shifts every day, and was always in a bad mood.

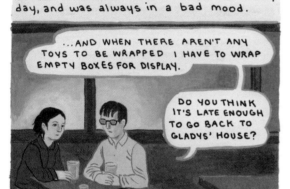

...AND WHEN THERE AREN'T ANY TOYS TO BE WRAPPED I HAVE TO WRAP EMPTY BOXES FOR DISPLAY.

DO YOU THINK IT'S LATE ENOUGH TO GO BACK TO GLADYS' HOUSE?

He did get us invited to some work parties.

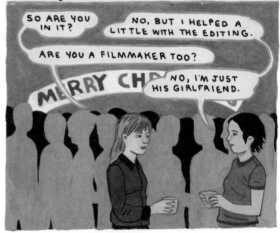

SO ARE YOU IN IT?

NO, BUT I HELPED A LITTLE WITH THE EDITING.

ARE YOU A FILMMAKER TOO?

NO, I'M JUST HIS GIRLFRIEND.

MERRY CHR

I didn't have proper footwear for the snow, so I bought some new boots, which gave me such bad blisters that it hurt to walk.

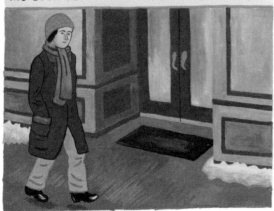

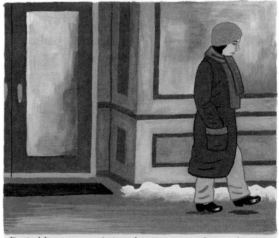

But it wasn't like I had anywhere to go.

And that is why I transformed myself into a chair.

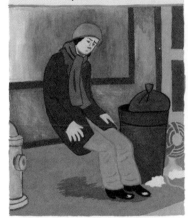

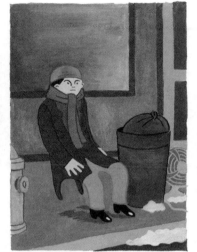

I stood on the sidewalk and waited.

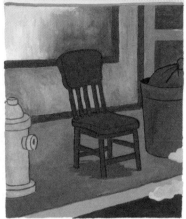

Soon a man came and took me home.

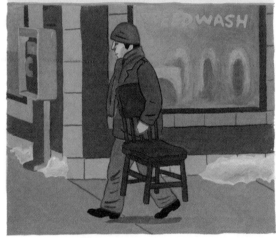

He showed me off to his friends.

IT'S A BIT RICKETY, BUT IT'S A GOOD CHAIR.

GOOD SCORE!

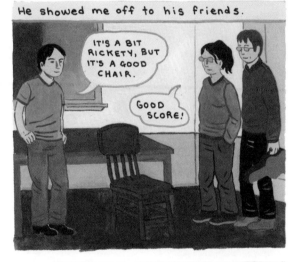

When he was away, I'd turn myself back into a girl, and lounge around his house.

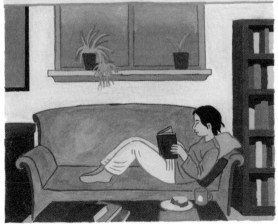

When he came home I became a chair again.

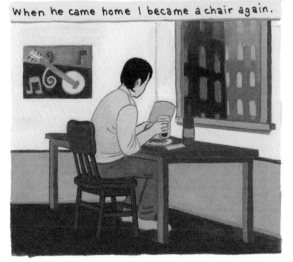

I wondered how Jordan was doing.

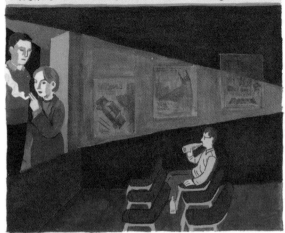

I wondered how the car was.

I decided I wouldn't be missed much.

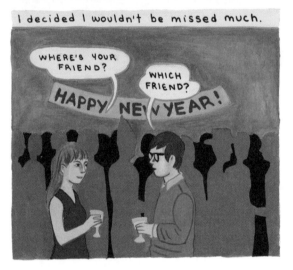

But the days slip by so pleasantly that such thoughts don't linger long in my mind.

Sometimes, there are close calls.

But then, I've never felt so useful.

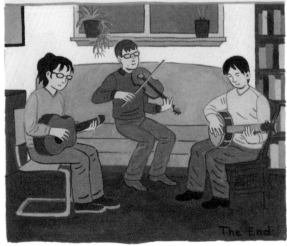

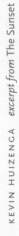

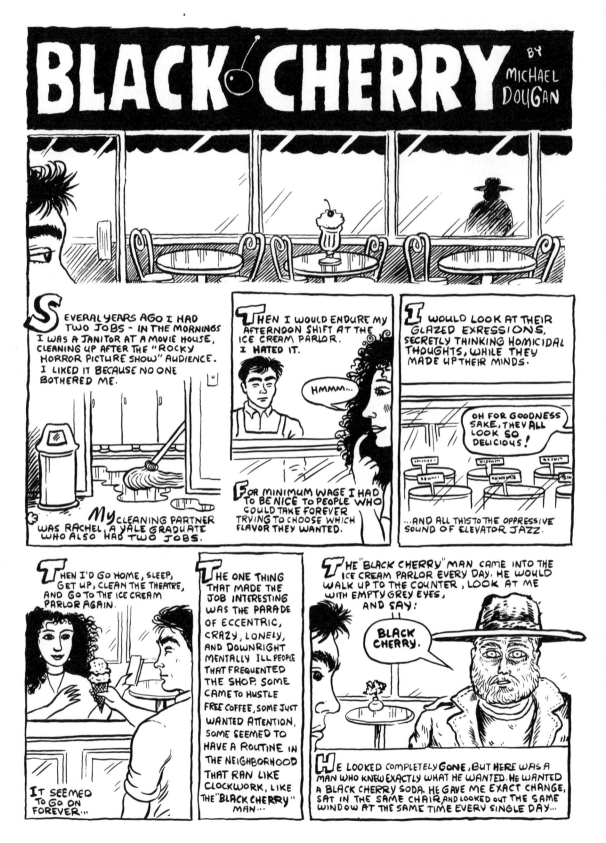

BLACK CHERRY

BY MICHAEL DOUGAN

SEVERAL YEARS AGO I HAD TWO JOBS — IN THE MORNINGS I WAS A JANITOR AT A MOVIE HOUSE, CLEANING UP AFTER THE "ROCKY HORROR PICTURE SHOW" AUDIENCE. I LIKED IT BECAUSE NO ONE BOTHERED ME.

My CLEANING PARTNER WAS RACHEL, A YALE GRADUATE WHO ALSO HAD TWO JOBS.

THEN I WOULD ENDURE MY AFTERNOON SHIFT AT THE ICE CREAM PARLOR. I HATED IT.

HMMM...

FOR MINIMUM WAGE I HAD TO BE NICE TO PEOPLE WHO COULD TAKE FOREVER TRYING TO CHOOSE WHICH FLAVOR THEY WANTED.

I WOULD LOOK AT THEIR GLAZED EXPRESSIONS, SECRETLY THINKING HOMICIDAL THOUGHTS, WHILE THEY MADE UP THEIR MINDS.

OH FOR GOODNESS SAKE, THEY ALL LOOK SO DELICIOUS!

...AND ALL THIS TO THE OPPRESSIVE SOUND OF ELEVATOR JAZZ.

THEN I'D GO HOME, SLEEP, GET UP, CLEAN THE THEATRE, AND GO TO THE ICE CREAM PARLOR AGAIN.

IT SEEMED TO GO ON FOREVER...

THE ONE THING THAT MADE THE JOB INTERESTING WAS THE PARADE OF ECCENTRIC, CRAZY, LONELY, AND DOWNRIGHT MENTALLY ILL PEOPLE THAT FREQUENTED THE SHOP. SOME CAME TO HUSTLE FREE COFFEE, SOME JUST WANTED ATTENTION, SOME SEEMED TO HAVE A ROUTINE IN THE NEIGHBORHOOD THAT RAN LIKE CLOCKWORK, LIKE THE "BLACK CHERRY" MAN...

THE "BLACK CHERRY" MAN CAME INTO THE ICE CREAM PARLOR EVERY DAY. HE WOULD WALK UP TO THE COUNTER, LOOK AT ME WITH EMPTY GREY EYES, AND SAY:

BLACK CHERRY.

HE LOOKED COMPLETELY **GONE**, BUT HERE WAS A MAN WHO KNEW EXACTLY WHAT HE WANTED. HE WANTED A BLACK CHERRY SODA. HE GAVE ME EXACT CHANGE, SAT IN THE SAME CHAIR, AND LOOKED OUT THE SAME WINDOW AT THE SAME TIME EVERY SINGLE DAY...

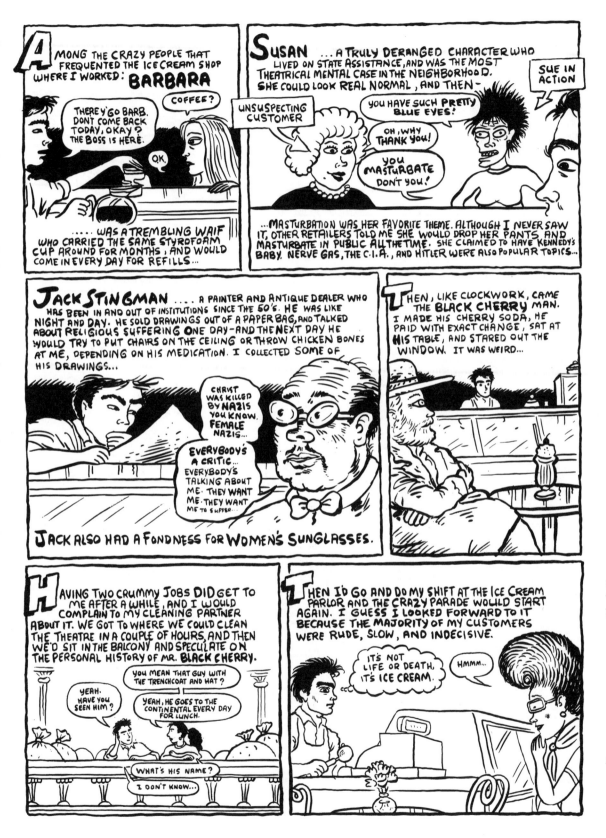

AMONG THE CRAZY PEOPLE THAT FREQUENTED THE ICE CREAM SHOP WHERE I WORKED: **BARBARA**

THERE Y'GO BARB. DON'T COME BACK TODAY, OKAY? THE BOSS IS HERE.

COFFEE?

OK.

..... WAS A TREMBLING WAIF WHO CARRIED THE SAME STYROFOAM CUP AROUND FOR MONTHS, AND WOULD COME IN EVERY DAY FOR REFILLS...

SUSAN ... A TRULY DERANGED CHARACTER WHO LIVED ON STATE ASSISTANCE, AND WAS THE MOST THEATRICAL MENTAL CASE IN THE NEIGHBORHOOD. SHE COULD LOOK REAL NORMAL, AND THEN—

UNSUSPECTING CUSTOMER

SUE IN ACTION

YOU HAVE SUCH PRETTY BLUE EYES!

OH, WHY THANK YOU!

YOU MASTURBATE DON'T YOU!

...MASTURBATION WAS HER FAVORITE THEME. ALTHOUGH I NEVER SAW IT, OTHER RETAILERS TOLD ME SHE WOULD DROP HER PANTS AND MASTURBATE IN PUBLIC ALL THE TIME. SHE CLAIMED TO HAVE KENNEDY'S BABY. NERVE GAS, THE C.I.A., AND HITLER WERE ALSO POPULAR TOPICS...

JACK STINGMAN A PAINTER AND ANTIQUE DEALER WHO HAS BEEN IN AND OUT OF INSTITUTIONS SINCE THE 50'S. HE WAS LIKE NIGHT AND DAY. HE SOLD DRAWINGS OUT OF A PAPER BAG, AND TALKED ABOUT RELIGIOUS SUFFERING ONE DAY—AND THE NEXT DAY HE WOULD TRY TO PUT CHAIRS ON THE CEILING OR THROW CHICKEN BONES AT ME, DEPENDING ON HIS MEDICATION. I COLLECTED SOME OF HIS DRAWINGS...

CHRIST WAS KILLED BY NAZIS YOU KNOW. FEMALE NAZIS...

EVERYBODY'S A CRITIC... EVERYBODY'S TALKING ABOUT ME. THEY WANT ME. THEY WANT ME TO SUFFER...

JACK ALSO HAD A FONDNESS FOR WOMEN'S SUNGLASSES.

THEN, LIKE CLOCKWORK, CAME THE **BLACK CHERRY** MAN. I MADE HIS CHERRY SODA, HE PAID WITH EXACT CHANGE, SAT AT HIS TABLE, AND STARED OUT THE WINDOW. IT WAS WEIRD...

HAVING TWO CRUMMY JOBS DID GET TO ME AFTER A WHILE, AND I WOULD COMPLAIN TO MY CLEANING PARTNER ABOUT IT. WE GOT TO WHERE WE COULD CLEAN THE THEATRE IN A COUPLE OF HOURS, AND THEN WE'D SIT IN THE BALCONY AND SPECULATE ON THE PERSONAL HISTORY OF MR. **BLACK CHERRY.**

YOU MEAN THAT GUY WITH THE TRENCHCOAT AND HAT?

YEAH. HAVE YOU SEEN HIM?

YEAH, HE GOES TO THE CONTINENTAL EVERY DAY FOR LUNCH.

WHAT'S HIS NAME?

I DON'T KNOW...

THEN I'D GO AND DO MY SHIFT AT THE ICE CREAM PARLOR AND THE CRAZY PARADE WOULD START AGAIN. I GUESS I LOOKED FORWARD TO IT BECAUSE THE MAJORITY OF MY CUSTOMERS WERE RUDE, SLOW, AND INDECISIVE.

IT'S NOT LIFE OR DEATH, IT'S ICE CREAM.

HMMM...

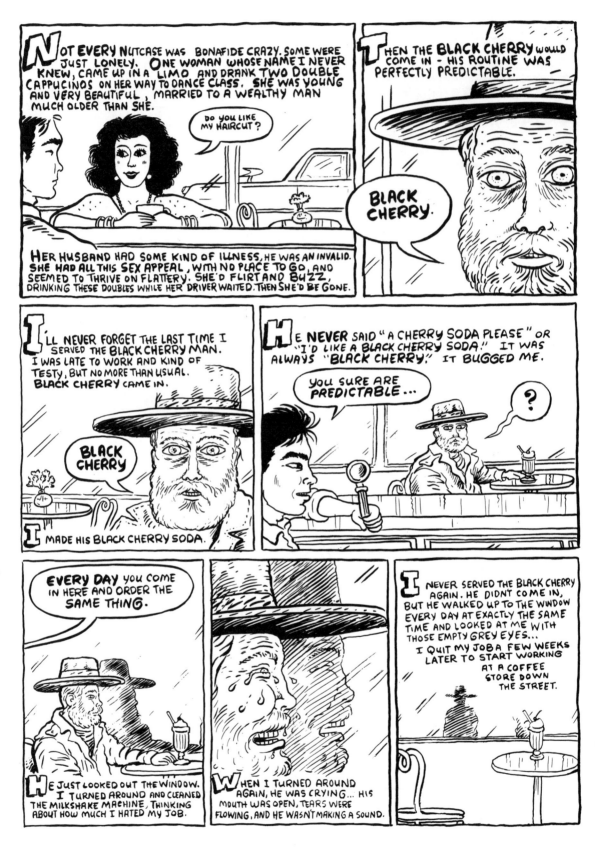

MICHAEL DOUGAN Black Cherry

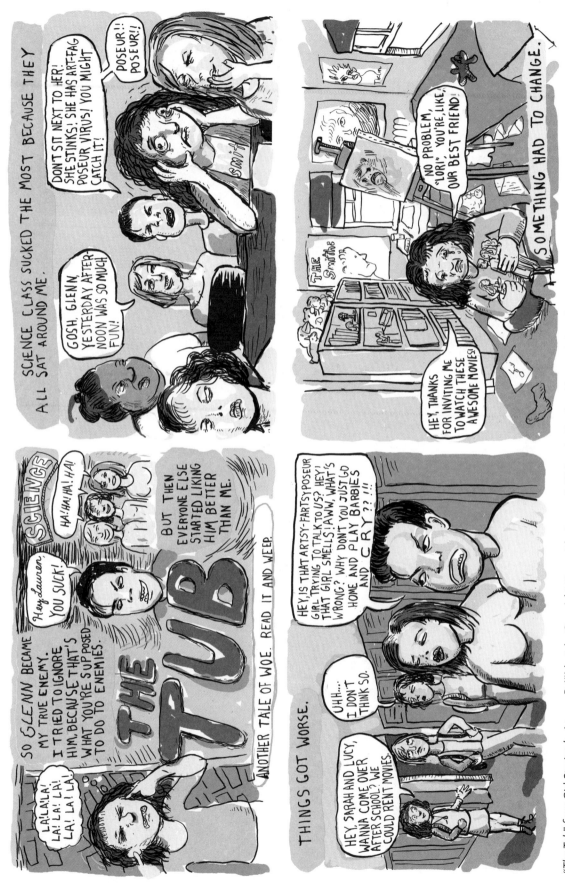

LAUREN R. WEINSTEIN The Tub

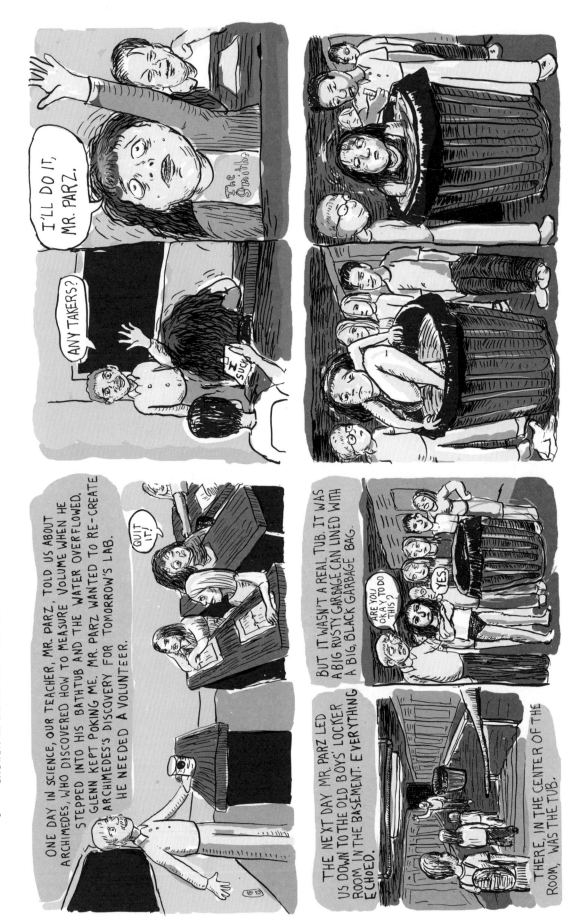

LAUREN R. WEINSTEIN The Tub

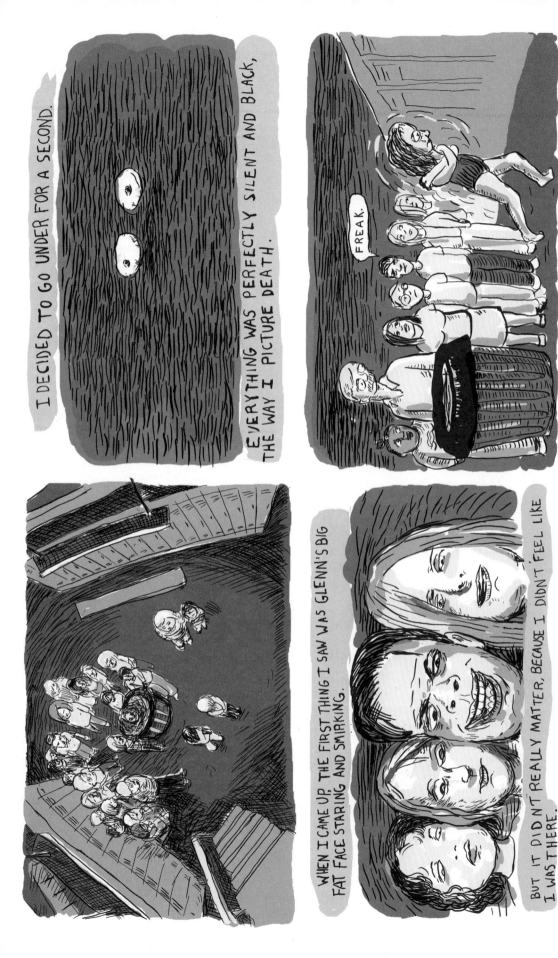

I DECIDED TO GO UNDER FOR A SECOND.

EVERYTHING WAS PERFECTLY SILENT AND BLACK, THE WAY I PICTURE DEATH.

FREAK.

WHEN I CAME UP, THE FIRST THING I SAW WAS GLENN'S BIG FAT FACE STARING AND SMIRKING.

BUT IT DIDN'T REALLY MATTER, BECAUSE I DIDN'T FEEL LIKE I WAS THERE.

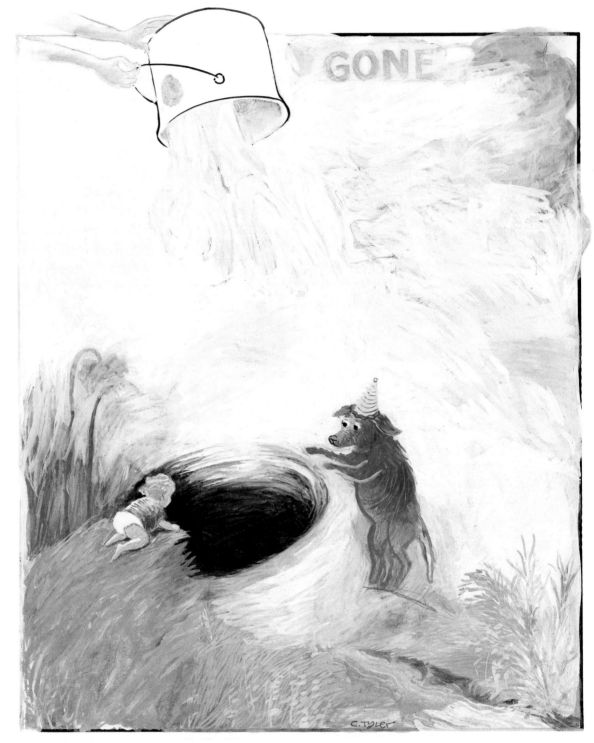

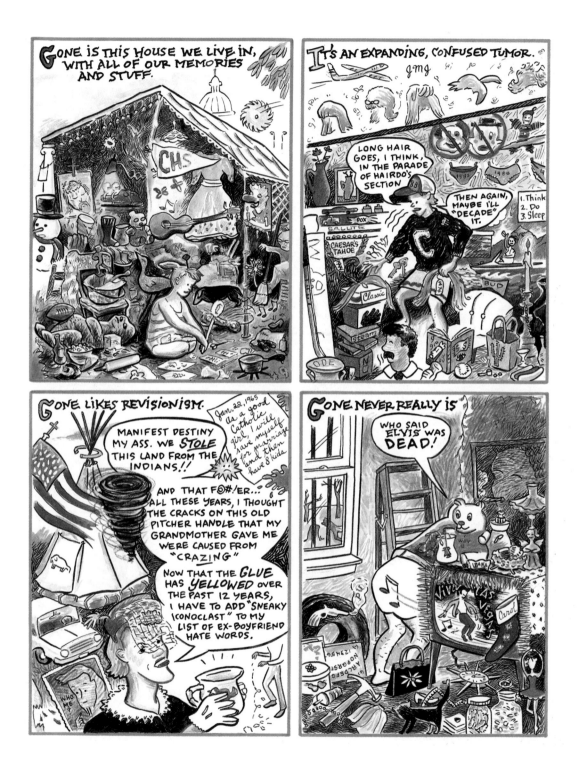

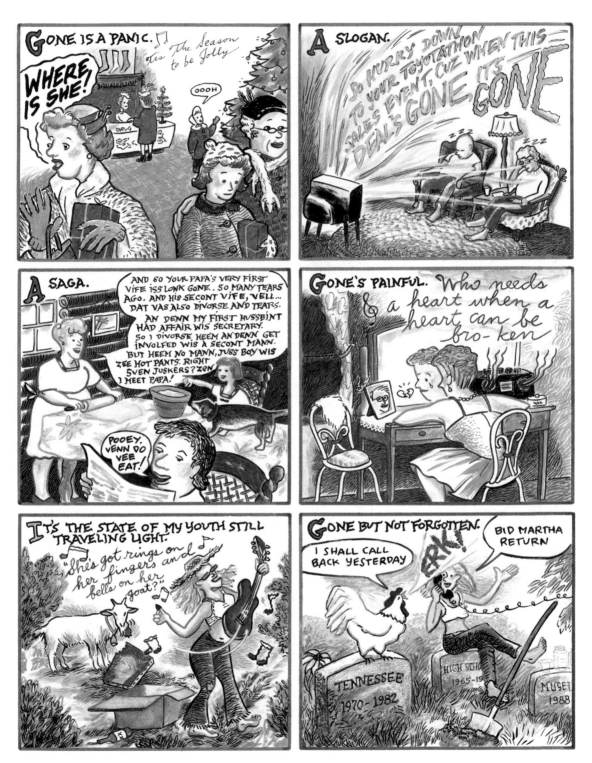

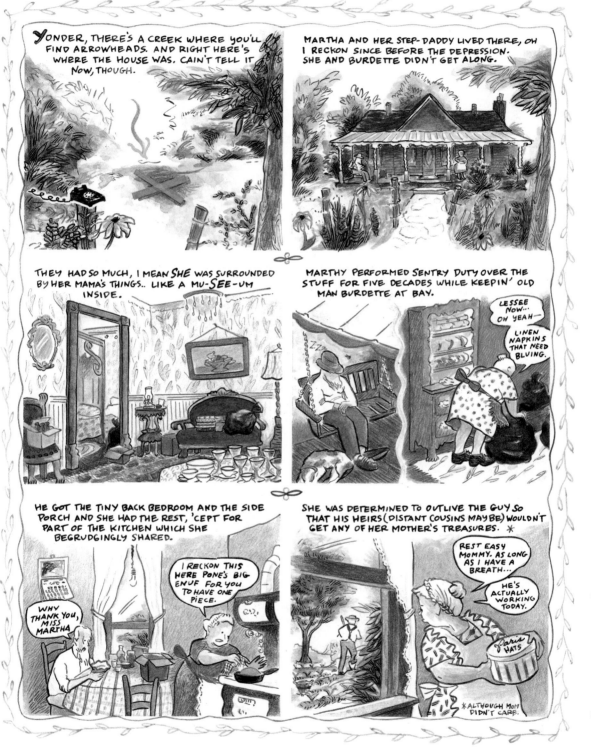

YONDER, THERE'S A CREEK WHERE YOU'LL FIND ARROWHEADS. AND RIGHT HERE'S WHERE THE HOUSE WAS. CAIN'T TELL IT NOW, THOUGH.

MARTHA AND HER STEP-DADDY LIVED THERE, OH I RECKON SINCE BEFORE THE DEPRESSION. SHE AND BURDETTE DIDN'T GET ALONG.

THEY HAD SO MUCH, I MEAN *SHE* WAS SURROUNDED BY HER MAMA'S THINGS.. LIKE A MU-*SEE*-UM INSIDE.

MARTHY PERFORMED SENTRY DUTY OVER THE STUFF FOR FIVE DECADES WHILE KEEPIN' OLD MAN BURDETTE AT BAY.

LESSEE NOW... OH YEAH—

LINEN NAPKINS THAT NEED BLUING.

HE GOT THE TINY BACK BEDROOM AND THE SIDE PORCH AND SHE HAD THE REST, 'CEPT FOR PART OF THE KITCHEN WHICH SHE BEGRUDGINGLY SHARED.

WHY THANK YOU, MISS MARTHA

I RECKON THIS HERE PONE'S BIG ENUF FOR YOU TO HAVE ONE PIECE.

SHE WAS DETERMINED TO OUTLIVE THE GUY SO THAT HIS HEIRS (DISTANT COUSINS MAYBE) WOULDN'T GET ANY OF HER MOTHER'S TREASURES. *

REST EASY MOMMY. AS LONG AS I HAVE A BREATH...

HE'S ACTUALLY WORKING TODAY.

Paris HATS

*ALTHOUGH MOM DIDN'T CARE.

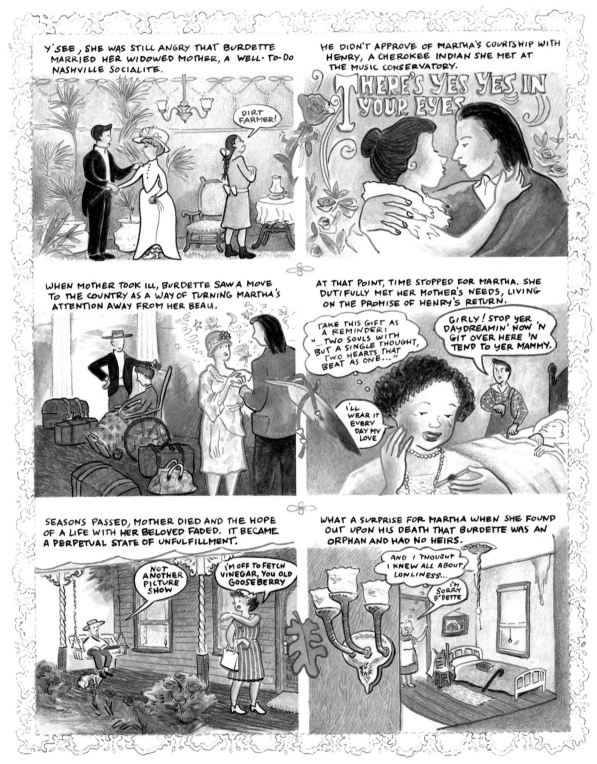

HER DEPRESSION LIFTED WHEN RICHARD MADE HIS DEBUT, SIX WEEKS AFTER THE FUNERAL... CLAIMIN' TO BE A COUSIN. SORT OF —

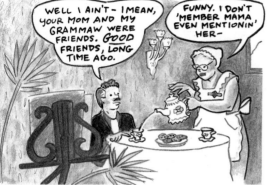

HE USED "CHIN MUSIC" TO EARN HER TRUST, TO GET WHAT HE WANTED MOST: HER FABULOUS TREASURE TROVE OF FURNISHINGS.

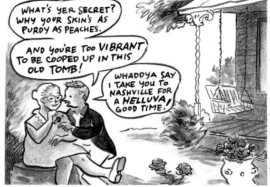

ITS A SADLY FAMILIAR STORY. SOMEHOW HE GETS POWER OF ATTORNEY, SOON HAS HER DECLARED INCOMPETENT AND SHE'S OFF TO A NURSING HOME.

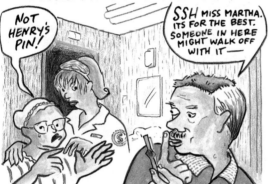

THE FEROCIOUS PLUNDER LEFT NOT EVEN A PANTRY PRODUCT UNTOUCHED. WINDOWS, DOORS, MOULDING, FIXTURES, EVEN FLOOR BOARDS WERE TAKEN OUT.

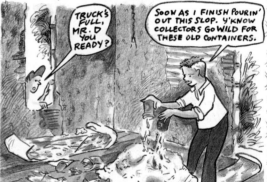

MARTHA SUCCUMBED TO A BAD FLU. MEANWHILE, HER PLACE WAS TORCHED — FOLKS SAY IT WAS QUITE A PROFESSIONAL JOB, SUCH AN EVEN BURN.

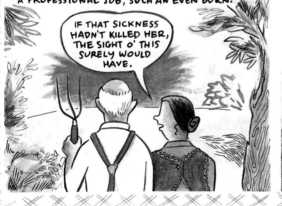

YESSIREE, *GONE* CAN BE SO COMPLETE!

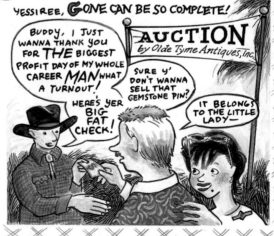

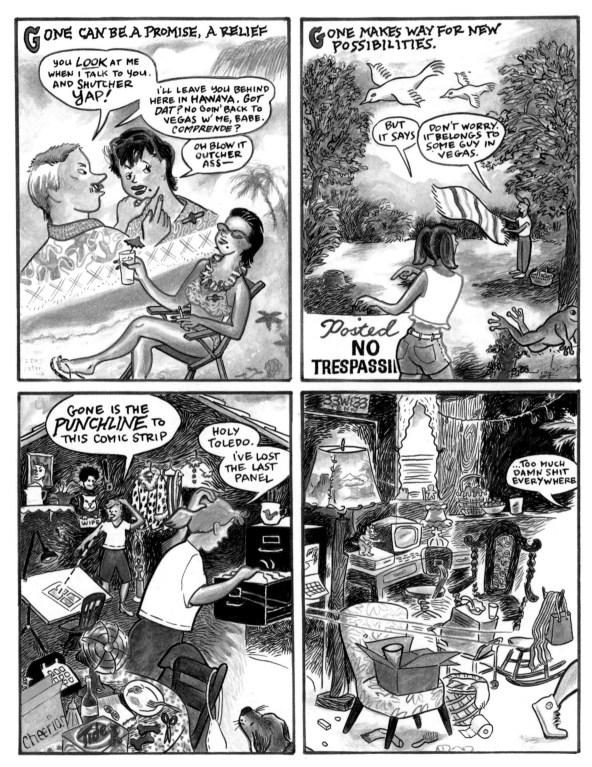

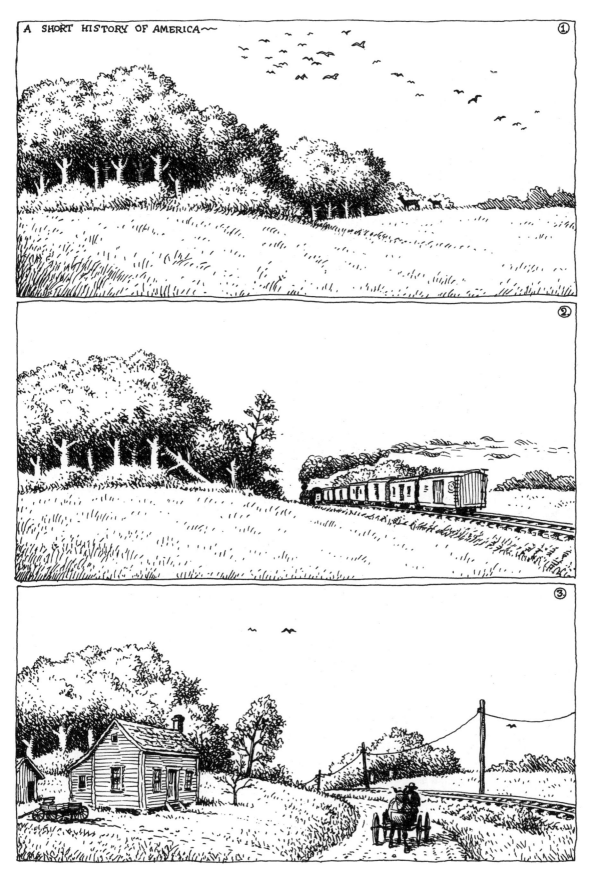

ROBERT CRUMB A Short History of America

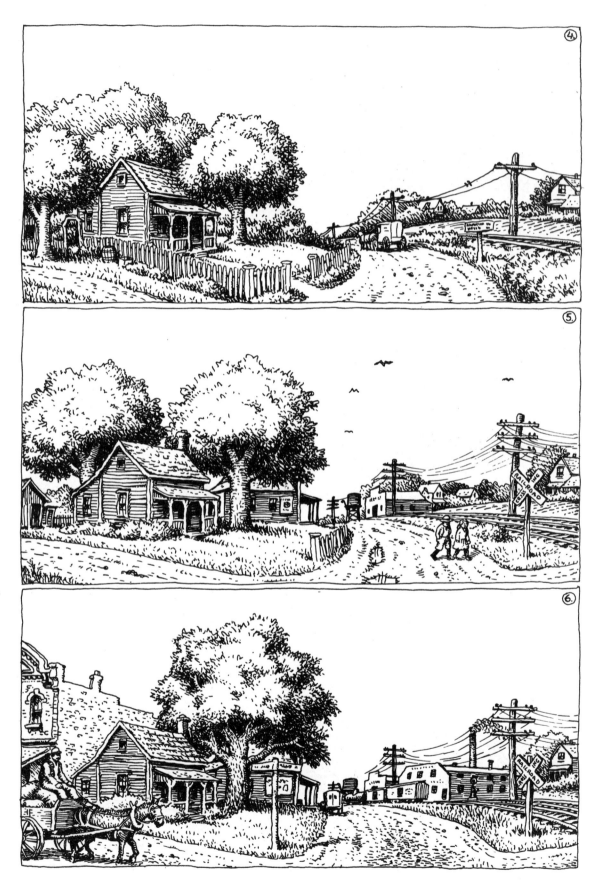

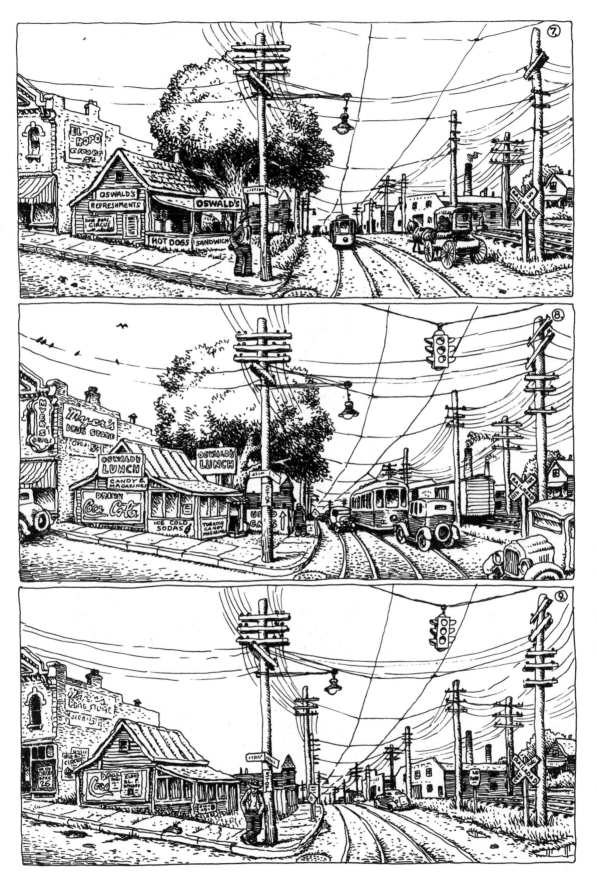

ROBERT CRUMB A Short History of America

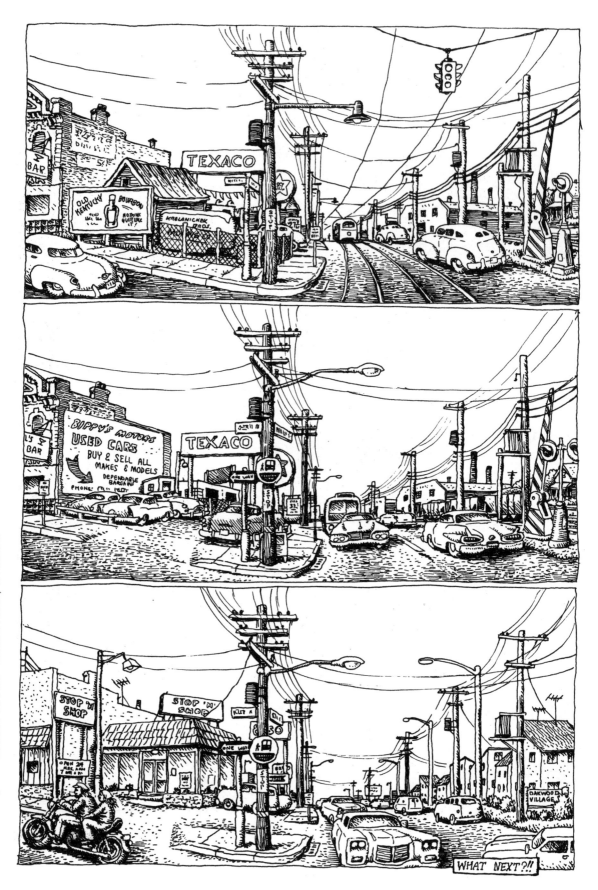

ROBERT CRUMB A Short History of America

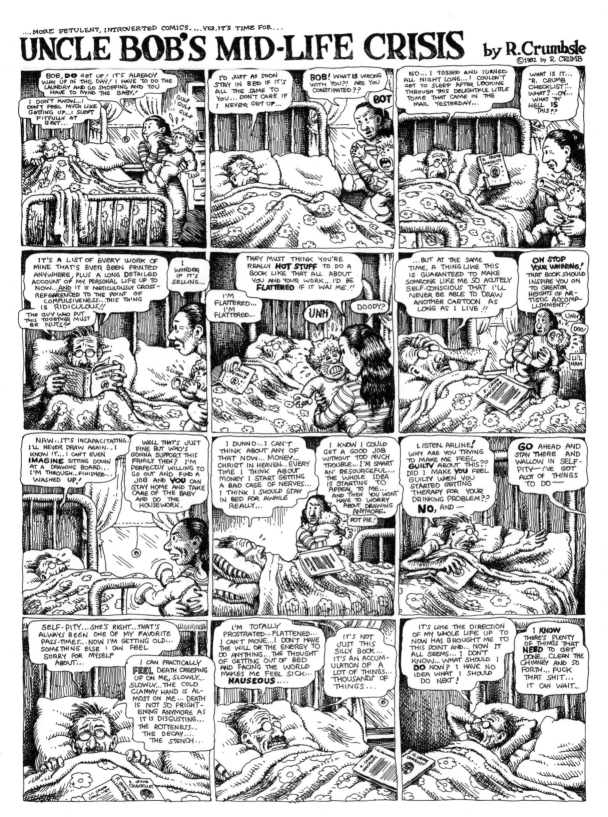

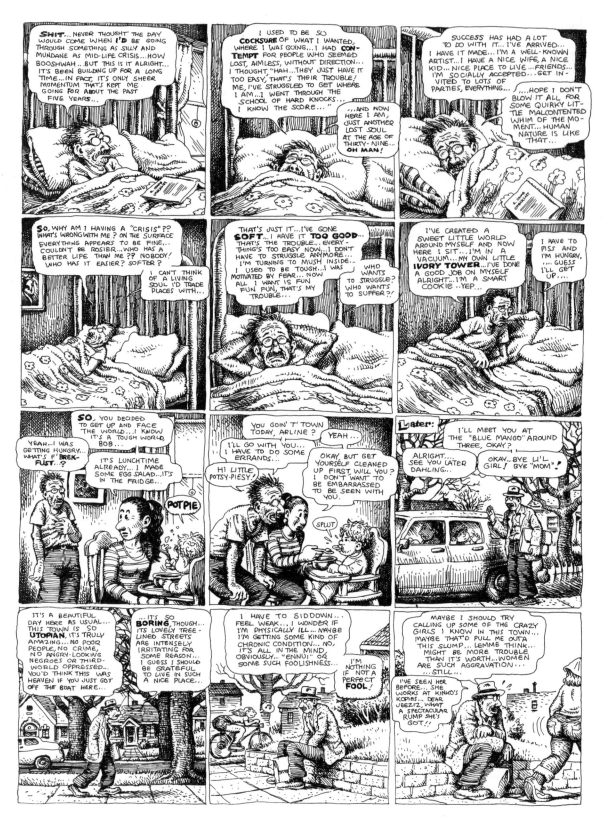

ROBERT CRUMB Uncle Bob's Mid-Life Crisis

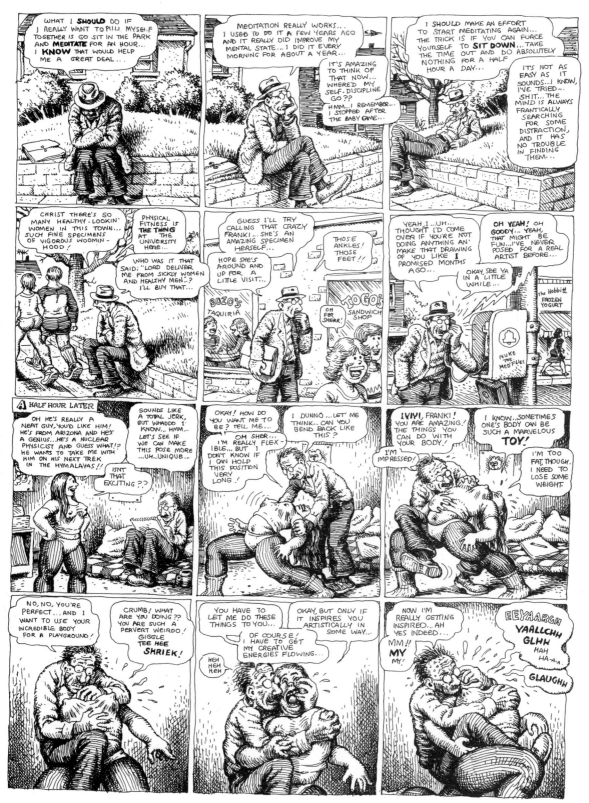

ROBERT CRUMB Uncle Bob's Mid-Life Crisis

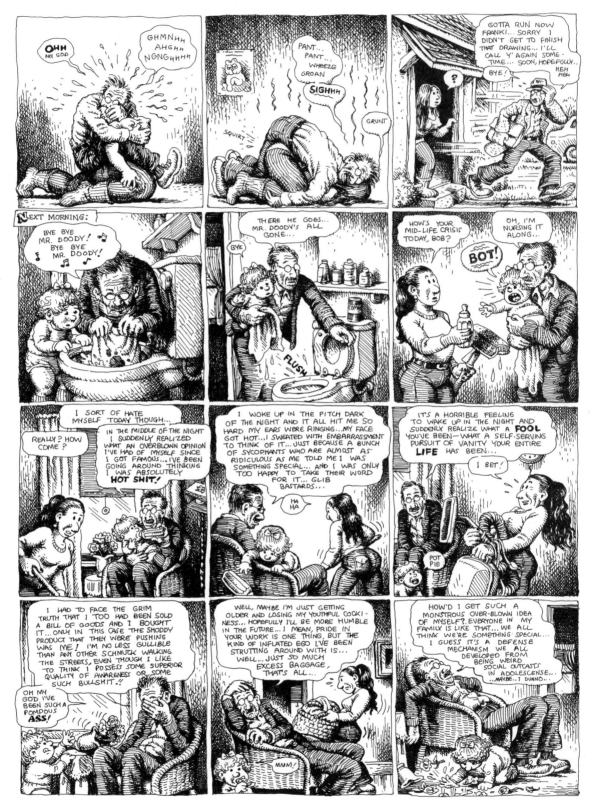

ROBERT CRUMB Uncle Bob's Mid-Life Crisis

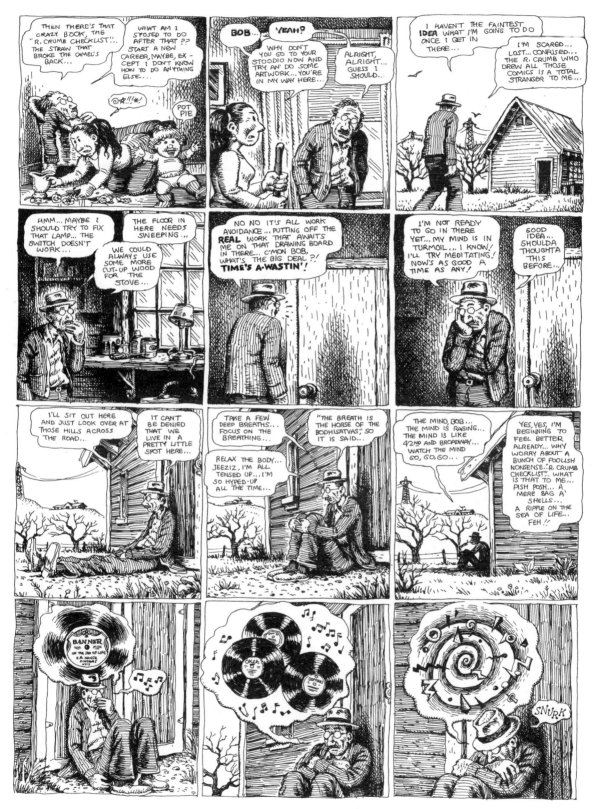

ROBERT CRUMB Uncle Bob's Mid-Life Crisis

307

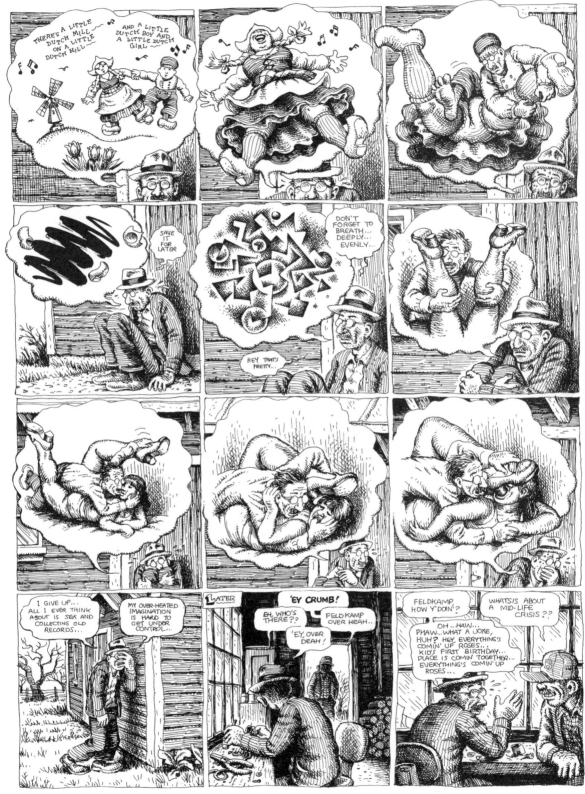

ROBERT CRUMB Uncle Bob's Mid-Life Crisis

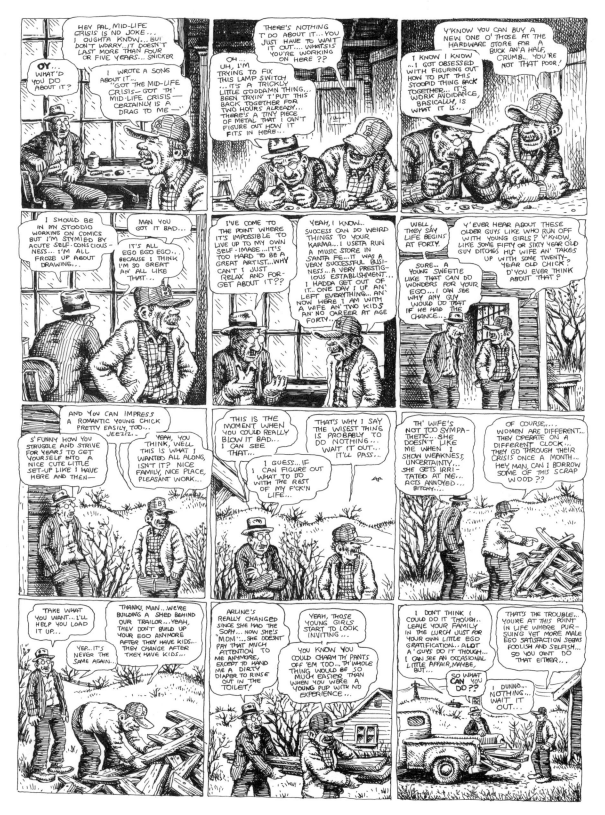

ROBERT CRUMB Uncle Bob's Mid-Life Crisis

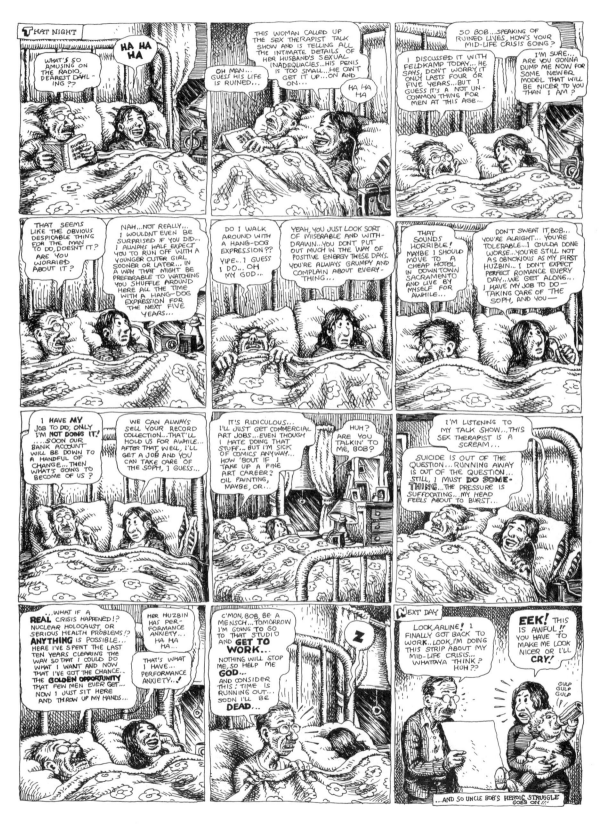

ROBERT CRUMB Uncle Bob's Mid-Life Crisis

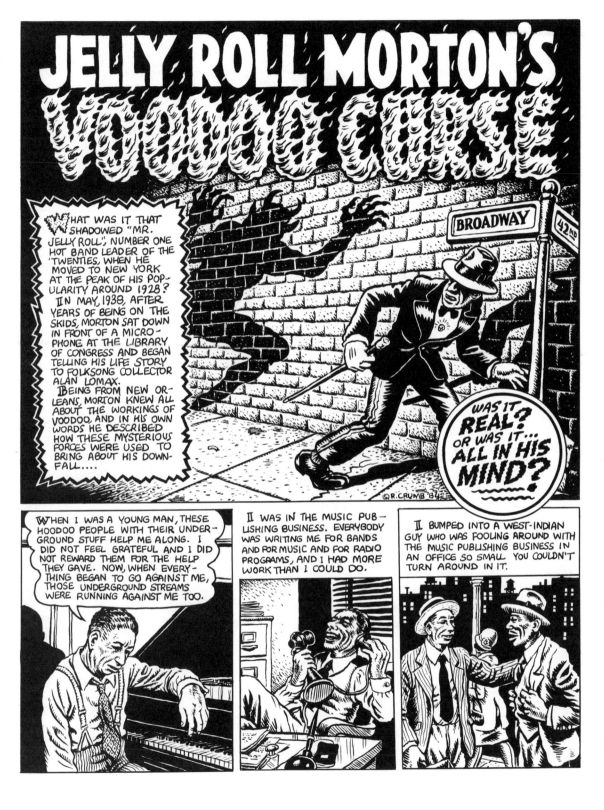

JELLY ROLL MORTON'S VOODOO CURSE

WHAT WAS IT THAT SHADOWED "MR. JELLY ROLL", NUMBER ONE HOT BAND LEADER OF THE 'TWENTIES, WHEN HE MOVED TO NEW YORK AT THE PEAK OF HIS POPULARITY AROUND 1928?

IN MAY, 1938, AFTER YEARS OF BEING ON THE SKIDS, MORTON SAT DOWN IN FRONT OF A MICROPHONE AT THE LIBRARY OF CONGRESS AND BEGAN TELLING HIS LIFE STORY TO FOLKSONG COLLECTOR ALAN LOMAX.

BEING FROM NEW ORLEANS, MORTON KNEW ALL ABOUT THE WORKINGS OF VOODOO, AND IN HIS OWN WORDS HE DESCRIBED HOW THESE MYSTERIOUS FORCES WERE USED TO BRING ABOUT HIS DOWNFALL....

BROADWAY 42ND

WAS IT REAL? OR WAS IT... ALL IN HIS MIND?

©R.CRUMB '84

WHEN I WAS A YOUNG MAN, THESE HOODOO PEOPLE WITH THEIR UNDERGROUND STUFF HELP ME ALONG. I DID NOT FEEL GRATEFUL AND I DID NOT REWARD THEM FOR THE HELP THEY GAVE. NOW, WHEN EVERYTHING BEGAN TO GO AGAINST ME, THOSE UNDERGROUND STREAMS WERE RUNNING AGAINST ME TOO.

I WAS IN THE MUSIC PUBLISHING BUSINESS. EVERYBODY WAS WRITING ME FOR BANDS AND FOR MUSIC AND FOR RADIO PROGRAMS, AND I HAD MORE WORK THAN I COULD DO.

I BUMPED INTO A WEST-INDIAN GUY WHO WAS FOOLING AROUND WITH THE MUSIC PUBLISHING BUSINESS IN AN OFFICE SO SMALL YOU COULDN'T TURN AROUND IN IT.

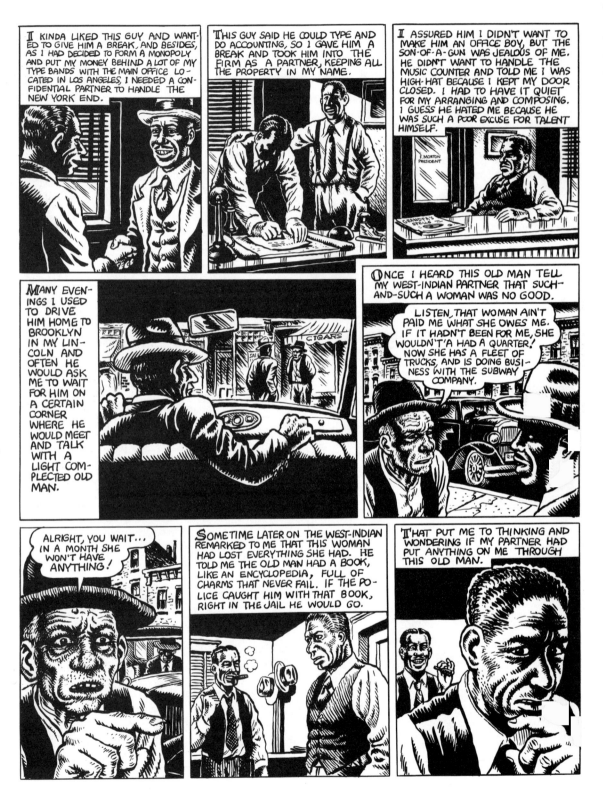

ROBERT CRUMB Jelly Roll Morton's Voodoo Curse

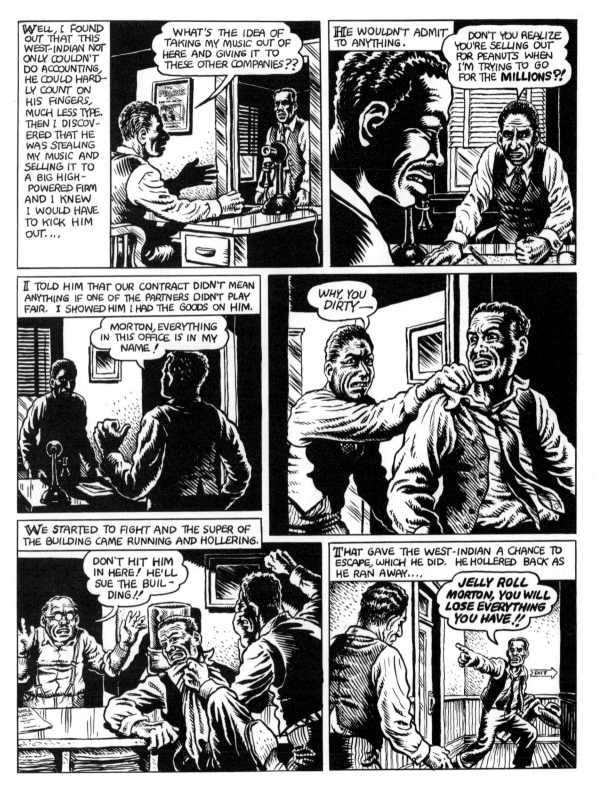

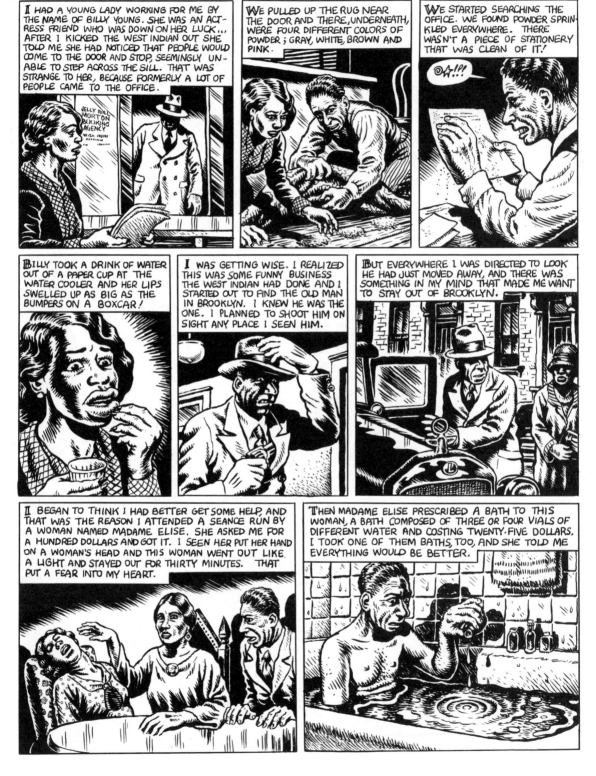

I HAD A YOUNG LADY WORKING FOR ME BY THE NAME OF BILLY YOUNG. SHE WAS AN ACTRESS FRIEND WHO WAS DOWN ON HER LUCK... AFTER I KICKED THE WEST INDIAN OUT SHE TOLD ME SHE HAD NOTICED THAT PEOPLE WOULD COME TO THE DOOR AND STOP, SEEMINGLY UNABLE TO STEP ACROSS THE SILL. THAT WAS STRANGE TO HER, BECAUSE FORMERLY A LOT OF PEOPLE CAME TO THE OFFICE.

JELLY ROLL MORTON BOOKING AGENCY

WE PULLED UP THE RUG NEAR THE DOOR AND THERE, UNDERNEATH, WERE FOUR DIFFERENT COLORS OF POWDER; GRAY, WHITE, BROWN AND PINK.

WE STARTED SEARCHING THE OFFICE. WE FOUND POWDER SPRINKLED EVERYWHERE. THERE WASN'T A PIECE OF STATIONERY THAT WAS CLEAN OF IT!

@#!?!

BILLY TOOK A DRINK OF WATER OUT OF A PAPER CUP AT THE WATER COOLER AND HER LIPS SWELLED UP AS BIG AS THE BUMPERS ON A BOXCAR!

I WAS GETTING WISE. I REALIZED THIS WAS SOME FUNNY BUSINESS THE WEST INDIAN HAD DONE AND I STARTED OUT TO FIND THE OLD MAN IN BROOKLYN. I KNEW HE WAS THE ONE. I PLANNED TO SHOOT HIM ON SIGHT ANY PLACE I SEEN HIM.

BUT EVERYWHERE I WAS DIRECTED TO LOOK HE HAD JUST MOVED AWAY, AND THERE WAS SOMETHING IN MY MIND THAT MADE ME WANT TO STAY OUT OF BROOKLYN.

I BEGAN TO THINK I HAD BETTER GET SOME HELP, AND THAT WAS THE REASON I ATTENDED A SEANCE RUN BY A WOMAN NAMED MADAME ELISE. SHE ASKED ME FOR A HUNDRED DOLLARS AND GOT IT. I SEEN HER PUT HER HAND ON A WOMAN'S HEAD AND THIS WOMAN WENT OUT LIKE A LIGHT AND STAYED OUT FOR THIRTY MINUTES. THAT PUT A FEAR INTO MY HEART.

THEN MADAME ELISE PRESCRIBED A BATH TO THIS WOMAN, A BATH COMPOSED OF THREE OR FOUR VIALS OF DIFFERENT WATER AND COSTING TWENTY-FIVE DOLLARS. I TOOK ONE OF THEM BATHS, TOO, AND SHE TOLD ME EVERYTHING WOULD BE BETTER.

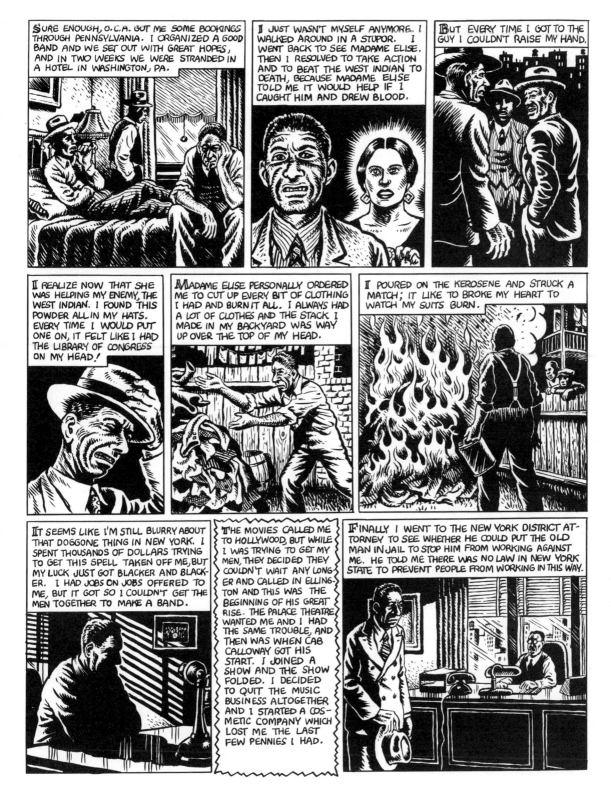

SURE ENOUGH, O.C.A. GOT ME SOME BOOKINGS THROUGH PENNSYLVANIA. I ORGANIZED A GOOD BAND AND WE SET OUT WITH GREAT HOPES, AND IN TWO WEEKS WE WERE STRANDED IN A HOTEL IN WASHINGTON, PA.

I JUST WASN'T MYSELF ANYMORE. I WALKED AROUND IN A STUPOR. I WENT BACK TO SEE MADAME ELISE. THEN I RESOLVED TO TAKE ACTION AND TO BEAT THE WEST INDIAN TO DEATH, BECAUSE MADAME ELISE TOLD ME IT WOULD HELP IF I CAUGHT HIM AND DREW BLOOD.

BUT EVERY TIME I GOT TO THE GUY I COULDN'T RAISE MY HAND.

I REALIZE NOW THAT SHE WAS HELPING MY ENEMY, THE WEST INDIAN. I FOUND THIS POWDER ALL IN MY HATS. EVERY TIME I WOULD PUT ONE ON, IT FELT LIKE I HAD THE LIBRARY OF CONGRESS ON MY HEAD!

MADAME ELISE PERSONALLY ORDERED ME TO CUT UP EVERY BIT OF CLOTHING I HAD AND BURN IT ALL. I ALWAYS HAD A LOT OF CLOTHES AND THE STACK I MADE IN MY BACKYARD WAS WAY UP OVER THE TOP OF MY HEAD.

I POURED ON THE KEROSENE AND STRUCK A MATCH; IT LIKE TO BROKE MY HEART TO WATCH MY SUITS BURN.

IT SEEMS LIKE I'M STILL BLURRY ABOUT THAT DOGGONE THING IN NEW YORK. I SPENT THOUSANDS OF DOLLARS TRYING TO GET THIS SPELL TAKEN OFF ME, BUT MY LUCK JUST GOT BLACKER AND BLACKER. I HAD JOBS ON JOBS OFFERED TO ME, BUT IT GOT SO I COULDN'T GET THE MEN TOGETHER TO MAKE A BAND.

THE MOVIES CALLED ME TO HOLLYWOOD, BUT WHILE I WAS TRYING TO GET MY MEN, THEY DECIDED THEY COULDN'T WAIT ANY LONGER AND CALLED IN ELLINGTON AND THIS WAS THE BEGINNING OF HIS GREAT RISE. THE PALACE THEATRE WANTED ME AND I HAD THE SAME TROUBLE, AND THEN WAS WHEN CAB CALLOWAY GOT HIS START. I JOINED A SHOW AND THE SHOW FOLDED. I DECIDED TO QUIT THE MUSIC BUSINESS ALTOGETHER AND I STARTED A COSMETIC COMPANY WHICH LOST ME THE LAST FEW PENNIES I HAD.

FINALLY I WENT TO THE NEW YORK DISTRICT ATTORNEY TO SEE WHETHER HE COULD PUT THE OLD MAN IN JAIL TO STOP HIM FROM WORKING AGAINST ME. HE TOLD ME THERE WAS NO LAW IN NEW YORK STATE TO PREVENT PEOPLE FROM WORKING IN THIS WAY.

IN 1935 MORTON LEFT NEW YORK AND MOVED TO WASHINGTON, D.C., WHERE HE PLAYED PIANO ALONE AT "THE JUNGLE INN", A SMALL BLACK NIGHT CLUB. SEVERAL YEARS LATER HE MADE A MODEST COME BACK DURING THE REVIVAL OF INTEREST IN NEW ORLEANS JAZZ, BUT BY 1941 JELLY ROLL MORTON WAS DEAD. ALAN LOMAX INTERVIEWED MORTON'S FIRST WIFE, ANITA GONZALEZ, AFTER HIS DEATH. ANITA HADN'T SEEN HIM FOR TWENTY YEARS, BUT HE HAD RETURNED TO HER, BROKE AND SICK, NEAR THE END.

JELLY WAS A VERY DEVOUT CATHOLIC, BUT VOODOO, WHICH IS AN ENTIRELY DIFFERENT RELIGION, HAD HOLD OF HIM TOO.

I KNOW. I NURSED AND SUPPORTED HIM ALL DURING HIS LAST ILLNESS AFTER HE HAD DRIVEN ACROSS THE CONTINENT IN THE MIDST OF WINTER WITH THAT BAD HEART OF HIS.

THE WOMAN, LAURA HUNTER, WHO RAISED JELLY ROLL, WAS A VOODOO WITCH. YES, I'M TALKING ABOUT HIS GODMOTHER WHO USED TO BE CALLED EULALIE ECHO. SHE MADE A LOT OF MONEY AT VOODOO. PEOPLE WERE ALWAYS COMING TO HER FOR SOME HELP AND SHE WAS GIVING THEM BEADS AND PIECES OF LEATHER AND ALL THAT.

WELL, EVERYBODY KNOWS THAT BEFORE YOU CAN BECOME A WITCH YOU HAVE TO SELL THE PERSON YOU LOVE THE BEST TO SATAN AS A SACRIFICE. LAURA LOVED JELLY BEST. JELLY ALWAYS KNEW SHE'D SOLD HIM TO SATAN AND THAT, WHEN SHE DIED, HE'D DIE TOO — SHE WOULD TAKE HIM DOWN WITH HER.

LAURA TAKEN SICK IN 1940 AND HERE COME JELLY ROLL DRIVING HIS LINCOLN ALL THE WAY FROM NEW YORK. LAURA DIED. AND THEN JELLY..., HE TAKEN SICK TOO. A COUPLE MONTHS LATER HE DIED IN MY ARMS, BEGGING ME TO KEEP ANOINTING HIS LIPS WITH OIL THAT HAD BEEN BLESSED BY A BISHOP IN NEW YORK. HE HAD OIL RUNNING ALL OVER HIM WHEN HE GAVE UP THE GHOST....

OH, BE SURE TO MENTION MY TOURIST CAMP IN YOUR BOOK, MR. LOMAX. OUR CHICKEN DINNERS ARE RECOMMENDED BY DUNCAN HINES.

ALL DIALOGUE TAKEN FROM "MR. JELLY ROLL" ©1950 by ALAN LOMAX

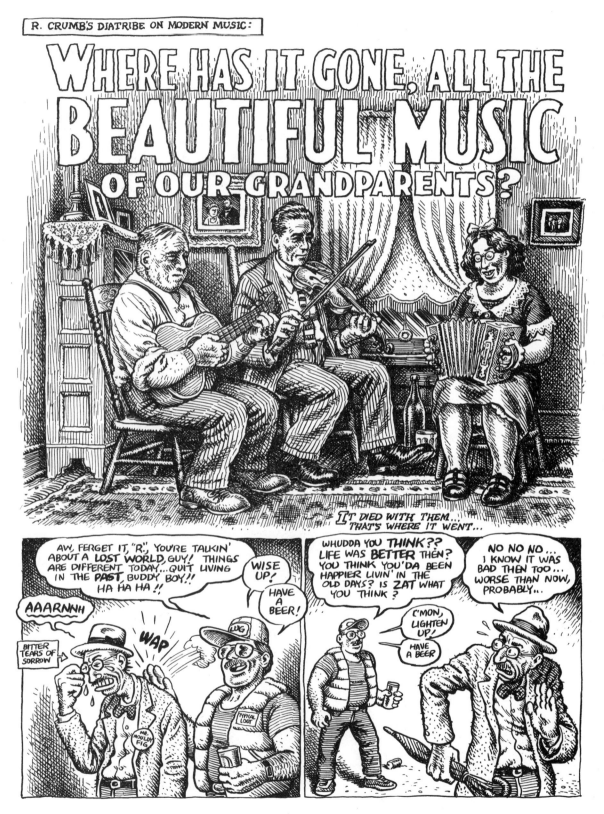

R. CRUMB'S DIATRIBE ON MODERN MUSIC:

WHERE HAS IT GONE, ALL THE BEAUTIFUL MUSIC OF OUR GRANDPARENTS?

IT DIED WITH THEM... THAT'S WHERE IT WENT...

AW, FERGET IT, "R.", YOU'RE TALKIN' ABOUT A **LOST WORLD**, GUY! THINGS ARE DIFFERENT TODAY...QUIT LIVING IN THE **PAST**, BUDDY BOY!! HA HA HA!!

WISE UP!

HAVE A BEER!

AAARNNH

BITTER TEARS OF SORROW

WAP

WHUDDA YOU **THINK**?? LIFE WAS **BETTER** THEN? YOU THINK YOU'DA BEEN HAPPIER LIVIN' IN THE OLD DAYS? IS **ZAT** WHAT YOU THINK?

NO NO NO... I KNOW IT WAS BAD THEN TOO... WORSE THAN NOW, PROBABLY...

C'MON, LIGHTEN UP! HAVE A BEER

ROBERT CRUMB Where Has It Gone, All the Beautiful Music of Our Grandparents?

317

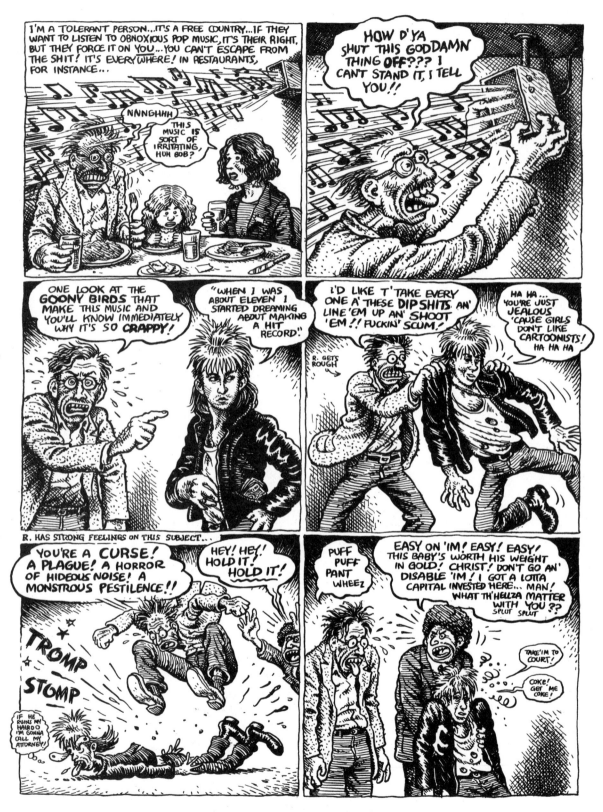

ROBERT CRUMB Where Has It Gone, All the Beautiful Music of Our Grandparents?

318

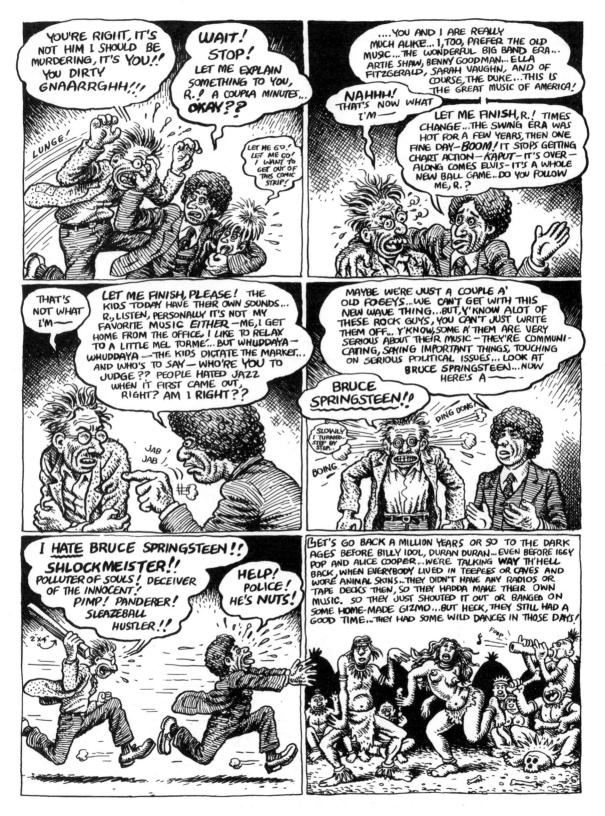

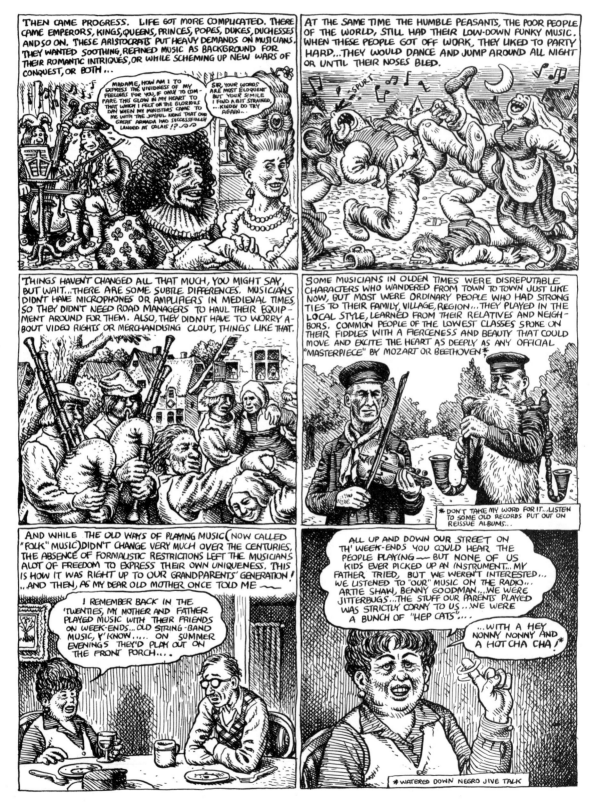

ROBERT CRUMB Where Has It Gone, All the Beautiful Music of Our Grandparents?

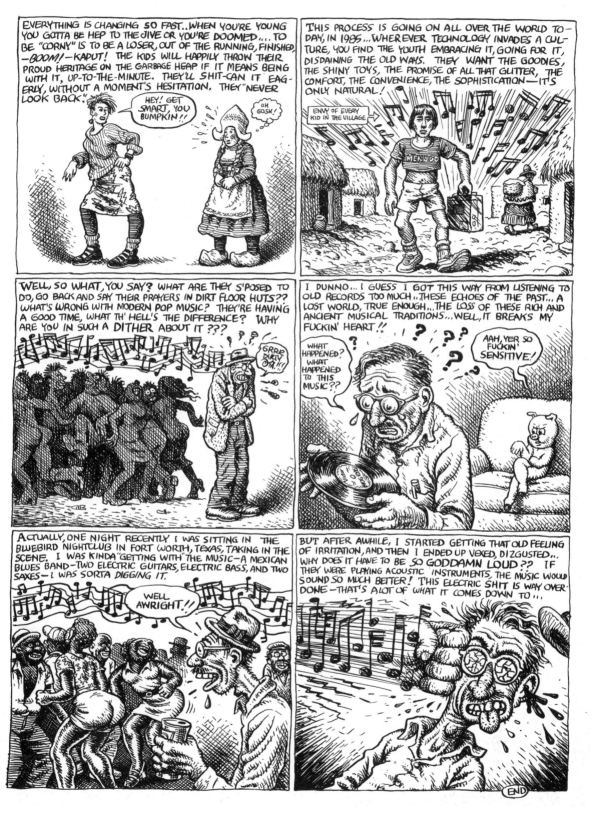

ROBERT CRUMB Where Has It Gone, All the Beautiful Music of Our Grandparents?

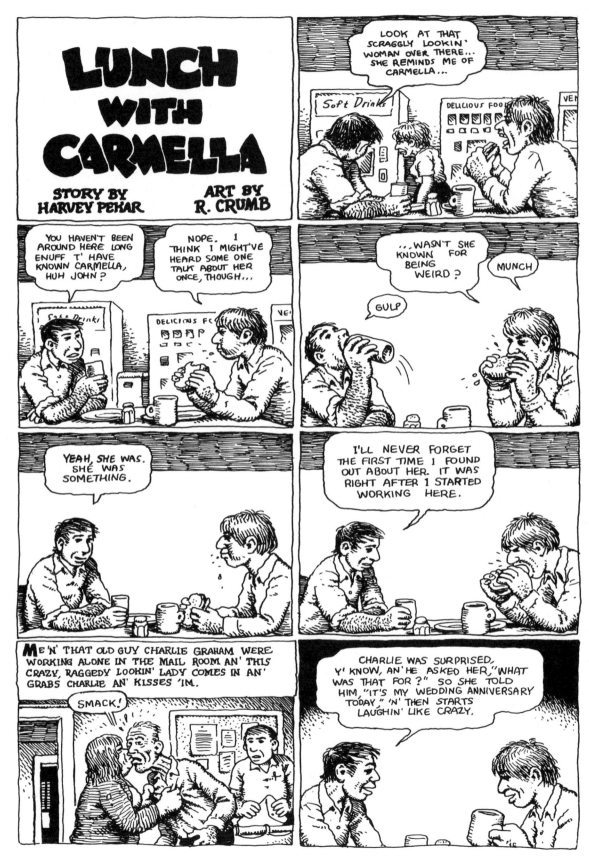

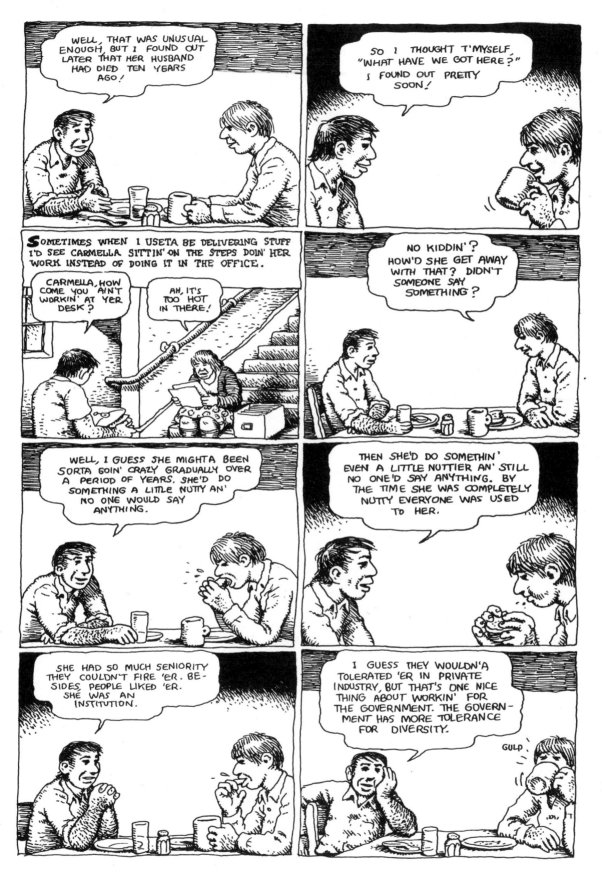

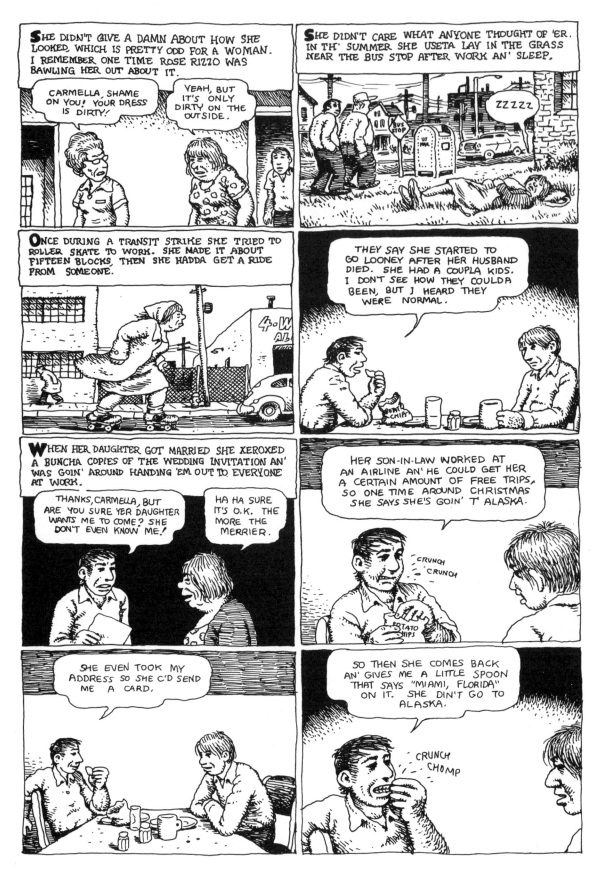

HARVEY PEKAR AND ROBERT CRUMB Lunch with Carmella

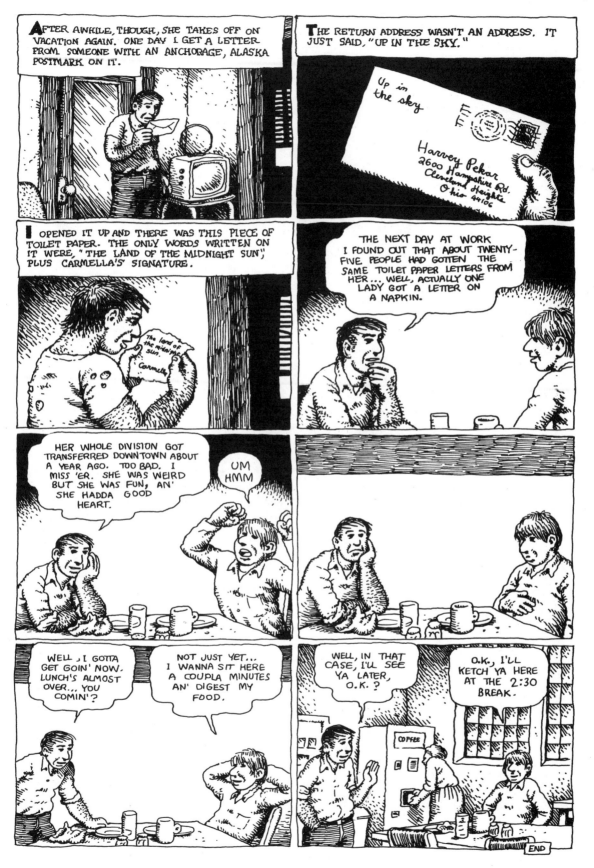

HARVEY PEKAR AND ROBERT CRUMB Lunch with Carmella

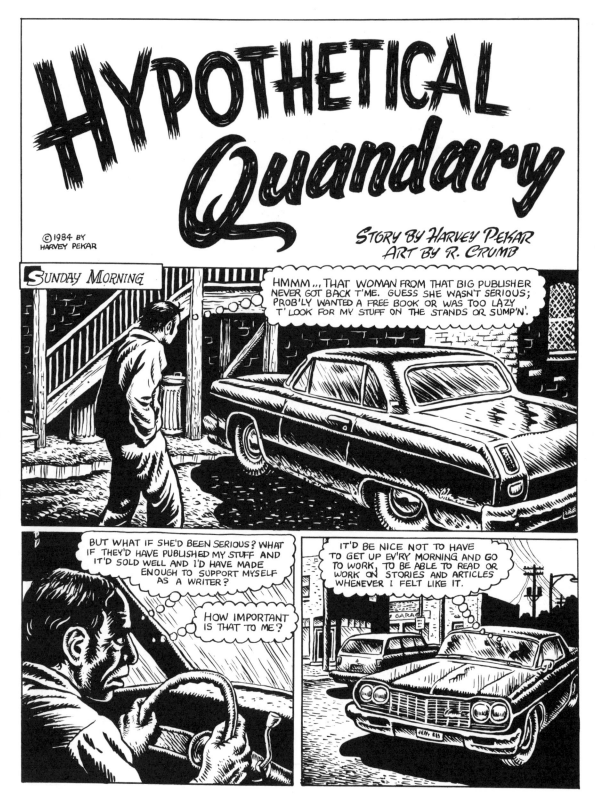

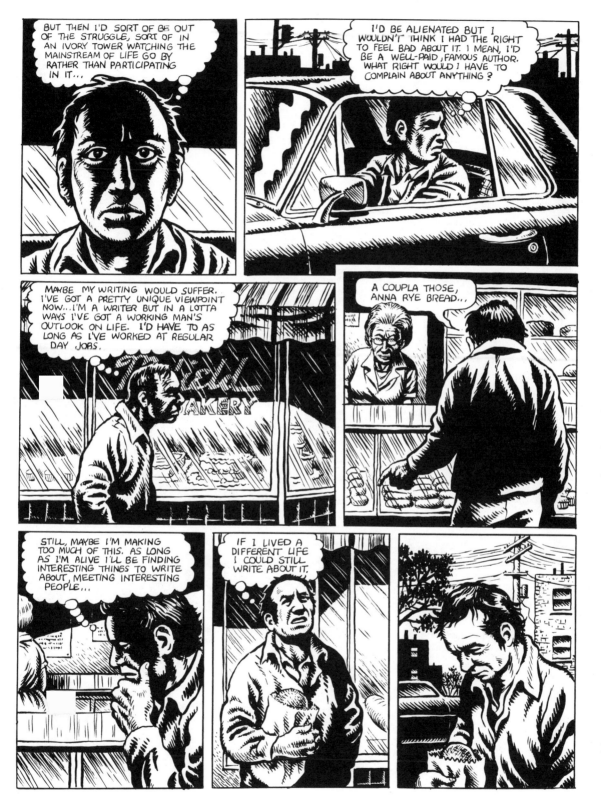

HARVEY PEKAR AND ROBERT CRUMB Hypothetical Quandary

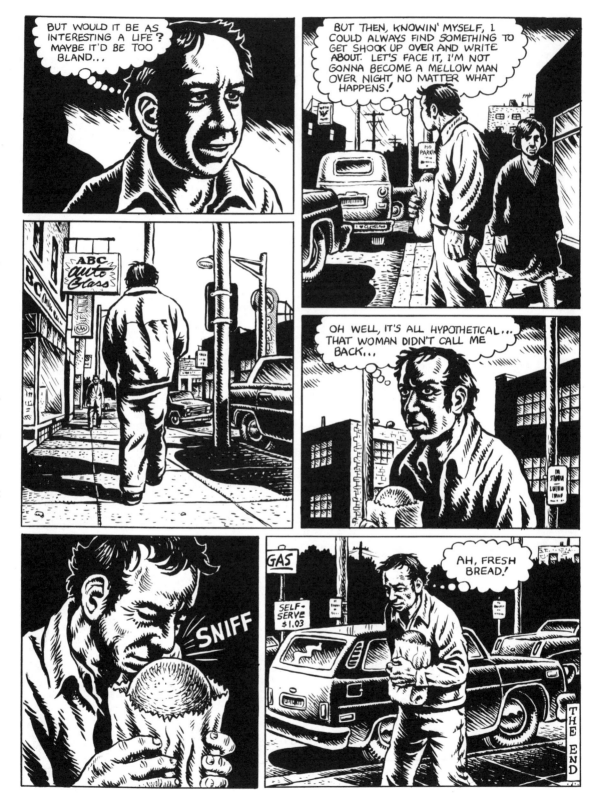

HARVEY PEKAR AND ROBERT CRUMB Hypothetical Quandary

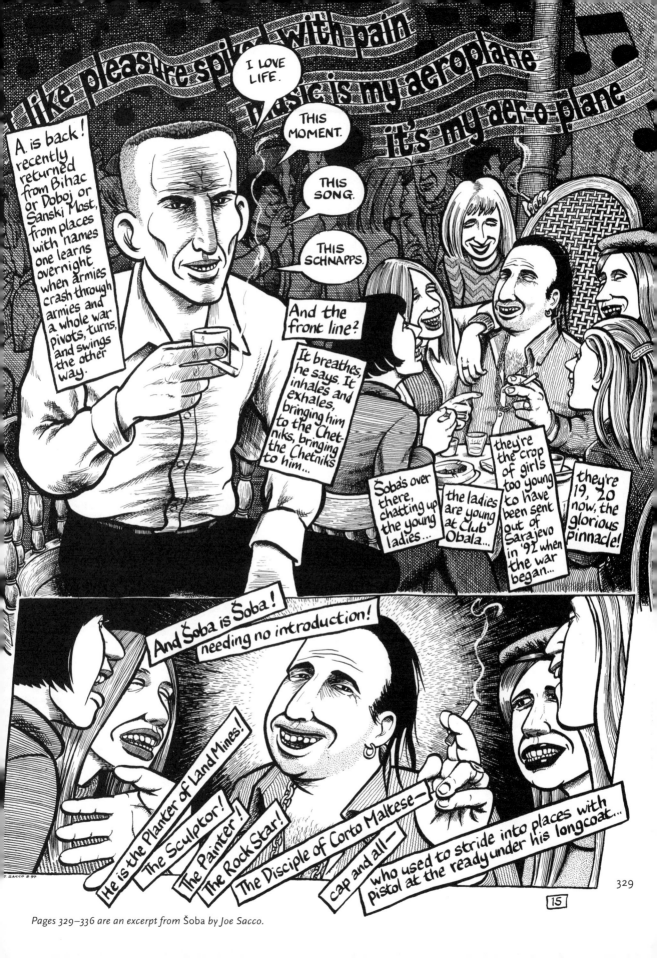

Pages 329–336 are an excerpt from Šoba by Joe Sacco.

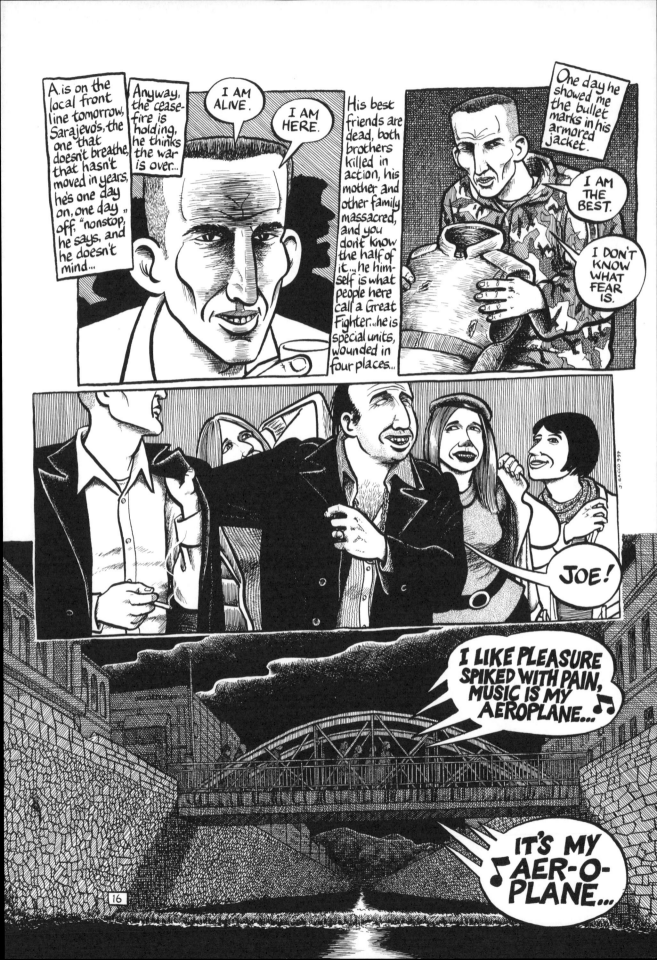

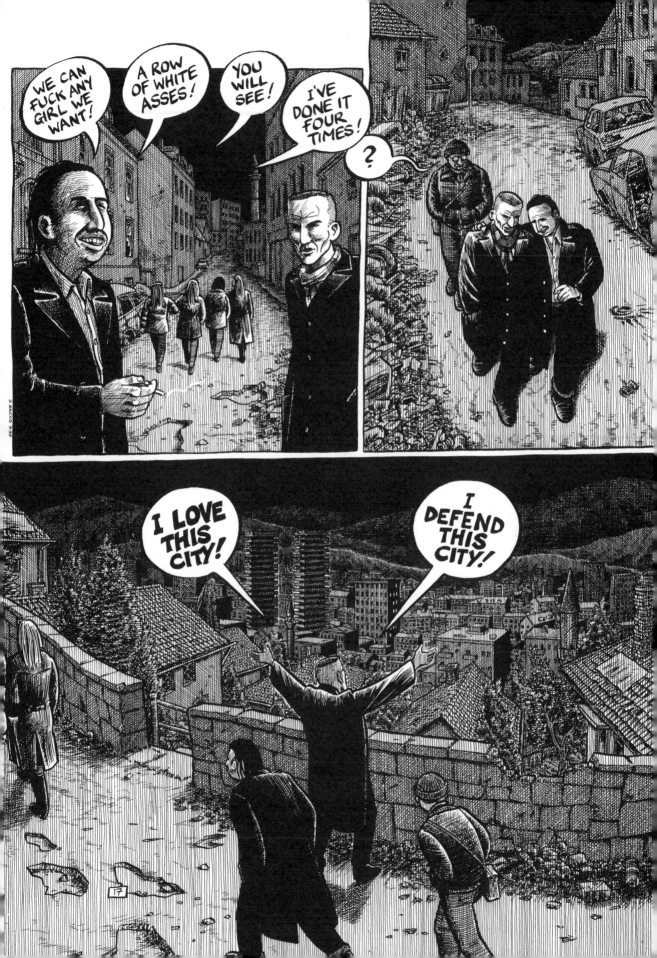

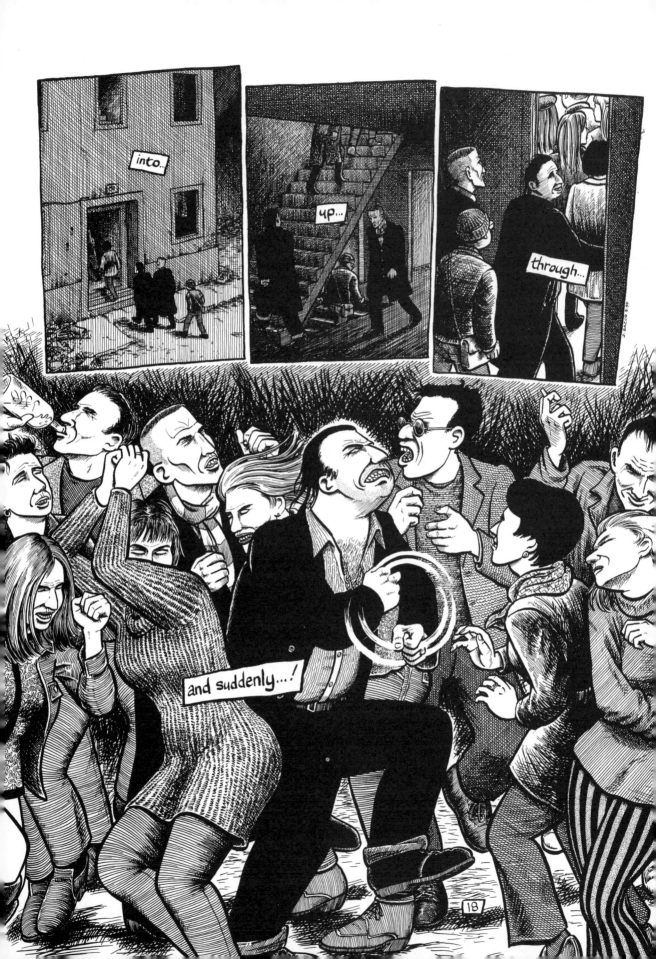

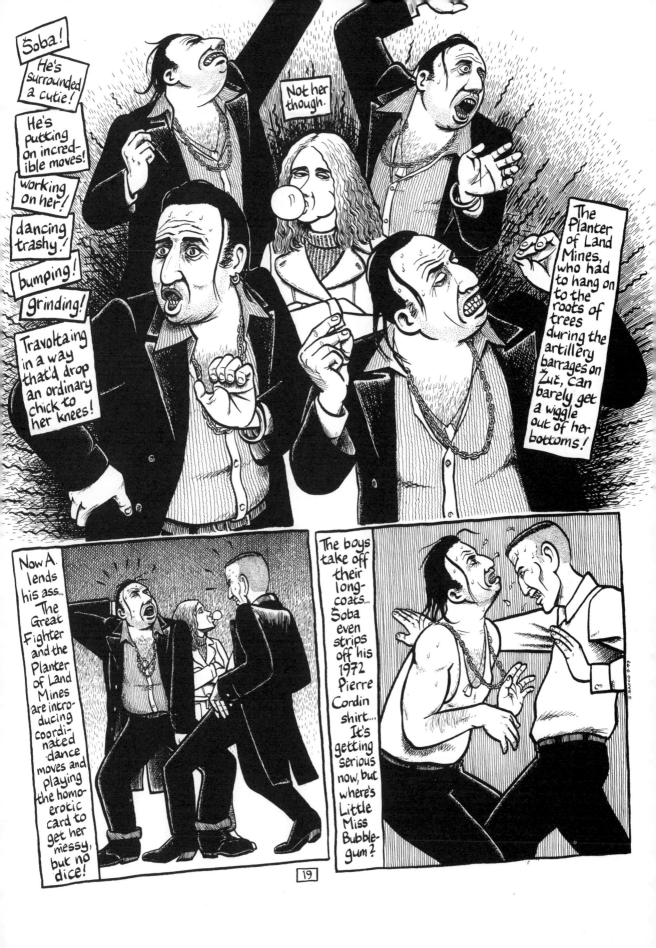

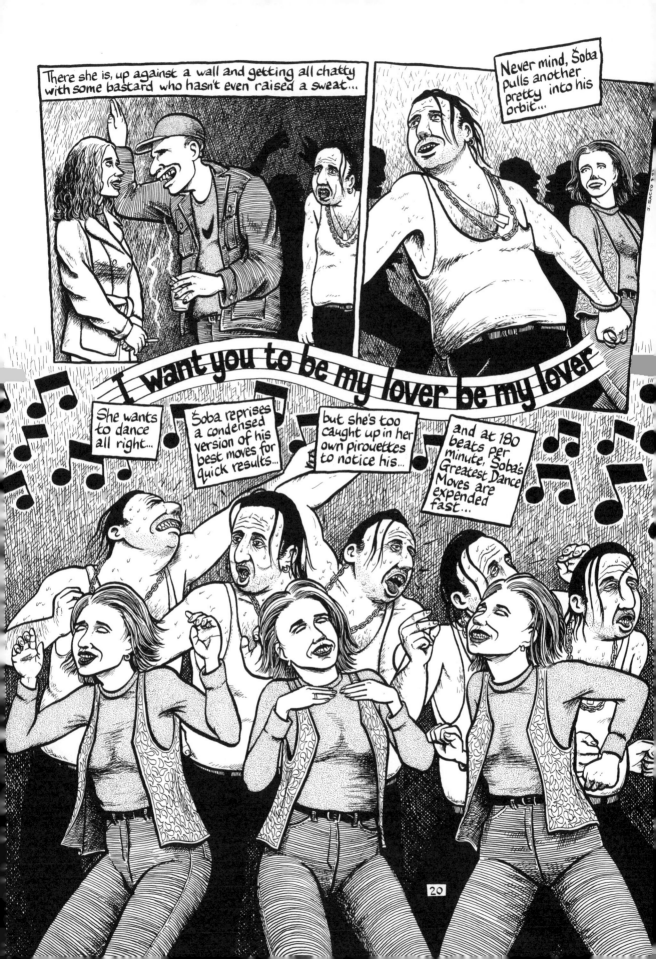

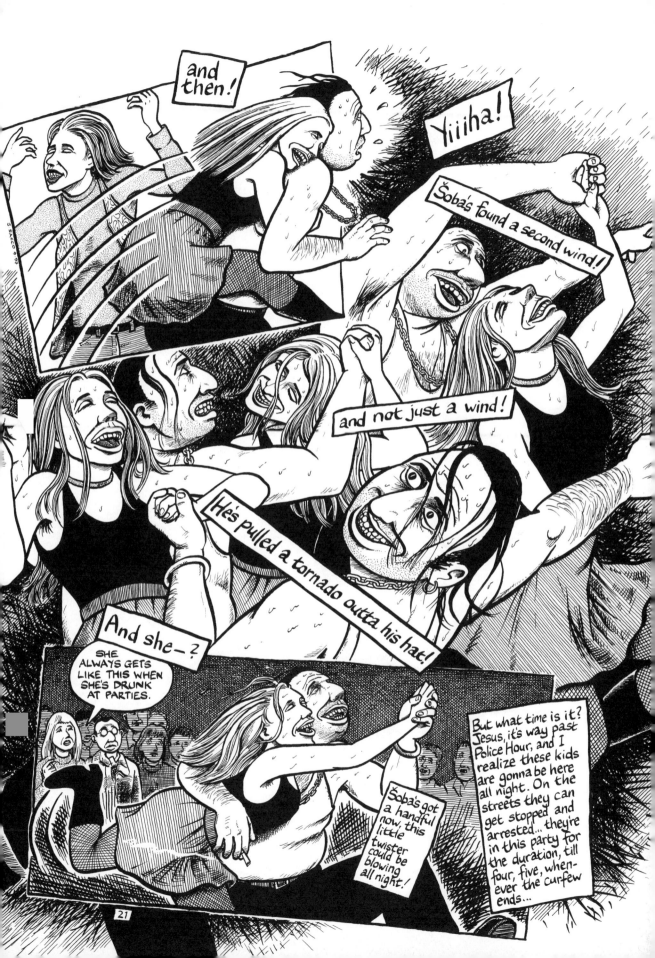

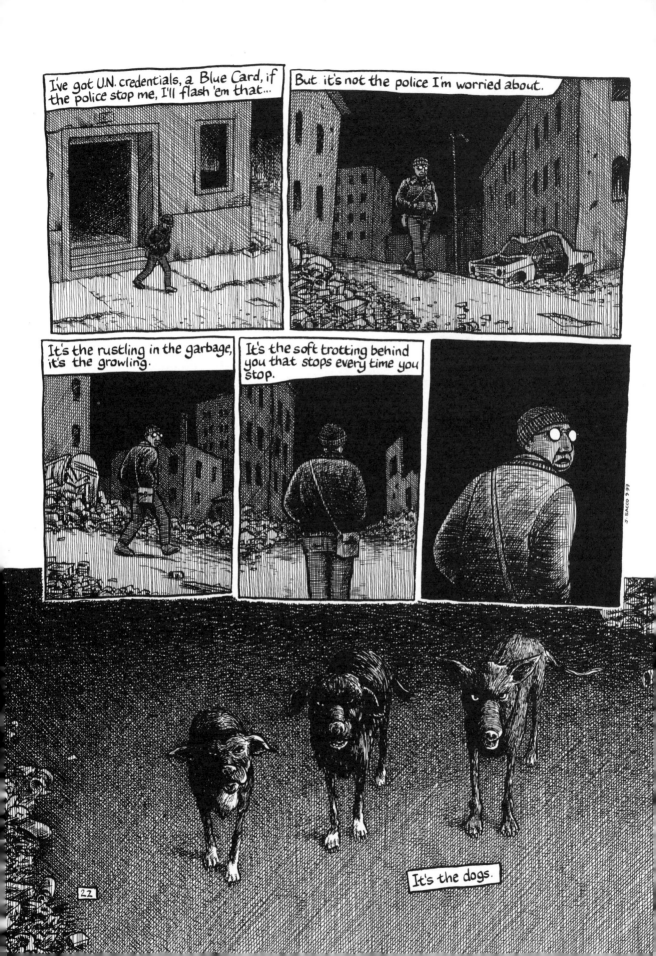

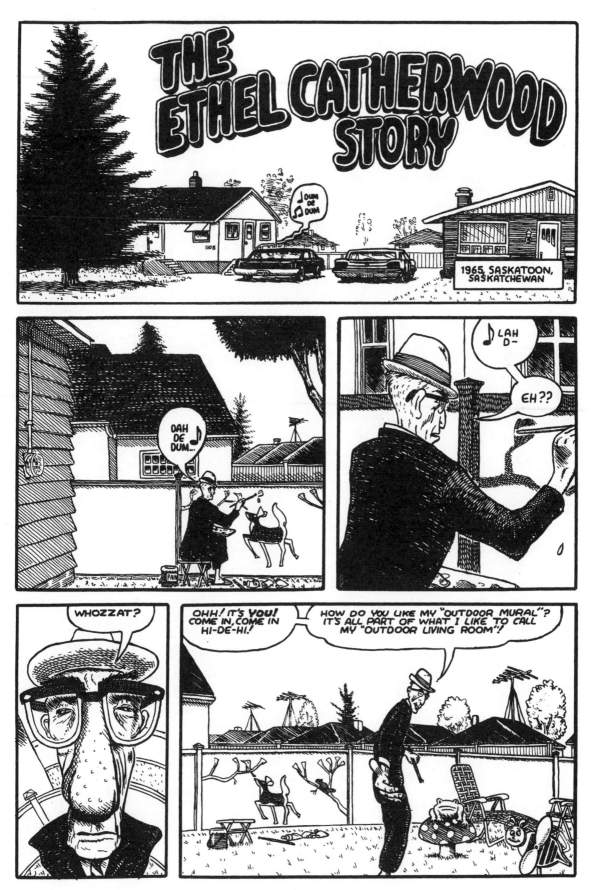

337

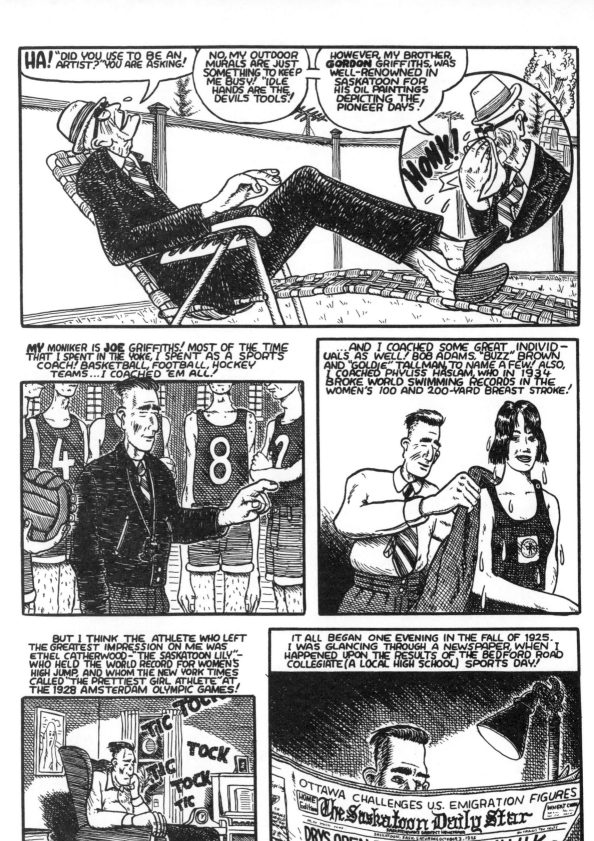

DAVID COLLIER The Ethel Catherwood Story

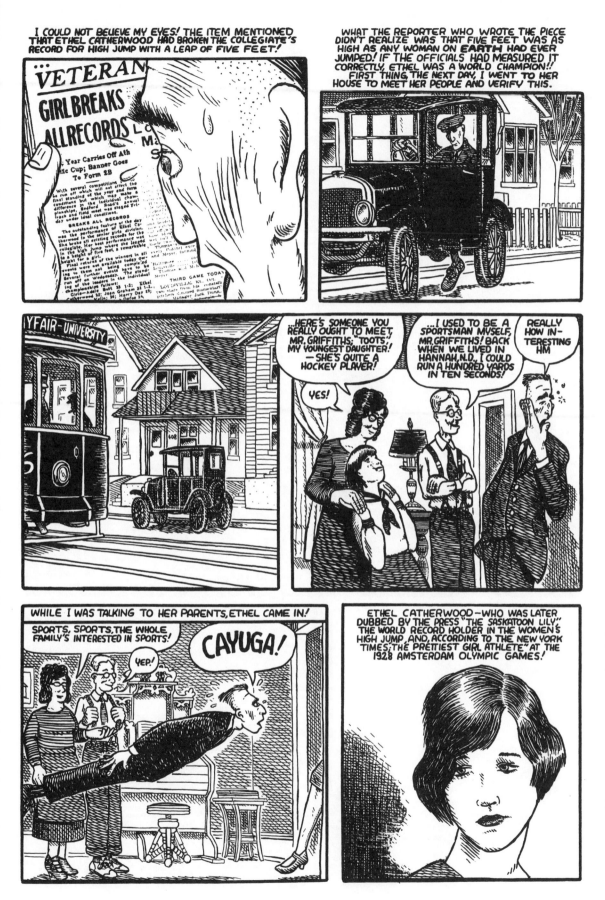

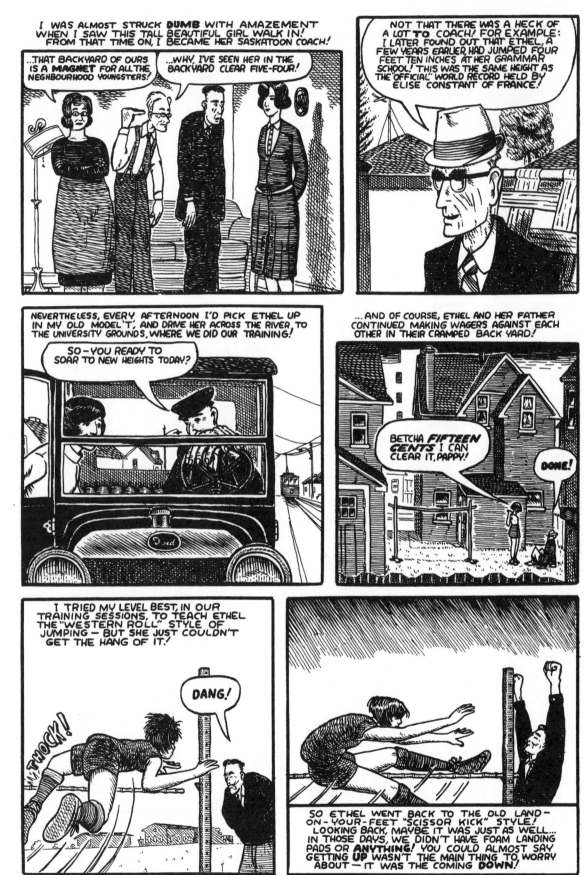

DAVID COLLIER The Ethel Catherwood Story

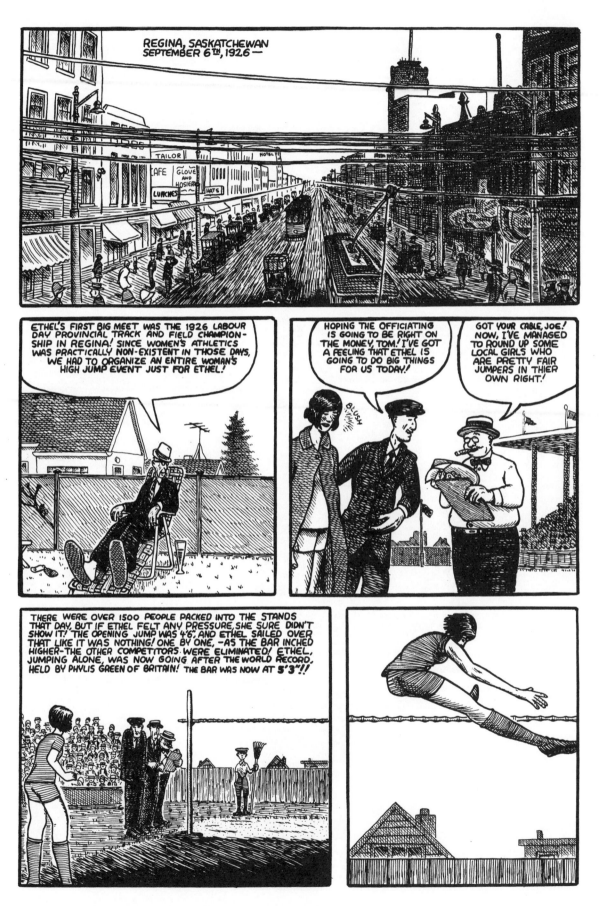

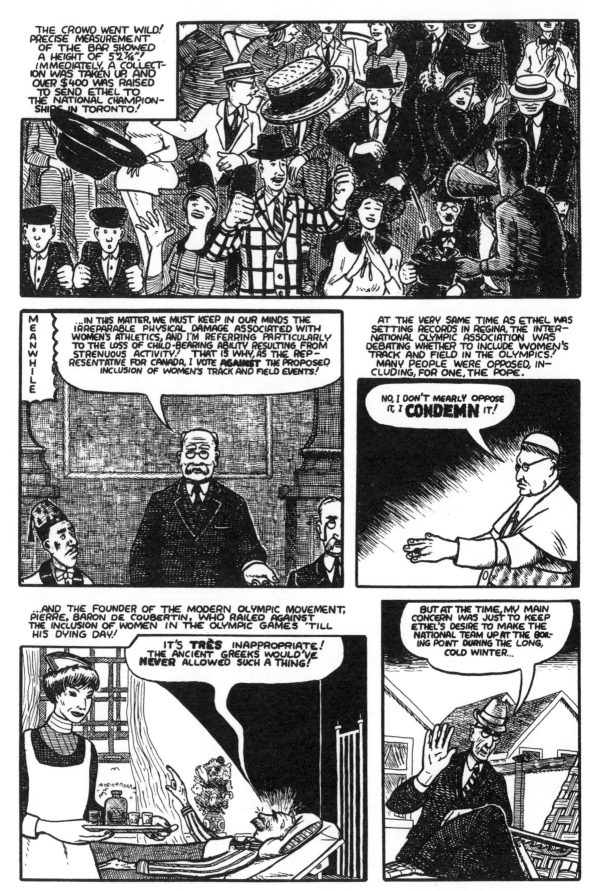

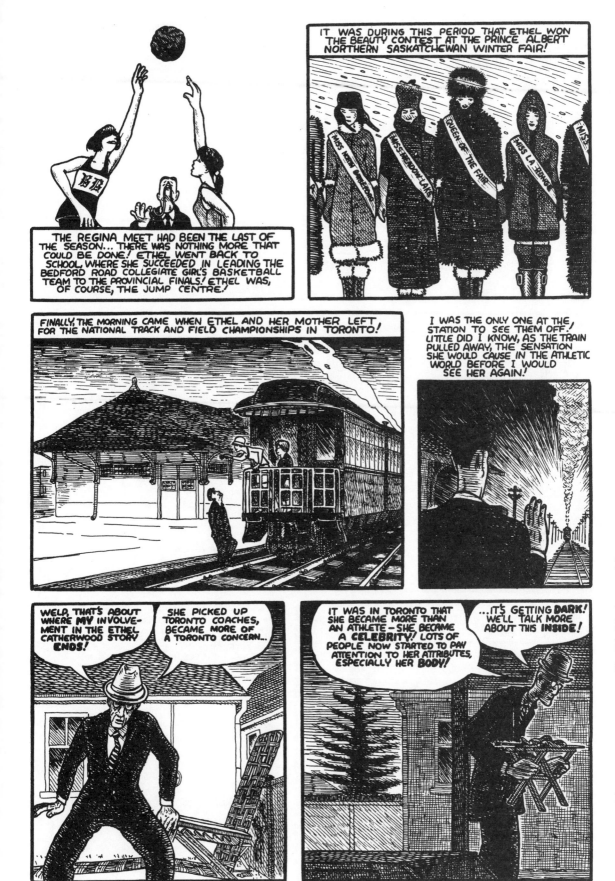

THE REGINA MEET HAD BEEN THE LAST OF THE SEASON... THERE WAS NOTHING MORE THAT COULD BE DONE! ETHEL WENT BACK TO SCHOOL, WHERE SHE SUCCEEDED IN LEADING THE BEDFORD ROAD COLLEGIATE GIRL'S BASKETBALL TEAM TO THE PROVINCIAL FINALS! ETHEL WAS, OF COURSE, THE JUMP CENTRE!

IT WAS DURING THIS PERIOD THAT ETHEL WON THE BEAUTY CONTEST AT THE PRINCE ALBERT NORTHERN SASKATCHEWAN WINTER FAIR!

MISS INDIAN HEAD MISS MEADOWLARK QUEEN OF THE FAIR MISS LA JEUNESSE MISS

FINALLY, THE MORNING CAME WHEN ETHEL AND HER MOTHER LEFT FOR THE NATIONAL TRACK AND FIELD CHAMPIONSHIPS IN TORONTO!

I WAS THE ONLY ONE AT THE STATION TO SEE THEM OFF! LITTLE DID I KNOW, AS THE TRAIN PULLED AWAY, THE SENSATION SHE WOULD CAUSE IN THE ATHLETIC WORLD BEFORE I WOULD SEE HER AGAIN!

WELD, THAT'S ABOUT WHERE MY INVOLVE-MENT IN THE ETHEL CATHERWOOD STORY ENDS!

SHE PICKED UP TORONTO COACHES, BECAME MORE OF A TORONTO CONCERN...

IT WAS IN TORONTO THAT SHE BECAME MORE THAN AN ATHLETE – SHE BECAME A CELEBRITY! LOTS OF PEOPLE NOW STARTED TO PAY ATTENTION TO HER ATTRIBUTES, ESPECIALLY HER BODY!

...IT'S GETTING DARK! WE'LL TALK MORE ABOUT THIS INSIDE!

DAVID COLLIER The Ethel Catherwood Story

343

REMEMBER, THERE WEREN'T TOO MANY FEMALE ATHLETES AROUND IN THOSE DAYS! I THINK A LOT OF PEOPLE HAD PRECONCEIVED NOTIONS OF WHAT A FEMALE ATHLETE WOULD LOOK LIKE—ALL TANNED AND MUSCLES—NOTIONS THAT ETHEL SHOOK! AT ANY RATE, THE PRESS HAD A FIELD DAY WITH HER!

From the instant this tall, slim graceful girl from the prairies tossed aside her cloak of purple, and made her first leap, the fans fell for her.

A flower-like face of rare beauty above a long slim body simply clad in pure white...

She looked like a tall, strange lily and was immediately christened by the crowd "The Saskatoon Lily."

I DON'T KNOW IF I MENTIONED THIS, BUT THE NEW YORK TIMES CALLED ETHEL "THE PRETTIEST OF ALL THE GIRL ATHLETES..!" IT'S TRUE! YOU CAN LOOK IT UP!

WELL, I SUPPOSE EVERYONE WHO HASN'T BEEN LIVING IN A CAVE FOR THE PAST 37 YEARS IS WELL AWARE OF WHAT HAPPENED NEXT!

THE FIRST EVER WOMEN'S OLYMPIC HIGH JUMP COMPETITION WAS HELD ON A DAMP AND CHILLY DAY! DURING THE MORNING TRIALS, ETHEL JUMPED POORLY AND MANAGED ONLY A SEVENTEENTH-PLACE LEAP! HOWEVER, THE AFTERNOON FINAL WAS THE ONLY EVENT THAT MATTERED!

CANADA

FOR MOST OF THE JUMPS IN THE FINAL, ETHEL WORE HER WARM-UP CLOTHES! IT MIGHT'VE BEEN BECAUSE OF THE WEATHER, BUT ALSO, JUMPING WITHOUT REMOVING YOUR SWEATSUIT HAS GOT TO HAVE PSYCHOLOGICAL EFFECTS ON YOUR OPPOSITION! AND MAKE NO MISTAKE ABOUT IT—THE HIGH JUMP IS A VERY PSYCHOLOGICAL GAME!

IN THE HIGH JUMP EVENT, YOU ARE ALLOWED TO MISS A HEIGHT TWICE, AND THEN YOU'RE OUT! ETHEL MISSED HER FIRST TRY AT 5 FEET!

DAMMIT!

SO ETHEL FINALLY TOOK OFF HER SWEATSUIT, AND MADE THE NEXT JUMP! BY THIS TIME, THERE WERE ONLY TWO OTHER COMPETITORS LEFT! CAROLIA GISOLF OF HOLLAND AND MILDRED WILEY OF THE U.S.A.!

NEDERLAND

CANADA

IT WAS A GRUELING AFTERNOON; THREE HOURS AFTER THE FIRST JUMPS, THERE WERE STILL THREE WOMEN IN CONTENTION! AND NOW THE BAR STOOD AT 5 FEET, 3 INCHES! ETHEL HAD NEVER SEEN COMPETITION LIKE THIS!

CANADA

USA

AND THEN SOMETHING HAPPENED TO ETHEL THAT I'D NEVER KNOWN TO HAPPEN TO HER BEFORE! SHE LOOKED OVER AT MILDRED WILEY—AND LOST ALL HER COMPOSURE!

EVERYBODY, FROM TIME TO TIME, HAS DOUBTS ABOUT WHAT THEY DO!

...DOUBTS ABOUT WHETHER IT'S REALLY WORTH THE INTENSITY AND HEARTACHE...

FOR ETHEL, THESE DOUBTS CAME AT EXACTLY THE WRONG MOMENT!!

HOWEVER, WHEN YOU OVERCOME THESE DOUBTS AND PRESSURES, YOU'LL FIND THAT YOU'VE BROUGHT SOMETHING OUT IN YOURSELF, SOMETHING THAT IS YOUR GREAT STRENGTH AND PURPOSE!

ETHEL CLEARED THE BAR AT 5 FEET 3 INCHES ON HER FIRST TRY! BOTH HER OPPONENTS FAILED...

I WISH I HAD BEEN THERE! THE NEW YORK TIMES REPORTED THAT ETHEL HAD "RECEIVED A TREMENDOUS OVATION WITH THE COOL GRACE OF A MOVIE STAR, BOWING AND BLOWING KISSES TO THE STANDS"!

SO CHARMING! SO FULL OF LIFE! OH THAT ETHEL!...SHE HAD A RAG DOLL AND A UKULELE THAT SHE CARRIED EVERYWHERE!

I GUESS YOU YOUNG FOLKS NOWADAYS WOULD CALL HER "GROOVY"!

AND THAT'S HOW I WANT TO REMEMBER MY ETHEL; AS A HAPPY PEP-STEPPER! THE REST OF IT... THE BAD NONSENSE THAT CAME LATER, ISN'T EVEN WORTH TALKING ABOUT!

DAVID COLLIER The Ethel Catherwood Story

DAVID COLLIER The Ethel Catherwood Story

CHRIS WARE *excerpt from Jimmy Corrigan: The Smartest Kid on Earth*

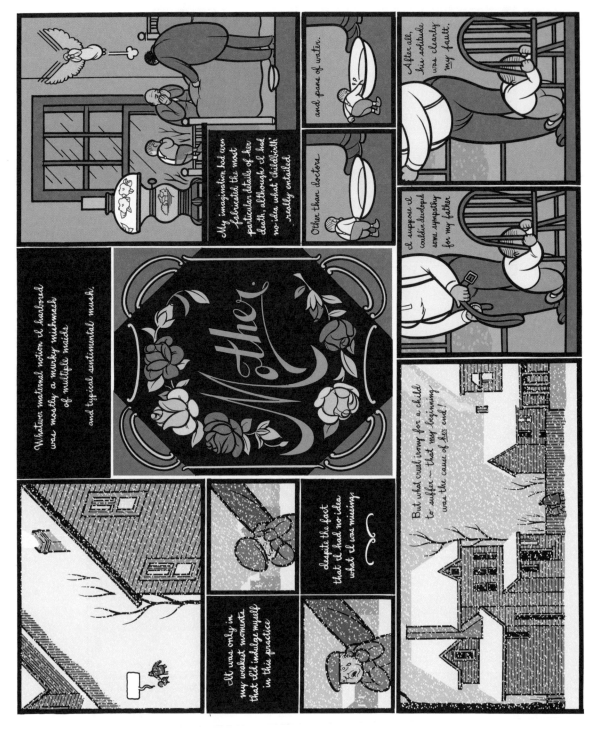

They tell us in church that we have to wait until we're dead to see all our relatives.

Do I really have to wait that long to meet her?

Beside, we could always find another one.

I felt bad for her, but she was probably better off elsewhere.

That night our pipes froze and the neighbors permitted us the use of their outhouse.

Apparently our maid had neglected to leave the faucets dripping, as my father had instructed her to.

The scratching and scrabbling of the hungry mice had led him directly to their hiding place.

And while such an error was not necessarily grounds for dismissal,

Her "crime" the night before was — the biscuits she'd secretly brought to my room had been discovered.

At first, of course, I was blamed for the theft, but she admitted her guilt saying she felt sorry for me going to bed hungry.

Such violation of my father's authority (however innocent) was more than he could tolerate, however.

I was grateful for her honesty, and while I would've tried to defend her, I decided to simply let nature run its course.

The next morning my father gave our maid her "notice."

CHRIS WARE *excerpt from Jimmy Corrigan: The Smartest Kid on Earth*

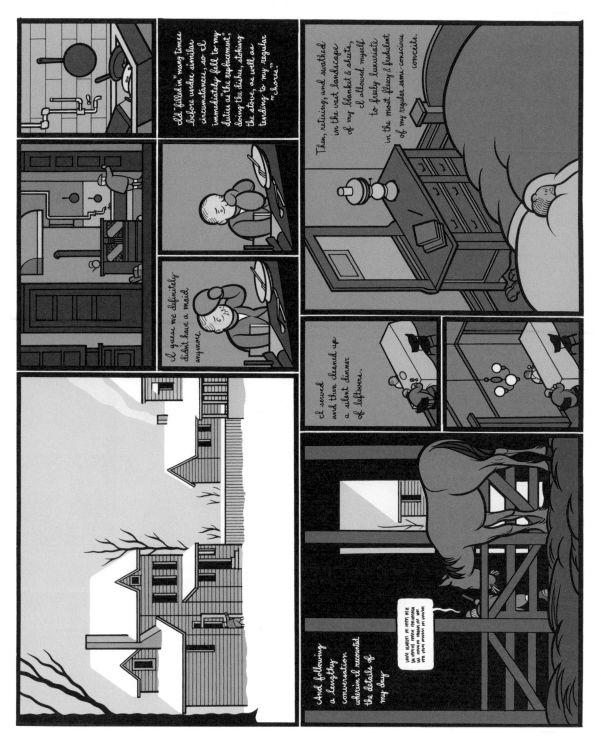

I'd "fooled-in" many times before under similar circumstances, so I immediately fell to my duties as the replacement; doing the dishes, stoking the stove, as well as tending to my regular "chores."

I guess we definitely didn't have a maid anymore.

Then, retiring and swathed in the vast landscape of my blanket & sheets, I allowed myself to freely luxuriate in the most fleecy & fraudulent of my regular semi-conscious conceits.

I sewed and then cleaned up a silent dinner of leftovers.

And following a lengthy conversation wherein I recounted the details of my day

CHRIS WARE *excerpt from* Jimmy Corrigan: The Smartest Kid on Earth

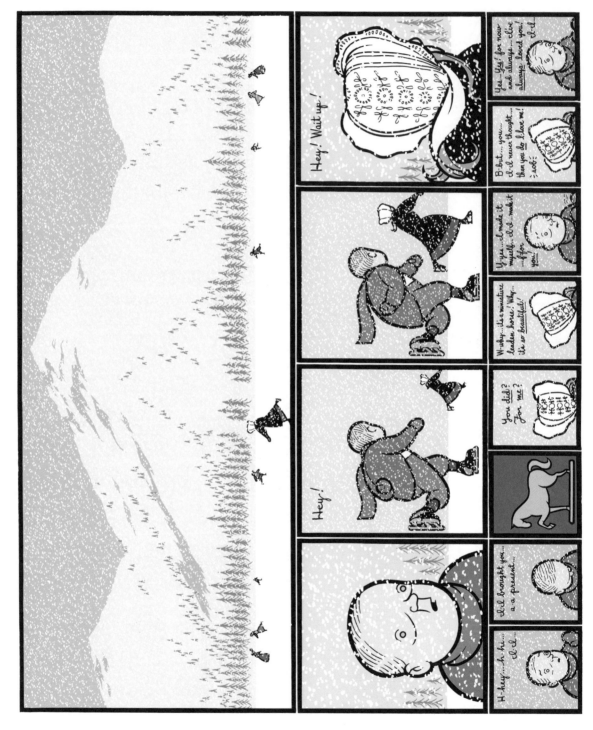

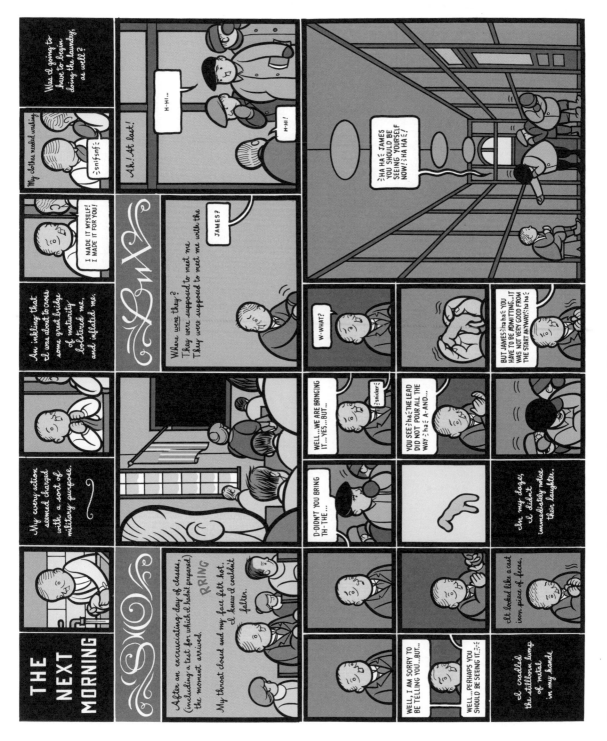

CHRIS WARE *excerpt from Jimmy Corrigan: The Smartest Kid on Earth*

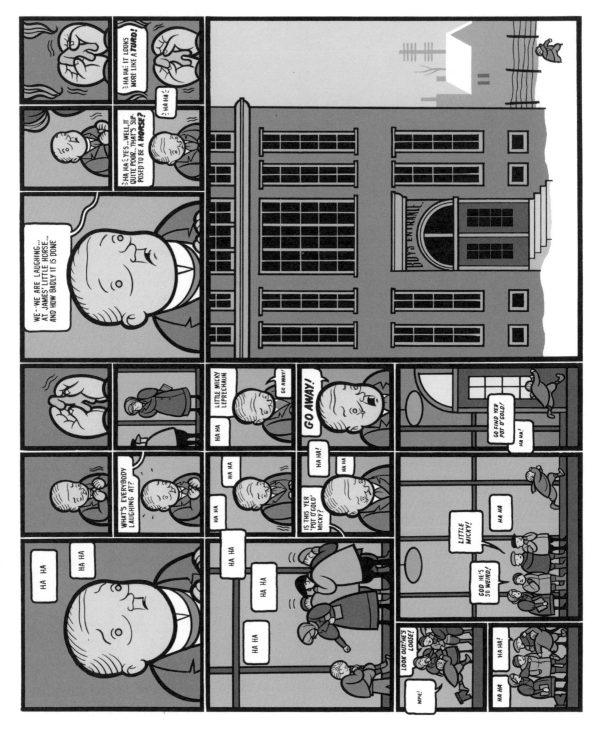

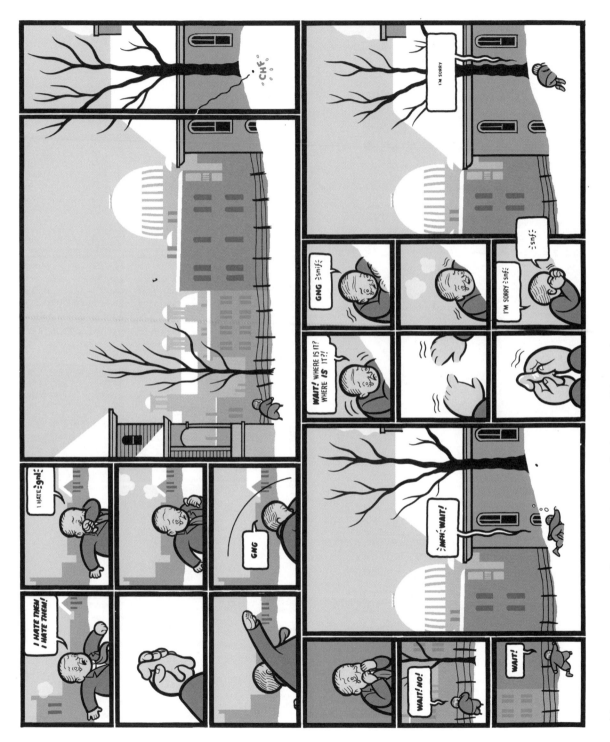

CHRIS WARE *excerpt from* Jimmy Corrigan: The Smartest Kid on Earth

THE REMAINING WINTER

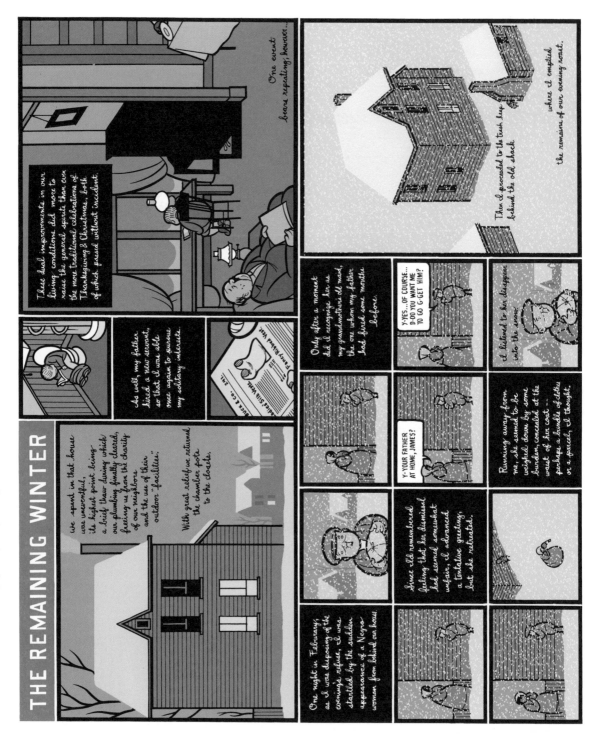

CHRIS WARE *excerpt from Jimmy Corrigan: The Smartest Kid on Earth*

CHRIS WARE *excerpt from Jimmy Corrigan: The Smartest Kid on Earth*

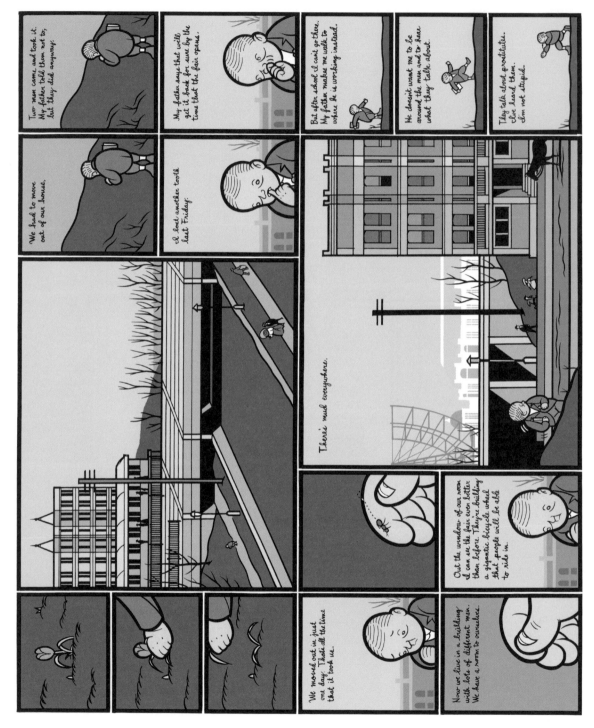

Two men came and took it. My father told them not to, but they did anyway.

We had to move out of our house.

My father says that will get it back for sure by the time that the fair opens.

I lost another tooth last Friday.

But after school I can't go there. My father makes me walk to where he is working instead.

He doesn't want me to be around the men and to hear what they talk about.

They talk about prostitutes. I've heard them. I'm not stupid.

There's mud everywhere.

We moved out in just one day. That's all the time that it took us.

Now we live in a building with lots of different men. We have a room to ourselves.

Out the window of our room I can see the fair even better than before. They're building a gigantic bicycle wheel that people will be able to ride in.

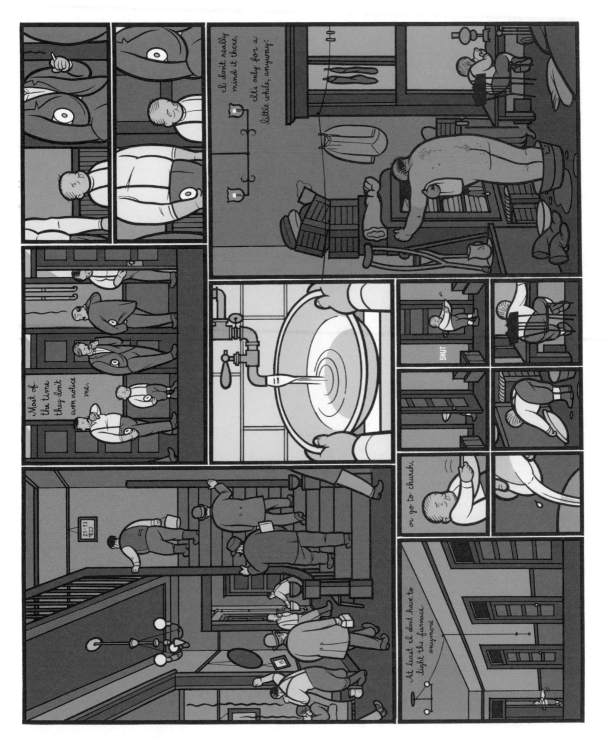

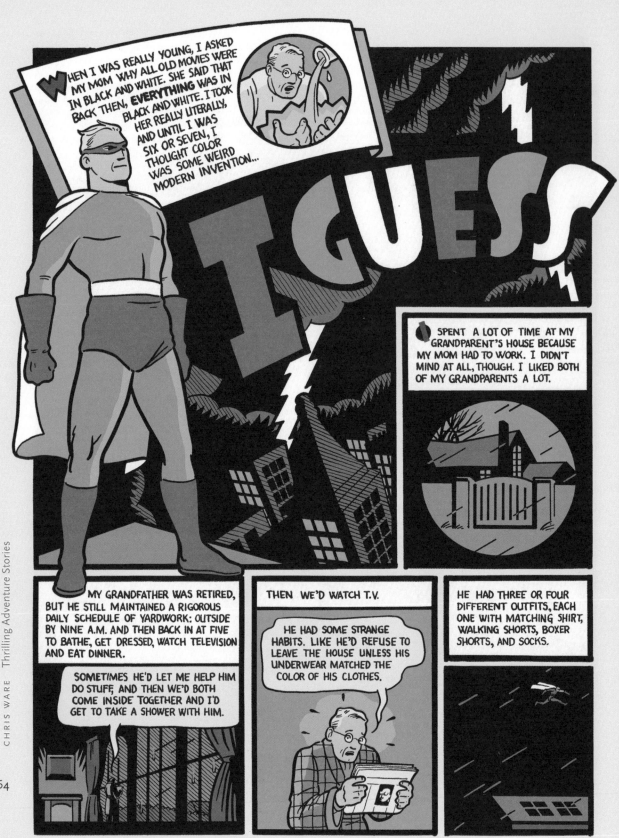

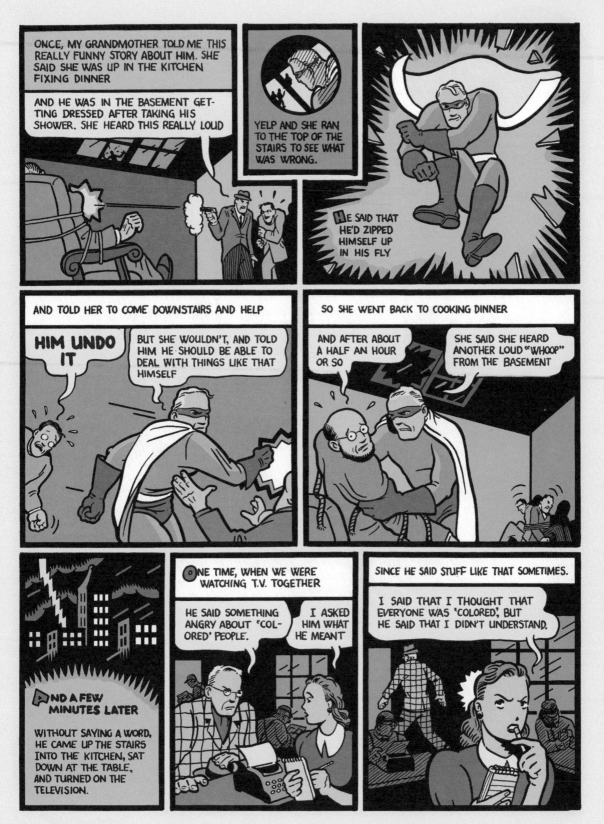

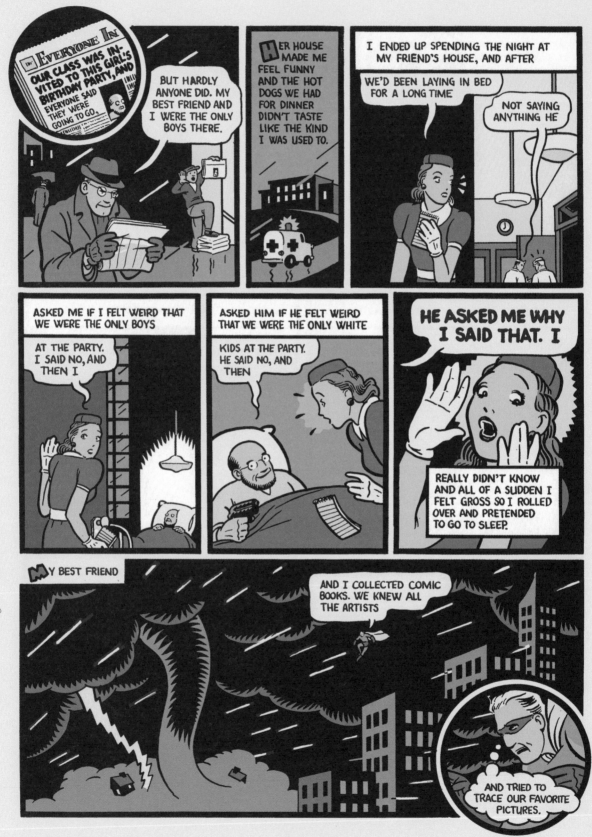

CHRIS WARE Thrilling Adventure Stories

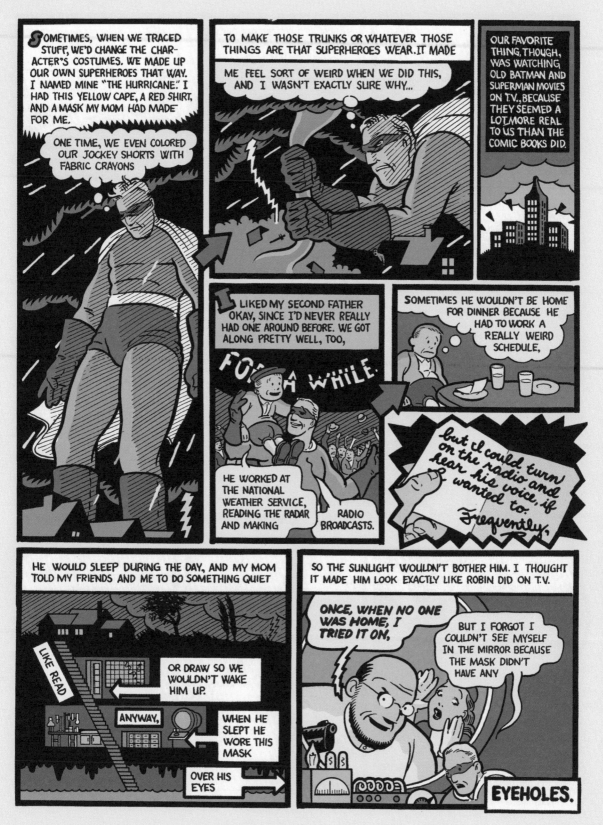

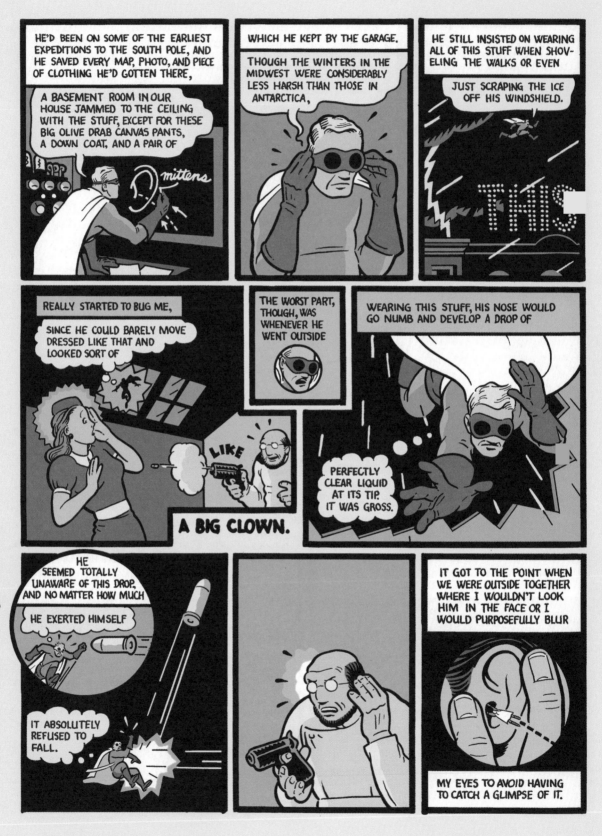

CHRIS WARE Thrilling Adventure Stories

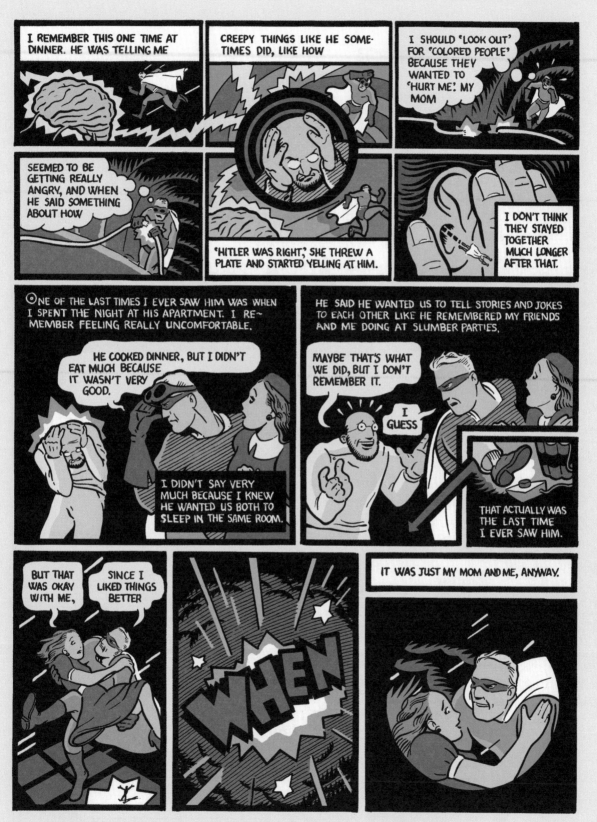

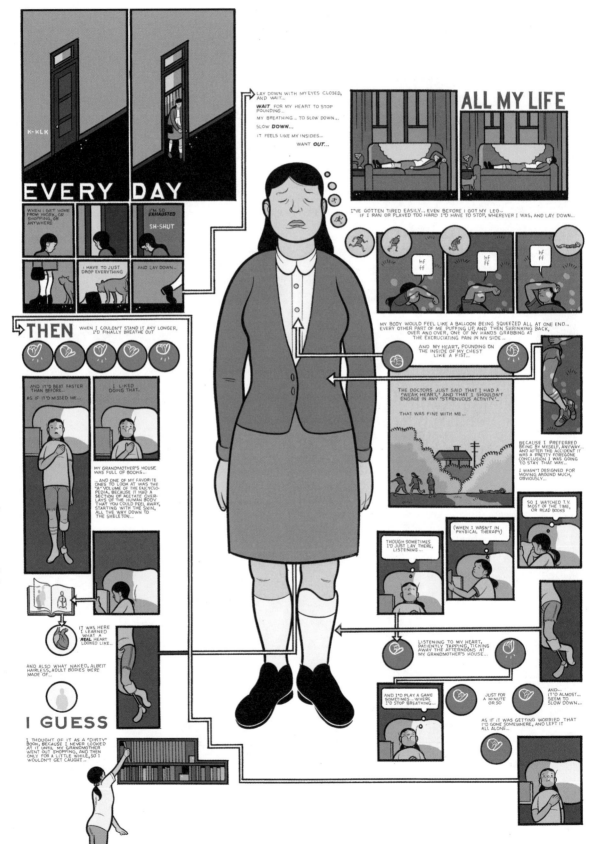

CHRIS WARE *excerpt from Building Stories*

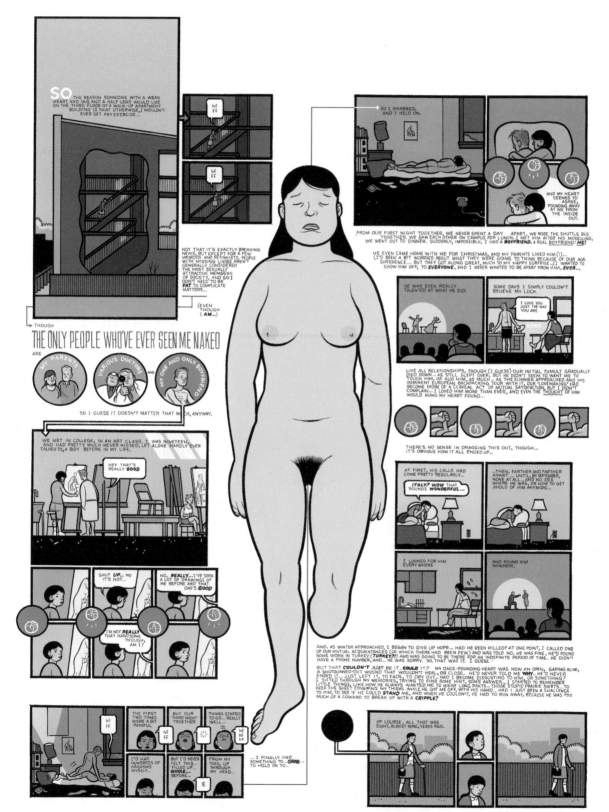

CHRIS WARE *excerpt from Building Stories*

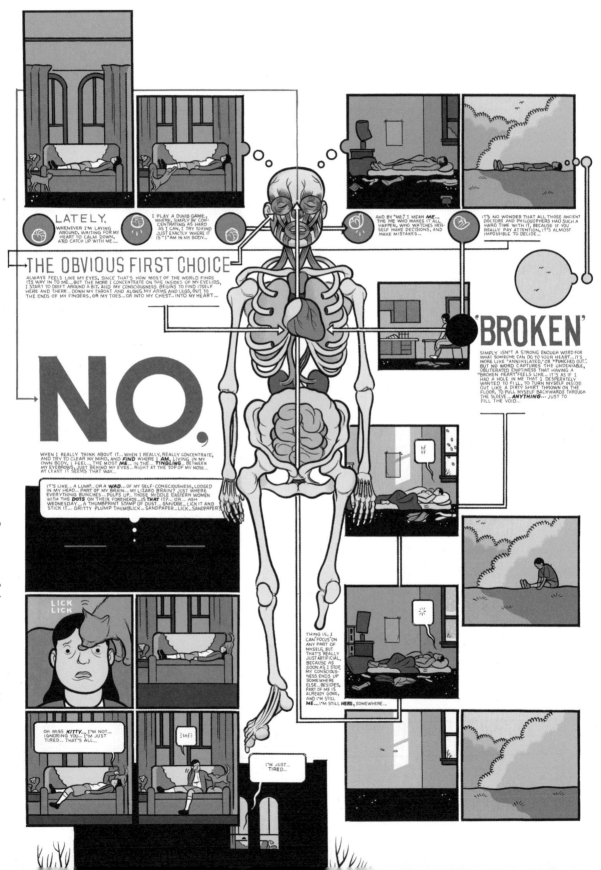

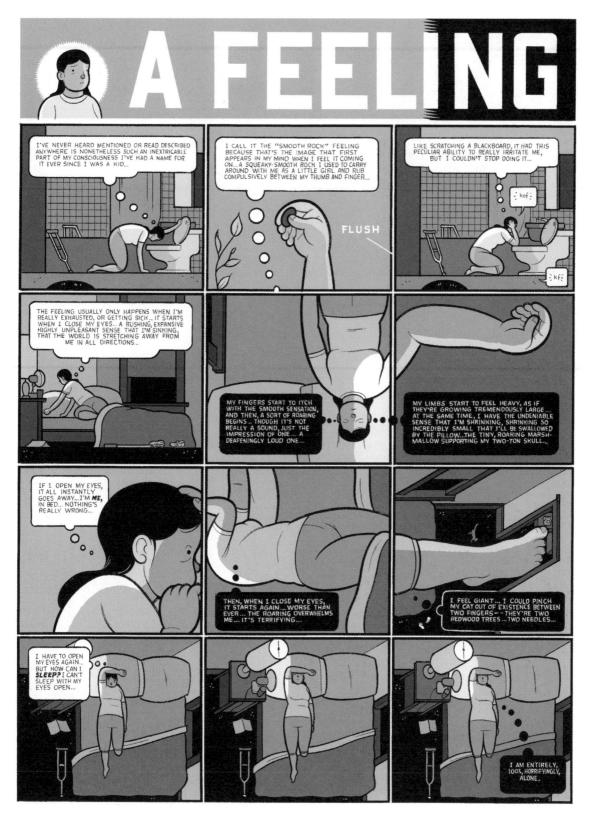

CHRIS WARE A Feeling

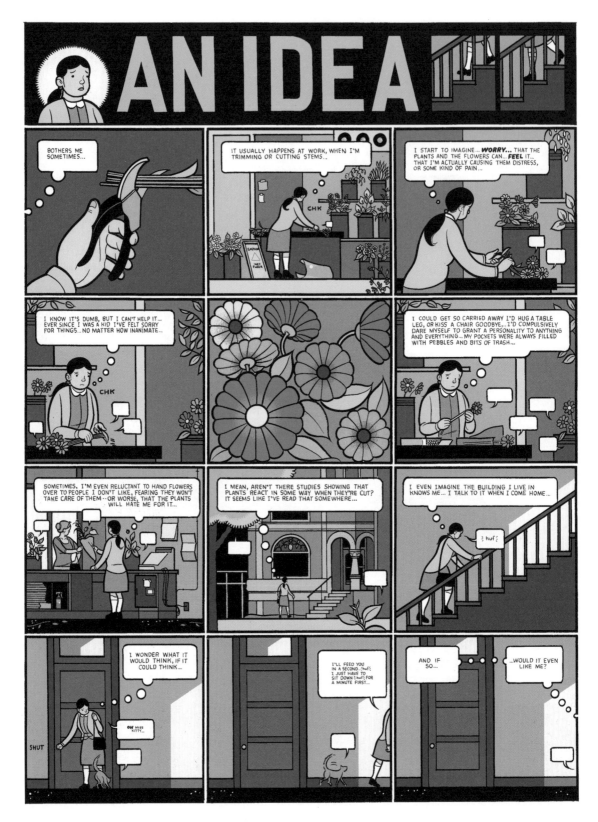

CHRIS WARE An Idea

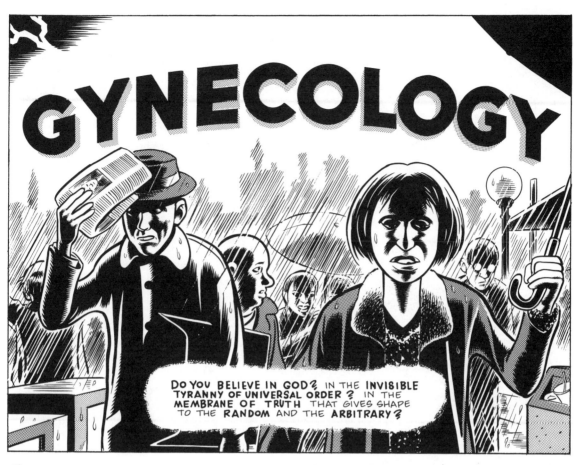

GYNECOLOGY

DO YOU BELIEVE IN GOD? IN THE INVISIBLE TYRANNY OF UNIVERSAL ORDER? IN THE MEMBRANE OF TRUTH THAT GIVES SHAPE TO THE RANDOM AND THE ARBITRARY?

THE MOVING EYE, FLUTTERING RANDOMLY, ALIGHTS ON THIS ARBITRARY MAN. IMMEDIATELY WE NOTICE HIS MANNERED, IMPRECISE STYLE; THE SUIT THAT, THROUGH NO FAULT OF ITS OWN, FAILS TO EVOKE A RUMPLED WILLIAM BENDIX...

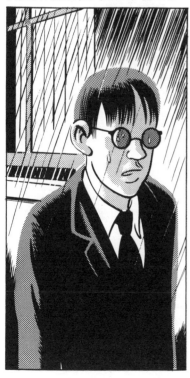

ACCORDING TO OFFICIAL RECORDS HIS NAME (AS OF 4/8/88) IS EPPS, HAVING EXCISED HIS FIRST NAME ON THAT DATE.

MOREOVER, IS THIS TENSENESS JUSTIFIED? WHAT SORT OF MAN IS OUR EPPS?

YOU WILL NOTICE A SUDDEN LURCH— IS IT BECAUSE OF THE THUNDER? THE WOMAN'S HAT? THE ARCHITECTURE?

AT THIS EXACT MOMENT ELEVEN YEARS AGO HE IS ON THE MAKE, FEIGNING ASEXUALITY TO WIN THE FAVOR OF TWO BEAUTIFUL, SEXUALLY AMBIGUOUS WOMEN...

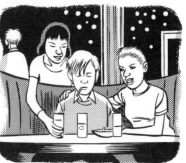

THIS PERSONA HAS BEEN DEVELOPED BY EPPS AS A MEANS TO GAIN ENTRANCE INTO THE LIVES OF COLD, ASSERTIVE WOMEN (HIS PREFERRED TYPE).

IT WORKS, BUT ONLY TO A POINT. HE CAN NEVER TAKE THE NEXT STEP WITHOUT FATALLY BETRAYING HIS ADOPTED CHARACTER. AFTER NINE MONTHS OF TRIAL AND ERROR HE WILL GIVE UP AND TRY SOMETHING NEW.

BUT THIS ALONE DOESN'T TELL US ANYTHING, BETTER TO START AT THE BEGINNING...

OUR EPPS APPEARS TO BE A QUIET CHILD, BORN OF MODEST MEANS... HERE'S SOMETHING: HE HAS A MENTALLY DEFICIENT OLDER BROTHER WHO GETS ALL THE ATTENTION...

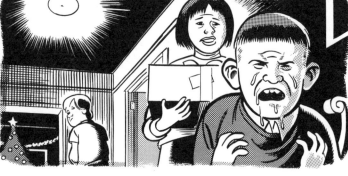

HE IS SOMETHING OF A COLLECTOR AND HAS ON PRIDEFUL DISPLAY A COMPLETE SET OF "DR. DISGUISE" FIGURES. HE CHANGES THE COSTUMES WEEKLY... HE ALSO HAS A MILD FASCINATION WITH NAZI GERMANY...

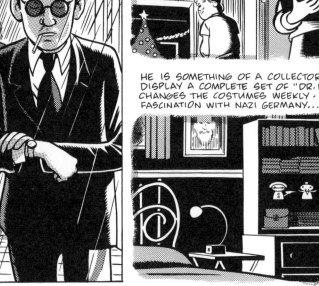

IN LATE ADOLESCENCE, A SWEDISH STEPFATHER ENTERS THE PICTURE, DISDAINFUL OF YOUNG EPPS (KNOWN THEN AS RAYMOND).

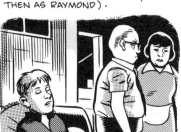
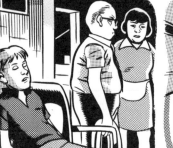

THIS HATEFUL MAN WILL ONE DAY PAY FOR EPPS TO GO TO ART SCHOOL AND LATER SERVE AS AN ALL-PURPOSE SCAPEGOAT.

SEVERAL YEARS AFTER ART SCHOOL, AFTER ASEXUALITY, AFTER MORBID VULGARITY, AFTER THE JOE LUNCH-PAIL COMMON MAN PHASE, EPPS DEVELOPS A NEW PERSONALITY.

HE READS CHESTER HIMES AND MALCOLM X AND LISTENS ATTENTIVELY TO MILES, MONK, ETC. HE TEMPORARILY WINS THE HEART OF A WOMAN NAMED BONITA (BUNNY) WHO ONCE SANG A MEDLEY FROM "THE WIZ" AT A HIGH SCHOOL ASSEMBLY...

SHE JOKINGLY CHIDES HIM (IN THE VOICE OF HER GRANDMOTHER) FOR ACTING NIGGERISH. HE USES HEROIN BUT NEVER MANAGES TO GET ADDICTED.

AFTER SIX WEEKS SHE LEAVES HIM AND BEGINS SYSTEMATICALLY DATING HIS FRIENDS.

I DON'T NEED A MAN TO ACT LIKE MY FATHER!

ON WHAT A BRITTLE THREAD DOES THE LIFE OF A MAN HANG!

TREVOR, YOU POOR DARLING!

SPEAKING IS MRS. TEN BOOM, WIFE OF A DR. TEN BOOM.

I DON'T LIKE "TREVOR". CAN'T YOU THINK OF SOMETHING ELSE?

THAT'S YOUR NAME AS FAR AS I'M CONCERNED! ...UNLESS YOU WANT TO TELL ME YOUR REAL NAME...

I SHOWED YOU MY DRIVER'S LICENSE...

OH CHRIST!

I'M SO GLAD TO SEE YOU PEOPLE TOGETHER AGAIN!

WAITER! EXCUSE ME!

* ACTUALLY A NON-DRIVER IDENTITY CARD. EPPG DOESN'T DRIVE.

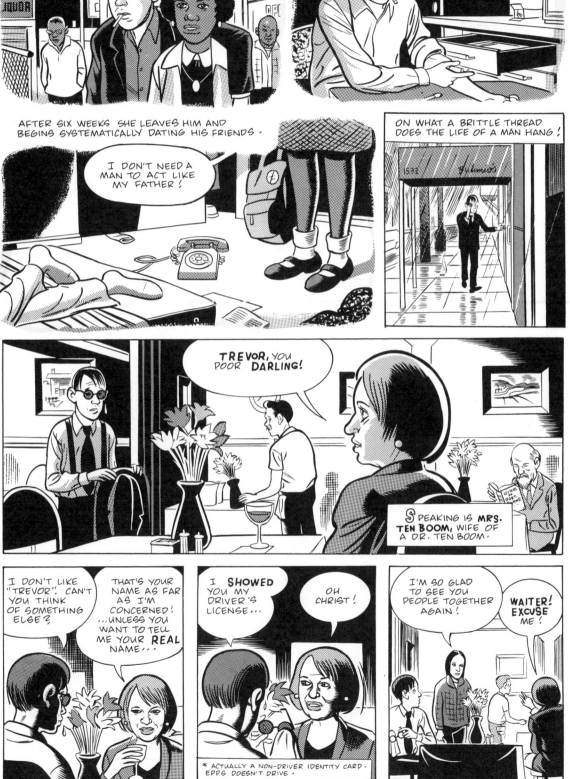

DANIEL CLOWES Gynecology

377

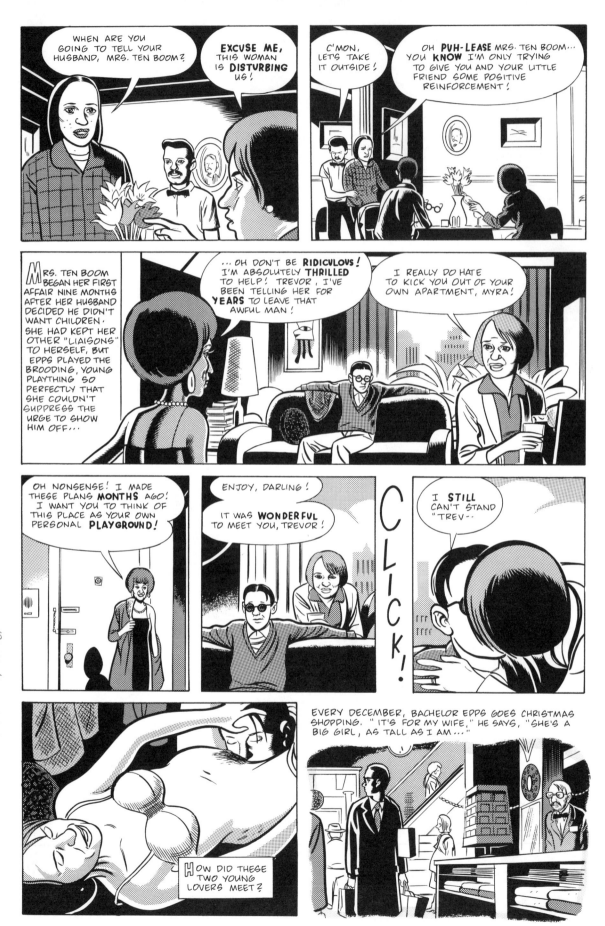

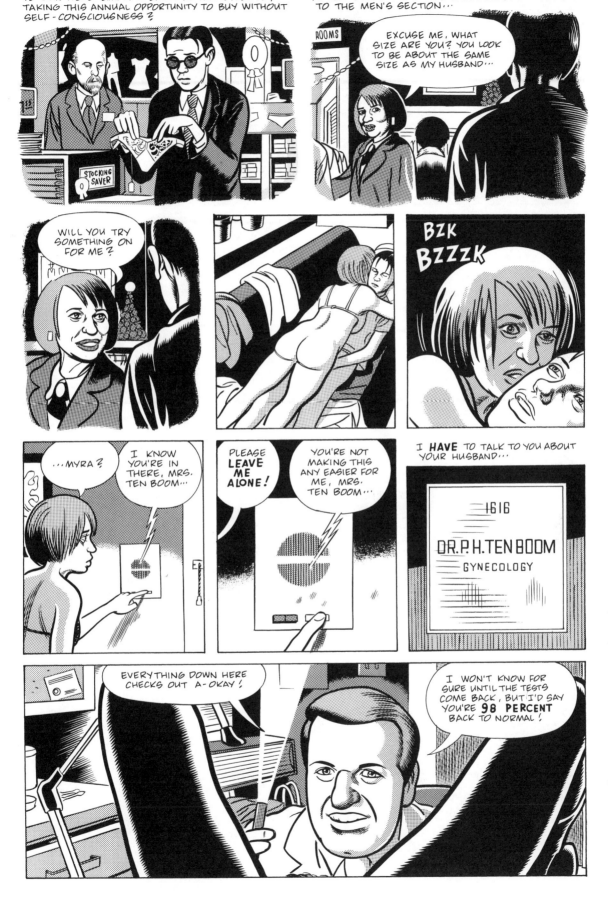

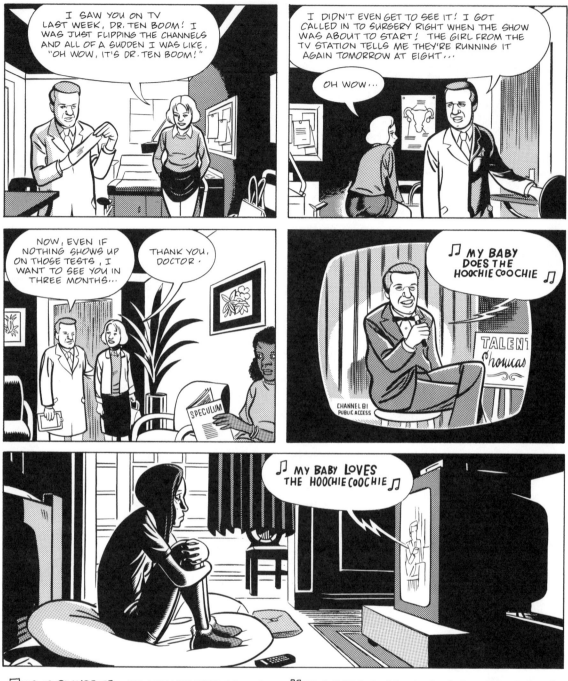

FROM HER ADOLESCENT HOMELIFE, CLOUDED BY THE STRANGE DYNAMIC BETWEEN FATHER AND MOTHER, AN OVERDEVELOPED FANTASY LIFE BEGINS...

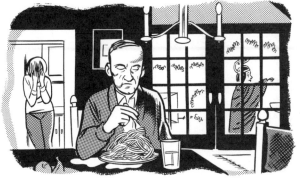

AT NINETEEN SHE HAD HAD NO SEXUAL EXPERIENCE, AND HAD NOT YET BEGUN MENSTRUATION, POSSIBLY THROUGH SHEER WILL POWER.

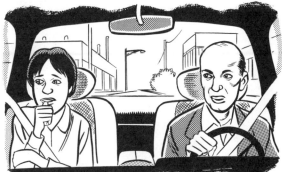

AGAINST THE INSISTENCE OF HER MOTHER, HER FATHER TAKES HER TO SEE A GYNECOLOGIST, DR. TEN BOOM. THIS REMAINS THE ONLY VIOLATION OF HER WOMANLY PLANES TO DATE.

THE OBSESSION (SUCH AS IT IS) HAS BLOSSOMED FROM THAT MOMENT; QUIETLY, AT FIRST...

TURNING CONFRONTATIONAL ONLY IN THE LAST YEAR AND ONLY THEN IN REGARD TO MRS. TEN BOOM, FOR WHOM SHE HOLDS A FRUSTRATING, HOSTILE EMPATHY.

I DON'T **WANT** TO KILL YOU...

TO CLAUDETTE, OUR EPPS IS AN ALLY; AN ANGEL OF COMPASSIONATE TEN BOOM DIVISION... OR PERHAPS SOMETHING MORE?

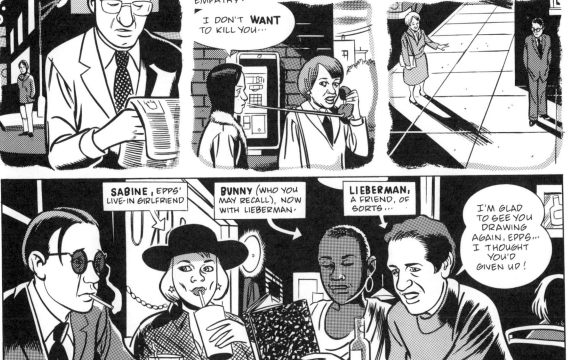

SABINE, EPPS' LIVE-IN GIRLFRIEND

BUNNY (WHO YOU MAY RECALL), NOW WITH LIEBERMAN.

LIEBERMAN, A FRIEND, OF SORTS...

I'M GLAD TO SEE YOU DRAWING AGAIN, EPPS... I THOUGHT YOU'D GIVEN UP!

DANIEL CLOWES Gynecology

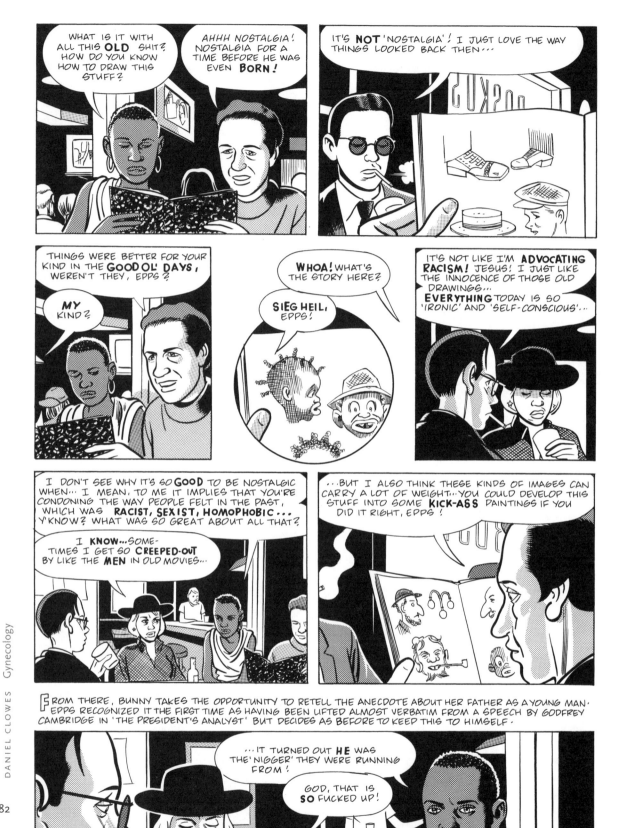

In STRAINING TO CONCEAL HIS EMBARRASSMENT, A MAGIC FIRING OF SYNAPSES BRINGS TO MIND THE LAST TIME HIS PAINTINGS WERE HELD ON DISPLAY (DURING A ROTHKO PHASE, AT A POST-GRADUATION EXHIBIT)...

FOR SOME REASON, A SEMI-FAMOUS CRITIC IS IN ATTENDANCE, AND YOUNG EPPS IS FLUSHED WITH UNREALISTIC HOPEFULNESS...

MIDWAY THROUGH THE EVENING, LIEBERMAN (WHO YOU KNOW) AND A **MR. PEACH** (KNOWN TO ALL AS AN UNREPENTANT MASTURBATOR) PASTE A PORNOGRAPHIC PICTURE OVER ONE OF THE SENSITIVE PHOTOGRAPHS TAKEN BY A FORMER CLASSMATE.

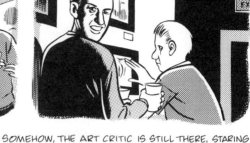

THE SHOW IS NOT GOING WELL. THE CROWD THINS EARLY ON AND THOSE WHO REMAIN ARE DRUNK.

SOMEHOW, THE ART CRITIC IS STILL THERE, STARING INTENTLY AT PEACH AND LIEBERMAN'S PASTED ON IMAGE...

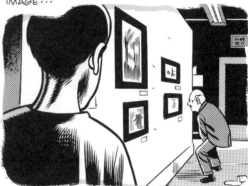

HE CONTINUES STARING, LOOKING BACK AND FORTH AT THE PICTURE AND ITS TITLE "MY STRUGGLE" BY JULIE BACON...

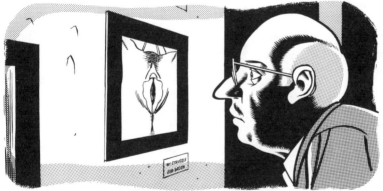

HOW COME YOU NEVER SHOW YOUR DRAWINGS TO **ME**?

I THOUGHT I DID...

SABINE AND EPPS MET WHEN SHE RESPONDED TO AN AD THAT READ: "FEM. FIG. MODEL WANTED FOR FINE ARTIST/PAINTER. ALL TYPES. LV. MSG."

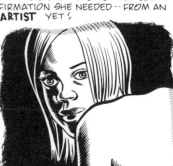

SHE HAD ALWAYS THOUGHT OF HERSELF AS A GLAMOROUS, UNUSUAL WOMAN AND THIS WAS JUST THE SORT OF CONFIRMATION SHE NEEDED -- FROM AN **ARTIST** YET!

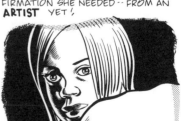

DANIEL CLOWES Gynecology

383

TO EPPS, THIS AD HAD BEEN NO MORE THAN A CHEAP PLOY TO MEET BRAZEN WOMEN...

MOVING IN TOGETHER WAS A BIG MISTAKE AND BOTH OF THEM KNEW IT, BUT WHAT COULD BE DONE?

ON ANOTHER NIGHT, AS THEY WATCH A LOW-BUDGET ART FILM MADE BY A FRIEND OF A FRIEND, EPPS NOTICES SOMETHING...

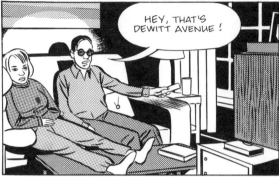

HEY, THAT'S DEWITT AVENUE!

I KNOW THAT EXACT BLOCK!

ROSA

EPPS PRESSES THE FREEZE-FRAME BUTTON.

HE LOOKS INTO THE VERY SAME WINDOW, ABOVE A SUSPICIOUS BODEGA, THAT HAD ONCE SHED LIGHT ON THE STUDIO APARTMENT OF A BELOVED GIRLFRIEND...

SHE FALLS ASLEEP AFTER THEIR FIRST AND ONLY SEXUAL CONGRESS AS EPPS SITS, BREATHLESS IN RAPTUROUS CONTEMPLATION...

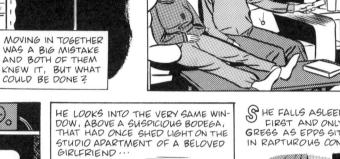

WITHIN AN HOUR OF WITHDRAWAL, HIS EYES BEGIN TO ITCH; HE STARTS COUGHING; HIS LUNGS CONTRACT... IS IT HER PILLOW (THE FEATHERS?) OR HER CAT?

HE WRITES A NOTE (THE ONE TIME HE WOULD WRITE 'LOVE' AND MEAN IT) AND LEAVES, NEVER IMAGINING THAT HE WOULD NOT BE INVITED BACK...

HE REMEMBERS A PAINTING DONE DURING THAT TIME...

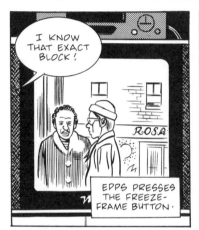

SLOWLY, A VISCOUS LOATHING COATS OVER HIS MEMORIES, SPARING NOTHING: THE PAINTING, THE GIRLFRIEND... "IF I KNEW THEN WHAT I KNOW NOW," HE THINKS...

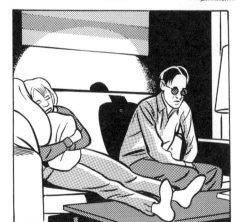

BITCH

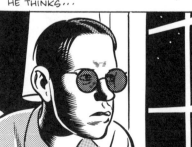

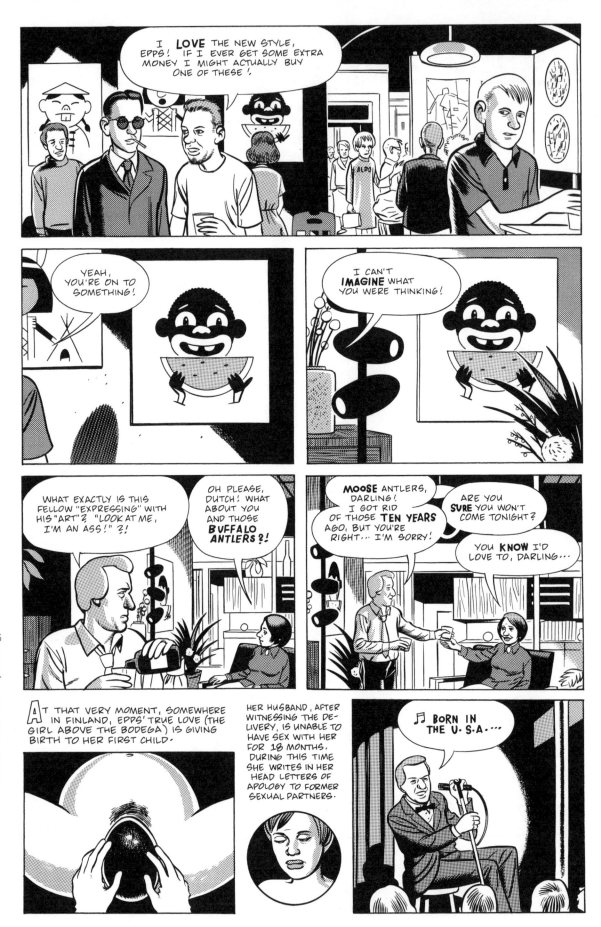

DANIEL CLOWES Gynecology

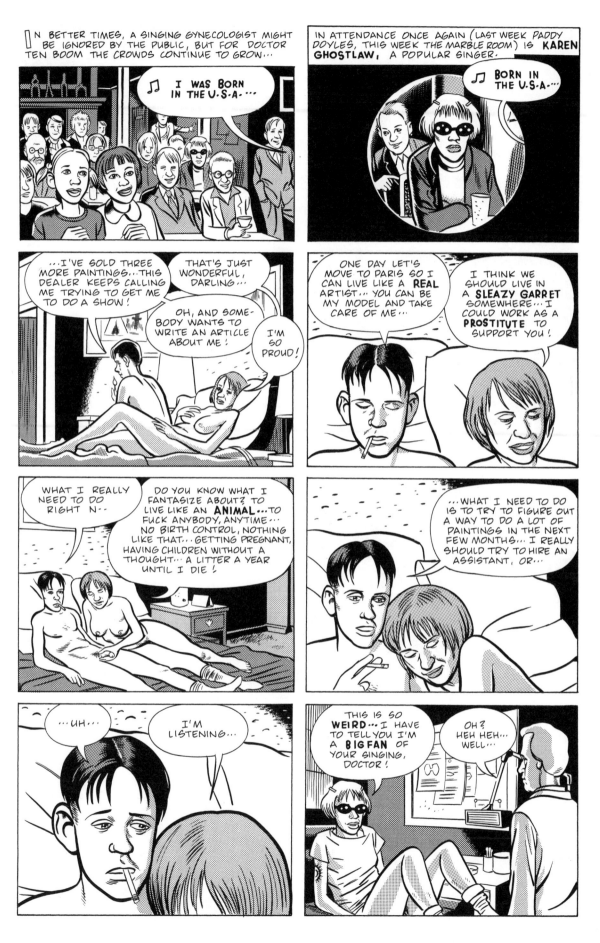

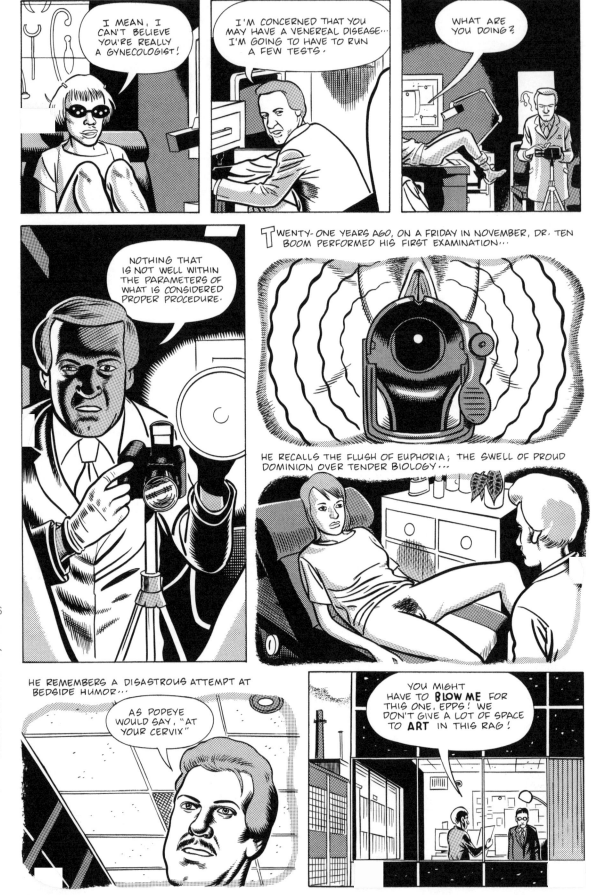

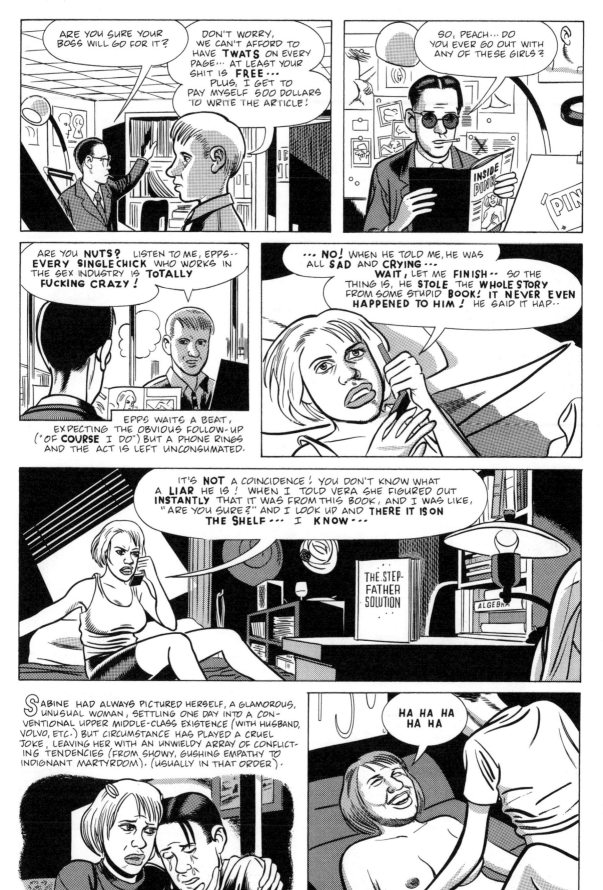

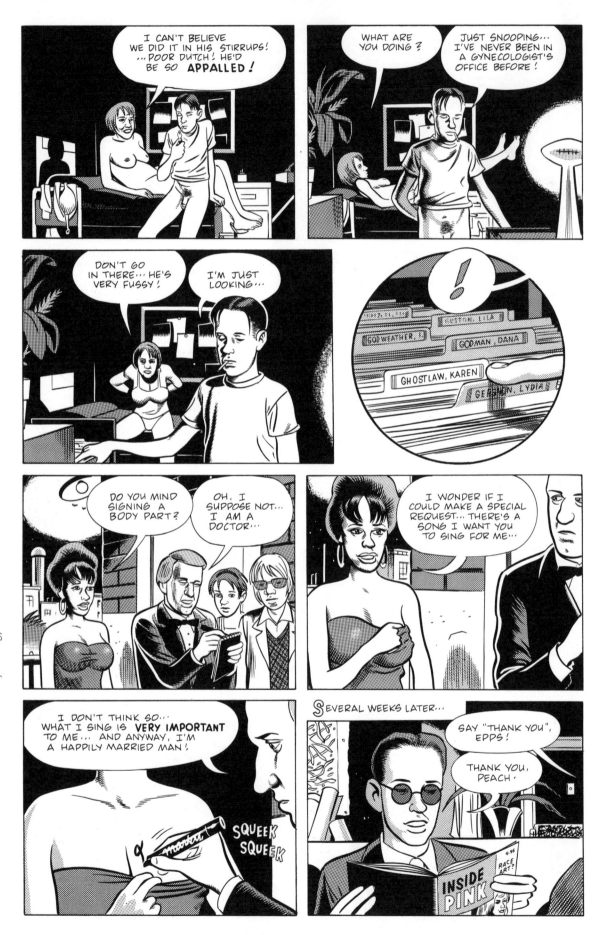

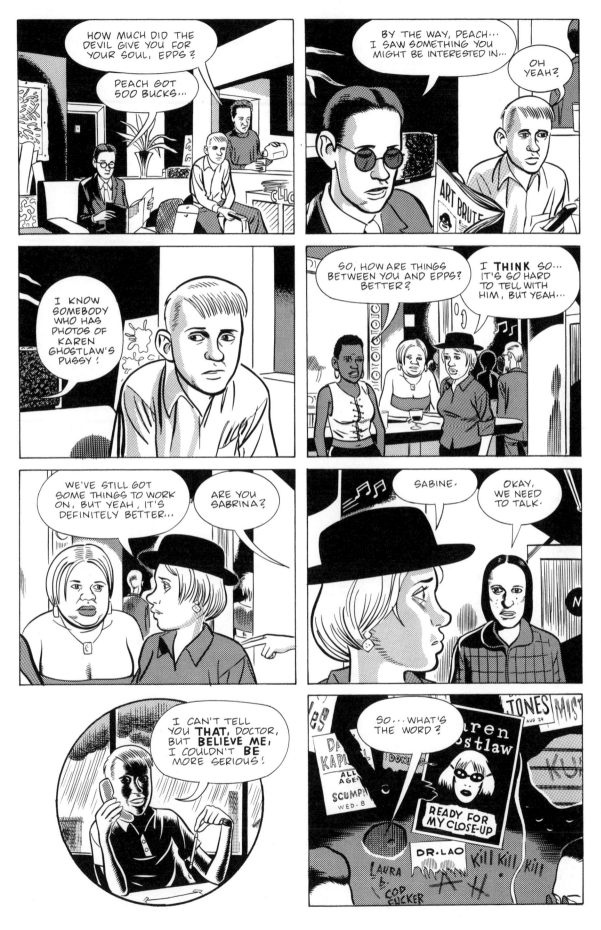

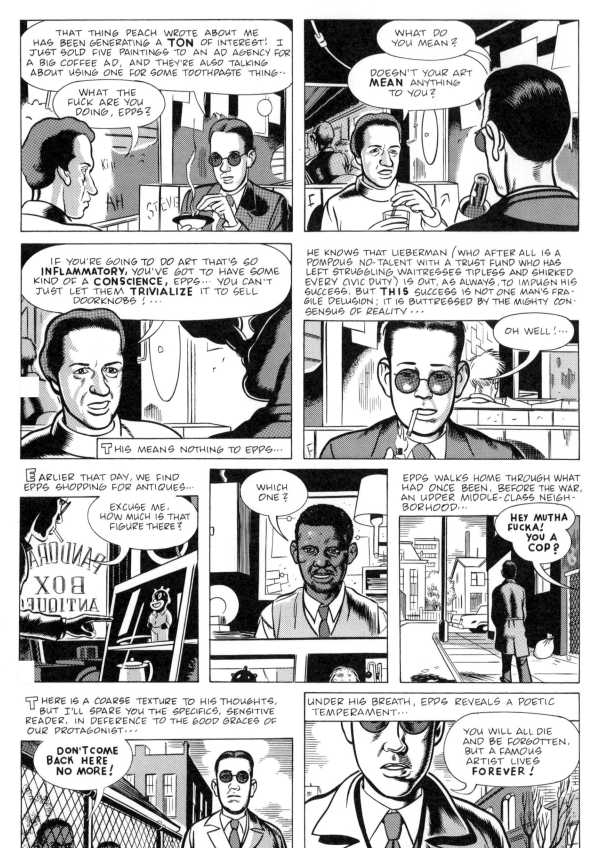

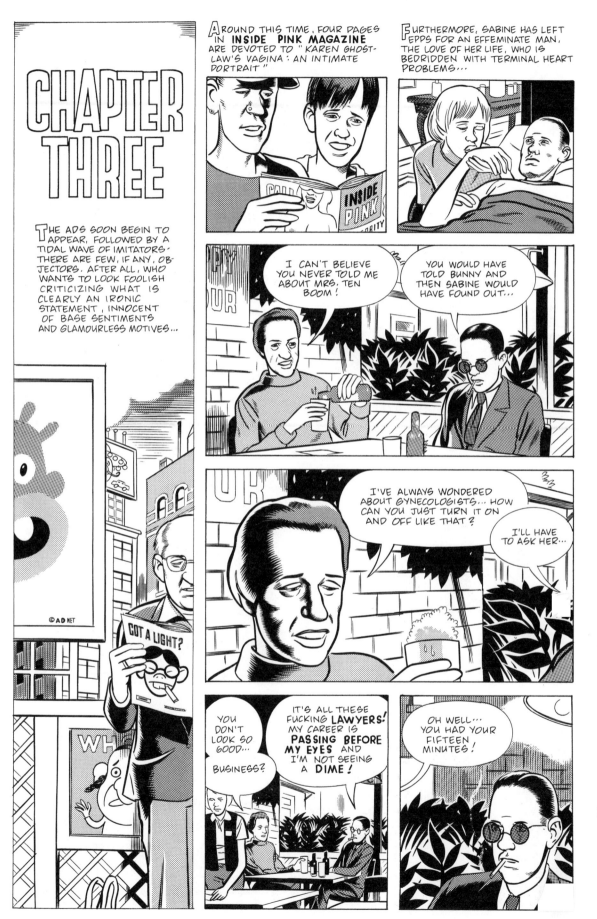

KAREN GHOSTLAW'S PEOPLE SUE DR. TEN BOOM AND THERE IS AN OUT-OF-COURT SETTLEMENT...

CAN WE TALK TO YOU FOR A MINUTE, DOCTOR?

LOOK, I'M SORRY... I'VE GOT A LOT ON MY MIND... WE'LL TALK LATER...

DON'T LEAVE YET...

I DON'T THINK THERE'S ANY POINT TO THIS, DARLING.

I JUST... IT'S LIKE I FEEL LIKE WHEN I WAS A KID AND MY STEP-FATHER USED TO TELL MY MOM SHE SHOULD--

OH PLEASE! DON'T YOU UNDERSTAND? I DON'T WANT TO PLAY ANYMORE!

"WHEN THINGS WERE GOING GOOD YOU HAD ALL THE TIME IN THE WORLD FOR ME, YOU SELFISH BITCH," THINKS EPPS. "WHAT KIND OF SELF-RESPECTING WOMAN WOULD MARRY A GYNECOLOGIST, ANYWAY? A MAN WHO LOOKS AT OTHER WOMEN'S PUSSIES ALL DAY... A MAN WHO CAN TURN OFF NATURAL HUMAN IMPULSES LIKE A LIGHT SWITCH WHENEVER HE FEELS LIKE IT..."

I SUPPOSE IT'S MY PROBLEM, DARLING... DON'T FEEL BAD...

THIS IS IT, EPPS THINKS. I'VE HAD MY TINY MOMENT OF SUCCESS --A GIRL ON EACH ARM, MONEY IN MY POCKET...

EPPS IMAGINES HIMSELF THE SPURNED HEROINE OF A VICTORIAN NOVEL, CRYING STAGEY, MELODRAMATIC TEARS...

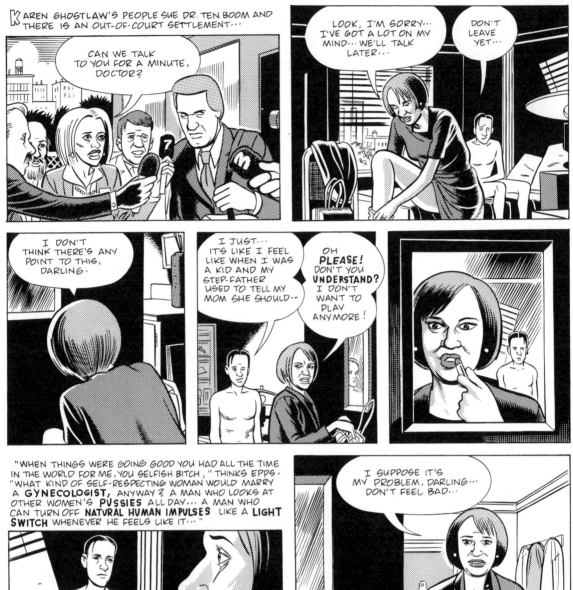

DANIEL CLOWES Gynecology

394

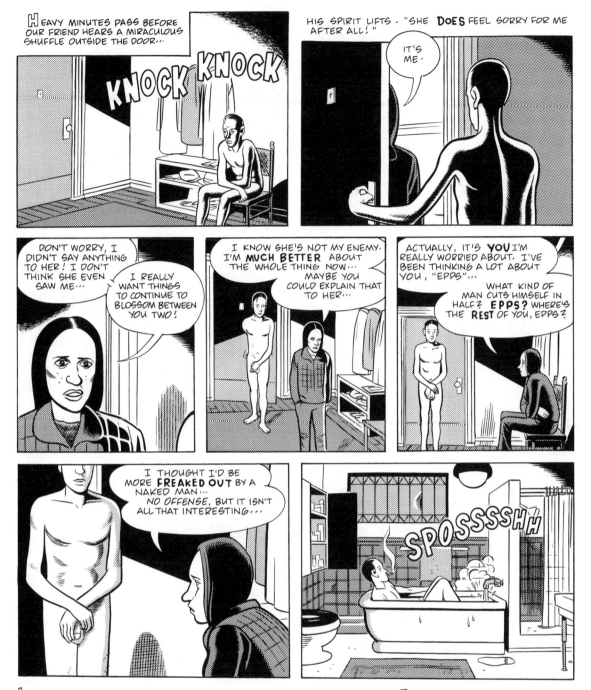

HEAVY MINUTES PASS BEFORE OUR FRIEND HEARS A MIRACULOUS SHUFFLE OUTSIDE THE DOOR...

KNOCK KNOCK

HIS SPIRIT LIFTS. "SHE **DOES** FEEL SORRY FOR ME AFTER ALL!"

IT'S ME.

DON'T WORRY, I DIDN'T SAY ANYTHING TO HER! I DON'T THINK SHE EVEN SAW ME...

I REALLY WANT THINGS TO CONTINUE TO BLOSSOM BETWEEN YOU TWO!

I KNOW SHE'S NOT MY ENEMY. I'M **MUCH BETTER** ABOUT THE WHOLE THING NOW... MAYBE YOU COULD EXPLAIN THAT TO HER...

ACTUALLY, IT'S **YOU** I'M REALLY WORRIED ABOUT. I'VE BEEN THINKING A LOT ABOUT YOU, "EPPS"...

WHAT KIND OF MAN CUTS HIMSELF IN HALF? EPPS? WHERE'S THE **REST** OF YOU, EPPS?

I THOUGHT I'D BE MORE **FREAKED OUT** BY A NAKED MAN... NO OFFENSE, BUT IT ISN'T ALL THAT INTERESTING...

SPOSSSSHH

IN THIS LUCID MOMENT, EPPS CONCENTRATES AND SEES THE WORLD WITH HARSH, OBJECTIVE CLARITY: ALL OF GOD'S CHILDREN ARE SIMPLE ANIMALS, OF NO MORE OR LESS INTEREST TO THE CLINICAL OBSERVER THAN A LEAF OR A CLAMSHELL...

HE HIMSELF, OF COURSE, IS THE EXCEPTION. HIS PERSONAL HISTORY CASCADES BEFORE HIM AS A PATTERNLESS COMPLEX OF CONFLICTING PHASES AND TANGENTIAL NOTIONS, DEFINING A HUMAN MATRIX SO UNFATHOMABLY OBSCURE AS TO YIELD AN INFINITE NUMBER OF CORRECT INTERPRETATIONS...

EPPS FEELS A DULL ACHE BEHIND HIS TONSILS. HE OPENS HIS MOUTH AND LOOKS TO THE MIRROR BUT SEES ONLY THE HANDSOME BLUR OF A TRAGIC, MISUNDERSTOOD GENIUS.

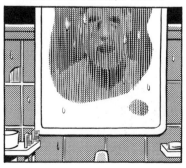

AFTER A CONCERT IN MIAMI, KAREN GHOSTLAW IS KILLED BY A BACKSTAGE MAIL BOMB. (ALAS, I HAVE NO CONTROL OVER SUCH THINGS (ONLY THE WEATHER, EARTHQUAKES, WHIRLPOOLS, VOLCANOS, ETC.))

DR. TEN BOOM QUITS GYNECOLOGY AND MRS. TEN BOOM IS, FROM THAT POINT ON, A FAITHFUL WIFE...

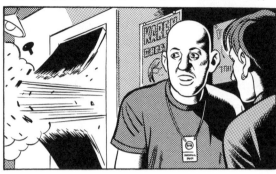
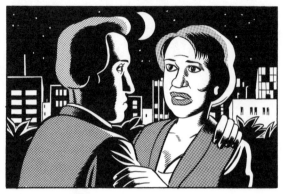

CLAUDETTE IS SENT TO DEATH ROW WHERE SHE BEGINS A ROMANTIC CORRESPONDENCE WITH A HIGH SCHOOL ENGLISH TEACHER...

BUNNY AND LIEBERMAN HAVE A CHILD...

FOR SEVERAL WEEKS DR. TEN BOOM HOVERS ON THE LOW END OF THE CHARTS WITH HIS RENDITION OF AN OLD ROY ORBISON SONG...

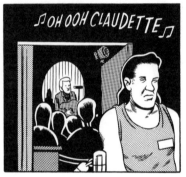

AND OUR EPPS? WE RETURN HIM TO THE STREET WHERE WE FOUND HIM. (ALLOW ME, IF YOU WILL, TO BRING IN A THUNDER CLOUD FOR EFFECT.)

SENSING PERHAPS HIS IMPENDING ESCAPE FROM THE BONDS OF OUR SCRUTINY (THE UNHOLY SURVEILLANCE OF INCONTROVERTIBLE GOD AND IMAGINARY READER), HE MOVES WITH BRISK DETERMINATION...

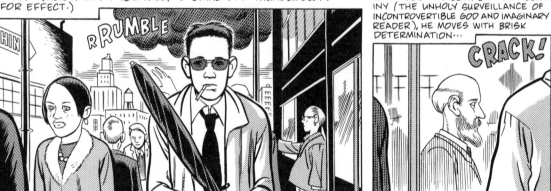

AS HE DISAPPEARS, WE ARE LEFT WITH THRILLING FRAGMENTS OF A NEW EPPS: THIS TIME, AN EMBITTERED, INTENTIONALLY UNFASHIONABLE, WORLD-WEARY MISANTHROPE (RECYCLING SUCCESSFUL MOTIFS FROM THE PAST (JAZZ, ALCOHOLISM)). THIS WILL LEAD OF COURSE TO CRIPPLING LONELINESS WHICH IN TURN WILL LEAD TO A BRIEF MARRIAGE TO A MANIC DEPRESSIVE SCULPTRESS WHO WILL FURTHER SEND OUR BOY CAREENING LIKE A PINBALL TOWARD YET ANOTHER FUTURE OF SEEMINGLY UNLIMITED POSSIBILITIES...

The following excerpt by Daniel Raeburn is adapted from "The Fallen World of Daniel Clowes," The Imp, No. 1, 1997.

In the first panel of "Gynecology," Clowes' narrator thunders, "Do you believe in God?"

This direct address points out that we believe a story only to the extent that we believe in its author's authority. Like a Zeus asserting that authority, Clowes throws a bolt of lightning in the first panel. The lightning evokes a revelation: "When the world is illuminated," Clowes explains to me, "and all of a sudden you see everything with perfect clarity."

This epiphanic flash augurs the story's climax, when Epps has a vision in his bathtub. Epps' vision? Humans are mere animals, each as inconsequential as a leaf. Of course, Epps sees himself as the exception. His life has meaning, so much that each and every contrary interpretation of his life is equally valid. Epps finds meaning in such abundance that he finds it all, ultimately, meaningless.

"That's my view of the world at the worst possible moment," Clowes says. "That's a lot of what this story was about: my worst-case thoughts. When I get as depressed as I can get, these are the thoughts that cross my mind."

In the final panel Epps is described as a pinball bouncing in a machine. His life, like the author's constructed story, is mechanical. But, as the author suggested in his opening, we can fathom a membrane of truth that connects this story's seemingly random machinations. That membrane, the proverbial ghost in the machine, is the reader's own interpretation. The interpretation may be only one of many, but it's God, for lack of a better word.

This is the conclusion that Clowes literally drew for himself: "I had these many ideas that I'd sketched out," he explains, "and somehow I created a way to link them all together that made sense, had some meaning." Clowes is not unlike Joseph Conrad's Marlowe, who said that his story's meaning was not inside the story but outside it, in the unseen. Cloudy meanings surround "Gynecology" and render its meaning visible as haze reveals the halo around the moon.

But what is the meaning radiating from this story? From the first bolt, light is the dominant visual metaphor. Epps and the wife of the singing gynecologist lie in adultery with all the lights on while the cuckold uses his penlight to peer deep into another dark maw of human birth. The characters are looking for themselves, and in doing so they invariably imitate other people. Clowes illuminates a world where everybody is at best a copycat, at worst a plagiarist.

"I think that everybody, every artist is, to some degree," Clowes says. "I have a lot of trouble seeing where my style begins and where the styles of my influences end. It's something I want to figure out."

Although Clowes maintains that he's not necessarily accusing himself of plagiarism, his story smells like guilt. Here's the catch: if an artist thinks his conscience has failed him, isn't his conscience then working? Or can an artist at work turn his conscience on and off like a light switch, just as a gynecologist at work should turn off his libido?

The reader's conscience is troubled by Epps' use of racist stereotypes to earn fame first as a fine artist, then as a commercial artist. The increasingly unclear line between ads and art is blurred by their mutual use of loaded images to sell themselves. Both are ironized, appearing to overturn stereotypes even as they exploit them for their own ends.

"Advertising sort of has this patina of PC-ness to it," Clowes says. "I think there's a lot of stuff on TV that's borderline questionable in terms of what it's saying about groups of people."

Does he think the use of such blatant stereotypes would fly in a real ad campaign?

"No, that was tweaked a little bit. I think something that's maybe not so cut and dried would fly in a slightly different climate."

The stereotypes in "Gynecology" arise not only from our culture but from within Clowes. Epps' use of stereotypes is rooted in his nostalgia—and nostalgia is one of Clowes' recurring bugaboos. The issue of *Eightball* that contains "Gynecology" has on its cover Sigmund Freud at the piano, playing a song entitled "The Psychopathology of Nostalgia."

"That title was based on an article I found in an old psychoanalytic journal," Clowes says. "As I read it I realized that this guy was basically talking about me. The article said specifically: 'The nostalgic will go to old movies and be unhappy because the audience laughs in the wrong places.' Things like that. I thought, 'Oh my god, I'm deeply troubled here.' So I tried to look at it in the harsh light of reality. The trouble with being nostalgic is that you can't really edit everything out of the past. You can be nostalgic for the music of the 1920s, but then you sort of have to inherently accept the way the culture was back then, and there are many things that were obviously wrong with the culture. It's a deep problem. It's a conundrum."

Dan's understanding of the racism inherent in his nostalgia seems right, yet not entirely justified. It seems a tad puritanical.

"I try to be mean," Clowes says. "I try to be hard on myself." I tell him that he is. "Good," he nods. He has turned his unforgiving satire on himself.

As Clowes digs within, he throws the stones he finds not at himself but at a dummy, a likeness he's created. The half-a-man Epps, like many of Clowes' protagonists, is only partly Clowes. It's as though Clowes were simultaneously claiming and disowning his guilt by displacing it on his doppelganger. Clowes even distances himself from his own artistic pronouncements of guilt. Bunny and Lieberman, the black and white couple who mouth Clowes' moral perspective on nostalgia, are compromised by their own plagiarism and hypocrisy.

"I don't think there's anybody in that story who's held in a less harsh light," Clowes says. "I sort of keep everybody in the same light."

In other words, the light of conscience doesn't get switched off. We're all guilty.

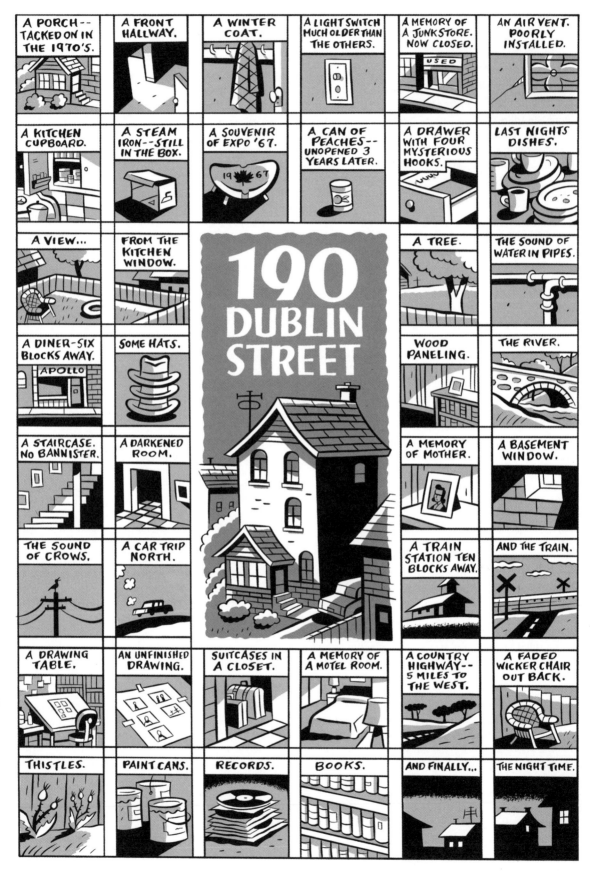

CONTRIBUTORS

Numbers at the end of each entry are the page where the artist's work appears in this book

Robert Armstrong is a cartoonist, illustrator, teacher, and musician and is perhaps best known for his *Mickey Rat* comics and *The Couch Potato Newsletter*. 136

Peter Bagge (Seattle) is best known for the alternative humor series *Hate*, starring his alter-ego Buddy Bradley. He currently is working on a miniseries titled *Apocalypse Nerd* and is a regular contributor to *Reason* and *Mad*. 80

Lynda Barry is an ancient cartoonist and writer whose books include *One Hundred Demons*, *Cruddy*, and *The Greatest of Marlys*. She lives on a farm in southern Wisconsin and will do so until she croaks. 46

Gabrielle Bell (Brooklyn) is the author of *Lucky* and *When I'm Old and Other Stories*. She regularly contributes to the ongoing Fantagraphics anthology *Mome*. 279

Marc Bell (Vancouver) is the creator of *The Stacks* and *Shrimpy and Paul and Friends*. He is currently editing the collection *Nog A Dod: Prehistoric Canadian Psychedooolia*. Marc is represented by the Adam Baumgold Gallery. 3

Jonathan Bennett (Brooklyn) is a book designer at St. Martin's Press and recently designed the latest issue of *Comic Art* magazine. He is a regular contributor to the Fantagraphics comics anthology *Mome*. 274

Mark Beyer: "I started making comics in 1975. I gave up drawing comics for good in 2000. Some of the books I had published were *Agony*, *Amy and Jordan*, and *Dead Stories*. I am now attempting to devote the rest of my life to more meaningful pursuits." 68

Mat Brinkman (Providence) has a book, *Teratoid Heights*, and draws a strip (*Multi-Force*) in *Paper Rodeo*. He is "now still working on noise and some drawings." 73

Chester Brown (Toronto) drew the comic book series *Yummy Fur*. His collections include *The Playboy*, *I Never Liked You*, *The Little Man*, and *Louis Riel*. He is currently re-serializing his story *Ed the Happy Clown* with new covers and endnotes. 224

Jeffrey Brown (Chicago) is best known for his bittersweet relationship graphic novels *Clumsy* and *Unlikely*. He is currently completing a small book about his childhood cat as well as a large collection of autobiographical short stories, *Little Things*. 264

Ivan Brunetti (Chicago) is often compared to Charlie Brown by his students. 86

Charles Burns (Philadelphia) is the author of *Black Hole* (Pantheon) as well as *Big Baby*, *El Borbah*, and *Skin Deep* (Fantagraphics). A book of recent photographs, *One Eye*, is being published by Drawn and Quarterly in 2006. 118

Daniel Clowes (Oakland) is the creator of the *Eightball* series, which has been collected in the books *Like a Velvet Glove Cast in Iron*, *Pussey!*, *Caricature*, *David Boring*, *Ice Haven*, and *Ghost World* among others (the latter was adapted by Clowes and Terry Zwigoff into an Oscar-nominated screenplay). He recently wrote the screenplay for *Art School Confidential*, loosely adapted from one of his comics. 375

David Collier (Hamilton, ON) is best known in Canada for the drawings he did at sea with the Navy (http://www.cbc.ca/arts/artdesign/artistonboard.html). He's in his 40s now, re-enrolled in the army, serving in a platoon where everyone else is half his age. His wife says he's having a midlife crisis. 337

Robert Crumb redefined comics forever with *Zap* in 1967 and has since created perhaps the finest body of work the medium has ever known. Fantagraphics is reprinting his entire oeuvre in its *Complete Crumb* series. He lives in southern France with his wife, Aline Kominsky-Crumb. 299

Henry Darger (1892–1972) is perhaps the quintessential "outsider artist" and has been the subject of many books and exhibits, as well as a documentary film. 62

Gene Deitch (Prague) won an Oscar and five nominations for his animated films. He currently makes children's films for Weston Woods/Scholastic. One of his best known is an adaptation of Maurice Sendak's *Where The Wild Things Are*. 94

Kim Deitch (New York): "I have been drawing and writing comic book stories since 1967 and love doing it. My current project is a book of illustrated fiction that I am doing with my two brothers, *Deitch's Pictorama*. My next book is *Shadowland* (Fantagraphics, 2006), which includes 'Young Ledicker' along with many other stories with that character. In early 2007, I will have another collection, *Alias the Cat* (Pantheon)." 126

Julie Doucet (Montreal) used to draw comics (*My Most Secret Desire*, *New York Diary*) and has done many different things since then. She now writes poems in French with words cut out from magazines. 256

Michael Dougan (Seattle) is an accomplished cartoonist and illustrator and is the author of *I Can't Tell You Anything*, which this editor hopes will be reprinted someday. 286

Debbie Drechsler (Santa Rosa) has been an editorial illustrator for the past 20 years, give or take a few. Her early comics were collected in the book *Daddy's Girl* (Fantagraphics), and her series *Nowhere* has been collected in a book called *The Summer of Love* (Drawn and Quarterly). 218

Lyonel Feininger (1871–1956) is known worldwide for his accomplishments as a painter, but began his career in art as a cartoonist and illustrator. His work was featured in the historic *Masters of American Comics* exhibit. 61

Phoebe Gloeckner is perhaps best known for her book *A Child's Life and Other Stories* and her illustrated novel *The Diary of a Teenage Girl*. 215

Justin Green (Cincinnati) is working on *The Last Will and Testament of Binky Brown*, to be published by Last Gasp, and continues to do a monthly comic for *Signs of the Times* magazine. 205

Bill Griffith is best known for the strip *Zippy*, syndicated by King Features to around 100 daily newspapers. In 2000 Fantagraphics published the first *Zippy Annual*, the latest of which are *Zippy: From Here to Absurdity*, and *Zippy: Type 'Z' Personality*. Griffith is married to cartoonist and editor Diane Noomin; they live in Connecticut. 27

John Hankiewicz (Westmont, IL) has self-published his comic *Tepid* since 1995 as well as several mini-comics. A collection of his recent comics, *Asthma*, is forthcoming. 272

Sammy Harkham (Los Angeles) edits the comics anthology *Kramer's Ergot* and draws the ongoing comic book series *Crickets* (Drawn and Quarterly). 173

Rory Hayes (1949–1983) was perhaps the ultimate underground artist: primitive, visionary, and wholly original. His work can be seen in Dan Nadel's *Art Out of Time*. 64

David Heatley (Brooklyn) does an ongoing comic series called *Deadpan* and contributes to the Fantagraphics anthology *Mome*. 276

Sam Henderson is living proof that Emmy nominees have to dive through couches for change. He has been a storyboard director for *SpongeBob Squarepants* and *Camp Lazlo* and recently did a video for They Might Be Giants. He can be seen regularly in *Nickelodeon* magazine, but his main vehicle is the comic book *The Magic Whistle*. 11

Gilbert Hernandez (Las Vegas), along with his brothers Jaime and Mario, has written and drawn over 60 issues of the series *Love and Rockets*. His solo books include *Fear of Comics*, *Luba in America*, and *Palomar: The Heartbreak Soup Stories*. 184

Jaime Hernandez was born in 1959 in Oxnard, California, the one-time lima bean capital of the world, then the heroin trafficking capital of the U.S., now the strawberry capital. He loves comics and has been drawing them professionally since 1982 (mostly *Love and Rockets*) and would like to continue doing them until he's a really old man. 190

George Herriman (1880–1944) is the creator of *Krazy Kat*, universally acknowledged as a masterpiece of the medium. Fantagraphics is currently reprinting his masterful Sunday pages in its *Krazy & Ignatz* series. 57

Walt Holcombe (Los Angeles) is currently working on a collection of his comics work, *Things Just Get Away From You*, for Fantagraphics, due out in 2007. 84

Kevin Huizenga (St. Louis) has contributed strips to the anthologies *Orchid*, *Drawn and Quarterly Showcase*, and *Kramer's Ergot 5*. He is currently working on the comic book series *Or Else* (Drawn and Quarterly) and *Ganges* (Fantagraphics). 283

Crockett Johnson's (1906–1975) comic strips were collected into the books *Barnaby* and *Barnaby and Mr. O'Malley*. He is also the creator of the classic series of children's books *Harold and the Purple Crayon*. 42

J. Bradley Johnson (San Francisco) has contributed to several anthologies over the years but has yet to make a whole comic book. He enjoys drawing and long late-night walks. 107

Ben Katchor (New York) was awarded a MacArthur Foundation Fellowship in 2000. Four collections of his strips have been published: *Cheap Novelties: The Pleasures of Urban Decay*; *Julius Knipl, Real Estate Photographer*; *The Jew of New York*; and *The Beauty Supply District*. 141

Kaz (New York/Los Angeles) continues to draw his weekly *Underworld* comic strip, which is self-syndicated across America and Europe; to date, five collections have been published by Fantagraphics: *Cruel and Unusual Comics, Bare Bulbs, Ink Punk, Duh,* and *My Little Funny.* 18

Frank King (1883–1969) created what may be the longest-running story in comic strip history, *Gasoline Alley.* This neglected, gentle masterpiece is being reprinted by Drawn and Quarterly in its *Walt and Skeezix* series. 59

James Kochalka (Burlington, VT) has created 16 graphic novels, as well as six music CDs with his band James Kochalka Superstar. He is currently working on two ongoing book series, *American Elf* and *SuperF*ckers,* as well as his first children's book for Random House. 43

Aline Kominsky-Crumb has a collection of autobiographical comics, *Love That Bunch* (Fantagraphics). She has collaborated with her husband, Robert Crumb, in *The Complete Dirty Laundry Comics* (Last Gasp), as well as in a series of recent strips for the *New Yorker.* 65

Harvey Kurtzman (1924–1993) is probably best known as the comic genius who created *Mad;* he also wrote, edited, and contributed to *Two-Fisted Tales* and *Frontline Combat,* war comics that refused to glorify war. 95

Jason Lutes is the author of *Jar of Fools* and the series *Berlin,* of which issues 1–8 have been collected into the first volume of an ambitious trilogy, *Berlin: City of Stones.* 162

Frans Masereel (1889–1972) was a painter and one of the greatest woodcut artists of the 20th century. He completed over 20 wordless novels in his career. 171

Joe Matt's autobiographical comic book series *Peepshow* has been collected in *Peepshow: The Cartoon Diary of Joe Matt, The Poor Bastard,* and *Fair Weather* (all published by Drawn and Quarterly). 233

David Mazzucchelli is an award-winning comics artist whose books include *Batman: Year One* (with Frank Miller) and *City of Glass: The Graphic Novel* (with Paul Karasik). Many of his own comics were published in his short-lived anthology *Rubber Blanket.* He teaches at the Rhode Island School of Design and New York's School of Visual Arts and is currently working on a new graphic novel. 30

Richard McGuire (Paris) currently is designing and directing part of an animated feature film called *Puer(s) du Noir* [Fear(s) of the Dark]. He is a regular contributor to the *New Yorker,* and known to cult music fans as the founder and bass player of the "no wave" band Liquid Liquid. 88

Tony Millionaire's grandparents taught him to love and draw scenes in the seaside town of Gloucester, Massachusetts. His comic strip *Maakies* appears weekly in the *Village Voice,* the *LA Weekly,* the *Chicago Reader,* the *Seattle Stranger,* and many other newspapers. He lives in Pasadena with his wife and two daughters. 24

Jerry Moriarty teaches at the School of Visual Arts in New York. Look for his work in *Kramer's Ergot 6.* 138

Mark Newgarden (Brooklyn) drew the cult classic syndicated feature *Mark Newgarden.* His recent books include *Cheap Laffs: The Art of the Novelty Item* and *We All Die Alone* (Fantagraphics). 12

Onsmith (Chicago) has published several mini-comics, such as *Spit-Toons* and *Baka-Geta,* and edited an anthology of one-panel cartoons, *Gag-Hag.* He is currently a student, and his comics appear sporadically in anthologies and alternative weeklies. 6

Gary Panter (Brooklyn), an Oklahoma-born illustrator, painter, designer, and part-time musician, is arguably one of the most influential graphic artists of his generation. He is a three-time Emmy Award winner for his work on *Pee-Wee's Playhouse,* as well as the recipient of a Chrysler Design Award in 2000. 110

Harvey Pekar is author of the recent graphic novels *Ego & Hubris* and *The Quitter.* The subject of the Oscar-nominated film *American Splendor,* his American Book Award–winning series of the same name has been published since 1976. Pekar's music and book reviews have been published in the *Boston Herald,* the *Austin Chronicle, Jazz Times,* and *Down Beat.* 322

John Porcellino was born in 1968 in Chicago. He has been self-publishing his own *King-Cat Comics and Stories* since 1989; several book collections of this work are available from publishers like La Mano, Drawn and Quarterly, Ego Comme X, and Reprodukt. www.king-cat.net. 268

Archer Prewitt's (Oak Park, IL) Harvey-nominated *Sof' Boy* series is published by Drawn and Quarterly, with stories in various comics collections (*Blab!, Zero Zero, Sturgeon White Moss,* etc.). He also is a recording artist on the Thrill Jockey label with his own band and guitarist for The Sea And Cake and Sam Prekop band. He is currently working on a story for an upcoming *Sof' Boy* collection. 100

Daniel Raeburn (Chicago) is the author of the book *Chris Ware.* His book about comic books, *The Imp of the Perverse,* is forthcoming from W.W. Norton. 397

Ron Regé, Jr. (Los Angeles) currently has two books in print from Drawn and Quarterly: *The Awake Field* (2006) and the republished *Skibber Bee-Bye* (2000). Several books in his *Yeast Hoist* series are also available from Buenaventura Press. Look for an unpublished story from 1997 in the *Kramer's Ergot 6* anthology (2006). Ron also plays percussion in the band Lavender Diamond. 52

Joe Sacco (Portland, OR) is the author-cartoonist of *Palestine, Safe Area Gorazde,* and other works of comics journalism. 329

Richard Sala (Berkeley) has produced a number of graphic novels and comic collections, including *Peculia, Hypnotic Tales, The Chuckling Whatsit,* and *Mad Night.* His illustrations have appeared in many magazines, books, and newspapers around the world. He is currently juggling work on three new books being released in 2006 and 2007. 96

Charles M. Schulz (1922–2000) single-handedly drew the *Peanuts* comic strip for 50 years. Fantagraphics is reprinting the entire run in its *Complete Peanuts* series. 37

Seth (born Gregory Gallant) is the author of *It's a Good Life If You Don't Weaken* and *Wimbledon Green.* He is currently serializing his graphic novel *Clyde Fans* in the pages of his comic book *Palookaville* (Drawn and Quarterly). He lives in Guelph, Ontario, with his wife, Tania. 36, 242, 398

R. Sikoryak (New York) has adapted the classics for *Raw, Drawn and Quarterly,* and

Hotwire. His cartoons have appeared in *Nickelodeon* magazine, the *New Yorker,* and *The Daily Show with Jon Stewart.* In his spare time he hosts the cartoon slide show series *Carousel.* 40

Otto Soglow (1900–1975) was a prolific cartoonist, perhaps best remembered for his *Little King* strip. His spot illustrations are still being used by the *New Yorker.* A good, solid collection of his work is sorely needed. 60

Art Spiegelman (New York) was awarded a 1992 Pulitzer prize for his two volumes of *Maus,* which was first serialized in *Raw,* the influential comix magazine he co-founded with his wife, Françoise Mouly, in 1980. His most recent book, *In the Shadow of No Towers* (Pantheon) was listed as one of the *New York Times* 100 Most Notable Books of 2004. He is currently struggling with a drawn introduction to a new edition of his 1970s work, *Breakdowns,* that threatens to become longer than the book it's introducing. 32, 149

Cliff Sterrett (1883–1964) created the *Polly and Her Pals* comic strip. Kitchen Sink printed two volumes of Sunday strips in the 1990s; perhaps someone else will soon take up the mantle. 58

James Sturm (White River Junction, VT) is the director and an instructor at the Center for Cartoon Studies. He is the author of the forthcoming *James Sturm's America* and is currently editing a series of graphic novels for Hyperion Books for Children. 166

Adrian Tomine (Brooklyn) is the writer-artist of *Optic Nerve, Sleepwalk and Other Stories,* and *Summer Blonde.* His work appears with some regularity in the *New Yorker,* and he is also the editor-designer of the English-language editions of Yoshihiro Tatsumi's comics. 176

Carol Tyler (Cincinnati) is the author of *Late Bloomer* (2005) and *The Job Thing* (1993). She also contributes to numerous other publications and is currently working on a family epic. www.bloomerland.com. 292

Chris Ware lives outside Chicago and is the author of *Jimmy Corrigan: The Smartest Kid on Earth.* He is currently serializing two new graphic novels in his ongoing periodical *The Acme Novelty Library,* the 17th issue of which is being released in late 2006. 35, 351

Lauren R. Weinstein (Brooklyn) is the author of *Inside Vineyland* and *Girl Stories,* and is now working on a *Girl Stories* sequel titled *Calamity.* 289

Wayne White (Los Angeles) lives with his wife, cartoonist Mimi Pond, and his kids, Woodrow and Lulu. He has won three Emmys as a designer for *Pee-Wee's Playhouse.* He is currently a painter with Clementine gallery in Manhattan and Western Project gallery in Los Angeles. 104

Karl Wirsum (Chicago) has appeared in *The Ganzfeld* 3 and 4. He teaches at the Art Institute of Chicago and is represented by the Jean Albano Gallery. cover

Jim Woodring (Seattle) is the author of *The Frank Book, Seeing Things,* and *The Book of Jim.* 77

Terry Zwigoff (San Francisco) directed the acclaimed documentary *Crumb* and co-wrote and directed the film adaptation of Daniel Clowes' *Ghost World.* He has most recently directed *Art School Confidential* (from a screenplay written by Clowes). 136